Fashioning Africa

EDITED BY JEAN ALLMAN

Fashioning Africa

Power and the Politics of Dress

INDIANA UNIVERSITY PRESS
Bloomington and Indianapolis

This book is a publication of

Indiana University Press
601 North Morton Street
Bloomington, IN 47404-3797 USA

http://iupress.indiana.edu

Telephone orders 800-842-6796
Fax orders 812-855-7931
Orders by e-mail iuporder@indiana.edu

© 2004 by Indiana University Press

The paper used in this publication meets the minimum requirements of American National Standard for Information Sciences—Permanence of Paper for Printed Library Materials, ANSI Z39.48-1984.

Manufactured in the United States of America

Library of Congress Cataloging-in-Publication Data

Fashioning Africa : power and the politics of dress / edited by Jean Allman.
p. cm. — (African expressive cultures)
Includes bibliographical references and index.
ISBN 0-253-34415-8 (cloth : alk. paper) — ISBN 0-253-21689-3 (pbk. : alk. paper)
1. Clothing and dress—Symbolic aspects—Africa. 2. Clothing and dress—Political aspects—Africa. 3. Women's clothing—Africa. I. Allman, Jean Marie. II. Series.
GT1580.F37 2004
391′.0096—dc22

2004000694

1 2 3 4 5 09 08 07 06 05 04

Contents

Acknowledgments

From the very beginning, this project has been an extraordinary collective effort. It started as a rather vague idea early in 2001, as I puzzled over the intersections of culture, fashion, and politics in Ghana. It then came together in a wonderful set of papers presented on two panels at the 2001 meeting of the African Studies Association in Houston, Texas. I owe my most profound gratitude, therefore, to the contributors to this volume—a most extraordinary group of interdisciplinary scholars who generously shared their expertise with me and with each other, and whose meticulous work and respect for deadlines kept this project on time and on target from the very beginning. Together, we owe much to the support, dedication, and enthusiasm of Dee Mortensen at Indiana University Press, and to the diligence and care of Jane Lyle and Shoshanna Green. What a pleasure it has been working with all of them. Finally, I would like to acknowledge the generous support of the University of Illinois Research Board and the Mellon Faculty Fellows Program, which has afforded me the time and the resources to complete the collection before you.

Fashioning Africa: Power and the Politics of Dress

Jean Allman

In July 1953, a short piece in the *Accra Evening News* entitled "Hats Off to Nkrumah" remarked on the rather sudden disappearance of men's headwear from the capital city:

> In the Gold Coast today, hats have become a rarity.
> The youngmen walk through the sun, bareheaded, wearing their hair the Nkrumah way, and ladies have taken to the turban and the headkerchief.
> For years Gold Coast citizens spent vast sums on hats & became so used to them that going about in the sun without a hat on became unbearable.
> Meanwhile, the men who introduced this infirmity were gradually discarding their hats.
> Eventually, they were to have become acclimatised to the tropics, while the African became a weakling in his own home.
> Then came Nkrumah on the scene. He opened the eyes of his people to the danger and off went the hats. . . . But this is just one of the positive affects of Nkrumahism.
> Hats off to Nkrumah. He is a dynamic leader.[1]

To some, the *Evening News* report may seem a rather frivolous human interest story set during the most tumultuous years of Ghana's struggle for independence from British colonial rule—a marginal slice of life tangential to the central stories of mass nationalist politics and the devolution of political power. For the contributors to this volume, however, the case of the disappearing hats is no fanciful aside. It is very much the central story—a story that is, at once, an assertion of citizenship, a call for nationalist unity against colonial domination, and a condemnation of the anglophilia of some urban elites.

Fashioning Africa is concerned with the ways in which power is represented, constituted, articulated, and contested through dress. It seeks to understand bodily praxis as political praxis, fashion as political language. Each chapter explores dress practice as it is embedded in fields of power—economic, political, gendered, or generational—in order to probe the ways in which modifications of the body through clothing have been used both to constitute and to challenge power in Africa and its Diaspora. Together, the chapters foreground the power of dress, the power of fashion as an incisive political language capable of unifying, differentiating, challenging, contesting, and dominating. As Joanne Entwistle has remarked,

dress "operates at the interface between the individual and the social world . . . the private and the public."[2] And it is precisely because of this strategic positioning that dress functions as a salient and powerful political language—one comparable in eloquence and potency to the spoken words of the most skilled orator or the written words of the most compelling propagandist. Yet most historical literature concerned with questions of power and political praxis in Africa has not been particularly attuned to bodily praxis or sartorial language. Clothing or dress has rarely attracted more than a footnote.[3]

Cultural Studies, Ethnography, and the Problem of History

In many ways, this lacuna is not so surprising when you consider the very different ways dress and fashion have been treated in the relevant academic literatures, with the bulk of scholarship being grounded in one or the other of two dominant paradigms: 1) a cultural studies or historical approach to fashion and 2) an anthropological or ethnographic approach to dress. The former has been specifically concerned with Western fashion as a system (including production and distribution) that has shifted across time and space, and hence is profoundly historical. It considers fashion to be an explicit manifestation of the rise of capitalism and Western modernity.[4] Ethnographic studies, on the other hand, have been concerned with dress more broadly defined as "an assemblage of modifications of the body and/or supplements to the body."[5] Leading scholars of this approach, like Ruth Barnes and Joanne Eicher, have insisted that fashion is not a dress system specific to the West and their work has consistently sought to liberate the idea of "fashion" from the theoretical clutches of Western modernity.[6] They have been joined by a handful of cultural studies scholars, including Craik, who has argued that

> Treating fashion as a marker of civilization, with all its attendant attributes, is the reason why fashion has been excluded from the repertoires of non-western cultures. Other codes of clothing behaviour are relegated to the realm of costume which, as "pre-civilised" behaviour, is characterised in opposition to fashion, as unchanging, fixed by social status, and group-oriented.
>
> This theoretical framework, with its rigid distinction between traditional and modern, has produced a remarkably inflexible and unchanging analysis of fashion.[7]

Despite the work of scholars like Craik, Eicher, Barnes, and others, however, the divide between these two approaches to dress and fashion has proven quite stubborn. And its intransigence, I would argue, especially in the context of Africa, is a problem of history, or better, of the failure of scholars to take African history seriously. The Eurocentric vision that plagues much work on fashion locates the motor of history squarely in Europe with what is portrayed as the virtually autonomous and self-contained rise of capitalism. Fashion is thus about status, mobility, and rapid change in a Western, capitalist world. At the same time, those outside of Europe (or Euroamerica) are relegated to the position of objects of ethnographic inquiry. They remain, as Eric Wolf characterized them over twenty years ago, "the

people without history," or, in this case, "the people without fashion." Unfortunately, much of the ethnographic work on African dress, because it has tended to operate in a normative present, has not provided a sustained, historical challenge to this Eurocentric vision. Yet it is through the foregrounding of African histories—local histories set in transnational contexts and transnational histories set in local contexts—that the stubborn binary "fashion studies of the West" vs. "ethnographies of costume for the rest" is transcended.[8]

In the past several years, the disruptive potential of history has become increasingly evident in the works of both historians and historical anthropologists of Africa. Jean and John Comaroff's monumental two-volume exploration of modernity in southern Africa—*Of Revelation and Revolution*—situates clothing and dress at the very center of the "long conversation" between Africans and Europeans over the meaning and substance of colonial rule. They argue in their chapter "Fashioning the Colonial Subject" that

> struggles over the way in which Tswana bodies were to be clothed and presented—struggles at once political, moral, aesthetic—were not just metonymic of colonialism. They were a crucial site in the battle of wills and deeds, the dialectic of means and ends, that shaped the encounter between Europeans and Africans.[9]

In the Comaroffs' work, the distinction between "dress" and "fashion" dissolves immediately in careful historical analyses of Tswana bodily praxis in the late nineteenth and early twentieth centuries. "Folk dress" and "fashion" both become part of a "more inclusive system of contrasts, a mutually intelligible language of style."[10] Similarly, Karen Tranberg Hansen's 2000 *Salaula: The World of Secondhand Clothing and Zambia* situates cloth and clothing at the very beginning of African encounters with the West. They "played pivotal roles," she argues, "in the political economy of the West's expansion and in the triangular North Atlantic slave trade." Although the primary focus of Hansen's study is contemporary secondhand clothing in Zambia, she locates her project in a lengthy historical investigation of modernity and African bodily praxis and thereby demonstrates how "clothing articulated African perceptions of class, status, and ethnicity during the rapidly changing colonial situation."[11]

Yet challenges to the "West vs. rest" binary have not come solely from southern Africa. Incorporating the research of a multidisciplinary range of scholars whose methods and modes of analysis bridge the split between cultural studies and ethnography, the contributors to Hildi Hendrickson's 1996 edited collection *Clothing and Difference* implicitly question the foundational premise of much Western scholarship that fashion is connected to Western modernity—a modernity, so the argument goes, from which the rest of the world was, until recently, excluded.[12] Although not primarily historical, Hendrickson's collection powerfully demonstrates the ways in which dress provides an unparalleled means for getting at a "distinctive African modernity"—what others, such as Charles Piot, have termed "vernacular modernities."[13] In so doing, *Clothing and Difference* has helped set the stage for scholars of material culture in Africa, particularly of dress, to mobilize and deploy a multidisciplinary vocabulary—honed in the fields of cultural studies, eth-

nography, art history, social history, and communications—in their explorations of what Hendrickson terms "embodied identities." More importantly for our purposes, the powerful case it makes for African modernities and for accessing those modernities through analyses of clothing and difference has paved the way for this collection and its distinctly historical agenda.

The essays collected here thus build upon the rich, longstanding ethnographic literature on dress in Africa and on cultural studies approaches to Western fashion, as well as on the recent, expanding scholarship that blurs the distinctions between these two paradigms by foregrounding historical analysis. They also draw from the enormous corpus of work produced by social and cultural historians over the past two decades who have been concerned with power, political praxis, and social change in Africa, from the local to the transnational, from the quotidian to the extraordinary.

Thematic Threads in Dressing History

By focusing on historical questions in the investigation of dress and political praxis, *Fashioning Africa* aims to challenge the Eurocentrism of much of the broader fashion studies literature and to bring history and politics to bear on the rich ethnographies of African dress.[14] The group of scholars contributing to this volume bring a diverse set of perspectives to dress, fashion, politics, and power. Included are anthropologists, historians, an art historian, and a communications studies scholar. All of their contributions are based on original and innovative primary research and range broadly across time and space—from pre- and early colonial Zanzibar to late colonial Lusaka to inner-city Minneapolis at the close of the twentieth century.

Although the contributions range widely, each foregrounds a set of common issues in the sartorial study of power. First, and perhaps most obviously, they all view clothing or dress as an enormously valuable, yet largely untapped, archive. In the face of what sometimes appears to be endless hand-wringing over the limitations of the colonial documentary archive and the impossibility of accessing the subjectivities of subaltern peoples,[15] the chapters which follow treat clothing, and dress generally, as an alternative archive which provides a window not only onto social change, but into African self-identities, self-representation, and domestic and community debates about sexuality and propriety. As Margaret Jean Hay points out in her mention of Oginga Odinga's attempts to calculate his date of birth, clothing can even constitute an archive that yields the kinds of dates and chronologies we usually associate with documentary evidence. But clothing is not simply a substitute for conventional archival silences. "Historians of dress and textiles," as Barbara Burman and Carole Turbin have recently written, "have learned to mine the meaning of material objects, visual and tactile culture, not as a substitute for verbal sources when these are unavailable, but in order *to reveal dimensions of political and social transformations that cannot be discerned in observed social behaviour or verbal and written articulations.*"[16]

And as an alternative archive, dress and clothing not only open up new dimen-

sions of social change but challenge us to reevaluate and redefine some of our operative categories. In many of the essays which follow, the focus on clothing forces us to reconsider our ideas of both "the public" and "the political" as predominantly male spaces. Conventional documentary archives, particularly colonial archives, seldom provide a record of women as autonomous public or political subjects and, if women are there at all, they exist as blurred images hovering near the margins of the body politic. The archives of dress and clothing, however, often locate women at center stage. In the chapters which follow, the focus on bodily praxis renders women's political praxis visible and sharply focused in stories of emancipation and citizenship (Fair) and of nation-building and nationalism (Akou, Allman, Byfield, Hansen, and Ivaska).

There is, moreover, something in the very nature of this alternative archive of dress and clothing—perhaps its positioning between the individual self and the social world—that renders it particularly, perhaps even uniquely, multivalent, capable of lending simultaneous insight into multiple overlapping themes. Burman and Turbin have recently argued that "because fashion is closer to personal identity than other material objects, it reveals significant social change at several levels, and subtle links between changes in individual and historical processes, especially with regard to gender ideologies."[17] The essays here certainly substantiate this contention. Not only are gender and gender ideology central concerns of many, but, through analyses of bodily praxis, each contributor is able to foreground multiple themes (in addition to gender) simultaneously—from class, generation, and race to ethnicity, citizenship, nation, and transnationalism.

Through these multivalent analyses, the authors bring historical weight to bear on one of the major conceptual themes foregrounded in the recent literature: dress is at the very core of African modernity (or modernities).[18] They reveal that dress and fashion have been centrally implicated in the forging of a distinct African modernity, through slavery and freedom, colonialism and conversion, ethnicity and nation, gender and generation, hybridity and cosmopolitanism, state-building and state authority, subjecthood and citizenship. Moreover, as part of their agenda of liberating modernity from Eurocentric paradigms, they dismantle the tradition vs. modernity binary by demonstrating that tradition does not exist either prior to or in opposition to the modern. Tradition and modernity are constructed simultaneously; they are mutually constitutive. The modern miniskirts of 1970s Lusaka, for example, were no more "modern" than *chitenge* suits, which appeared at roughly the same time, were "traditional" (Hansen). And what is "traditional" and what is "modern" when a properly cut *adire* (indigo tie-dyed cloth) allowed well-dressed citizens of Abeokuta, Nigeria, to be "modern" and "traditional" at the very same time (Byfield)? While the contributors are largely concerned with historicizing and thereby dismantling the tradition vs. modernity binary in the specific local contexts where vernacular modernities were forged, they also situate and then disassemble the binary in broader, global contexts. Both Rovine and Boateng chart the ways in which certain kinds of African textiles, like mudcloth and kente, entered the "modern" world of global fashion as representative of "tradition"—signifying an unadulterated, simple (often tribal) past.

Taken together, the chapters which follow underscore the contingent nature of dress as political praxis and political language. It is not possible to find a formula, a calculus of power and change over time, which determines the meaning of dress at any given historical juncture. In 1990s Minneapolis, many Somali women were choosing to wear "traditional" dress in order to forge national unity in their Diasporic community (Akou). Similarly, decades earlier in colonial Nigeria, what was viewed as "traditional" attire (that is, not Western) marked Yoruba women as anticolonial nationalists (Byfield). Yet in the 1940s and '50s, nationalist youth in Luanda looked both to cosmopolitan fashions (notably from the U.S. and Brazil) and to the "traditional" wear of their grandparents for sartorial inspiration, as they laid bare the hollowness of Portuguese assimilationist rhetoric (Moorman). If Western-inspired dress in 1950s colonial Angola embodied nation, in 1970s Tanzania and Zambia, in the form of the miniskirt, it threatened patriarchal authority in profound ways (Hansen and Ivaska).

Locality, then, is absolutely central to each author. The meanings of one particular item of clothing can be, and often are, completely transformed when moved across time and space. This is perhaps nowhere more evident than in the adoption of various forms of Western-style dress. Several chapters here argue that we cannot simply see it as evidence of European hegemony over subject populations.[19] As Hansen has argued, "clothing consumption in everyday African life might mediate quite different sensibilities than those Europeans took for granted."[20] Utilizing the notions of "cosmopolitan" or "worldly" in explaining African choices in dress, several contributors (Byfield, Fair, Hansen, Hay, Moorman, Renne) underscore the notion that while Western-style dress may have been "foreign" in origin, its gendered, social, and political meanings were constructed locally, in local circumstances, in local fields of power.[21] In short, fashion may be a language spoken everywhere, but it is never a universal language. It was, and remains, profoundly local, deeply vernacular.

Sections and Chapters

While all of the contributions to this volume grapple with a similar set of themes across time and space, neither chronology nor place provides an easy and obvious way to order the chapters. To the authors' credit, all of the contributions are strongly historical, with many moving from the precolonial to the postcolonial with relative ease. Moreover, each author is working with fluid, hybrid cultural forms, shifting borders and boundaries, as well as the simultaneity of the local and the global. The collection, therefore, is arranged in four parts: "Fashioning Unity," "Dressing Modern," "Disciplined Dress," and "African 'Traditions' and Global Markets."

Part 1. Fashioning Unity: Women and Dress; Power and Citizenship. Because archives of dress and fashion push women onto center stage, it is only appropriate to begin the collection with a section which explores the ways in which women have self-consciously employed dress to fashion new identities in rapidly changing political and social contexts. As we see in the three chapters included here, women

have utilized dress not only to forge unity, but also to mark difference (whether difference from an "other" or from a particular past). The first chapter, Laura Fair's "Remaking Fashion in the Paris of the Indian Ocean," explores sartorial and performative processes through which women constructed new identities as both national and transnational subjects in early-twentieth-century Zanzibar—identities aimed at overcoming earlier divisions between Arab and African, free and slave, and replacing them with a new and decidedly "modern" cosmopolitanism. Judith Byfield's "Dress and Politics in Post–World War II Abeokuta" recounts the activist politics of the Abeokuta Women's Union, and examines the ways in which rules about "moderating" dress were used by the union to smooth over the socio-economic differences among members in order to create a unified constituency. "Nationalism without a Nation," by Heather Akou, focuses on the more recent past and the complex political and social identities expressed in the dress of Somali women in Minneapolis–St. Paul, especially a national identity, in the face of the dissolution of the Somali nation-state.

Part 2. Dressing Modern: Gender, Generation, and Invented (National) Traditions. The three chapters in this section specifically explore the meanings of Western-style dress in local African contexts. In so doing, they foreground both African modernities and local relationships (of gender, generation, class, and ethnicity) which impart meaning to Western-style dress. As the Comaroffs have written, "Western dress . . . opened up a host of imaginative possibilities for . . . Africans."[22] The contributors to this section explore some of those imaginative possibilities. Margaret Jean Hay's "Changes in Clothing and Struggles over Identity in Colonial Western Kenya" demonstrates how social and political tensions in 1920s western Kenya were played out in contestations over clothing—how much clothing Africans should wear, and what kind. She is particularly concerned with conflicts between "traditionalists" and Christians, between young men and elders, and between women and their fathers and husbands. In "Putting on a *Pano* and Dancing Like Our Grandparents," Marissa Moorman keeps our lens focused on Western-style dress, but in the context of urban youth culture. She demonstrates the ways in which cosmopolitan dress practices were, with music and dance, central to how young Angolans came to imagine the Angolan nation. Finally, in "Anti-mini Militants Meet Modern Misses," Andrew Ivaska takes us into the immediate post-independence era with a focus on the miniskirt and its banning in Tanzania in the 1960s. He examines the ways in which miniskirts became targets in the state's campaign for "national culture" and were central to a national debate over the very notion of "the modern."

Part 3. Disciplined Dress: Gendered Authority and National Politics. The three chapters in this section focus on the politics of dress in the context of the post-colonial nation state, specifically on the ways fashion articulates, constitutes, and contests gendered political authority. Elisha Renne's "From Khaki to *Agbada*" looks at political representation through dress, specifically the shift from "khaki" (military) to "agbada" (civilian) rule in Nigeria. She argues that the historical association of khaki uniforms with colonial and later Nigerian military rule suggests that the shift to civilian dress not only represents different forms of political power and

rule but also reenacts a version of national independence. Jean Allman's "'Let Your Fashion Be in Line with Our Ghanaian Costume'" analyzes the intimate connections among clothing, gender, nation, and power in Nkrumah's Ghana by looking at efforts by non-governmental organizations and the state to transform people from the north into proper "Ghanaians" through dress. Finally, Karen Tranberg Hansen's "Dressing Dangerously" explores how gendered, sexualized meanings have been attached to certain forms of clothing on women's bodies from independence to the present in Zambia.

Part 4. African "Traditions" and Global Markets: The Political Economy of Fashion and Identity. The volume's final section, in many ways, is a mirror reflection of the second. While part 2 explores "Western-style clothes" and their contested meanings in local African contexts, part 4 examines "traditional" African textiles as they circulate in Western contexts. In so doing, the two contributions foreground power in discussions of global fashion, Afrocentric identity, and the expropriation and exploitation of indigenous cultural forms in the world economy. In "Fashionable Traditions," Victoria L. Rovine examines the transformations in meaning that occur as Malian "mudcloth" or *bogolan* travels, stretching its formal properties and symbolic significance to suit new circumstances. Similarly, Boatema Boateng's "African Textiles and the Politics of Diasporic Identity-Making" explores the role of Ghanaian *kente* and *adinkra* in the construction of Pan-African Afrocentric identities in the African Diaspora, while investigating the implications of mass-produced, cheap, machine-woven reproductions on the livelihoods of Ghanaian producers. The collection ends with a brief afterword from Phyllis M. Martin, who returns us to the broader picture through a thematic discussion of bodily praxis as political praxis.

It is our collective aim that the chapters assembled here provide new insight into the multiple, yet often undocumented, ways power has been fashioned in Africa and its Diaspora through bodily practice. Local and historical examinations of dress contribute enormously to our understandings of the political and material ties that bind struggles for Black freedom and independence in Africa to those throughout the Atlantic world.[23] They also speak directly to ongoing transnational investigations of the political and cultural dynamics of gender, generation, ethnicity, and nation. Such work can and must serve as a collective challenge to Eurocentric scholarship, which not only continues to write Africa out of global histories by ignoring its rich and complex past, but persists in reinscribing colonial notions of static and timeless tradition upon African peoples.

Notes

1. "Hats Off to Nkrumah," *Accra Evening News,* July 29, 1953.
2. Joanne Entwistle, *The Fashioned Body: Fashion, Dress, and Modern Social Theory* (Cambridge: Polity, 2000), 6–7.
3. Perhaps one of the most important exceptions can be found in the work of Jean

and John Comaroff, particularly their *Of Revelation and Revolution: Dialectics of Modernity on a South African Frontier*, vol. 2 (Chicago: University of Chicago Press, 1997), esp. 215–73.

4. For a brief discussion of the origins and development of this perspective on fashion, see Jennifer Craik, *The Face of Fashion: Cultural Studies in Fashion* (London and New York: Routledge, 1993), 6–7. Until recently, these scholars of fashion have had to struggle against charges of marginality or triviality and fight to have their work taken seriously as academic scholarship. "[F]our hundred years of development of dress history in Europe and the United States," Lou Taylor argues, "has taken place outside the boundaries of 'academic respectability' and the residues of this prejudice remain a debated issue." Only in the last decade, Taylor says, has this scholarship "broken free of the shackles that have held it back for far too long." See Lou Taylor, *The Study of Dress History* (Manchester: Manchester University Press, 2002), 1–2.

5. Joanne B. Eicher and Barbara Sumberg, "World Fashion, Ethnic, and National Dress," in *Dress and Ethnicity*, ed. Joanne B. Eicher (Oxford: Berg, 1995), 298. Ethnographers of dress generally have not been forced to struggle against charges of disciplinary impropriety. Material culture, including male and female dress, has long been at the core of ethnography and anthropology. See also Ruth Barnes and Joanne B. Eicher, eds., *Dress and Gender: Making and Meaning in Cultural Contexts* (Oxford: Berg, 1992).

6. Their efforts have not been entirely successful. Many scholars of Western fashion continue to insist on the exclusion of non-Western forms of dress. Entwistle has been among the most vociferous in arguing for the importance of maintaining the boundary between the study of Western fashion and non-Western dress and costume. In her view, there is a broad consensus among scholars of fashion that "fashion" is a specific "aspect of western modernity." The evidence "for treating fashion as a historically and geographically specific system of dress," she argues, "is overwhelming and convincing." Entwistle, *Fashioned Body*, 26–27.

7. Craik, *Face of Fashion*, 4.

8. That local and transnational histories can move us past this binary is powerfully demonstrated in *Gender and History* 14, no. 3 (2002), special issue on "Material Strategies Engendered," edited and introduced by Barbara Burman and Carole Turbin, and in Wendy Parkins, ed., *Fashioning the Body Politic: Dress, Gender, Citizenship* (Oxford: Berg, 2002). While the contributions deal largely with European gender history, there are important studies of Tanzania and China.

9. Comaroff and Comaroff, *Revelation and Revolution*, 222.

10. Ibid., 262.

11. Karen Tranberg Hansen, *Salaula: The World of Secondhand Clothing and Zambia* (Chicago: University of Chicago Press, 2000), 24, 52.

12. Hildi Hendrickson, *Clothing and Difference: Embodied Identities in Colonial and Post-colonial Africa* (Durham, N.C.: Duke University Press, 1996).

13. See Hendrickson, introduction to *Clothing and Difference*, esp. 3–14. On vernacular modernity, see Charles Piot, *Remotely Global: Village Modernity in West Africa* (Chicago: University of Chicago Press, 1999), 1–26, 172–78.

14. By and large, history and politics have not been central to social analyses of dress in Africa, although there are some very important exceptions. In addition to Comaroff and Comaroff, Hansen, and Hendrickson, cited above, see, espe-

cially, Phyllis Martin, "Contesting Clothes in Colonial Brazzaville," *Journal of African History* 35, no. 3 (1994): 401–26; Laura Fair, *Pastimes and Politics: Culture, Community, and Identity in Post-abolition Urban Zanzibar, 1890–1945* (Athens: Ohio University Press, 2001); Judith Byfield, "'Unwrapping' Nationalism: Dress, Gender, and Nationalist Discourses in Colonial Lagos," *Discussion Papers in the African Humanities* 30 (Boston: African Studies Center, 2000); Hildi Hendrickson, "Bodies and Flags: The Representation of Herero Identity in Colonial Namibia," in her *Clothing and Difference*, 213–44; and Joanne B. Eicher and Tonye V. Erekosima, "Why Do They Call It Kalabari? Cultural Authentication and the Demarcation of Ethnic Identity," in Eicher, *Dress and Ethnicity*, 139–64.

15. The scholarship is vast, but see, for starters, Gayatri Spivak, "Can the Subaltern Speak?" in *Marxism and the Interpretation of Culture,* ed. Cary Nelson and Lawrence Grossberg (Urbana: University of Illinois Press, 1988), 271–313. For an Africanist's reflections on the work of the Subaltern Studies Group, see Frederick Cooper, "Conflict and Connection: Rethinking Colonial African History," *American Historical Review* 99, no. 5 (1994): 1516–45.

16. Barbara Burman and Carole Turbin, "Introduction: Material Strategies Engendered," *Gender and History* 4, no. 3 (2002): 375. Emphasis mine.

17. Ibid.

18. See Hendrickson, introduction to *Clothing and Difference,* 13.

19. As Fred Cooper has written, "It is far from clear what Africans thought about the symbolic structure of colonial power or the identities being inscribed on them. The cultural edifice of the West could be taken apart brick by brick and parts of it used to shape quite different cultural visions." Cooper, "Conflict and Connection," 1527.

20. Hansen, *Salaula,* 39.

21. For an important and fascinating discussion which differentiates between the "Western" and the "cosmopolitan," see Thomas Turino, *Nationalists, Cosmopolitans, and Popular Music in Zimbabwe* (Chicago: University of Chicago Press, 2000), esp. 7–9.

22. Comaroff and Comaroff, *Revelation and Revolution,* 235.

23. For an excellent example of this scholarship, see Doran H. Ross, *Wrapped in Pride: Ghanaian Kente and African American Identity* (Los Angeles: UCLA Fowler Museum of Cultural History, 1998), esp. chapter 10, "Kente and Its Image outside of Africa."

Part One: *Fashioning Unity:*
 Women and Dress;
 Power and Citizenship

1 Remaking Fashion in the Paris of the Indian Ocean: Dress, Performance, and the Cultural Construction of a Cosmopolitan Zanzibari Identity

Laura Fair

Dress has historically been used as one of the most important and visually imme-diate markers of class, status, and ethnicity in East African coastal society. As one of many forms of expressive culture, clothing practice shaped and gave form to social bodies.[1] This chapter explores the social, cultural, and performative pro-cesses through which women constructed new individual and collective identities in early-twentieth-century urban Zanzibar.[2] Dress played a critical role in this process, as did the creation of new forms of ritual—particularly that associated with women's puberty initiation ceremonies—in which new forms of dress were worn as public articulations of women's new definitions of self. Drawing on cul-tural elements from their varied, transnational pasts, women in urban Zanzibar crafted newly imagined identities as Zanzibaris, an identity that sought to over-come historical divisions between Arab and African, slave and free, and replace them with a new and decidedly modern cosmopolitanism. As it does in English, the term "cosmopolitanism" connoted "sophisticated, urbane, worldly," and "free from provincial prejudices."[3] It also carried important political implications, as women crafted this cosmopolitanism by weaving together threads from the diverse cultural heritage of their parents, with the aim of creating a larger, more inclusive fabric of citizenship within the isles. Cosmopolitanism, as a discursive and perfor-mative practice, did not imply a necessary reverence for the West, or even Arabia, but rather a sophisticated appreciation for international mixing and appropriation of cultural styles and symbols from multiple, geographically dispersed sites. These processes became particularly pronounced after the abolition of slavery in Zanzi-bar in 1897, and continued beyond the period discussed here. And although both male and female slaves participated in efforts to enhance respect for their rights in island society, the ways they publicly expressed their changing definitions of self were often gendered in important ways.[4] Significantly, elite women were also far

more likely than elite men to ally themselves with the efforts of the underclass. Here I argue that gendered experiences of domestic slavery and ethnicity empowered women to imagine and create hybrid cultural formations that were unimaginable for most men. This hybridity was embodied in the process of biological reproduction, publicly performed during the course of puberty initiation rituals, and made visually apparent on a daily basis through the widespread adoption of new clothing fashions. The cosmopolitanism that was asserted by women and expressed through dress and ritual at the turn of the century was the first step taken to define a national identity as Zanzibari.

Zanzibar in the Nineteenth Century

Unguja and Pemba are the two largest of a group of islands off the northeast coast of Tanzania which came to be collectively known as Zanzibar. Zanzibar town, on the western side of Unguja, was in the early nineteenth century a small and relatively unimportant Swahili fishing village. But when the sultan of Oman, Seyyid Said, decided to move his capital to the town in the 1830s, the fortunes of the isles changed rather dramatically. Over the course of the next fifty years, Zanzibar town grew to become a sprawling trading city of more than eighty thousand permanent residents. By mid-century Zanzibar had become the premier trading entrepôt linking traders and goods from Europe, the Americas, and India with those from East and East-Central Africa. Amongst the most important commodities imported from Europe and India during the nineteenth century was cloth, while by far the most lucrative goods exported from East Africa were ivory and slaves. Slaves, and the profits derived from both their sale and their labor, were at the very heart of Zanzibar's economic transformation.[5] Slave labor transformed the forest- and shrub-covered coral islands of Unguja and Pemba into the most productive clove plantations in the world, netting vast profits for plantation owners, the majority of whom were immigrants from Oman. Swahili, Yemeni, Omani, and Indian immigrant traders also utilized slave labor to transport goods from ships to warehouses, to package materials for trade, and to provide domestic and other services to support crews and fellow merchants from across the globe. As the wealth of Zanzibar grew over the course of the nineteenth century, tens of thousands of free immigrants from neighboring Swahili towns, the Arabian peninsula, and South Asia decided to settle permanently in the isles. By far the largest segment of the islands' urban and rural population, however, were slaves captured from the East African mainland. On the eve of the twentieth century, it was estimated that some three-fourths of Zanzibar's African population either were slaves or had recently been manumitted.[6]

Dress served as a critically important and immediately visible marker of class and status difference in nineteenth-century Zanzibar. The fewer and less ornate clothes one wore, the lower was one's status. Slaves in nineteenth-century Zanzibar typically wore only the slightest of clothes, which were usually made of the rudest and cheapest white cloth, known as *merikani* because it came from the United States. Male and female slaves during this era often wore only one piece of cloth,

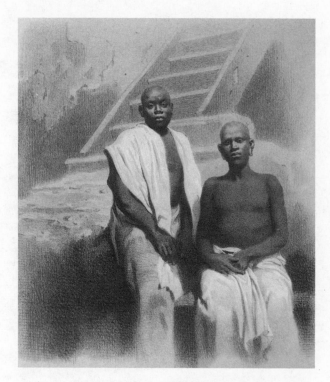

Figure 1.1. Male slaves wearing *merikani* cloth. Reprinted from Charles Guillain, *Documents sur l'histoire, la géographie, et le commerce de l'Afrique orientale* (Paris: A. Bertrand, 1856), vol. 3.

which men wrapped around their waists and women tied under their armpits. Because over 95 percent of those who lived in Zanzibar, including slaves, were Muslims,[7] the coverings men and women wore on their heads were also very important markers of class and status. Male slaves were forbidden to wear caps on their heads, while female slaves were prohibited from wearing headcloths or veils. Perhaps as a further marker of their low social status, many slaves of both genders shaved their heads. Slaves were also required to go barefooted while in the presence of the freeborn.[8]

At the other end of the social hierarchy were members of aristocratic Omani households, who wore the most elaborate costumes and headdresses. Several yards tremely expensive cloth, imported from abroad, was wrapped around the of Omani men to form a *kilemba*. Somewhat similar headwrappings were imes worn by Omani women as well, although typically a woman of the ar- acy would be seen by those outside of her immediate family only while wearing a richly embroidered face mask known as a *barakoa*, an embroidered cap, a long silk scarf known as an *ukaya* that hung from the head to the back of the knees, and a long-sleeved, knee-length shirt with frills around the collar accompanied by

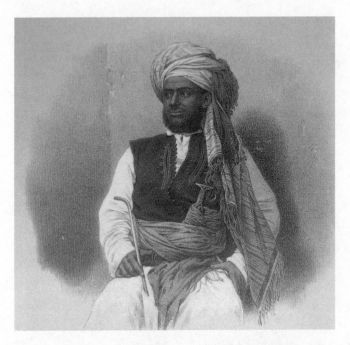

Figure 1.2. A male Arab of Zanzibar wearing a *kilemba, kanzu,* and short jacket. Reprinted from Guillain, *Documents sur l'histoire,* vol. 3.

matching frilled pants, known as *marinda*. The clothing of freeborn Swahili varied by gender and class, but typically included some form of cap or headscarf for both men and women, sewn or wrapped cloth which covered the body from the shoulder to at least the knee, if not the ankle, and shoes. Swahili men's clothing typically included a long, white, loose-fitting gown, known as a *kanzu*, and a sewn cap, known as a *kofia*. While the value and quality of the cloth worn by the poorest Swahili woman may have varied little from that worn by slaves, whenever possible, when leaving home, a free Swahili woman would mark her status by covering her head with a cloth or cap and her shoulders with a longer cloth that reached to the ankles.[9] Locally made sandals of leather were also worn by fashion- and status-conscious Swahili.

Abolition and the Fashioning of New Identities

Immediately after abolition in 1897, many former slaves began to assert their social and economic autonomy—some by bargaining for reduced labor obligations to their owners, others by leaving their masters and mistresses and moving either to unoccupied land in the countryside or to town.[10] Former slaves also asserted their status as free individuals by adopting previously forbidden forms of dress, transforming Islamic rituals so that they were more inclusive of women and men who were devout and pious but formally uneducated, and identifying them-

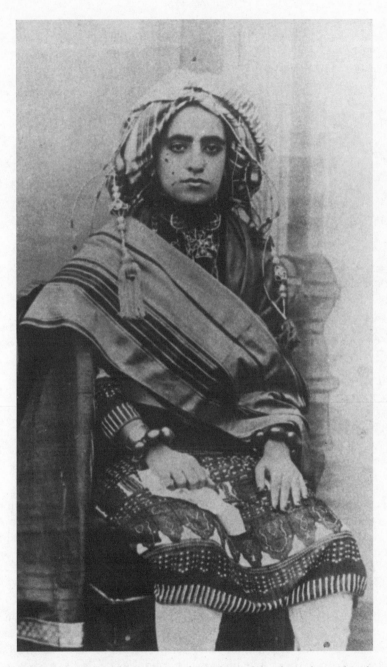

Figure 1.3. Seyyida Salme, princess of Zanzibar and daughter of Seyyid Said (also known as Emily Ruete). Courtesy of Zanzibar National Archives.

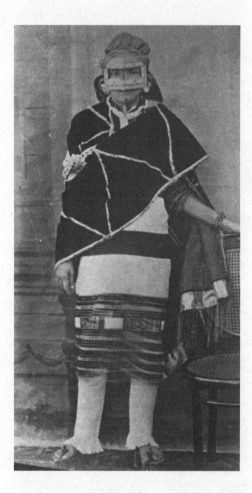

Figure 1.4. Seyyida Salme, princess of Zanzibar, wearing a *barakoa* and *marinda*. Courtesy of Zanzibar National Archives.

selves as freeborn Muslim Swahili, rather than as members of the ethnic communities from which their enslaved parents were drawn. Adopting Swahili-style clothing was one means of giving bodily form to these new identities as free "Swahili." By 1900, the Swahili kanzu and kofia had become the most common form of dress worn by men in the isles.

During the early years of the twentieth century "Swahili" women also transformed their dress, abandoning cloth associated with servility and increasingly adopting a new form of cotton piece-good, known as a *kanga*. The first kangas, known as *kanga za mera,* were actually produced locally in the 1890s by innovative merchants hoping to capitalize on island women's desires for more varied clothing fashions.[11] Kanga za mera were made by block-printing on sheets of white merikani cloth, primarily with dyes of black or red. These new fashions were highly popular, although their popularity was nothing compared to that of the brightly colored imported kangas which became the rage after 1897, the year of the abolition decree.[12] Although the price of a new pair of kangas was five times the cost of

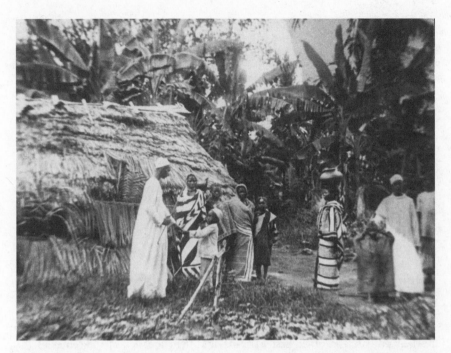

Figure 1.5. Women wearing *kanga* and men wearing *kanzu* and *kofia* in Zanzibar, c. 1910. Courtesy of Zanzibar National Archives.

the cloth typically worn by slave women, the former were greatly preferred. British trade reports speak of the vast new market opportunity provided to British manufacturers and traders by island women who were said to be busily transforming themselves from slaves into "slaves of fashion." The reputation of island women as highly fashion-conscious buyers engaged in endless displays of conspicuous consumption appears to date from this era. "Zanzibar is the Paris of East Africa," wrote one official in 1900, "and the Zanzibar belles are admittedly the glass of fashion. To keep up their reputation for smart dressing involves the frequent purchase of new *kangas*, of which, I understand, a Zanzibar girl will possess as many as two to three dozen sets at one time."[13]

Women in turn-of-the-century Zanzibar took great pride in establishing the fashion trends of East Africa. While new, attractive kanga designs sold rapidly in the first weeks after their arrival in Zanzibar town, each went quickly out of fashion. "It must not be supposed that a woman with any proper respect for herself or for her family will be seen in these patterns in three months' time," warned one British official.[14] Traders and manufacturers were therefore encouraged to produce small batches of particular designs in order to capitalize on women's preferences for "limited edition" prints. They were also warned of Zanzibari women's very particular tastes, and encouraged to send samples to the isles first, to determine if a particular color and design combination would appeal to island women before em-

barking on large-scale production. In 1900, a newly arrived "smart" kanga design would sell for four to five rupees in the first week of arrival, rapidly dropping in price to a low of one rupee within two months. After that the only hope a merchant had for disposing of his remaining stock was to ship it off to an associate in Pemba, who, in turn, would ship his unsold stock off to another shopkeeper on the mainland.[15]

Within three years after the abolition of slavery the typical fashions seen in the isles had been radically transformed. As both men and women began to disassociate themselves from their heritage as slaves and claim new identities as free Swahili they appropriated new forms of clothing to give visible expression to their changing definitions of self.[16] Whenever economically possible, these new "Swahili" men and women began to wear clothing that covered more of their bodies than previously allowed, including heads, shoulders, legs, and feet. Both men and women seized upon consumption—particularly of imported clothing—as a way to express social and economic autonomy. Among women, however, the availability of new and ever-changing kanga designs also fostered a desire for conspicuous consumption and display. By wearing the latest style to hit the town, a woman demonstrated to her chosen audience that she had money to spare. Consumption, particularly of imported goods, became an important social marker of cosmopolitanism for members of this generation, demonstrating both their relative wealth, compared to their parents and other East Africans, and their location at the center of the transnational flow of goods and ideas between East Africa and the wider world.

Sexuality, Puberty Initiation, and the Ritual Creation of Cosmopolitan Zanzibari Identities

The parents of the first generation of postabolition island youth were heavily cognizant of the plurality of cultures and peoples who called Zanzibar home, as many of them were either immigrants themselves or the children of immigrants. They were also well aware of the importance of culture as a tool for constructing and defining social boundaries. In turn-of-the-century urban Zanzibar, there were thousands of individuals whose parents came from different ethnic communities. "Mixed" children with Arab fathers and African mothers were also numerous, particularly in town. Often what allowed people to be perceived as members of the Arab aristocracy, rather than as slaves, was not their skin tone or language, but the cloth and cultural fabrics in which they wrapped their bodies while in public.[17] Slave women were also very aware of the constructed nature of ethnic identities in the isles, as many women who were not themselves defined as "Arab" gave birth to children who were, because ethnicity followed the father's line. The combination of Islamic law and East African customary practice made these children the social equals of any children the father had with a free woman, with equal rights of inheritance. Perhaps the most prominent example of the status afforded children born of slave mothers and Arab fathers can be found in the household of Zanzibar's first sultan, Seyyid Said. All of Said's children, numbering over

one hundred, were born to slave concubines, yet these children grew to become the core of Zanzibar's "Arab" aristocracy, because their father was the sultan from Oman. During the era of slavery, slave mothers privately taught their children about their homelands and cultures, but typically both the mothers and the children were prohibited by the male elite from publicly displaying such cultural affinities.[18] After the abolition of slavery, however, many of these women began to encourage their children to participate more fully in forms of cultural expression that transcended the boundaries of "proper" Arab behavior. As one woman of these children's generation explained the mothers' choices, "They were free now and their masters/husbands could no longer stop them."[19]

During the first decades of the twentieth century, these concubines of the elite joined together with women from other class and ethnic backgrounds to craft new forms of ritual and public performance that gave further expression to their growing perceptions of themselves—and more particularly their children—as embodiments of a cosmopolitan Zanzibari sophistication that transcended the allegedly rigid ethnic and cultural boundaries of the nineteenth century. Creating and popularizing identities as cosmopolitan Zanzibaris was a political strategy that emphasized the importance of compromise and hybridity, while simultaneously exaggerating the politically strategic role and efficacy of culture itself as an agent of social change.[20] For urban Zanzibari women, one of the premier venues in which such cosmopolitan identities were publicly expressed was a new form of female puberty initiation ritual, known as *mkinda*, which women created during the years immediately following abolition.[21] This new ritual form recognized and valorized the historical role of slave women's sexuality in giving birth to children who had the privileged opportunity to take the best from each of their parents' cultures and blend it together to create something new, something uniquely Zanzibari.[22]

In the nineteenth century, a genre of initiation ceremonies performed for girls at the onset of puberty, known as *unyago*, became widely popular throughout coastal East Africa as a result of the widespread capture and enslavement of women from mainland ethnic communities with long traditions of performing such ceremonies. Older women provided young girls with information regarding female sexuality and morality through the performance of unyago rituals and dances. These ceremonies began at menarche when a girl was introduced to an elderly female teacher, commonly known as a *kungwi*, who taught her about the physical changes taking place in her body and how to maintain personal hygiene during menstruation. When a number of girls in a given area reached puberty, their mothers and instructors would prepare a collective initiation ceremony which, depending on the cultural group, lasted between seven days and several months. Through a series of lectures, dances, songs, and demonstrations girls were taught about male and female physiology, the physical aspects of sexuality, desire, and orgasm, fertility enhancement and prevention, pregnancy, birth, childcare, and how to live peacefully with elders, husbands, and in-laws.[23] At the completion of instruction, public dances were held to celebrate the young women's reincorporation into society as adults.

While some women of the elite along the Swahili coast began to have certain

aspects of these teachings provided to their daughters in the nineteenth century, they usually did so privately and individually, rarely allowing their daughters to be incorporated into the large groups of unyago initiates. The sexual purity and alleged sexual restraint of elite women was considered a defining mark of their social status, as was their observance of purdah, which further prevented them from displaying their bodies in the public rituals and dances that typically accompanied the completion of unyago celebrations. As Bakia binti Juma, who participated in both unyago and mkinda, said,

> You never saw an Arab dancing *unyago* in Zanzibar. Sometimes they would have their daughters taught about matters of *unyago* inside by her *somo* [private instructor], but you would never see her at an initiation ceremony because she is *mwungwana* [freeborn, of high social standing].[24]

Elite women interviewed by Margaret Strobel in Mombasa similarly suggested that the dances associated with initiation "were for slaves, for lower-class people."[25]

Immediately after the abolition of slavery, however, a new form of initiation, known as mkinda, became widely popular in urban Zanzibar. In contrast to earlier forms of initiation, which tended to segregate initiates according to the ethnic, linguistic, or geographical origins of their parents on the African mainland, this new form of female initiation brought together women from a wide range of class, linguistic, and cultural backgrounds. Any young woman who lived in urban Zanzibar was eligible to participate. Forms of unyago unique to particular ethnic communities continued to be performed as well, but, explained Amina Seif Othman, an elderly lead instructor of mkinda, "a woman who had any hope of improving her children's status, who wanted them to be part of something that transcended slavery, also had their daughters initiated in mkinda."[26] Another woman made similar remarks, explaining, "Our mothers danced the [*unyago*] dances from home, but we Swahili [who were moving beyond our parents' status as slaves] danced mkinda. This was the dance of our generation."[27] Both Africans and Arabs danced mkinda, said Latifuu Ali Marzuk, "but especially those of us of mixed blood . . . many of us mixed children danced."[28] Other women of mixed Arab and African parentage similarly defined mkinda as the form of initiation danced by mixed children. "This was a hybrid dance," they said; "everyone danced. It wasn't just for the Yao or Manyema [two predominant ethnic groups within Zanzibar's slave population]. It was for all of us in Unguja. This was where all of us mixed girls learned about women's matters."[29] For women of this generation, whose coming of age coincided with the dawning of a new century, it was time to affirm and celebrate the hybridity that made them, and Zanzibar, who and what they were. The dances associated with mkinda were public celebrations that marked the transformation of young girls into women, but they were simultaneously celebrations of the historical power of women's sexuality to create bridges between the island's diverse ethnic and cultural communities, particularly between Africans and Arabs.

Dancing mkinda also provided women from both ends of the social spectrum with opportunities to improve their social lives in important ways. As Amina Seif Othman explained to me, "these dances had their roots amongst the *washenzi*

[non-Muslim, rural, uncivilized, and slave] communities on the mainland. The Arabs [in Zanzibar] didn't have such a dance. They knew that these dances were a lot of fun and they wanted to dance. But they said, 'To dance in the poor section of town with former slaves, we can't do that.' But after abolition we joined together and created a new dance that everyone could participate in together." Mkinda drew on the teachings of earlier forms of unyago, yet it was regarded as a more "respectable" form of initiation. The topics of instruction were nearly identical to those of unyago, as was the method of instruction, including very explicit dances depicting means of achieving sexual arousal and methods of sexual intercourse. The first instructors were also women of slave ancestry. Mkinda's respectability therefore came less from a revision in the teachings than from the widespread participation of free, wealthy, and elite women in its performance. Even women of the royal family participated, and during the early decades of the twentieth century both an "unruly" concubine of one sultan and a "well-behaved" wife of another became leaders of competing mkinda groups.[30] For women of the elite, participating in these rituals affirmed their identities as sexual subjects, rather than merely objects of male desire or control. Rusoona, the concubine of Sultan Ali bin Hamoud (1902–11), was chastised by her husband for her participation, yet according to both her friends and archival sources her participation in mkinda was but one part of a larger effort to assert her independence from her master/husband and from patriarchal control over her sexuality and reproductive powers more generally.[31] For women of lower status as well, choosing to participate in mkinda publicly proclaimed their social and cultural equality with women from freeborn, wealthy, and aristocratic families. Assuming the right to participate in various forms of ritual alongside women of the elite was one of many ways in which former slaves utilized culture to assert their equality and demand recognition as citizens of the isles.

The types of clothing worn during the public celebrations that marked the end of mkinda initiations were also highly symbolic of the cosmopolitan and hybrid identities of this generation. The public celebrations held at the end of the private instruction involved two separate kinds of dances, *kunguiya* and *ndege*. Dancers in each wore particular forms of clothing, which taken together further signified women's attempts to transcend dominant ideologies of rigid dichotomy between slave and free, African and Arab, and to visually unite them in the public imagination. The first dance, kunguiya, was performed at night, often in a public square or open space adjacent to the home where the girls' instruction had taken place. While performing kunguiya, the young initiates were adorned in two kangas. Buying up a batch of recently imported, limited-edition kangas to be worn by all the initiates at that year's kunguiya performance, or perhaps even commissioning the production of kangas with a particular color, pattern, or name, was also an important sign of Zanzibari women's collective power to influence the global process of commodity production and distribution. Furthermore, the wearing of identical kangas symbolized a growing sense of social and cultural equality amongst the women who participated in mkinda. All of the women who danced kunguiya, regardless of class, status, or heritage, wore identical kangas during the performance, which visually marked them as equals. In one dance women wore kangas bearing

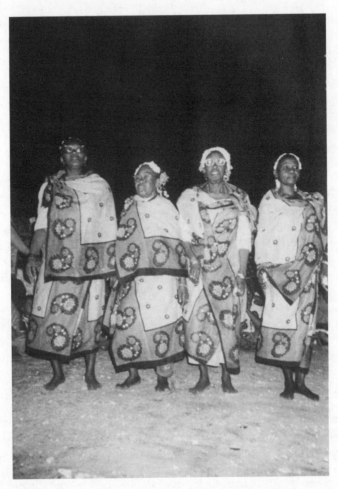

Figure 1.6. Women dancing *kunguiya*. Photo by Laura Fair.

the *jina* (saying or proverb) *Mpaji ni Mungu,* or "God is the giver." The textual message of the kanga itself thus further encodes the Islamic ideal of religious equality and respect for cultural difference within the imagination of the dancing initiates and their viewing public.[32]

Gifts of multiple sets of kangas were also *de rigueur* from parents to initiates and their instructors at the completion of the ceremonies. Several women recalled these gifts of kangas as marking their transformation from girls into not just women but *fashionable* women; they now had—and for many it was the first time they had ever had—several different pairs of the latest kangas from which to choose when they went out.

During the performance of ndege, the second dance associated with mkinda, dancers wore a costume explicitly associated with female members of the nineteenth-

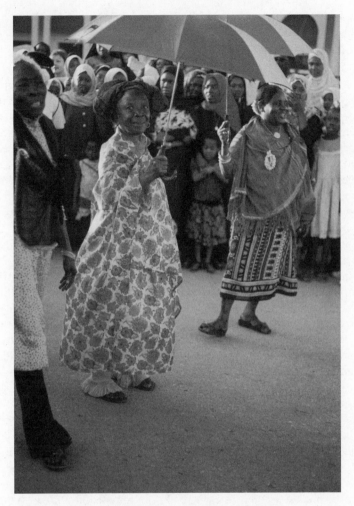

Figure 1.7. Women dancing *ndege*. Photo by Laura Fair.

century Arab aristocracy. The most distinctive elements of this costume were frilled marinda pants, a kilemba or turban, elaborate amounts of jewelry, and a parasol which matched the outfit. In the nineteenth century, such a costume was known as *nguo za kiarabu* (Arab clothing), but as increasing numbers of Zanzibari women began to appropriate this fashion during the performances associated with mkinda initiation, it became much more commonly known as *mtindo wa kiparisi* (the fashion of little Paris, or simply "fancy dress"). This change in the name given to these outfits provides further evidence of women's attempts to transcend the boundaries of nineteenth-century Arab hegemony by appropriating elements of Arab costume, which others found appealing, renaming them, and making them part of a cosmopolitan fashion that any woman with such tastes could wear.[33]

Women whose parents were historically prohibited from wearing such fashions were quite conscious of the ways in which their adoption of this *mtindo wa kiparisi* furthered their own goal of being perceived as members of a new, upwardly mobile, and cosmopolitan generation. As Rahma Himid explained, "The Arabs were the ones who really wore those outfits, but those of us Swahili who were upwardly mobile wore them too."[34] Other women echoed her remarks, saying that in the past only Arabs were allowed to wear marinda and a kilemba, but in the early years of the twentieth century Swahili women who wanted to "dress up" or appear "worldly" wore them too. For the majority of Zanzibari women, the ndege dance processions were the first time they ever had the occasion to wear marinda. Although many continued to wear *mtindo wa kiparisi* on occasions when their fanciest dress was called for, it is significant that mkinda provided them with the ritual space in which they were initially encouraged to transcend the visual markers that differentiated their mothers from women of the nineteenth-century Arab elite.

In addition to being associated with the nineteenth-century Arab elite, "marinda required several yards of expensive cloth and the costs associated with tailoring and embroidery were exorbitant," said Nunu binti Salum, so that the prestige associated with such costumes was further enhanced by their costs. As Latifuu Ali Marzuk explained, "For many this was really a chance to show off their wealth. Women competed! People even pawned their homes in order to . . . dance ndege." Elaborate amounts of gold jewelry was another requirement for participation in ndege processions. "You couldn't dance ndege with only two or three gold bracelets," said Amina Seif Othman; "[in our group] you wouldn't dare to dance without gold bracelets reaching nearly to your elbows."[35] At the turn of the century, many women also danced with their hair elaborately decorated with gold coins and charms. The costs associated with dancing ndege meant that not everyone could participate in such rituals, yet a surprising number of women whose families were fairly poor had their daughters initiated in mkinda precisely because participating in such a ritual publicly proclaimed their intent to transform their family's status over the generations. By the 1930s, thousands of urban women, many of whom lived in the poorest sections of town, had been initiated in mkinda. As with all forms of initiation, the bonds made between women through mkinda often lasted a lifetime. Former initiates returned year after year to instruct younger girls and to assist them with their own transformations into womanhood. Mkinda provided women with a ritualized space where they could discuss their concerns as women, regardless of class, ethnicity, or heritage, and collectively forge an emergent sense of urban identity and belonging.

The power of culture to symbolically unite women of different class and status backgrounds was further demonstrated through the performance styles of the two dances associated with mkinda. During the performance of kunguiya, Arab women came out of purdah, took off their barakoa, and danced in kangas matching those of all other initiates. Significantly, initiates danced kunguiya in bare feet. The form and movement of the dance itself was also a hybrid synthesis of African and Arab elements. The dance was performed in a circle, with initiates facing the center, a form common amongst many types of East African dance. The movements, how-

ever, were much more characteristic of dance styles associated with Arabs in East Africa, involving slow and deliberate arm, head, and neck movements and very little movement of the hips, legs, or feet.[36] The performance style of ndege, on the other hand, consciously invoked the parades of titled members of society, which were common within many nineteenth-century Swahili coastal towns.[37] In the course of ndege processions, initiates and their mentors paraded through the streets, which were lined with crowds of observers. "The dancers would go very, very slowly through town," explained Subira Mzee. "There was no sweating, no, no sweating. You would gracefully primp and flaunt your beauty while displaying your parasol and arms laden with gold."[38] The parasols carried during the performance of ndege were also considered to be one of the most important symbolic elements of nineteenth-century male ruling-class attire. Women were only rarely allowed to carry such emblems of power, and slaves were only allowed to touch them if they were carrying them over the head of their master or mistress.[39] By appropriating the symbols of the former elite, including parasols and processions, urban women were claiming political citizenship in twentieth-century island society. From 1900 through the 1930s, when these dances were at their most popular, Zanzibari women earned respect and adoration through their participation in these pageants, in which they adorned themselves with symbols of previously exclusive patrician privilege.

Zanzibar, as an island populated largely by immigrants, is a place where one might expect to find signs of hybridity. It is one of many Swahili settlements along the East African coast, and its inhabitants were certainly influenced by Swahili cultural concepts and ideals that celebrated the rich mixture of African and Arab heritage that defined them as a group. The Swahili have been known throughout history for their economic and cultural eclecticism, and often Swahili individuals point to this worldliness as a key defining characteristic of their identities. In most places and times along the Swahili coast, however, Arab culture has always been the dominant ideal. What made one cultured or civilized (*mstaarabu*) was being like an Arab. Significantly, although Kiswahili is a gender-neutral language, the term "mstaarabu" is almost exclusively applied to men. In the years following the abolition of slavery in Zanzibar women directly challenged this ideal. The new cosmopolitanism advocated by urban women affirmed that true sophistication came from rising above the confines of both patriarchal privilege and provincial prejudice. Through their construction of new forms of fashion, performance, and ritual, women challenged dominant notions of racial, ethnic, and cultural purity, drawing public attention to the fact that hybridity was the reality in most urban residents' lives. As biological and cultural hybrids, these women crafted a new and inclusive social space in urban society and symbolically advocated for an expansion of citizenship in the isles beyond the male Arab "norm." The cosmopolitanism that women crafted was elitist in some regards, as it relied on the consumption of particular commodities, including kangas and marinda, as well as their conspicuous display in public, yet it was simultaneously inclusive of women from a range of ethnic backgrounds. A surprising number of women from poor families partici-

pated in these rituals and adopted these new fashions, as kangas and *mtindo wa kiparisi* allowed them to publicly display their emergent identities as modern, twentieth-century Zanzibaris.

Notes

1. For a discussion of such practices elsewhere on the African continent, see Hildi Hendrickson, ed., *Clothing and Difference: Embodied Identities in Colonial and Post-colonial Africa* (Durham, N.C.: Duke University Press, 1996); Phyllis Martin, "Contesting Clothes in Colonial Brazzaville," *Journal of African History* 35, no. 3 (1994): 401–26; Karen Tranberg Hansen, *Salaula: The World of Secondhand Clothing and Zambia* (Chicago: University of Chicago Press, 2000); and Janet MacGaffey and Remy Bazenguissa-Ganga, *Congo-Paris: Transnational Traders on the Margins of the Law* (London: The International African Institute in association with James Currey, 2000).

2. This process of identity transformation occurred throughout the isles of Zanzibar during this period, but the specific dances discussed here were performed only in Zanzibar town, on the island of Unguja. For a broader discussion of these processes, see Laura Fair, *Pastimes and Politics: Culture, Community, and Identity in Post-abolition Urban Zanzibar, 1890–1945* (Athens: Ohio University Press, 2001).

3. Timothy Brennan, *At Home in the World: Cosmopolitanism Now* (Cambridge, Mass.: Harvard University Press, 1997), 19.

4. Fair, *Pastimes and Politics,* 195–264.

5. Abdul Sheriff, *Slaves, Spices, and Ivory in Zanzibar* (London: James Currey, 1987); Fair, *Pastimes and Politics,* 10–20.

6. This estimate was made in 1895 by Sir Lloyd Mathews, first minister of the sultan of Zanzibar. Report of Sir Lloyd Mathews, quoted in *Report of the Commission on Agriculture* (Zanzibar: Zanzibar Government Printing Office, 1923), 38. In 1898 Henry Stanley Newman estimated that two-thirds of the protectorate's population were either slaves or former slaves. Henry Stanley Newman, *Banani: The Transition from Slavery to Freedom in Zanzibar and Pemba* (London: Headley Brothers, 1898), 183.

7. Frederick Cooper, *Plantation Slavery on the East Coast of Africa* (New Haven, Conn.: Yale University Press, 1977) and "Islam and Cultural Hegemony: The Ideology of Slaveowners on the East African Coast," in *The Ideology of Slavery,* ed. Paul Lovejoy (Beverly Hills: Sage, 1981), 271–301.

8. Mtoro bin Mwinyi Bakari, *The Customs of the Swahili People: The Desturi za Waswahili of Mtoro bin Mwinyi Bakari and Other Swahili Persons,* ed. and trans. James Allen (Los Angeles: University of California Press, 1981), 173; Richard Burton, *Zanzibar: City, Island, and Coast* (London: Tinsley Brothers, 1872), vol. 1, 428.

9. Fair, *Pastimes and Politics,* 65–109.

10. Frederick Cooper, *From Slaves to Squatters: Plantation Labor and Agriculture in Zanzibar and Coastal Kenya, 1890–1925* (New Haven, Conn.: Yale University Press, 1980).

11. Jeannette Handby, *Kangas, 101 Uses* (Nairobi: Lino Typesetters, 1984); Elisabeth Linnebuhr, "Kanga: Popular Cloths with Messages," in *Sokomoko: Popular Culture in East Africa*, ed. Werner Graebner (Atlanta: Rodopi, 1992), 81–90; Saida Yahya-Othman, "If the Cap Fits: Kanga Names and Women's Voice in Swahili Society," *Swahili Forum* 4 (1997): 135–49.

12. Department of Overseas Trade, *Zanzibar, Report on Trade*, 1897, 14.

13. *Trade Report for the Island of Pemba for the Year 1900* (London: HMSO, 1901), 15.

14. *Zanzibar, Report on Trade*, 1897, 14.

15. *Trade Report for the Island of Pemba*, 15; *Zanzibar, Report on Trade*, 1897, 14; Ethel Younghusband, *Glimpses of East Africa and Zanzibar* (London: John Long, 1908), 34–35.

16. At the turn of the century slaves and former slaves made up 70–75 percent of Zanzibar's total population. By the time of the first complete census, in 1924, however, only 12 percent of the protectorate's African population were defining themselves as Nyasa, Yao, or Manyema, the three principal ethnicities from which Zanzibar's slave populations were drawn. *Report of the Zanzibar Native Census* (Zanzibar: Zanzibar Government Printer, 1924).

17. Jonathan Glassman, *Feasts and Riot: Revelry, Rebellion, and Popular Consciousness on the Swahili Coast, 1856–1888* (Portsmouth, N.H.: Heinemann, 1995), 61–64, 117–74; Randall Pouwels, *Horn and Crescent: Cultural Change and Traditional Islam on the East African Coast, 800–1900* (Cambridge: Cambridge University Press, 1987), 75–80; A. H. J. Prins, *The Swahili-Speaking Peoples of Zanzibar and the East African Coast: Arabs, Shirazi, and Swahili* (London: International Africa Institute, 1961), 13. By the late nineteenth century, most Arabs in Zanzibar did not in fact speak Arabic, but rather Swahili. Many individuals who were members of aristocratic Arab families were also often extremely dark in complexion. M. A. Ghassany, interview by author, May 14, 1992; C. P. Rigby, *Report on the Zanzibar Dominions* (Bombay: Education Society Press, 1861), 5; Sir Charles Eliot, *The East African Protectorate* (London: Edward Arnold, 1905), 114. All the interviews I did took place in Zanzibar and were conducted in Kiswahili.

18. See the file on Rusoona binti Tamim, ex-sultan's concubine, Zanzibar National Archives (hereafter ZNA) AB 10/108; Emily Ruete, *Memoirs of an Arabian Princess from Zanzibar* (1888; reprint, New York: Marcus Weiner, 1989), 10, 32; Bakia binti Juma, July 10, 1992; Fatma binti Baraka (Bibi Kidude), September 15, 1991; interviews by author.

19. Adija Saloum Bakari, interview by author, August 3, 1995. The Kiswahili term used, *mwabana*, can translate as either "husbands" or "masters."

20. Brennan, *At Home*, 13–14.

21. Women dated the emergence of mkinda to the reign of Sultan Seyyid Hamoud bin Muhammed, who ruled from 1896 to 1902. Amina Seif Othman, July 19, 1995; Adija Saloum Bakari, July 27, 1995; Mariam Mohamed Ali, August 10, 1995; interviews by author.

22. Although unyago and several other forms of initiation are widely practiced throughout East Africa, mkinda appears to be unique to Zanzibar, and particularly Zanzibar town.

23. Margaret Strobel, *Muslim Women in Mombasa, 1890–1975* (New Haven, Conn.: Yale University Press, 1979), 10–12, 196–203; Mtoro, *Customs of the Swahili*

People, 45–59; Leila Sheik-Hashim, *Unyago: Traditional Family Life Education among the Muslim Digo, Seguju, Bondei, Shambaa, and Sigua of Tanga Region* (Dar es Salaam: Tanzania Media Women's Association, 1989); S. J. Mamuya, *Jando na Unyago* (Nairobi: East African Publishing House, 1975); Fatma binti Baraka (Bibi Kidude), September 30, 1991; Amani Stadi, March 8, 1992; Kiboga Bakari, August 1, 1995; BiMkubwa Stadi Fundi, August 8, 1995; interviews by author.

24. Bakia Binti Juma, interview.

25. Shamsa Muhamad Muhashamy, in *Three Swahili Women: Life Histories from Mombasa, Kenya,* ed. and trans. Sarah Mirza and Margaret Strobel (Bloomington: Indiana University Press, 1989), 98.

26. Amina Seif Othman, interview.

27. Adija Saloum Bakari, interview, August 3, 1995.

28. Latifuu Ali Marzuk, interview by author, August 15, 1995.

29. Adija Saloum Bakari, interview, August 3, 1995; Amina Seif Othman, interview.

30. Amani Stadi, August 3, 1992; Bakia binti Juma; Adija Haji Simai, January 17, 1992; Latifuu Ali Marzuk; Kiboga Bakari, August 15, 1995; interviews by author.

31. Adija Saloum Bakari, interview, August 3, 1995; Amina Seif Othman, interview; file on Rusoona binti Tamim, ZNA AB 10/108.

32. During this period there were also efforts on a variety of levels to reform Islamic ritual practice in East Africa in ways that enhanced the status of former slaves. August Nimtz, *Islam and Politics in East Africa: The Sufi Order in Tanzania* (Minneapolis: University of Minnesota Press, 1980); Fair, *Pastimes and Politics,* 17–19, 174–82.

33. The cumbersome barakoa was not only not adopted by non-Arab Zanzibari women, it was abandoned by Arab women as well, shortly after the turn of the century.

34. Rahma Himid, interview by author, July 19, 1995.

35. Nunu binti Salum, interview by author, March 18, 1992; Latifuu Ali Marzuk, interview; Amina Seif Othman, interview.

36. The movements themselves were described by women as being akin to those formerly used during the performance of *lelemama,* a women's dance popular along the Swahili coast. For more on lelemama, see Strobel, *Muslim Women in Mombasa;* Marjorie Ann Franken, "Anyone Can Dance: A Survey and Analysis of Swahili Ngoma Past and Present" (Ph.D. diss., University of California, Riverside, 1986); Kelly Askew, "Female Circles and Male Lines: Gender Dynamics along the Swahili Coast," *Africa Today* 46, no. 3 (1999): 67–105.

37. Mtoro bin Mwinyi Bakari, *Customs of the Swahili People,* 122–43, 222–24; Glassman, *Feasts and Riot,* 154–57.

38. Subira Mzee, interview by author, July 17, 1995.

39. Interestingly enough, when the postrevolutionary Afro-Shirazi Party took control of mkinda, as it did of all forms of culture after the revolution in 1964, it allowed women to retain control over most elements of the ndege costume, but required them all to carry matching umbrellas distributed by the ruling party. Under the Chama Cha Mapinduzi Party, this policy is still in force today.

2 Dress and Politics in Post–World War II Abeokuta (Western Nigeria)

Judith Byfield

> Market women supporters of the Action Group were furious on Thursday
> night, and several of them yesterday refused to cook for their Action Group
> husbands.
> Why?
> As one put it to a representative of the *West African Pilot* yesterday, the women
> had been erroneously led to believe that the Action Group would win and had
> donned . . . their best attire to dance to the tunes of Sakara, Sekere and Aro and
> Gbedu music only to be disappointed in the end.[1]

The Action Group's loss to the National Council of Nigeria and the Cameroons
(N.C.N.C.) in the 1952 by-elections to the Western House of Assembly clearly up-
set those women supporters who had put on their best clothes in anticipation of a
celebration. The Action Group did not plan this effort. Rather, the women's sarto-
rial preparation emerged from an appreciation of the cultural meaning that would
be conveyed by their dress. In Yoruba society's rich aesthetic and cultural land-
scape, dress communicated a range of ideas and social conventions, including iden-
tity, character, and status. Though subject to rapidly evolving styles and fashions,
dress could be adapted to express everything from material conditions to ideologi-
cal debates. Thus it became a critical tool in the contentious and symbolically rich
world of politics. There was no one relationship between dress and politics. Politi-
cal actors deployed dress in multiple ways to express varied notions and ideas. For
example, dress played an integral role in the development of nationalist thought.
Cultural nationalists of the late nineteenth and early twentieth centuries displayed
their critique of colonialism by shedding Victorian dress and recommitting to "tra-
ditional" Yoruba dress. This visual medium of political expression communicated
multiple messages to a diverse audience in Lagos and other urban centers. To Brit-
ish political, commercial, and missionary agents it signaled that these members of
the elite had distanced themselves from colonial culture and an uncritical accep-
tance of its values. It also signaled their participation in a regional political discus-
sion as well as their desire to align themselves politically and culturally with Yoruba
society.

This chapter examines the multiple political uses of dress in the Yoruba town of Abeokuta in the dynamic and politically tumultuous years immediately after World War II. The town experienced a significant rise in women's political activism as women tried to meet their financial and social obligations during this period, which was also characterized by economic crisis.[2] This agitation led to the formation of the Abeokuta Women's Union (AWU), perhaps the most important women's organization in the postwar period. Under the leadership of Mrs. Funmilayo Ransome-Kuti, a teacher and nationalist, this organization staged a tax revolt that led to the temporary exile of the traditional king and Sole Native Authority, *Alake* Ademola II, a temporary abolition of taxes on women, and the inclusion of women on the local governing councils. The AWU was organized along much the same lines as associations formed in the political context of colonial Nigeria. It had a formal constitution and bylaws that expressed its mission and goals as well as what was expected of its members. It championed democracy, independence, political service, and women's involvement in the formal organs of political power. The constitution also included prescriptions on dress. The analysis that follows explores the AWU's dress policy, its implications, and the wider ways in which the organization used dress as a medium of political expression and protest.

Changes in Women's Dress

Dress, as Barnes and Eicher define it, is a comprehensive term for direct body changes such as tattoos and hairstyles, and items added to the body such as clothing and jewelry.[3] Among the Yoruba, clothing and its accessories constitute the most important form of aesthetic expression.[4] Dress did not merely cover the body, it indicated one's gender, character, wealth, and status, and it determined and negotiated social relationships. Yoruba popular thought often expressed the relationship between dress and social interaction, as in the saying *"iri ni si ni isonilojo"*— one's appearance determines the degree of respect one receives.[5]

In the nineteenth century, Yoruba women's apparel consisted of an undergarment, a knee-length apron or petticoat called a *tobi* that was tied around the waist with a strong cord or band, two or three wrappers, and a headdress. Age determined the combination of cloths women wore. Art historian T. M. Akinwumi argues that unmarried women wore a wrapper, the *irobinrin,* and a small headscarf, the *idiku,* when they went out.[6] His description varies slightly from that of the nineteenth-century Yoruba historian Samuel Johnson. Johnson claimed that unmarried women generally wore two wrappers. The under-wrapper was usually a heavier cloth that women fixed above the breasts. A lighter cloth sufficed for the upper wrapper, which went around the waist.[7] Married women used a third cloth, the *iborun,* as a shawl or as a covering for the head and back. The headdress, or *gele,* finished a woman's outfit. Elderly women had the exclusive right to another headscarf, known as the *ikaleri,* which they sometimes used to carry gifts presented to them.[8] Men's apparel, on the other hand, included gowns, vests that were worn under the gowns, and trousers. Men's garments were fitted and those of wealthier men were decorated with ample embroidery, while women's clothing was not tailored

and did not appear to involve the elaborate embroidery found on some men's pieces.

The importance of dress meant that people had to be aware of changing fashions, but new fashions reflected more than fickle trends. Fashion, as Braudel reminds us, is also a search for a new language through which each generation can repudiate its immediate predecessor and distinguish itself from it.[9] The variety of dress available in Abeokuta in the nineteenth century allowed more than just intergenerational dialogue. Clothing spoke of economic opportunities and socioeconomic divisions as well as the formation of new social groups defined by their adherence to new gods and new values.

Abeokuta was one of the early centers of missionary activity. Among the town's Christian population, British styles were the norm. The earliest Christians, the Saros, were men and women liberated from slave ships who initially settled in Sierra Leone, where they were introduced to Christianity and to British clothing and culture. The first Saros to arrive in Abeokuta in 1839 received permission to continue wearing European clothing.[10] Certain garments, which formed the standard wardrobe of those in the mission stations, became emblems of the new way of life. One such garment, singled out by the American Baptist Rev. R. H. Stone, was a knee-length shirt that all boys in his mission station wore.[11]

Although certain clothes defined social groups, such as religious communities, those garments did not always stay restricted to those communities. Their use became popularized and their social meaning broadened. Sarah Tucker, who wrote a history of early missionary work in Abeokuta, reported that "independently of any religious motive, some of the gay young men affect the Mohamedan costume, and wear wide sack-like trousers, much embroidered, and confined close around the ankle, with loose upper garment, and turban. . . . Some of them are beginning to adopt the English dress."[12] A similar trend occurred in women's clothing. By the end of the nineteenth century, women were increasingly adopting a tailored blouse, the *buba*. As tailored blouses became more broadly accepted they lost their status as distinctive markers of Christian conversion, since women who practiced Islam and Yoruba religion also adopted them. The adoption of tailored blouses supports Barnes and Eicher's contention that fashion sometimes prevails over ideology and overtakes a symbol that was once politically potent.[13]

Since dress was an important component of Yoruba aesthetics, the type of cloth used to construct one's outfit was equally important. The quality of the cloth indicated an individual's socioeconomic status and wealth, because only those with sufficient wealth could acquire the finest cloths. Samuel Crowther, Jr., the son of the renowned Egba missionary, noted that the alake and chiefs asked him to recommend merchants in England to whom they could send cotton in exchange for cloths.[14] Missionaries and other travelers often described the fine imported silks and velvets worn by political elites. Several factors defined a fine cloth: the quality of the weave, the use of silk instead of cotton thread,[15] the novelty or workmanship of the design, and the depth of color, especially of indigo-dyed cloths. Also important were the amount of fabric used and the fineness and heaviness of any embroidery.[16]

Practical considerations also encouraged the use of some imported cloths. As Renne points out, Manchester prints and calico were not durable, but they were affordable. They were also lighter and more comfortable. Despite these practical considerations, important ideological factors also lay beneath the adoption of these inexpensive European fabrics. European cloth was associated with *olaju*, enlightenment. Among other things, imported cloth expressed people's identification with a wider "civilized" world, progress, and change.[17] The ways in which these cloths were finished by local dyers and worn suggest that they also connected consumers to Yoruba history and aesthetics. Cloths like *adire*, the indigo tie-dyed cloth for which Abeokuta was famous, allowed consumers to be simultaneously "modern" and "traditional." Untailored wrappers and indigo-dyed cloths placed twentieth-century women in the same cultural universe as women of the mid-nineteenth century, but they had modernized that universe through the use of imported cloths, resist patterning, tailored blouses, and shoes.[18]

Dress and Nationalist Discourse

In Sierra Leone, the Creoles, descendants of Afro-British, African American, and Jamaican immigrants, had launched a dress reform movement in the late 1880s. Dress reformers saw the elimination of European dress as the first important step in bringing about a gradual independence from all European customs. They did not, however, adopt the dress styles of the indigenous communities in Sierra Leone. They invented a new wardrobe that served to distinguish them both from Europeans and from the communities in the hinterland, which they considered "barbarian aborigines."[19] This movement quickly spread to Nigeria, but there it had some distinguishing features.

In Lagos, early cultural nationalists identified very strongly with Yoruba culture. The newspapers, especially the *Lagos Weekly Record* and the *Lagos Standard,* instituted a vigorous campaign of cultural consciousness that tried to stimulate greater interest in African history, language, and culture.[20] Some of the major issues under discussion were the use and study of the Yoruba language (especially in schools), African dress, polygamy, the education of women, and Yoruba secret societies.[21] Inspired by Edward Blyden, some early nationalists began to study Yoruba culture seriously.[22] In 1903, the Lagos Native Research Society was founded, and an important body of histories and oral traditions were recorded. Samuel Johnson, a priest trained by the Church Missionary Society (CMS), completed his first draft of *The History of the Yorubas* in 1896, although it was not published until 1921. Johnson's text was the first major study of the Oyo empire and is still an important resource for contemporary historians of precolonial Yoruba history.[23]

Other nationalists showed their support in more personal ways. Some dropped their European names and adopted African names,[24] while others hyphenated their European name with an African name. So the Joneses, for example, became the Adeniyi-Joneses.[25] Two well-known personalities from Abeokuta who changed their names were Rev. J. H. Samuel, secretary of the Egba United Government, who

changed his name to Adegboyega Edun, and G. W. Johnson, former secretary of the Egba United Board of Management, who became Oshokale Tumade Johnson.[26] Inspired by the Sierra Leone dress reform movement, some also abandoned European dress and began wearing Yoruba dress. The author of an 1896 article in the *Lagos Standard* characterized European dress as unsuitable for the African climate and a symbol of mental bondage.[27] Another commentator, Rev. Mojola Agbegi, charged that European names and dress were concrete reminders of Africans' ambivalent cultural and social positions; "every African bearing a foreign name is like a ship sailing under false colors, and every African wearing a foreign dress in his country is like the jackdaw in peacock's feathers."[28]

Most discussions of the cultural nationalist movement of this period highlight men's participation, but some women also shared this critique of European dress and cultural values. The daughters of Richard Blaize, the wealthy Egba Saro merchant and founder of the *Lagos Times*, made names for themselves by wearing traditional dress on special occasions. One daughter, Mrs. Gibson, wore an "unusual combination of *adire* 'tie dye' wrapper and differently patterned European prints as buba-like overblouse, head-tie, and shawl . . . [while] her sister . . . combined hand-woven cloth, *adire* and European prints."[29] Their adire wrappers indicated the sisters' rejection of Christian society's dictates. For members of the early-educated Christian elite, the choice between Western and Yoruba dress for public occasions made a significant political statement.

In western Nigeria, Yoruba dress became the standard for cultural nationalists. Purists watched evolutions in Yoruba dress styles vigilantly and challenged them in public forums such as the newspapers. In 1937, for example, women's wrappers became the center of a controversy over "going Fantee." Commentators, such as the Yoruba sociologist N. A. Fadipe, questioned the national consciousness of Yoruba women who adopted the Fantee mode of wearing wrappers.[30] He insisted that Yoruba women had to introduce improvements that were uniquely Yoruba.

Many of the participants in the dress reform movement and in the later debates about dress and nationalism were members of Nigeria's emerging intelligentsia. During the first two decades of the twentieth century they were primarily concentrated in the southern part of the country, in the southern Yoruba centers and the Niger Delta. Many of the prominent members of this community came from Christian educated families, many of them Saro.[31] Funmilayo Ransome-Kuti belonged to this group. Her father's parents, Sarah Taiwo and Ebenezer Sobowale Thomas, married in Sierra Leone. After Thomas's untimely death, Sarah remarried and returned to Abeokuta. Ransome-Kuti's father, Daniel Thomas, was mission-educated and a trained tailor and carpenter. Her mother, Lucretia Adeosolu, was also Western-educated. She attended a Church Missionary Society school, where she trained as a seamstress.[32] Daniel and Lucretia Thomas's lives show the effects of the cultural nationalist movement at the end of the nineteenth century. Daniel's uncle, Samuel Coker, was one of the leading members of the independent church movement, whose members supported the notion that one could practice polygamy and be a Christian in good standing.[33] Daniel Thomas obviously shared this belief

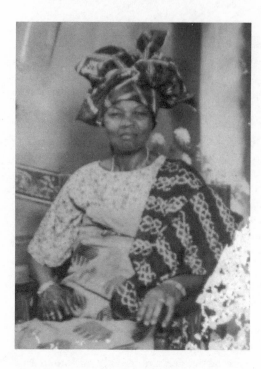

Figure 2.1. Funmilayo Ransome-Kuti's mother, Lucretia Thomas. Courtesy of Kenneth Dike Library, University of Ibadan.

because he had two wives: Lucretia, who lived in Abeokuta town, and Rebecca, who lived on the farm. The children of both mothers were raised as Anglicans, spoke fluent English and Yoruba, and wore both English and Yoruba dress.[34]

Funmilayo Ransome-Kuti also belonged to a new generation of the intelligentsia. Zachernuk argues that by the 1930s, this group had evolved into a "modern intelligentsia, shaped by contemporary Atlantic thought, colonial politics, and indigenous intellectual traditions." The new intelligentsia stayed abreast of developments in other parts of the African diaspora, as had their predecessors. They retained the idea of using transatlantic links to their own advantage, but, unlike the earlier generation of nationalists, "rejected African American claims to race leadership." Increasingly their political energies were focused on Nigeria and local problems. The leading voices of this new intelligentsia championed independence and insisted that Western education was an unequivocal prerequisite for leadership.[35] Funmilayo Ransome-Kuti and her husband, Rev. I. O. Ransome-Kuti, were leading figures in this group of young, educated nationalists. She was educated at the Abeokuta Grammar School and the Wincham Hall School for Girls in England, while Rev. Ransome-Kuti attended Abeokuta Grammar School and Fourah Bay College in Sierra Leone.[36] They were both close friends of Ladipo Solanke, one of the founders of the West African Students Association in London. Rev. Ransome-Kuti was one of the founders of the Nigerian Union of Teachers, principal of the Abeokuta Grammar School, and a member of the Elliot Commission, whose recommendation led to the establishment of University College of Ibadan. In addi-

Figure 2.2. Funmilayo Ransome-Kuti with Princess Remi Ademola, daughter of Alake Ademola II.

tion, both Ransome-Kutis were founding members of the National Council of Nigeria and the Cameroons, the leading nationalist organization in the 1940s. As well-traveled members of this new intelligentsia, they were equally comfortable in Western and Yoruba attire. Their daughter recalled that Mrs. Ransome-Kuti wore either Yoruba or English dress at home. Her father, on the other hand, exclusively wore English dress at home when they were growing up, but many pictures of him in public settings show him in Yoruba as well as Western clothing.[37]

The Emergence of the Abeokuta Women's Union

The AWU came into existence in 1946. In many ways, its emergence reflected the coming together of two different strands of women's organizations—market women and Christian-educated women of the Abeokuta Ladies Club (ALC). The first meeting of the ALC was held on March 15, 1945, at the Abeokuta Grammar School. At that meeting the alake, Ademola II, was named patron and Mrs. Ransome-Kuti was elected president. The executive also included Mrs. O. Akinwumi (treasurer), Mrs. O. Sowunmi (secretary), and Miss Bisi Sodeinde (assistant secretary). At that meeting the group decided to meet twice a month, and that members should contribute 6d each month to the club's purse.[38] Wole Soyinka, whose mother was also a member of the ALC, characterized it as an organization concerned primarily with teaching middle-class etiquette.[39] To a degree this was

Figure 2.3. Rev. and Mrs. Ransome-Kuti and students from Abeokuta Grammar School. Courtesy of Kenneth Dike Library, University of Ibadan.

reflected in the club's minutes. The ALC catered dinners (4/6d per person), lunches (3/6d per person), and teas (2/6d per person) for any group that approached them. They also planned social evenings, picnics, and lessons in "English Cookery" for young women. Membership was selective. Potential members were suggested during meetings and then invited to attend. During their meeting of June 1, 1945, plans for a Ladies Club Auxiliary dominated the discussion. This auxiliary would be made up of secondary school girls who would become full members of the ALC in the future. Members generated a list of six young women who were still in school and extended invitations to them.[40]

The ALC's minutes reveal that its members were concerned with a range of social issues. During their meeting on February 8, 1946, Mrs. Ransome-Kuti "reported a case of seizure of rice at Isabo market by some Native Authority policemen." She also recounted the steps she had taken to have the rice returned to its owners.[41] At a special meeting on March 16, 1946, the ALC approved a list of eight resolutions, which was then forwarded to the Resident, the alake, and members of the Egba Council.[42] The list included demands for improved public sanitation, public playgrounds for schoolchildren, government support for adult education, and no tax increase on women. These resolutions reflected the club members' increasing contact with market women through their literacy classes and increasing awareness of the issues this group of women confronted. Shortly after the resolutions were approved, the ALC decided to have a meeting of all the *iya egbes*, the heads of market women's commodity associations.[43]

Ransome-Kuti's involvement with the market women strengthened her political

engagement with gender and class issues. Autobiographical vignettes produced by Ransome-Kuti for a biography captured her deepening political sensibilities. "There is a big gap between the life led by the educated women and the sufferings of the illiterate market women. Some educated women never knew the hardship of paying tax, being clergymen's wives."[44]

In order to identify more closely with this constituency, she decided to abandon Western clothing. She wore only Yoruba wrapped cloth, in order to "make women feel and know I was one with them."[45] Soyinka suggests that dress did indeed separate these two groups of women. In *Ake,* he refers to educated women as *onikaba,* gown wearers, while market women are *aroso,* wrapper wearers.[46] Ransome-Kuti's exclusive use of Yoruba dress clearly had political dimensions. Johnson-Odim and Mba note that no public photograph of her taken after the late 1940s shows her in anything other than Yoruba dress.

We must ask: Why would market women have been interested in a coalition with the ALC? To answer this question we have to look at the economic and political circumstances market women faced during the war and the years immediately following. Women involved in local production and in the processing and sale of foodstuffs were hit hard by the economic restrictions imposed by the war. Indigo dyers, for example, saw their markets shrink as traders from French colonies were banned from Nigeria. Food sellers had to contend with price controls on local foodstuffs. At the same time, there was a sharp increase in demand for food, especially rice, to feed the military personnel in Lagos. The contention around rice offers one example of the unending economic crisis market women confronted.

Correspondence from the chief secretary's office shows that demand for foodstuffs became increasingly critical, since the entire requirements of the armed forces had to be met in full in West Africa.[47] It was assumed that the bulk of supplies would come from Nigeria while the other colonies—Gold Coast, Sierra Leone, and Gambia—would work to be at least self-sufficient in certain items. As early as 1942, it was noted that the availability of guinea corn and rice was cause for concern. In February of that year, the director of agriculture recommended in a confidential memo that the movement of rice from the main producing areas—western Sokoto, Bida Division, and Ilorin Province—be prohibited. Although Abeokuta was not one of the main rice-producing areas, rice grown within the province became increasingly important to the rice supply estimates for both the military and civilian population in Lagos. To ensure adequate supplies, Abeokuta farmers were assigned a production quota of three thousand tons, the government set the price at £13/ton, and the export of rice was prohibited except by special permit.[48] The rise of an "unofficial" market compromised the state's efforts to obtain sufficient rice at the set price. Rice producers, traders, police, and railway staff ignored the export prohibition and smuggled rice out of the province, where it could be sold for much more. In 1943, three thousand tons of rice "disappeared" from Abeokuta.[49] In order to stem the smuggling, those caught exporting rice illegally were given prison terms rather than fines.[50]

By October 1943, the rice situation had reached a crisis. Captain Pullen, who

was in charge of bulk supplies for the Lagos market, predicted that if he was not able to get rice from Abeokuta, the whole bulk-marketing scheme would collapse.[51] Colonial officials began contemplating extreme measures:

> We have now reached a point where it seems unlikely that anything but physical requisition looks like having any result. Put brutally, the civilian population of Abeokuta has, for reasons of profit, refused to make any effort to feed the Army. Between feeding the Army and making profits, there is only one choice. The ultimate answer is that the Army is in a position to fetch its own food out of the hands of those who are holding it up.[52]

Although it is unclear whether a formal order was given to requisition rice, reports of rice seizure from market women became commonplace. In many instances, rice was taken from women traders without payment. Although the war ended in 1945, the restrictions imposed on Nigeria's economy were not lifted immediately and the controls on rice and other staples continued into 1947.

The rice sellers likely welcomed Mrs. Ransome-Kuti's intervention on their behalf. Nonetheless, in Abeokuta it was unusual for a woman of her socioeconomic background to agitate on behalf of market women. Furthermore, Abeokuta's market women had their own commodity associations, and these associations had a strong record of bringing their grievances and concerns to the Egba Council. Egba Council minutes reveal numerous occasions during the 1920s and 1930s when different groups of market women confronted the local government over grievances such as the high cost of market stalls, competition from non-resident traders, and the bans on caustic soda and synthetic dyes. Records show that during the 1920s the *iyalode* of the Egbas, the highest-ranking woman in the town, often presented market women's grievances to the Egba Council. Ransome-Kuti's literacy was an obvious asset, but illiteracy had not been an insurmountable problem in the past. When indigo dyers challenged the alake's ban on caustic soda and synthetic dyes in the 1930s, they hired both a Nigerian and a British lawyer to represent them.[53]

Nonetheless, by the 1930s a political vacuum of sorts existed and this was most apparent in the women's title structure. When the iyalode of the Egbas, Madam Jojolola, died in 1932, the title lapsed. In the precolonial period the iyalode of the Egbas had been the women's representative to the alake. The creation of the title recognized women as a political constituency within the town's affairs, and the nineteenth holder of the title, Madam Tinubu, was a wealthy merchant who helped enthrone and overthrow alakes. Under colonialism, select male title holders were incorporated into the local governing council. While the holder of the iyalode title was recognized as the leader of and spokeswoman for the town's women, she was not invited to sit on the council. The records show that Madam Jojolola questioned women's absence from the council and the lack of attention paid to women's titles; nonetheless she continued to be a strong advocate for women until shortly before her death. When the title lapsed, there was no central figure who represented the majority of women of the town. Women's political leadership was fragmented. There were the heads of the commodity associations and township iyalodes, and the Christian women even borrowed from the old title structure to create an iya-

lode of the Christians. In the immediate postwar period, then, market women faced political fragmentation, price controls, rising inflation, and a planned tax increase. Thus Ransome-Kuti's skills and willingness to agitate on behalf of market women began to fill an important vacuum.

As a result, the Abeokuta Women's Union represented a wide cross section of women. They were poor and wealthy, market women, teachers, shop owners, literate and non-literate. They also reflected the town's religious diversity, including Christians, Muslims, and Orisha devotees.[54] Many came from Abeokuta town, but many also came from its outlying villages, bearing food for their co-protesters.[55] The organization's constitution strongly reflected its socioeconomic diversity and its desire for unity. Its official aims and objectives were

I. To establish and maintain unity and cooperation among all women in Egbaland.
II. To defend, protect, preserve and promote the social, economic, cultural and political rights and interests of the women in Egbaland.
III. To encourage mass education among the women through teaching its members to read and write.
IV. To cooperate with all organizations seeking and fighting genuinely and selflessly for the economic and political freedom and independence of the people.
V. To raise and maintain necessary and adequate funds to carry out the aims and objects of the Union.[56]

Membership in the AWU, unlike in the ALC, was open to all women in Abeokuta. Regular meeting days followed the calendar of markets; the AWU met once a month on the last Omida market day. The constitution also enshrined an advocacy role for the AWU: "The Union will always be ready to take up any financial members complaints whenever such report is made known to the Union." The AWU's political charge was apparent in the organization's motto as well: "Unity, Cooperation, Selfless Service and Democracy." Special rules also alluded to the multiclass nature of the Union: for example,

No member of the Union should think herself better than others, all must move freely and happily.
There should be moderation in the way the members dress for public occasions.

In contrast to the selective and elite Abeokuta Ladies Club, the Abeokuta Women's Union positioned itself as the voice for all women and attempted to modulate their socioeconomic differences.

The Politics of Dress and Undress

As a member of the Christian educated elite and a founding member of the main nationalist organization, the N.C.N.C., Ransome-Kuti understood the power and politics of dress. Many argued that she used it quite effectively. Observers noted that Ransome-Kuti did not try to distinguish herself in dress or language from the women she represented. She wore Yoruba dress, consisting of gele (head-tie), iro (wrapper), and buba (blouse). Even when speaking to the colonial authorities on behalf of the AWU, she spoke in Yoruba, and her words were trans-

Figure 2.4. Women gathering. Courtesy of Kenneth Dike Library, University of Ibadan.

lated into English.[57] Such actions clearly demonstrated her political loyalties to the majority of Egba women, who primarily spoke Yoruba in the course of their daily interactions and wore traditional dress.

A second level of dress politics appears to have been at work. The AWU's policy on dress suggests that its leadership wanted to visually reflect internal unity. In this context, moderation held several likely meanings. It would discourage women from wearing elaborate or expensive cloths, jewelry, or shoes that would clearly identify them as well off. In addition, this strategy did not require any added expenditure on matching cloths or emblems. Photographs of women at AWU gatherings show that all of them wore the same articles of Yoruba dress. Moderation in dress achieved a certain level of uniformity, and rendered this diverse group of women into visual equals. Moderation also helped to nurture unity among the members of the AWU. Dressing in moderation and in Yoruba dress reminded AWU members of their shared goals and aspirations.

Participants in protests recalled that the women and the numerous children who followed along behind them often wore white handkerchiefs or scarves on their heads. Some also placed the handkerchiefs on their wrists and waved them as they marched through the town, gathering supporters on their way to the alake's palace.[58] Chief and Mrs. Adeyinka recalled a lot of singing and dancing, which created a carnival-like atmosphere.[59] The songs, however, were not meant to entertain. They were meant to abuse the alake, for they questioned his virility and integrity, among other things. The women's repertoire also included songs usually sung at funerals.[60]

This strong show of unity was essential because the AWU had detractors. The protests divided the town as various social and political groups aligned either with

the AWU or with *Polo,* an organization created by the alake's supporters. The AWU, for example, had the strong support of the *majeobaje* ("those who want to improve the town"), a group led by Rev. Ransome-Kuti. While the women took to the streets and put pressure on the alake and the colonial government, Rev. Ransome-Kuti and the majeobaje gathered critical support in the Egba Council. He was able to persuade a significant number of *ogboni* chiefs in the council to withdraw their support from Ademola.

AWU supporters also used undress as part of their protest strategy. In one of the mass rallies to pressure the alake to abolish taxes on women, Soyinka noted that tension grew as one of the council members, the *balogun* of the Egbas, remarked,

> The world is spoilt, the world is coming to an end when these women . . . can lay siege to the place and disturb the peace. . . . Go home and mind your kitchens and feed your children. What do you know about the running of state affairs? Not pay tax indeed! What you need is a good kick on your idle rumps.[61]

As a result of the balogun's insults, the women stripped his fellow council members down to their shorts and used their chiefly regalia to beat them. Soyinka's mother did not agree with the use of violence and hid one of the council members in her shop.

This was not the only time that detractors were stripped of their clothes. Council minutes reveal that this happened in several parts of the town, as supporters of the women assaulted people in the "public streets by stripping them into nakedness and ridiculing them."[62] Opponents were also beaten, and in several instances their homes were vandalized. Chief E. B. Sorunke, a former member of the majeobaje, recalled a set of young male supporters whom he characterized as thugs, for they attacked "not only ogboni . . . all Egba chiefs, stoning and damaging their property."[63] As the town became increasingly ungovernable, officials considered calling in the army.[64] The level of unrest in the town was revealed most dramatically when protesting women began to remove their own clothing outside the palace. Participants spoke of older women stripping naked or down to a small underskirt as they called for the alake to leave office.[65] Within Yoruba society it was taboo to view an elderly woman naked; some suggested that it could even result in the death of the viewer (who was intended in this case to be Ademola). This act of undressing in public expressed the women's deep contempt for the alake. By removing their clothes, the women symbolically removed their respect for Ademola and ultimately stripped him of his authority. Some suggest that once the protest reached this stage, the alake had no choice but to leave Abeokuta.[66]

In his memoir, Soyinka aptly refers to this tax revolt as the "great upheaval." Ademola had been a part of Abeokuta's government since the end of the nineteenth century. He had been an adviser to the alake Gbadebo I, even accompanying him to Britain in 1904. He assumed the throne in 1920 following Gbadebo's death. Despite some early misgivings by colonial officials, he proved to be a diligent and loyal functionary within the colonial state. He was regarded by many as the model Sole Native Authority. Colonial officials often arranged for other traditional rulers to

Figure 2.5. Alake Ademola II in London for the coronation of George V. Courtesy of his son, Omoba Adegbola Ademola.

visit Abeokuta so that they could see how a well-functioning Native Authority operated.[67] Ademola had also weathered many attacks on his model of leadership, as well as charges of financial misconduct and even conspiracy to commit murder.[68] Those charges did little to weaken his hold on Abeokuta and the faith British Residents placed in him. In 1934 he was awarded the title of Commander of the Order of the British Empire, and in 1937 he traveled to London to attend the coronation of George V. It was hard for anyone to imagine that the women's tax agitation could lead to his exile. It was indeed a great upheaval.

An event of this magnitude demanded symbolism on a grand scale, and dress provided one avenue through which the spectacle of this political confrontation became imprinted in people's memories. Participants animatedly recalled the singing and dancing and the white head-ties. Traditional dress and the white head-scarves and handkerchiefs blurred the variety of occupations, economic positions, and religions among the protesters. Clothing demonstrated that they launched their critique from their shared position as Yoruba women subject to political decisions not of their own making. The white handkerchiefs identified them in obvious and defiant ways to those who were bystanders or who did not share their critique of colonialism or the alake.

With equal animation, participants and observers recalled moments when cloth-

ing was removed and bodies exposed. Context infused meaning into those moments of exposure, but certain common elements united them. Whether they were stripping chiefs of their clothes or taking off their wrappers in front of the alake's palace, undressing expressed women's loss of respect for those in authority.[69] In the symbolically rich landscape of Yoruba culture, dress provided a vocabulary as well as a tool through which the members of the AWU registered their political opinions. The women were adamant that Ademola had to go, and in taking off their clothes they not only revealed their bodies, they also revealed their resolve.

Notes

The research for this chapter was supported by a grant from the Rockefeller Center at Dartmouth College, a Fulbright Fellowship, and an NEH fellowship (FB-38725). I would like to thank Jean Allman, Shoshanna Green, and the anonymous reader for insightful comments on earlier drafts of this chapter.

1. "Action Group Hired Drummers & Women Return Dismayed—Election Result Shatters Plans," *West African Pilot*, November 28, 1952.

2. For a fuller discussion of the postwar economic crisis see G. O. Olusanya, *The Second World War and Politics in Nigeria, 1939–1953* (London: Evans Brothers for the University of Lagos, 1973); and Lisa A. Lindsay, "Domesticity and Difference: Male Breadwinners, Working Women, and Colonial Citizenship in the 1945 Nigerian General Strike," *American Historical Review* 104, no. 3 (1999): 783–812.

3. Ruth Barnes and Joanne B. Eicher, eds., *Dress and Gender: Making and Meaning in Cultural Contexts* (Oxford: Berg, 1992), 15. This definition, they argue, takes us away from classifications that use ethnocentric and value-charged terms.

4. Justine M. Cordwell, "The Art and Aesthetics of the Yoruba," *African Arts* 16, no. 2 (1983), 58.

5. Babatunde Lawal, *The Gelede Spectacle: Art, Gender, and Social Harmony in an African Culture* (Seattle: University of Washington Press, 1996), 15, and "Some Aspects of Yoruba Aesthetics," *British Journal of Aesthetics* 14, no. 3 (1974), 245.

6. T. M. Akinwumi, "The Commemorative Phenomenon of Textile Use among the Yoruba: A Survey of Significance and Form" (Ph.D. diss., Institute of African Studies, University of Ibadan, 1990), 24.

7. Samuel Johnson, *History of the Yorubas from the Earliest Times to the Beginning of the British Protectorate* (1921; reprint, London: Routledge and Kegan Paul, 1973), 112. Also see Eve de Negri, "Yoruba Women's Costume," *Nigeria Magazine*, no. 72 (1962), 10–12.

8. Akinwumi, "Textile Use," 24.

9. Fernand Braudel, *Capitalism and Material Life, 1400–1800*, trans. Miriam Kochan (New York: Harper and Row, 1967), 236.

10. Thomas Birch Freeman, *Journals of Various Visits to the Kingdoms of Ashanti, Aku, and Dahomi* (1844; 3rd ed., London: Frank Cass, 1968), 231.

11. R. H. Stone, *In Afric's Forest and Jungle, or, Six Years among the Yorubans* (Lon-

don: Oliphant, Anderson and Ferrier, 1900), 216. These shirts were sewn on a sewing machine that the Stones got after they relocated to Abeokuta during the Ijaye war, c. 1860. This is one of the earliest reported sewing machines in the region.

12. Sarah Tucker, *Abbeokuta or Sunrise within the Tropics: An Outline of the Origin and Progress of the Yoruba Mission* (London: James Nisbet, 1853), 24–25. Tucker's volume highlighted Abeokuta's importance to the strategy of the Church Missionary Society in Nigeria. She did not visit Abeokuta, but she drew on the accounts of explorers such as Barth and Clapperton and missionary journals and newspapers. Also see S. O. Biobaku, *The Egba and Their Neighbors* (Oxford: Clarendon, 1957), 31.

13. Barnes and Eicher, *Dress and Gender*, 23. Certain restrictions applied to the adoption of the buba. Akinwumi notes that it was initially restricted to married women. Akinwumi, "Textile Use," 24.

14. Samuel Crowther, Jr., journal for the quarter ending June 25, 1856, Church Missionary Society, CA 2/037A, microfilm, Center for Research Libraries.

15. Silk in Nigeria is derived from a non-mulberry silkworm, *anaphe venata*. M. O. Ashiru, "Silkworms as Money Spinners: *Anaphe* vs. *Bombyx*—A Status Report on Nigeria," an invited lecture given to the Nigerian Field Society, Ibadan branch, at the School of Forestry Hall, Jericho, Ibadan, April 13, 1988. Also see M. O. Ashiru, "Sericulture in Nigeria," *Indian Silk*, October 1979.

16. Margaret Thompson Drewal and Jennifer Isaacs, *Yoruba Art in Life and Thought*, ed. David Dorward (Bundoora, Victoria, Australia: African Research Institute, La Trobe University, 1988), 2.

17. Elisha Renne, *Cloth That Does Not Die: The Meaning of Cloth in Bunu Social Life* (Seattle: University of Washington Press, 1995), 173. For a discussion of the nuances and contextual meanings associated with olaju, see J. D. Peel, "Olaju: A Yoruba Concept of Development," *Journal of Development Studies* 14, no. 2 (1978): 139–65.

18. Mrs. Fry, "The Yoruba People, Their Peculiarities of Dress, European Dress Affected," *West Africa*, June 18, 1904, 592. Fry noted that canvas shoes had steadily become more common among men, and women and girls were beginning to wear them on state occasions.

19. Leo Spitzer, *The Creoles of Sierra Leone: Responses to Colonialism, 1870–1945* (Madison: University of Wisconsin Press, 1974), 117–19.

20. Fred I. A. Omu, *Press and Politics in Nigeria, 1880–1937* (Atlantic Highlands, N.J.: Humanities, 1978), 107.

21. Titilola Euba, "Dress and Status in 19th-Century Lagos," in *History of the Peoples of Lagos State*, ed. Ade Adefuye, Babatunde Agiri, and Jide Osuntokun (1987; reprint, Lagos: Lantern, 2002), 154; and Omu, *Press and Politics in Nigeria*, 108–15.

22. Blyden was Liberia's first ambassador to England (1877–78), and president of Liberia College from 1880 to 1884. He was also one of West Africa's earliest and most prolific writers on African history and Pan-Africanism. Blyden visited Lagos and the hinterland in 1890 and 1895, and served as agent for native affairs from 1896 to 1897. Omu, *Press and Politics in Nigeria*, 136. Also see Hollis Lynch, *Edward Wilmot Blyden, Pan-Negro Patriot, 1832–1928* (Oxford: Oxford University Press, 1964), 232–35.

23. J. A. Ajayi, "Samuel Johnson: Historian of the Yoruba," *Nigeria Magazine,* no. 81 (1984): 141-46.

24. E. A. Ayandele, *The Missionary Impact on Modern Nigeria, 1842-1914: A Political and Social Analysis* (1966; reprint, Essex, U.K.: Longman, 1988), 251-60.

25. Gbemi Rosiji, *Lady Ademola: Portrait of a Pioneer: The Authorized Biography of Lady Kofoworola Aina Ademola, MBE, OFR* (1996; 2nd edition, Ibadan: Macmillan Nigeria, 2000), 44. Lady Ademola noted that her family, the Moores, stubbornly resisted this trend.

26. The Egba United Board of Management (EUBM), created in 1861, was the Egba's first attempt to incorporate features of the British government in Lagos into their political structure. For a fuller discussion of the EUBM see Biobaku, *The Egba and Their Neighbors.* The Egba United Government was created with the support of the Lagos government in 1898. Treaty agreements recognized the independence of this government until the British abrogated it in 1914. See Agneta Pallinder-Law, "Government in Abeokuta, 1830-1914: With Special Reference to the Egba United Government, 1898-1914" (Ph.D. diss., Gotesborgs University, 1973).

27. "Outward Adornment," *Lagos Standard,* March 11, 1896; Euba, "Dress and Status," 159.

28. Rev. Mojola Agbebi, M.A., Ph.D., "The Spiritual Needs of the Africans," *Lagos Standard,* July 31, 1895 (supplement); Ayandele, *Missionary Impact,* 254-55.

29. Euba, "Dress and Status," 160. Elite women also joined the debate on polygamy. A few women publicly defended Yoruba marriage and polygamy. Increasingly, elite women also questioned the economic dependence that had become an expected part of Christian marriage and respectability. They began to advocate greater economic independence for women and tried to improve girls' educational and employment opportunities. Kristin Mann, *Marrying Well: Marriage, Status, and Social Change among the Educated Elite in Colonial Lagos* (Cambridge: Cambridge University Press, 1985), 89-91.

30. N. A. Fadipe, "Stirring Up West Africa," *West Africa,* September 26, 1936, 1340.

31. Philip Zachernuk, *Colonial Subjects: An African Intelligentsia and Atlantic Ideas* (Charlottesville: University Press of Virginia, 2000), 51-54. Also see Mac Dixon-Fyle, *A Saro Community in the Niger Delta, 1912-1984: The Potts-Johnsons of Port Harcourt and Their Heirs* (Rochester, N.Y.: University of Rochester Press, 1999).

32. Cheryl Johnson-Odim and Nina Emma Mba, *For Women and the Nation: Funmilayo Ransome-Kuti of Nigeria* (Urbana: University of Illinois Press, 1997), 23-24.

33. Ayandele, *Missionary Impact,* 201-202; also *Jacob Kehinde Coker: Father of African Independent Churches,* compiled by S. A. Dada (Ibadan, Nigeria: AOWA, 1986).

34. Johnson-Odim and Mba, *For Women and the Nation,* 26-27.

35. Zachernuk, *Colonial Subjects,* 123, 118, 113-14.

36. Johnson-Odim and Mba, *For Women and the Nation,* 30.

37. Dulopo Ransome-Kuti, interview by author, Isaba, Abeokuta, October 9, 2003. A photograph of the Rev. and Mrs. Ransome-Kuti in *West Africa* shows her in Yoruba dress and the Reverend in Western dress. See "The Ransome-Kutis of Abeokuta" in *West Africa,* May 12, 1951. The same photograph was also used in

the article "Sunrise within the Tropics," *West African Review,* January 1953, Ransome-Kuti Papers, box 1, folder 1, Kenneth Dike Library, University of Ibadan, Nigeria.

38. Minutes, Abeokuta Ladies Club, March 15, 1945, Ransome-Kuti Papers, box 87.
39. Wole Soyinka, *Ake: The Years of Childhood* (New York: Random House, 1981), 177–78.
40. Minutes, Abeokuta Ladies Club, June 1, 1945, Ransome-Kuti Papers, box 87.
41. Minutes, Abeokuta Ladies Club, February 8, 1946, Ransome-Kuti Papers, box 87.
42. Abeokuta Ladies Club's Resolutions, 1946, Ransome-Kuti Papers, box 87, folder 1.
43. I could not locate the minutes of that meeting, but the decision to hold it was significant and possibly signaled the beginning of the institutional coalition between market women and the ALC. Johnson-Odim and Mba note that the ALC changed its name to the Abeokuta Women's Union in March 1946, around the same time that the resolutions were passed and the meeting with the iya egbes planned.
44. Clara Odugbesan, "Bere: The Achievement and Contribution of a Brave Nigerian Woman Leader," Ransome-Kuti Papers, box 1, folder 2.
45. Johnson-Odim and Mba, *For Women and the Nation,* 66.
46. Soyinka, *Ake,* 178–82.
47. Report on Foodstuffs, chief secretary's office, 26/37909/S.14, pp. 1, 6, 10, National Archives, Ibadan (hereafter NAI).
48. Department of Commerce and Industry (hereafter DCI), 1/1—4041/S.20/C1, p. 65, NAI.
49. DCI 1/1—4041/S.20/C.2, p. 4, NAI.
50. Commissioner of police vs. Adeyemi Shodipe, Abudu Ramonu, Sanni Okete, and Adeagbo Adio, supreme court of Nigeria, in the district court of Ebute Metta, DCI 1/1—4041/S.20/C.2, NAI.
51. DCI 1/1—4041/S.2/C1, p. 3, NAI.
52. DCI 1/1—4041/S.20/C1, p. 41, NAI.
53. Judith A. Byfield, *The Bluest Hands: A Social and Economic History of Women Dyers in Abeokuta (Nigeria), 1890–1940* (Portsmouth, N.H.: Heinemann, 2002), 160–68.
54. Abiodun Aloba, ed. *The Fall of A Ruler or The Freedom of Egbaland* (Ake, Abeokuta: Egba Women's Union, Abeokuta Press, c. 1949).
55. Soyinka, *Ake,* 216.
56. This and later quotations are from Abeokuta Women's Union, Constitution—Rules and Regulations, Ransome-Kuti Papers, box 87, folder 1.
57. Johnson-Odim and Mba, *For Women and the Nation,* 76.
58. For example, Alhaja Akinpelu, interview by author, Totoro, Abeokuta, September 24, 2003.
59. Chief and Mrs. Adeyinka, interview by author, Totoro, Abeokuta, September 3, 2003.
60. Chief Sorunke, interview by author, Keesi, Abeokuta, August 19, 2003.
61. Soyinka, *Ake,* 212.
62. "Looting and Damage of Atupa's Parlour House," letter to the secretary of the Native Administration, February 26, 1951, Egba Council Records, Ake 2/1, file 41, National Archives, Abeokuta (hereafter NAA).
63. Chief Sorunke, interview.

64. Chief Adegboye Ademola, interview by author, Ikoye, Lagos, September 19, 2003.

65. For example, Alhaja Akinpelu, interview.

66. For example, Chief Sorunke, interview.

67. For example, see a letter from the emir of Kano to Ademola regarding the visit of the emir's son to Abeokuta, April 20, 1944, Civil Court Record book, Egba Council Records, 2/1, NAA.

68. A letter from A. Kayode, solicitor, dated February 7, 1933, charged Ademola with taking rents collected on properties belonging to Mr. O. O. Otegbola; also see Statement of Mr. Odelola on Conspiracy against the Alake, May 3, 1932, both in Ake 2/1, file 51, NAA.

69. I am told that during the struggles to unseat General Ibrahim Babangida in the 1990s, women in Ikine and Ijebu also removed their clothes. Chief Makinde, interview by author, Ibara, Abeokuta, October 10, 2003.

3 Nationalism without a Nation: Understanding the Dress of Somali Women in Minnesota

Heather Marie Akou

In the 1990s, migration to Minnesota from Africa grew by more than 600 percent.[1] A large proportion of these newcomers were from Somalia. When their national government collapsed in 1991, many Somalis fled the country for refugee camps in other parts of East Africa. Today, they live in a worldwide diaspora—in Kenya, Saudi Arabia, Italy, the United Kingdom, the United States, Finland, and Australia, along with many other countries. The metropolitan area of Minneapolis–St. Paul (the "Twin Cities") has become home to the largest community of Somalis in the United States—an estimated thirty to forty thousand people.[2]

Many immigrants in the Twin Cities have styles of "ethnic dress" that are worn for special events: weddings and funerals, the Chinese New Year, or the Festival of Nations in downtown St. Paul. Somalis, however, have taken a more deliberate approach to dress. Like the Amish and Hasidic Jews, many Somalis wear ethnic dress not just for holidays but every day. This is particularly true of Somali women, who are far more likely to wear the *jilbab* or *garbasaar* than a pair of blue jeans. A number of women (and even a few men) have filed lawsuits against their employers for the right to wear what they believe is appropriate to their religion (Islam) and Somali culture. Why is clothing so important to this group of people?

For Somali refugees, a strong sense of collective identity—projected through clothing—is almost all they have left of their nation. Unable to return to, or in many cases even to visit their homeland (which is still involved in a violent civil war), Somalis use clothing to keep their memories and dreams alive and to shape the future of a new Somali nation. The strength of their approach lies in the fact that Somalis have a long history of connecting dress with nationalism. In the late 1800s and early 1900s, clothing for both men and women was used as a visual symbol of resistance against the colonial governments of British and Italian Somaliland. Later, in the 1970s and '80s, Somalis turned to religion and religious dress (particularly that of women) as a means of resisting the oppressive dictatorship of Siad Barre, and as part of a trend toward revivalism and political transformation throughout the Islamic world. Rather than viewing the dress of Somali women in

the Twin Cities simply as a case of "ethnic dress," I would argue that it needs to be understood in this historical context of nationalist movements.

Conceptualizing National Dress

The concept of national dress is nearly as old as the concept of the nation. Reminiscing about the American Revolution in 1856 (perhaps because of the approaching Civil War), Mary Fry wrote an article to the *Ladies Repository* demanding, "Let Us Have a National Costume." Rebuking other Americans for buying European fashions when their parents and grandparents had fought so hard to gain independence from Great Britain, she wondered,

> Is it true that Americans . . . have already become so incompetent, so utterly wanting in the article of ingenuity, that they can not even contrive to model for themselves a costume at once neat, comfortable, and elegant; and which might be regarded by other nations as something of an index to their professed democratic principles?[3]

In the 1800s and early 1900s, a series of revolutions, the Napoleonic wars, and two world wars created an interest in national dress in many parts of Europe, including Norway (which seceded from Sweden), Scotland, Germany, France, and Russia. In the late 1950s, ambassadors from the newly independent nations of Ghana and Nigeria wore variations of "national dress" to the United Nations. Their abandonment of the three-piece suit was a striking visual symbol of transformation from colonial to independent state. At the same time, their specific choices of dress—*kente* cloth and the *agbada*—revealed new sources of identity and tension. The agbada was a style of Nigerian dress that combined elements of clothing from the Hausa and Yoruba. Although it would have been challenging to incorporate even more ethnic symbolism, this "national dress" excluded other groups such as the Igbo and highlighted their marginalization in national politics. In the 1970s, the governments of Nigeria and Zaire banned citizens from importing, buying, or wearing Western styles of dress. The ban was intended to instill national pride, but also to bolster the national economy by supporting local industries and blocking the outflow of money to Europe and India for the purchase of clothing and textiles.

Among scholars who study textiles and clothing, interest in nationalism and national dress is much more recent. In a 1993 article titled "Eurocentrism in the Study of Ethnic Dress," Suzanne Baizerman, Joanne Eicher, and Catherine Cerny offered one of the first critiques and definitions of the concept of "national costume":

> The emergence of the term can be correlated with political and social developments of nineteenth and twentieth century Europe, a time of considerable upheaval precipitated by the Industrial Revolution. The establishment of national dress signified political and/or social autonomy of a people becoming embedded in the romanticism of the period. The term reflected attempts to preserve cultural traditions and social institutions threatened by increasing modernization. Sentiment and nostalgia surrounding national dress reinforced efforts to perpetuate national identity.[4]

In her book *The Study of Dress History* (published in 2002), Lou Taylor divided examples from a more comprehensive review of dress literature into three basic categories: "national struggle," "national cultural revival," and "commodified national dress." She argued that national dress comes from an "urban, politicized, elitist and educated" source, and that "the process of inventing a 'national' dress usually involves the appropriation of peasant styles as romanticized and utopian icons of democratic struggle and national cultural revival."[5] This has largely been true in Europe (which is where almost all of Taylor's examples come from), but I believe the case of Somali dress points to another possibility—nationalism without a nation.

Somali national dress has not emerged as a "romantic" or "utopian" symbol, but reflects a series of real attempts by ordinary people to foster social, economic, and political change. This process has not been particularly "elite" or even very organized, but it has been flexible and strong enough to survive the civil war and loss of the nation. With the collapse of the central government in Somalia, nationalism has actually become more important than ever. No one can take Somali identity or the future of a Somali nation for granted. Somali dress practices clearly fall within the parameters of "national dress"—but it is national dress unlike that which is typically investigated by other scholars.

A History of Somalia and Somali Dress

Much of the Horn of Africa is a desert. Because of this, the economy was traditionally based on pastoralism. For centuries, Somalis traveled with their herds of camels and sheep between pastures in the interior and market towns along the coastline. Trade along the northern coast is described in *The Periplus of the Erythraean Sea,* a Greco-Egyptian shipping manual from the first century A.D.,[6] but many additional towns were built beginning in the tenth century A.D. by Arab and Persian settlers. Somalis controlled caravan trade to the interior. In this way, they were able to exchange "pastoral and wild products such as ghee, skins, gum, incense, ostrich feathers, ivory and livestock for grain and clothing."[7] Even so, many Somalis wore clothing made of leather instead of cloth. They processed the material themselves, using hides from their own livestock.[8]

This began to change in the early 1800s when trade to and from East Africa intensified. After the sultan of Oman established his court on the island of Zanzibar in 1832, the selling price of ivory tripled.[9] The slave trade was also greatly expanded, but Somalis were largely protected from being captured as slaves by their early and widespread conversion to Islam (since fellow believers cannot be owned). Profits from the sale of ivory and livestock (which was used by the British to provide food for growing colonies around the Indian Ocean as well as raw materials for shoe and leather industries back home) allowed Somalis to begin investing in larger volumes of cloth, clothing, and jewelry. Although men and women both wore ornaments for ritual purposes (often leather pouches containing verses from the Qur'an), women wore the more valuable pieces of jewelry—manufactured in Arabia and the coastal towns from materials such as silver, amber, coral, and

carnelian—both as decoration and as a form of portable wealth.[10] Neighboring groups of pastoralists, such as the Oromo and Rendille (who lived further inland), were not as involved in coastal trade and continued wearing leather well into the twentieth century.[11]

With the invention of the steamship and opening of the Suez Canal in 1869, increasing amounts of cloth from Europe and even the United States began to pour in.[12] Being in a strategic position along the Gulf of Aden, Somali territory was quickly divided into five separate colonies by the governments of Britain, France, Italy, and Ethiopia. The Horn of Africa is also less than one hundred miles from the Arabian Peninsula. By the 1800s, the city of Mecca had become not only a center for pilgrimage, but the center of a growing Islamic resistance to British and French imperialism. Traveling from many different parts of the world, including Yemen, Iraq, Pakistan, Egypt, and the Sudan, pilgrims often remained in Mecca for months or even years to conduct business and advance their religious and political education.

Mohammed Abdulle Hassan, a Somali who became the leader of an armed resistance movement against the British, made the pilgrimage to Mecca when he was in his early thirties and remained there as a student for three years.[13] Hassan spent much of his time with a Sudanese scholar involved in Mahdism—a movement to end British rule and establish a government based on Islamic law. Filled with a new sense of conviction, his objectives upon returning home were "to inveigh strongly against the prevailing laxity in religious practice and revive 'the religious spirit in his people' [and] to fight excessive materialism and consumerism." In his efforts to build a more nationalist consciousness, he urged Somalis not to be seen

"wearing 'infidel clothing,' sporting foreign hair styles, 'walking' like an unbeliever, or exhibiting outlandish manners of any sort." He further objected to "studying the books of unbelievers or participating in their gatherings or festivals," for this could be "confused too easily with love for them." This was tantamount to advocating a boycott of the British.[14]

By the year 1900, Hassan had persuaded six thousand men to join his army.[15] As word of the resistance spread, the number of "dervishes" continued to grow. (The word "dervish" also commonly refers to a person involved in Islamic mysticism.) As a symbol of the army's commitment to religious nationalism, the soldiers were given turbans (which were unusual for Somalis) along with uniforms that closely resembled the clothing worn by pilgrims at Mecca.

The Dervishes were issued at the outset with a simple uniform consisting of three measures of white American or Indian cloth . . . two to be wrapped or worn around the body while one served as a head-dress. As a result of this, [they] were known as Duub-ᶜAd, men of the white turbans. A black or brown rosary went with the plain, loosely fitting white robes.[16]

After five years, the army of British Somaliland gave up on fighting Hassan and retreated back to the coastline. The British were not completely defeated, but their expansion into the interior of Somali territory was halted until the 1920s.

Although popular in many parts of Somaliland, Hassan's armed resistance was not universally accepted. His rigid views on religion and the British angered many leaders of other established religious orders[17] as well as merchants involved in the import/export trade. Hassan could also be brutal to Somalis who opposed him and his army. Even so, this was not the only nationalist movement. Other Sufi leaders defied the British and Italian governments by building schools and promoting the authority of Islamic law. Religion was commonly viewed as a means of resistance against colonial rule. Nearly all of the photographs I have seen from the early to mid-1900s show Somalis wearing styles of dress from the Middle East—either wrapper sets (worn by pilgrims in the city of Mecca as well as Bedouins in southern Arabia[18]) or simple tailored styles such as *saalwar qamis* (a style of dress that includes pants with a long tunic and is still very popular in Arabia and South Asia today). Very few photographs show Somalis wearing European-style clothing.

Somalia became an independent nation in 1960, but sizeable numbers of Italian and British expatriates continued to live in the country. In much of the region, wrappers of plain white cloth were exchanged for lightweight, colorful new imports from India and Japan. These textiles were used for a new style of clothing: a loose-fitting dress called *dirac* with a long piece of cloth called garbasaar that could be used to cover the entire head and body. (The term *garbasaar* may be related to the Indian *sari,* a wrapped garment made from similar fabrics.) In urban areas such as the capital, Mogadishu, Western fashions began to filter in. In a life history published in 1994, one Somali woman (using the pseudonym "Aman") described her experiences in Mogadishu after living in the countryside.

> One night one of my friends took me to a party. There were a lot of handsome men there. There were a couple of whites there too, even though the party was mainly for Somalis—all of them were well educated, and the majority worked in banks or in big offices for the government. . . . I was embarrassed at the way I looked—my clothes, my hair—my dress and the way I acted weren't like the other girls. . . . The girls here didn't wear sarongs like we did in [the village]. Their dresses were sewn together, shorter, prettier. They even had better shoes—European shoes I had never seen before.[19]

Overall, Western styles of dress were more popular for men than women. One barrier to their acceptance among women was the Western fashion for miniskirts in the 1960s and '70s. A woman who exposed too much of her body was in danger of shaming her family by being labeled a prostitute. A police division called the *buona costuma* (good costume) was created to monitor prostitution and Somali women's dress.[20] An immigrant in Minneapolis told me how she had once been arrested as a teenager for wearing a miniskirt. When her father (who worked for the government and was mortified at having to post bail for his daughter) arrived at the station, he specifically forbade her to ever wear a miniskirt again.[21] (When we met she was modestly dressed in a long skirt and a head covering.) "Aman" was also arrested for wearing Western fashions.

> He said . . . he had to arrest me because I was a *sharmuuto* [prostitute], I was wearing a short skirt. I was bad for the city, I was a shame to the city, so he had to clean me

out. I *was* wearing a short dress with a shawl, but even if I had been a prostitute, he didn't have the right to slap me and kick me.[22]

In 1969, the government of Somalia was overthrown in a military coup and Siad Barre was installed as a dictator. Under his leadership the country became embroiled in the Cold War, siding with the Soviet Union in order to counter American support for the Ethiopian regime of Haile Selassie. Although Islam and the Sufi brotherhoods were still critically important to many Somalis, Barre tried to secularize the government by basing it on scientific socialism. This alienated many religious leaders. In the 1970s he used Soviet weapons in a failed attempt to capture the Ogaden region of Ethiopia, destabilizing parts of the country by creating thousands of internal refugees. Barre was increasingly suspicious of any opposition and started to imprison or even execute people he saw as a threat to his power. Educated people who could afford to do so often left for universities in Egypt, Italy, the United Kingdom, and the United States or went into exile.

A Somali woman now living in the Washington, D.C., area recounted to me how she had left Mogadishu in the early 1980s to attend college. Back home for a visit, she found that many people were returning to religion for moral support as well as a safe place to discuss politics—even Barre had to respect the sanctity of the mosque. More and more women were wearing new styles of dress from the Middle East, particularly a long overcoat called a *shuka* (a word used in other parts of East Africa as a generic reference to something that covers the body) and a scarf called a *khimar* that covers the neck and hairline. Although my informant had never covered her head when she was living in Somalia (and still does not), a man threw stones at her, saying that she was "ruining the country" by not dressing more religiously.[23]

These new styles of dress also indirectly reflected the growth of Islamism—a movement to resist or even overthrow corrupt secular governments and establish new ones based on Islamic law. The Iranian Revolution of 1979 was an early success of that movement. In the 1980s, Iranian activists began traveling to other parts of Central Asia, North Africa, and the Persian Gulf to promote the idea that Islamic dress should be worn as a symbol of political and social transformation.[24] In Jordan, Syria, and Palestine, the garment called shuka by Somalis is known as jilbab. In Iran, the combination of shuka and khimar is called *rupush-rusari*. Iranians may have traveled to Somalia, but it is more likely that Somalis encountered Islamism and the political use of dress when they traveled to parts of North Africa and the Middle East for the pilgrimage, to attend college, or to work as migrant laborers. It was also in this time period, for example, that Somali men began pairing button-down shirts with the *macawis,* a sarong-like garment worn by other Muslim migrant laborers from Malaysia and Indonesia.[25]

In the late 1980s, the government of Somalia became very unstable. Armed rebels took control of several cities. Siad Barre responded with a campaign of bombings and executions, but he was overthrown in January 1991.[26] In the chaos that followed, hundreds of thousands of people were killed in the fighting or starved

to death. Many people fled to refugee camps in Ethiopia, Djibouti, and Kenya with little more than the clothes on their backs. Some were able to sail across the Gulf of Aden and find refuge in Yemen; others went on the pilgrimage to Saudi Arabia and never returned home. Some of the first countries outside of the region to accept refugees were the former colonial powers of Italy and Great Britain, as well as members of the British Commonwealth such as Canada and Australia. The United States, which entered Somalia under "Operation Restore Hope" but was forced to retreat after an embarrassing failed mission in which eighteen soldiers were killed, did not accept refugees until 1994.

Somali Women's Dress in Minneapolis–St. Paul

As part of immigration and social service reforms in the early 1990s, the U.S. government decided to settle new refugees in many parts of the country to keep areas such as New York and California from being overwhelmed. Some Somalis were directed to Minneapolis–St. Paul because churches and non-profit agencies there already had significant experience with refugee resettlement, having sponsored thousands of Hmong, Vietnamese, and Oromo refugees in the 1970s and '80s. Finding a good educational system and relatively affordable housing, the initial community of Somalis in Minneapolis–St. Paul grew rapidly. In the economic boom of the late 1990s it was also relatively easy to find jobs for people who couldn't speak English. Many Somalis left other parts of the country in order to join friends and family members in the Twin Cities.

Other residents of Minneapolis–St. Paul are often curious about why Somalis dress the way they do. In my experience they tend to assume that all Somali women dress in the same "traditional" way, but there are actually several major forms of dress within the community. Most Somali men and boys wear button-down shirts, pants, and jackets, which are generally loose-fitting and modest, but not unusual compared to mainstream clothing in Minnesota. A common interpretation of the Qur³an is that men should cover everything from their midsection to their knees. Women are expected to wear clothing that covers everything but their hands and face. Although a majority of women in Somalia did not cover themselves to this extent, a renewed focus on religion (as a way to cope with the stresses of migration, living in a non-Muslim country, and trying to build a new Somali nation) means that few Somali women in Minnesota are able to wear ordinary styles of American dress. The exception to this is outerwear such as sweaters, mittens, and heavy coats, which are necessary to survive the winter in one of the coldest parts of the continental United States. Even so, it's possible to hide much of this under other layers of clothing and maintain a markedly Somali appearance.

Teenage girls and women who have been living in the United States (or a third country such as Sweden or Germany) for several years generally wear more Western styles of dress. Long skirts, loose-fitting button-down shirts, turtlenecks, sweaters, and simple headscarves give an appearance that is modest but relatively mainstream. The *masar*, for example, is a scarf made from a single rectangle or triangle of cloth. It can be draped over the head and around the shoulders or worn in a style

Styles of Dress Worn by Somali Women in Minnesota

Cultural:
(names in Somali)

1. *garbasaar*
2. *dirac*
3. *gorgoro*
4. *shuka*

Religious:
(names in Arabic)

5. *hijab*
6. *jilbaab (jelaabib)*
7. *niqab*
8. *khimar*

Westernized:
(names in English)

9. *masar*
10. blouse
11. skirt
12. jeans

Figure 3.1. Styles of dress worn by Somali women in Minnesota. Drawings by Heather Marie Akou.

that resembles African-American head wraps. The second option is less common because it's not as modest (it doesn't cover the neck) and because many Somalis do not want to be viewed as African-Americans or even Africans. This is a very complex issue that stems from the slave trade in East Africa, colonization, and stereotypes of African-Americans.[27]

The second major style of dress (which is labeled "cultural" in figure 3.1) refers directly back to clothing worn in Somalia in the 1970s and '80s. In the first few years Somalis were living in Minnesota, it was not easy to obtain the appropriate material for outfits of garbasaar and dirac. Enterprising women who had just arrived from East Africa or were able to get a supply from relatives would go from door to door in the Somali community selling lengths of cloth to make these garments, sometimes for hundreds of dollars.[28] Viewed as a precious symbol of Somali history and identity, the garbasaar and dirac was a style of dress particularly sought after for weddings.

Cloth imported from East Africa, India, and Japan became more readily available when Suuqa Karmel (in Minneapolis) and the African International Marketplace (in St. Paul)—referred to as the "Somali malls"—were built in 2000 and 2001 respectively. Both are filled with small businesses (many of them run by women)

Figure 3.2. Somali women at a wedding celebration in Rochester. Photograph by Jodi M. O'Shaughnessy, *Rochester (Minn.) Post-Bulletin,* July 12, 2001. Reprinted courtesy of the *Post-Bulletin.*

selling everything from carpets, coffee, and platform shoes to Internet service, haircutting, and tailoring. Many of the shops are lined with rows of beautiful material for matching sets of garbasaar and dirac. Tailors can sew the garments within a few days or sometimes even on the spot. Also imported from the Middle East are the button-down overcoat known as shuka and the head covering called khimar. The shuka is becoming less common (probably because alternatives such as the garbasaar, the jilbab, and Western styles of dress have become more meaningful in the context of life in Minnesota), but the khimar is still very popular. Twenty years ago, this head covering was simply a triangle of cloth (or a square folded into a triangle) that was draped over the head and shoulders and sometimes pinned under the chin. A new tailored form comes prepackaged in two pieces—one that covers the hairline and a second one that fits closely around the face and falls over the shoulders. This new khimar is easy to wear and popular for children. Although the garbasaar and jilbab are generally not worn until puberty, it is not uncommon for Somali girls in Minnesota to begin wearing the khimar (along with a modest skirt and blouse) at age five or six when they start going to school.

The jilbab (one style of "religious" dress in figure 3.1) was not common in Somalia but has become quite popular in Minnesota. This is actually a set of three matching garments—a skirt, a masar that wraps around the hair, and a tailored head covering (sometimes called *hijab*) that fits closely around the face and drapes over the shoulders. The last piece can extend anywhere from the chest to the knees. Longer head coverings are more expensive (because they use more fabric), but they

project a more devout appearance. On a practical side, the jilbab is usually sewn from a plain-colored, opaque fabric, which is easily obtained at local fabric stores. This clothing is also easier to wear than the garbasaar (which is wrapped around the body and needs continual adjustment) as well as warm in the winter—it's easy to hide other layers of clothing, such as sweaters and coats, underneath. Older women who wear the jilbab often include a head covering called a *shash* instead of a plain masar. For Somali, Oromo, and Afar women who lived in the Horn of Africa in the 1800s and early 1900s, the shash was a gauzy piece of indigo or black fabric that a married woman would wear over a special hairstyle. Today, it still signifies that a woman is married, but the hair is hidden from view and the material itself is a black silk scarf with a printed design and is imported from India.

Many residents of Minneapolis–St. Paul can easily recognize the jilbab as religious or Muslim dress. It resembles the habit of Catholic nuns as well as clothing worn by the Iranian, Afghani, Iraqi, and Palestinian women who have appeared almost nightly in television news programs since the events of September 11, 2001. This is not just a coincidence. The jilbab reflects a renewed effort throughout the Muslim world to resist some of the devastating effects of globalization and create social and economic change through Islamism. Al-Itixaad, a Somali Islamist movement, has actively advocated the creation of a new national government based on Islamic law. It has also promoted the idea that Somali women should "wear the hijab and not merely traditional flimsy headscarves [i.e., the garbasaar]."[29] Over the last two decades, individuals and governments in countries as diverse as Turkey, the Sudan, and Malaysia have looked to clothing in Iran (which does have a government based on Islamic law) as a model for their own dress. This exchange of ideas has been facilitated by transnational migration. Oil money has allowed countries such as the United Arab Emirates and Qatar to build world-class universities that attract students from throughout the Middle East and to hire workers (ranging from professors to manual laborers and domestic servants) from all over the world.

At the same time, there are limits to what Somalis will actually wear. In the late 1990s, a small percentage of Somali women in Minnesota began wearing the *niqab*, a very conservative head covering that allows only the eyes to show. Although this garment is widespread in Saudi Arabia (another country with an Islamic government), since September 11th the niqab has virtually disappeared in Minnesota. Few are willing to risk being assaulted or targeted for discrimination because of this provocative head covering. Because the niqab covers all facial features but the eyes, it has also become nearly impossible to apply for a green card, passport, or driver's license while wearing it, and difficult to conduct business in secure buildings such as courthouses, banks, and airports.

Some Somalis also believe that the niqab and jilbab should be avoided because they represent a form of "Arabization"—a departure from their own culture that could be as damaging as Westernization. Recent photographs taken by journalists in East Africa have shown that some Somali women are wearing the jilbab, but many of my informants have insisted that Somalis *never* wore that style of dress before they came to the United States. They are intensely concerned that they could lose their culture—a common worry for refugees that is magnified for Somalis be-

cause of the unprecedented collapse of their nation. Although they readily identify themselves as Muslims, the centrality of Arab and Persian culture within Islam is a source of continual concern (not just for Somalis but also for other Muslims who are not Arab or Persian). These customs and styles of dress (such as the jilbab) are not a substitute for Somali ways of life. As Charles Gesheketer has noted, "Despite strong links to the Arab world, Somalis do not consider themselves 'Arabs.'"[30] Some women are making a compromise between the jilbab and older forms of Somali dress by wearing a colorful, patterned skirt instead of a plain one. Others sew the jilbab using plain but colorful materials such as magenta and mint green polyester crepe. Although these garments are very similar to the Iranian *chador*, few Somalis wear the jilbab in black, navy blue, or gray—colors which in Iran represent austerity and mourning for relatives killed in the revolution and the war with Iraq.[31]

At the same time, the word *jilbab* has special meaning because it appears in the Qur'an. Verse 33:59 describes how the wives of the prophet Mohammed (and by extension, all Muslim women) should be dressed: "O Prophet! Tell thy wives and thy daughters and the women of the believers to draw their cloaks [jilbab] round them (when they go abroad). That will be better, so that they may be recognized and not annoyed."[32]

As Somalis have renewed their focus on religion, communal prayers have become very important. More than a dozen new mosques have been built in the Twin Cities and celebrations for Ramadan fill the convention center in downtown St. Paul as well as an indoor soccer arena in one of the suburbs. More than ever, Somali women are getting an education and reading the Qur'an for themselves. Some have decided that the colorful, semi-transparent fabrics of the garbasaar and dirac are not modest enough for a proper Muslim woman. This belief is especially common among those who have come to believe that the loss of Somalia was a sign from God that Somalis were not being good enough Muslims.[33] Paying more attention to religion is a way of rebuilding their lives and hopefully the nation itself. A Palestinian teacher who had several Somali students in his classes told me he was a little unnerved at their intense devotion to certain religious practices. Students would rise from their desks and leave the room at the exact time for daily prayers, regardless of what the rest of the class was doing.[34]

> A woman's body is, in many instances, the property of her nation. She symbolically represents her nation and its political, religious, and cultural ideologies. [She] becomes an ambassador on duty for her nation.
>
> —Fagheh Shirazi, "Islamic Religion and Women's Dress Code"[35]

As might be expected during a civil war, there are many debates in the community concerning how Somalis should think and behave in order to build a new nation. Whether women will choose to wear cultural, religious, or Westernized styles of dress is not an idle question. Dress is a visual symbol that reflects and shapes personal and political attitudes, and their choices about it can shape the future of Somali nationalism and Somali identity. Even some men, who had been wearing more Western styles of dress, have consciously begun to grow beards and wear gar-

ments such as the saalwar qamis, *kufi* (a close-fitting cap), and *kaffiyeh* (a checkered shawl that has become a common political symbol in the Middle East).

For decades, Americans have assumed that new immigrants and refugees would go through a process of assimilation (or at least acculturation), gradually shedding the lifestyles of their homelands for a new set of thoughts, behaviors, and styles of dress. Although many may have followed this pattern, Somalis (so far) largely have not. Scholars should recognize that Somalis have a long history of interacting with people from other cultures and that dress has been absolutely central in shaping their political and cultural identity in the course of these interactions. What seems like "ethnic" or "traditional" dress in Minnesota is not just a quaint reminder of home. At the Somali malls, at celebrations, and in simply going about their ordinary activities, Somalis are not only keeping their memories alive but are also setting the stage for what will happen to their nation in the future.

Notes

1. Lourdes Medrano Leslie, "Immigration: Africans Find They 'Have Everything Here,'" *Minneapolis Star Tribune,* June 4, 2002, metro edition, B1.
2. This figure is based on community estimates. The number of Somalis in Minnesota continues to grow as individuals and families join friends and relatives from other countries and parts of the United States. Leslie Brooks Suzukamo, "Refuge and Renewal," *St. Paul Pioneer Press,* February 20, 2000, city edition, A1, A12–13; Kristin Tillotson, "Somalis Adapt to Life in a Strange Land," *Minneapolis Star Tribune,* March 22, 1998, A12; Leslie Brooks Suzukamo, "Somali Main Street," *St. Paul Pioneer Press,* April 24, 2000, Washington County edition, B1, B4.
3. Mary E. Fry, "Let Us Have a National Costume," *Ladies Repository* 16 (November 1856): 735.
4. Suzanne Baizerman, Joanne B. Eicher, and Catherine Cerny, "Eurocentrism in the Study of Ethnic Dress," *Dress* 20 (1993): 25.
5. Lou Taylor, *The Study of Dress History* (Manchester: Manchester University Press, 2002), 213–14.
6. William H. Schoff, trans. and annotated, *The Periplus of the Erythraean Sea: Travel and Trade in the Indian Ocean by a Merchant of the First Century* (New York: Longmans, Green, 1912).
7. Abdi Ismail Samatar, *The State and Rural Transformation in Northern Somalia, 1884–1986* (Madison: University of Wisconsin Press, 1989), 27.
8. Ioan M. Lewis, *Peoples of the Horn of Africa: Somali, Afar, and Saho* (Lawrenceville, N.J.: Red Sea, 1998), 131. See also Richard Burton, *First Footsteps in East Africa, or, An Exploration of Harar* (1856; reprint of the 1894 edition, New York: Dover, 1987), 170.
9. Lee V. Cassanelli, *The Shaping of Somali Society: Reconstructing the History of a Pastoral People, 1600–1900* (Philadelphia: University of Pennsylvania Press, 1982), 153.
10. Lewis, *Peoples of the Horn,* 132.

11. See, for example, photographs taken by the Italian anthropologist Enrico Cerulli for a series of books on Somalia published in 1957, 1959, and 1964, as well as photographs taken by Angela Fisher in the 1970s and early '80s for her *Africa Adorned* (New York: Harry Abrams, 1984).

12. Richard W. Beachey, "The East African Ivory Trade in the Nineteenth Century," *Journal of African History* 8, no. 2 (1967): 267–90.

13. Abdi Sheik-Abdi, *Divine Madness: Mohammed Abdulle Hassan (1856–1920)* (London: Zed, 1992), 48.

14. Ibid., 58–59.

15. Samatar, *State and Rural Transformation*, 38.

16. Sheik-Abdi, *Divine Madness*, 197.

17. Ali Abdirahman Hersi, "The Arab Factor in Somali History: The Origins and Development of Arab Enterprise and Cultural Influences in the Somali Peninsula" (Ph.D. diss., University of California, Los Angeles, 1977), 251.

18. For descriptions of Arab dress at that time, see Nancy Lindisfarne-Tapper and Bruce Ingham, eds., *Languages of Dress in the Middle East* (Surrey, U.K.: Curzon, 1997), as well as Yedida Kalfon Stillman, *Arab Dress: A Short History from the Dawn of Islam to Modern Times*, ed. Norman A. Stillman (Leiden: Koninklijke Brill NV, 2000).

19. Virginia Lee Barnes and Janice Boddy, *Aman: The Story of a Somali Girl* (New York: Vintage, 1994), 155–56.

20. Michael Maren, *The Road to Hell: The Ravaging Effects of Foreign Aid and International Charity* (New York: Free Press, 1997), 38.

21. Field notes, September 2002.

22. Barnes and Boddy, *Aman*, 215.

23. Field notes, December 2002.

24. Nayereh Tohidi, *Iran and the Surrounding World: Interactions in Culture and Cultural Politics* (Seattle: University of Washington Press, 2002), 210.

25. Mohamed Diriye Abdullahi, *Culture and Customs of Somalia* (Westport, Conn.: Greenwood, 2001), 118.

26. The central government of Somalia has yet to be legitimately replaced. The northern half of the country declared a return to sovereignty as Somaliland (formerly British Somaliland), but other countries have not yet recognized it as a new nation.

27. For further explanation, see Abdi Kusow, "Migration and Identity Processes among Somali Immigrants in Canada" (Ph.D. diss., Wayne State University, 1998); or Catherine Besteman, *Unraveling Somalia: Race, Violence, and the Legacy of Slavery* (Philadelphia: University of Pennsylvania Press, 1999).

28. Field notes, April 2001.

29. Rima Berns McGown, *Muslims in the Diaspora: The Somali Communities of London and Toronto* (Toronto: University of Toronto Press, 1999), 35.

30. Charles Geshekter, "The Death of Somalia in Historical Perspective," in *Mending Rips in the Sky: Options for Somali Communities in the 21st Century*, ed. Hussein M. Adam and Richard Ford (Lawrenceville, N.J.: Red Sea, 1997), 65–98.

31. Fagheh Shirazi, "Islamic Religion and Women's Dress Code: The Islamic Republic of Iran," in *Undressing Religion: Commitment and Conversion from a Cross-Cultural Perspective*, ed. Linda Arthur (Oxford, U.K.: Berg, 2000), 113–30.

32. Muhammad Marmaduke Pickthall, *The Meaning of the Glorious Qurʾān: Text and Explanatory Translation* (Mecca: Muslim World League, 1977), 449.

33. Berns McGown, *Muslims in the Diaspora*, 80. See also Dianne Lynn Heitritter,
 "Meanings of Family Strength Voiced by Somali Immigrants: Reaching an In-
 ductive Understanding" (Ph.D. diss., University of Minnesota, 1999), 96.
34. Field notes, May 2001.
35. Fagheh Shirazi, "Islamic Religion and Women's Dress Code," 122.

Part Two: *Dressing Modern: Gender,*
 Generation, and Invented
 (National) Traditions

4 Changes in Clothing and Struggles over Identity in Colonial Western Kenya

Margaret Jean Hay

Massive economic, political, and cultural changes followed the imposition of British colonial rule in western Kenya in the early 1900s. These included military defeat,[1] the imposition of taxes, forced labor, forced cultivation, the imposition of chiefs and headmen, and the presence of foreign missionaries. These far-reaching changes in the world around them triggered changes in western Kenyans' self-perceptions that were played out at one level in changing forms of dress. Individual patterns of dress were instruments chosen and manipulated to express these evolving identities; they were the most visible symbol of the colonial order in rural homesteads and were at the center of a series of contestations in social and political relationships.

Changes in the dominant patterns of dress in western Kenya can be divided into three broad periods. The years from 1895 to the First World War were characterized by open-ended experimentation with the new forms of clothing and adornment seen on strangers at markets and chiefs' camps.[2] This period also saw a broader struggle over whether the appropriate style of dress for modern Africans would reflect coastal/Swahili influences or Western traditions of clothing.[3] In a second period, roughly between the two world wars, the growing adoption of Western clothing styles reflected the expansion of the labor market, the spread of Christianity, and the strength of women's market earnings. Individual choices about dress coalesced into broader packages of identity and self-expression that came into conflict, reflecting a polarization between those who had adopted European forms of dress and traditionalists who rejected many of the changes that accompanied colonial rule. This period of struggle is the focus of the present paper. A third period, lasting roughly from the end of World War II up to the end of the colonial period, was marked by the nearly complete adoption of European-style clothing among the people of western Kenya and the gradual disappearance of the older forms of dress based on skins and jewelry.

Indigenous Dress at the Turn of the Century

Conceptions of proper dress in the early 1900s centered around the minimal forms of clothing (usually constructed from hides), together with paint and

adornment (of plaited fiber, beads, wire, and carved bone), appropriate for specific situations: attending funerals, meeting one's in-laws, going to market, or traveling some distance from home. Women and girls usually wore a short, simple apron of sisal fiber (or a more elaborate beaded one for special occasions), along with waist beads, bead necklaces, and coils of iron wire on their arms or legs. Married women wore a soft fiber tassel suspended from a cord around their waist and hanging low in back (called *chieno* in Luo). The tassel served as the equivalent of today's wedding ring, and Luo girls who had to travel away from home sometimes tied on a chieno for protection from would-be suitors. Women often had raised cicatrices on the front and sides of their torso below the breasts and sometimes on their back and upper arms, and young women sometimes had decorative patterns shaved into their hair.

Married men usually wore a small goatskin around their loins and sometimes a larger skin tied over one shoulder. Wealthy or influential men (referred to as "chiefs" in European accounts) wore beaded cloaks of goat or leopard skin, numerous earrings, and coils of wire around their arms and legs. Warriors were distinguished by stunning headdresses of ostrich feathers or carved tusks, red and white paint on their faces, lengths of iron wire wrapped around their arms and legs, and the spears and shields they carried. All adults dressed with particular care for funerals. Thus the most picturesque photo opportunities for resident Europeans or travelers came when they encountered people on their way to or from a funeral. Photographic evidence confirms that the use of beads and wire by both men and women had increased significantly in the early 1900s, one result of expanding trade contacts with the coast and the greater presence of imported goods.[4]

British Attempts to Impose a Coastal Mode of Dress

Photographic evidence over the first two decades of British rule (roughly 1895–1915) shows both continued use of indigenous forms of clothing and experimentation with new forms. Western visitors in the early 1900s were stunned by the sight of western Kenyan peoples "in their fullest undress,"[5] and "the naked Kavirondo" became a major tourist attraction, often captured in photographs. This first period of colonial rule is much better documented in photographic collections than the second phase.[6] Geologist Felix Oswald was startled to find himself among "a tribe of naked savages, who ornamented themselves with coils of iron wire like the [ancient] Caledonians," and felt he had been transported back in time.[7] Many visitors found the married woman's tassel ridiculous, "a tail at the bottom of the spine, which waggles in a ludicrous way as they walk."[8] Yet officials and missionaries reacted with equal scorn to African men who copied Western forms of clothing; they tried to impose a coastal mode of dress instead. Churchill ridiculed African chiefs in Western-style clothing who cherished "any old, cast-off khaki jacket or tattered pair of trousers," and argued that officials should present "suitable ceremonial robes" to the chiefs and encourage their spread throughout the general population.[9] In 1909 Chief Mumia and a few other western Kenyan leaders recognized as paramount chiefs were issued a dark cloak trimmed with embroidery (to be worn over a *kanzu*, a long, loose white garment like a nightshirt), a turban, and

a ceremonial baton topped with silver. Other chiefs were issued a simpler cloak and fez, while headmen got a waistcoat and a fez cap with a white metal badge on it.[10] A number of photographs, of both individuals and groups, record Luo and Luyia chiefs in the official uniform of white kanzu with dark robes.[11]

Early Anglican missionaries tried to discourage the Kenyan propensity for European-style clothing, seeing it as a threat to the African character of the church they wanted to create.[12] Colonial officials and missionaries wanted the people of western Kenya to cover their naked bodies while still looking exotic. Missionaries wanted African men to wear a kanzu; women and girls were encouraged to wrap a two-meter length of plain cloth (*nanga*, sometimes *nanza*) around their bodies.

British perceptions of the ideal forms of African clothing were influenced by their long contact with Zanzibar and the Swahili coast.[13] Many Ganda nobles and Christian converts in Uganda had adopted the same forms by the early twentieth century, no doubt influenced by the long-term presence of Muslim Swahili traders at the Ganda court.[14] Most settlers also preferred their male domestic servants to wear a kanzu, often with the addition of an embroidered vest and fez, reflecting the clothing of the Swahili or Somali domestic servants they had seen in Mombasa and Nairobi.

While Luo and Luyia chiefs and headmen accepted the ceremonial robes for formal occasions, in their everyday lives they often preferred to dress like the British. As early as 1908 the provincial commissioner reported a growing tendency among the men living near Kisumu, the provincial capital, to wear Western-style clothes, "usually consisting of a khaki tunic, trousers, boots, and a helmet."[15] By 1910 he could note a "small but increasing" market demand for second-hand coats, jackets, and shorts.[16] Many western Kenyans saw donning Western clothing as appropriating symbols of modernity and power from the intruders who had conquered them, as they had adopted many elements of material culture and a wide range of medicines from neighboring peoples in the past. Missionaries and officials gradually bowed to popular preference and stopped insisting on the Swahili mode. One symbol of this change came in 1930, when the old "tribal retainers" who had supported the chiefs and headmen were reorganized as a tribal police force and provided with khaki uniforms and leather belts and badges.[17]

While kanzus remained a common form of male dress along the coast and in southern Uganda through the colonial period, in western Kenya both the white kanzus and the ceremonial robes gradually disappeared from the official agenda and from photographs in favor of khaki shirts and shorts or trousers. From 1920 onward, struggles over clothing would be waged between those dressed in Western-style garments and those who preferred the older, indigenous modes based on skins, sisal, beads, and wire. The Swahili styles that remained dominant in coastal towns were no longer part of these discussions.

Here I will focus on three different aspects of the internal struggles that took place within the communities of western Kenya over clothing and identity in the 1920s and 1930s: (1) conflicts between Christians and labor migrants in Western-style clothing and Luo traditionalists or cultural purists in skins and beads, (2) conflicts over authority and respect between elders and young men, and (3) con-

flicts over sexuality and control between fathers and daughters and between husbands and wives. The emphasis will be on broad patterns of change over time, though it is important to acknowledge that there has always been a wide range of individual and regional variation.

Of course what we really want to know is how western Kenyans themselves felt about competing modes of dress, and why they made the choices they did. That perspective is very difficult to obtain, and I suspect many potentially helpful informants for the 1920s and earlier have now died. When I collected extensive oral accounts of the colonial experience in the 1960s and 1970s, my primary focus was on economic change, though I did get some intriguing clues about dress and identity. When I returned in 1988 specifically to focus on changing forms of dress, I was not allowed to pursue fieldwork, although archival and museum sources were available. The evidence on which these arguments are based includes written materials and photographic collections in archives, libraries, and museums; travelers' accounts (and the photographs they include); and limited interviews. Given the relative lack of diaries, published autobiographies, and personal correspondence that might tell us how western Kenyans themselves perceived the early period of colonial rule, I want to suggest that the study of dress—especially through photographic evidence—is one of the few sources available for understanding changes in African self-identities and ambitions during this period in western Kenya, although the results are suggestive rather than conclusive.

While there were African photographers in Nairobi, Mombasa, Zanzibar, and other urban areas, the hundreds of photographs predating World War II I've examined for this project were almost all taken by British and other visitors. The vast majority reflect chance encounters with groups of Africans at large markets, at chiefs' camps, or along the road. Foreign photographers did occasionally intervene to compose the image in certain ways (having a man and a woman stand together, suggesting a relationship that might not have existed, or posing people at different angles—for example, to show one married woman's apron from the front and another's "tail" from the side). While coastal photographers were actively involved in dressing their subjects (providing elegant cloth, jewelry, umbrellas, and other accessories from the resources in their studios), I have found no evidence suggesting that the photographers discussed here ever took an item of clothing or jewelry from one person and had it placed on someone else. In other words, we can assume with some degree of confidence that the people in these photographs had themselves chosen and assembled the various items of their dress shown in the images. The warrior with face paint, feather-and-tusk headdress, and a skin cloak, riding a bullock to a funeral, is making a very different statement about his identity in that situation than a chief wearing his official robe and fez along with military-style boots, or a young man in khaki shirt, trousers, jacket, and cloth cap.

Christians and Labor Migrants vs. Traditionalists

Christianity spread rather quickly in western Kenya and is today the religion of the great majority of the people. Missionaries and African Christians worked

Figure 4.1. A teacher's house: Butsotso. This image from the early 1930s shows both the clothing and housing styles (rectangular brick house, with a metal roof and inset windows) that missionaries and officials encouraged "modern" individuals to adopt. The more traditional round mud houses with thatched roofs can be seen in the background. From Günter Wagner, *The Bantu of Western Kenya* (London: Oxford University Press for the International African Institute, 1970), facing page 11, reproduced by kind permission of the International African Institute.

actively to promote the adoption of new forms of dress as well as belief; indeed, the early Christian converts were known alternately as *jo-nanga,* "people of cloth," or *jo-somo,* "people who read."[18] Note that early African Christians had a much greater influence on their local communities than did the expatriate missionaries. Only children at boarding schools were taught by white missionaries; the great majority of Christian converts were taught by lay African teachers in hundreds of small schools, under the supervision of foreign missionaries.[19] In addition to African Christians using their powers of persuasion, a number of mission-trained girls actively sewed and marketed Western-style dresses to rural women, who were relatively underserved by shops that focused on men's clothing.[20]

Joan Arwa of Seme was introduced to a new religion and a new form of dress simultaneously: "When [the first Luo Christians] found me grinding, they helped me, then told me to go to church the next day. . . . Then they gave me a piece of cloth to tie around my waist."[21] Missionaries gave lengths of cloth to their female converts and taught them how to tie the cloths to cover their bodies. When Martin

Changes in Clothing and Struggles over Identity 71

Oyugi was baptized at Asumbi, "the priests gave me a white shirt, a blanket, and a hoe. And if these things got worn out, you could go and get new ones."[22]

While early female converts were given cloth to wrap or tie Swahili-style, by the 1920s girls at mission schools were taught to hand-sew their own dresses from fabric given to them.[23] A number of mission girls among the Luyia were able to use these sewing skills to achieve a degree of financial independence after leaving school.[24] While mission girls in the 1920s were learning to sew by hand, boys were provided shirts and shorts for daily wear. Japuonj Joseph was one of the early Christian teachers at Ng'iya, and his daughters remember the mission campaigns to have converts adopt the new clothes.[25] When Baring-Gould visited the Kisumu mission station in 1927, she found boys in tailoring classes using treadle sewing machines to produce the shirts and shorts distributed to all the boys at school.[26] In some areas boys were also given long white kanzus for church services and Christian ceremonies.

Oginga Odinga, who later played a key role in Kenyan national politics, was so struck by an item of Western-style clothing he saw as a young boy that he uses it in his autobiography to reconstruct his date of birth.[27] The adoption of new forms of clothing led to profound cultural conflicts that lasted for two decades and sometimes longer, often paralleling the lines between Christians (the people of cloth) and non-Christians (or traditionalists). In the 1920s the Christians' use of clothing was seen as a shocking symbol of their having turned their backs on the ancestors. Some families were torn apart by these changes, as wives or daughters were driven out of the home and fathers and sons were estranged. The father of Anglican teacher Yona Obara tried to kill him by witchcraft for his apostasy. Rachel Oguri was chased away from her home because of her conversion to Christianity and her European-style clothes. Rebekah Hokaka told of being driven away from her marital home in South Nyanza by in-laws who found her arrogant and resented both her clothing and her literacy. In several areas of Central and North Kavirondo, communal hostility led to the building of separate Christian villages where the newly converted could gather at night to pray and to sleep.[28]

These early Christians were also the first to try new crops and new tools (maize, cotton, imported hoes, grist mills) and to challenge old taboos that prescribed the division of labor between men and women, forbade the planting of trees, and imposed gender-based dietary restrictions. Many had a sense of themselves as modern and progressive people, and as converts whose new religion would protect them against the resentment of others.[29] Perhaps because of their travels outside western Kenya and interaction with Africans from other areas as well as closer contacts with British missionaries, officials, and private employers, these early Christians consciously embraced their role as innovators and committed themselves to a notion of economic and social progress.[30]

Labor migration was another force for changes in dress during these early years; employers preferred clothed workers and labor migrants were exposed to new forms of dress and new consumer goods.[31] While British families preferred to have male domestic servants wear the kanzu indoors, those who employed African workers outdoors on their farms or plantations, building roads or railways, favored

the more familiar khaki shorts and shirt. Migrant laborers quickly learned that putting on shirt and shorts would get them a higher rate of pay from a potential employer. Nearly all of the "Kavirondo" witnesses before the Native Labour Commission acknowledged using their wages to buy clothing.[32]

A few groups of adventurous young Luo left their homes in Seme as early as 1913 to see the world and find employment on European plantations and in Nairobi. They "were bored with looking after goats," and while some of them returned home to stay after one contract, many of the others worked regularly outside Seme for the next three decades. When they came home to visit, they wore fine clothing, brought new clothes and bicycles as gifts for family and friends, and greatly impressed the young women they courted.[33] Men from western Kenya soon provided a substantial part of the labor force in the rest of Kenya, on the railways, on the docks in Mombasa, on sisal plantations in central Kenya, and elsewhere.[34] Despite the abuses of forced labor during wartime and into the early 1920s, a pattern of regular labor migration became the norm for up to half the population of adult men in many Luo and Luyia locations by 1930, and somewhat later among the Gusii. A missionary writing in Maseno in 1930 blamed these labor migrants for extensive social problems in the rural areas, many stemming from new styles of dress:

> These people spend heavily on fine clothes, ornaments, feasts, and dances. The men wear correct evening dress for dinner. . . . The ladies follow their example with fine low-cut dresses and high-heeled shoes. After dinner the "European" dances begin, lasting till early morning—and with fatal results. This spirit of irresponsibility and pleasure has spread to the Reserves and we are having difficulties with our young people, with numerous cases coming before Church Councils of sad moral lapses.[35]

Given these very visible ways in which Christians and labor migrants belonged to the new order, it is no surprise that the rebellion of different groups of cultural purists emphasized a return to indigenous forms of clothing as a central element. Atieno Odhiambo has described the cultural purists of Alego, men like Opiyo K'Ogwaw who rejected the whole package of education, culture, and clothes and stood firmly for indigenous aesthetics: beaded goatskin cloaks for men, raffia skirts for women. These purists smeared their bodies with ghee and couldn't stand the "stink" of imported soap or the new clothes. Opiyo himself adamantly refused to have anything to do with European clothing well into the 1950s.[36]

The leaders of a millennial movement known as Mumboism (or the Cult of Mumbo) called for a return to the old ways in which forms of dress played a key part. First documented in 1913, Mumboism tried to restore pride in indigenous customs, celebrated the venerated warriors of the past, and anticipated the imminent disappearance of Europeans from western Kenya.[37] Followers of Mumbo were instructed to reject Christianity and return to precolonial rituals, to perform daily sacrifices and the ritual greeting of the morning sun. Precolonial dances were revived as well. For our purposes here, it is particularly relevant that members threw away items of Western-style clothing and vowed to wear only clothing made from skins, let their hair grow long, and never wash.[38]

The mid-1920s marked the emergence in western Kenya of other groups of young men who rejected European clothing and schooling, organized all-night dance parties, and seduced women. One particularly troublesome (i.e., particularly popular) group called themselves "The Fornicators" and are mentioned in a series of different European accounts.[39] They were blamed for having caused numerous mission boys and girls to revert to "paganism." Marjorie Perham was very interested to hear of the group's activities during her 1929 visit to western Kenya. Two Catholic missionaries told her of "the evil-doings of a secret society of young men, 'The Fornicators,' who roam around the country having dances and orgies and are 'in' with some of the chiefs." Later on, Perham's group encountered a group of "weirdly dressed and painted 'Fornicators'" on the road, and she was able to photograph them. Her photograph suggests an interesting blend of indigenous and coastal forms of dress.[40]

Missionaries referred to such groups more broadly as "the young heathen party" and felt they were deliberately attempting to pull young people out of the mission churches. As a CMS missionary lamented as early as 1918,

> The attitude of the young heathen party would be amusing if it were not so serious. Unique dances have been held to attract readers ["Josomo"]; leaders have been chosen and given titles of DC [district commissioner], etc., others have been elected as teachers; a heathen Catechumenate has been formed in which members make vows to be faithful heathen and renounce Christianity and all its works. Whole districts have been affected and hundreds of people have discarded clothing for red ochre.[41]

Both missionary and official records of the 1920s and 1930s suggest that rural dances were getting out of control. A fascinating account of dancing in Central Kavirondo was prepared by Assistant District Commissioner Hale in 1932, with the notable subtitle "Dancing, Drinking, and Other Excesses."

> These youths dress up in the usual garb of skins, feathers, bells, and paint, . . . and have dances every Saturday and Sunday—in Samia they can be seen on the road nearly every day. They round up an equal number of girls and pair off. Dance all day and night, and then sleep together. Girl receives a small present.[42]

Besides a dour sense of not wanting anyone to have fun, the concerns expressed by European officials include the loss of labor productivity, the enticing of young people away from the missions, and the likelihood of these dancers spreading venereal disease. The opinions of the indigenous chiefs who were consulted ranged more widely. Several seemed to feel the real villain was the arrogance of youths who had been working outside the reserves. A chief from Sakwa felt the dances were "a great bane to the Missions, as the boys and girls who go to school are very much attracted by these dances and are very inclined to leave school, take off their clothes, and don the trappings of these dances (skins—paint—bells etc.)." On the other hand, a chief from Uyoma argued sympathetically that these dances were "the sport and fun of the country-side, without which there would be no fun nor rejoicing for the youth!"[43]

The photographic and archival evidence suggests that a combination of tradi-

tionalist and coastal styles of clothing was appropriate dress at these rural dances, but not the more restrictive European styles. This suggests a possible statement by the participants about a broader *African* identity rather than either indigenous or modern styles.

In that broad context we will turn to an examination of conflicts between young men in trousers and elders in robes or skins, and between Christian women and more traditionalist men, as seen in conflicts between fathers and daughters and between husbands and wives.

Conflict between Young Men in Trousers and Elders in Robes or Skins

At the forefront of both labor migration and Christian conversion were the young men of the warrior ranks, who had been dramatically deprived of both their normal employment (as the British claimed a monopoly over military functions) and their normal chances for income generation (as the warriors' opportunity to accumulate wealth had come from now-forbidden cattle raids). These young men may have recognized early on the implications of military defeat at the hands of British punitive expeditions and foreseen that status and wealth in the new order were best pursued through some degree of contact with the new rulers. They were the first to attend mission schools and to convert to Christianity, the first to become voluntary labor migrants, and hence among the first to adopt new forms of dress.

As early as 1911 there are reports of challenges to the authority of western Kenyan elders and general disrespect shown by these young men in shorts or trousers. British officials urged chiefs in their jurisdictions to settle court cases in consultation with their elders, "the old men who were formerly accustomed to assemble together and deal with Tribal affairs." Instead the colonial-appointed chiefs tended to rely on young men in Western-style clothing who (through labor migration or mission education) had acquired basic literacy and some familiarity with Swahili, skills that made them useful interlocutors with British officials.[44] Around Kisii in the late 1930s, Brett Shadle reports that "Many Gusii now disobeyed local elders' arbitration, which in the past . . . none had dared to question."[45]

D. R. Odindo Adhola, "the official headman of Asembo," drafted a book of instructions for Luo elders that was circulated by the administration in 1913. Odindo emphasized what he saw as a natural link between appointed chiefs and educated young men:

> If you are a clothed person and you hear a drum in the Chief's village, it is your duty to come and find out the cause of it. . . . I want every road to be a broad one. . . . It will be the duty of clothed people to measure the road properly. . . . I think every clan under a Headman should send a child to the school at Maseno or at Ajola's in order that these our children will be able to assist us properly in the work of writing and keeping the accounts.[46]

The elders felt themselves shunted aside under the new order and many of them resented both the British-appointed chiefs and the brash young men who had little

Figure 4.2. "Chief Mumia, Watiti, Muranga, Mtoto ya Sayen, and Abdulla." Chief Mumia (seated) wears the "suitable robes" and fez issued by the British along with purchased leather boots, while the young man to his left is dressed entirely in Western-style khaki clothes, shoes, and cap; the other men wear a combination of Swahili-style and indigenous dress. Hobley photograph Hob IV 40 19, copyright The British Museum.

interest in their peoples' history or traditions. In South Kavirondo, Wipper explains, "the [Mumbo] cult's rejection of European clothing may also have been tied up with its refusal to recognize these youths' claims to superiority."[47] Of course, young men's ability to generate their own bridewealth from their wages had radically altered the balance of power within the homestead.

Elders in the 1920s complained to British officials "that they did not have the same control over their young men as they used to."[48] In 1922 the provincial commissioner explained what he perceived as the disintegration of tribal organization this way: "individuals who have been to school will not submit themselves unreservedly to unrestricted tribal authority."[49] One chief in the Maseno area dragged four young CMS members before the district commissioner "for holding meetings likely to be subversive of authority." After their case had been dealt with, the four refused to return to their seats. They ran away from the hearing and took refuge in the house of Archdeacon Owen, where they were later arrested.[50] The authority these young men were challenging was not British; it was that of their less-educated elders.

Women's Struggles against the Control of Fathers and Husbands

At the same time that elders in western Kenya felt they were losing control over young men, many men believed they were losing control over their daughters and wives, and often associated that loss of control with women's adoption of both clothing and Christianity. As early as 1915 the provincial commissioner noted that "women are beginning to assert themselves, one of the signs being a demand to be clothed" and linked that trend with some recent cases of women declining to be bound by tribal custom.[51] Many husbands refused to provide their wives with Western clothing (and sometimes destroyed the new dresses women had bought for themselves). Brett Shadle has documented problems with young Gusii women who stole money from their fathers to buy clothing; in 1936 some Gusii fathers in Getutu pleaded with district officials to help them forcibly prevent their daughters from wearing Western dress.[52] Women in clothes were perceived as assertive, suspected of having affairs, and seen as broadly challenging patriarchal authority.

Husbands who rejected their wives' desire to wear Western-style clothing might have feared the mobility and independent sexuality of rural wives in Western garb. Writing in 1933, Nora Strange commented that "It is generally accepted that once a native woman adopts European dress, she sheds her morals."[53] In the 1920s and 1930s the majority of Luo, Luyia, and Gusii peoples believed that Africans in Western clothing were sexually promiscuous; they might also be hiding unspeakable things about their bodies. These concerns might have reflected in part the rapid spread of yaws, leprosy, and syphilis and other venereal diseases in rural areas after the First World War, diseases that might well be hidden under Western clothing.[54]

The 1920s represented a golden era of prosperity for agricultural production in western Kenya,[55] and some women used their profits to buy Western-style clothing

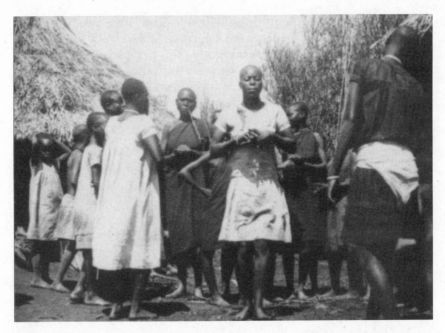

Figure 4.3. "Dancing at a wedding in the Lidgeriza fashion." The photograph shows women in both Western-style and coastal/Swahili-style dress at a wedding in the early 1930s. Reproduced by kind permission of the International African Institute from Wagner, *Bantu of Western Kenya*, facing page 352.

for themselves. British officials acknowledged that women were becoming signifi-
cant purchasers of consumer goods on their own account for the first time, and
were particularly interested in "the better type of clothing."[56] Already by 1926
some seventy-two African tailors had set up their sewing machines in front of
shops or tea rooms in Central Kavirondo district.[57] This was especially true of con-
verts to Christianity. When Elizabeth Baring-Gould visited the CMS mission sta-
tion at Maseno on her 1927 tour of assessment, Christian women and girls from
the nearby locations were invited to come and meet her: "There must have been
between 400 and 500 present, mostly neatly clad in a loose frock with low neck and
short sleeves, and with handkerchiefs [scarves] over their heads."[58]

The majority of the people in western Kenya had adopted modern forms of
clothing by the time of the Second World War, and quarrels over the quality and
the amount of clothing provided to co-wives had become one of the principal
forms of conflict within the homestead, rather than struggles over what form that
clothing should take. It is perhaps telling in this context that the most prominent
form of rebellion in western Kenya from the 1940s on involved breakaway churches
and charismatic movements whose members usually adopted long white robes for
men and loose-flowing white dresses and headscarves for women, suggesting Af-

rican modifications of both coastal and European—but not indigenous—styles of clothing.[59] Traditionalists in skins and beads had largely disappeared, and the men and women of western Kenya were proudly claiming an identity as modern Africans in modern clothes.

Notes

1. Recorded as "The War with the Europeans" in Luo oral history, and as "punitive expeditions" in British official records; see interviews in Kowe Historical Texts (deposited with the History Dept., University of Nairobi; hereafter KHT), and John M. Lonsdale, "The Politics of Conquest: The British in Western Kenya, 1894–1908," *Historical Journal* 20, no. 4 (1977): 841–70. The Gusii also experienced harsh punitive expeditions in 1905 and 1908; see Audrey Wipper, "The Gusii Rebels," in *Rebellion in Black Africa*, ed. Robert Rotberg (New York: Oxford, 1971), 164–208.

2. The Comaroffs have written provocatively about the notion of "bricolage," which seems appropriate in this context. Their work on the effort of missionaries to reshape the cultural as well as religious lives of their Tswana converts is exemplary here. See Jean Comaroff and John Comaroff, "Fashioning the Colonial Subject," chapter 5 in vol. 2 of their *Of Revelation and Revolution* (Chicago: University of Chicago Press, 1997).

3. These earlier struggles are described in greater detail in Margaret Jean Hay, "Who Wears the Pants? Christian Missions, Migrant Labor, and Clothing in Colonial Western Kenya," *Boston University Discussion Papers in the African Humanities*, no. 23 (Boston, Mass., 1992).

4. See, for example, Johnston's "Young Masai Woman . . . Having Iron Wire Coiled around Her Legs," photo 447, Harry Hamilton Johnston, *The Uganda Protectorate* (London: Hutchison, 1902), vol. 2, 807.

5. Winston Churchill, *My African Journey* (London: Hodder and Stoughton, 1908), 33.

6. The most important photographic collections consulted for this paper were the Captain W. B. Brook, A. C. Hollis, and George Gordon Dennis collections at the National Museum of Kenya, Nairobi; the Charles Edwin Collard and Rev'd Ernest Millar collections at the Royal Commonwealth Society, London; and the Charles W. Hobley and Gunter Wagner photographic collections at the Museum of Mankind, London.

7. Felix Oswald, *Alone in the Sleeping Sickness Country* (London: Kegan Paul, 1923), vii.

8. Church Missionary Society Archives, University of Birmingham (hereafter CMS/UB), Miss E. Baring-Gould, journal no. 8 of May 1927, acc. 21, 1. Baring-Gould made several tours of inspection of CMS missions in East Africa on behalf of the society. See also Arthur Conan Doyle, *Our African Winter* (London: John Murray, 1929), 245.

9. Churchill, *African Journey,* 31–33. Such robes were in fact distributed to chiefs and headmen shortly after his visit.

10. Nyanza Province Annual Report (hereafter NPAR) for 1909, Kenya National Archives (hereafter KNA), Records of the Provincial Commissioner, Nyanza Province (hereafter PC/NZA), 1/1/4, 69. Chiefs in Southern Kavirondo were presented with their uniforms slightly later. Southern Kavirondo District Annual Report, 1909–10, inc. in PC/NZA 1/1/5, NPAR for 1910, 1.

11. See, for example, photo 8, "At the Local Native Council meeting in NE Kavirondo," in Margery Perham, *East African Journey: Kenya and Tanganyika, 1929–30* (London: Faber and Faber, 1976), following 124; Brook photo of Chief Opala dated May 14, 1911, Brook collection, BRO/2, 142; Brook photo of Chief Anam at Kadimu, dated June 3, 1913, Brook collection, BRO/2, 196.

12. Robert W. Strayer, *The Making of Mission Communities in East Africa: Anglicans and Africans in Colonial Kenya, 1875–1935* (London: Heinemann, 1978), 19–20, 88–89.

13. See the detailed descriptions of Zanzibari clothing in Laura Fair, *Pastimes and Politics: Culture, Community, and Identity in Post-abolition Urban Zanzibar, 1890–1945* (Athens: Ohio University Press, 2001), chapter 3.

14. Formal photographs of Luo chiefs and headmen taken by Capt. Brook around 1910, A. C. Hollis's photos of the sultan of Zanzibar and the *liwali* of Lamu in the early 1900s, and Rev. Ernest Millar's photographs of "his boys" and of Ham Mukasa and Apolo Kagwa around 1902 show a remarkable similarity to each other and to the ideal forms of dress prescribed for western Kenya in the early 1900s. See also photograph #173, "An Arab Trader in Uganda," in Johnston, *Uganda Protectorate*, vol. 1, 217.

15. PC/NZA 1/1/3, NPAR for 1907–1908, xlii–xliii.

16. PC/NZA 1/1/5, NPAR for 1910, tables 13–16, xlii–xliii.

17. PC/NZA 1/1/25, NPAR for 1930, 28–29.

18. Also see Atieno Odhiambo, "From Warriors to Jonanga: The Struggle over Nakedness by the Luo of Kenya," *Matatu* 9 (1992): 11–25, and David Cohen and Atieno Odhiambo, *Siaya: The Historical Anthropology of an African Landscape* (Athens: Ohio University Press, 1989). "Readers" (or *josomo* in Luo) was the term used by missionaries for Africans who were receiving Christian instruction at the mission but had not yet been baptized.

19. Rev. Pleydell of the Church Missionary Society Maseno mission complained about the difficulties of trying to supervise over six thousand catechumens preparing for baptism in Central Kavirondo in 1918, spread over roughly a hundred schools with African teachers. CMS/UB, G3 AL Pleydell, December 1918.

20. In 1924 Luyia girls at the Quaker Boarding School in Maragoli had sold sixty-five dresses to women outside the mission in a short period of time. See Friends United Mission sources cited in Samuel S. Thomas, "Transforming the Gospel of Domesticity: Luhya Girls and the Friends Africa Mission, 1917–1926," *African Studies Review* 43, no. 2 (2000): 15.

21. Joan Arwa, interview, April 19, 1970, in KHT. It seems likely that some of these events were telescoped in her memory.

22. Martin Oyugi, interview by Judy Butterman, July 21, 1977, testimony in her "Kanyamkago Economic History Texts," deposited in Kenya National Archives.

23. The calico fabric given to girls for their uniforms was soft enough for hand stitching, whereas the stiffer khaki fabric for boys' uniforms required machine stitching.

24. See Thomas, "Transforming the Gospel." Tabitha Kanogo makes the same point

for Kenyan women more broadly in "Mission Impact on Women in Colonial Kenya," in *Women and Missions Past and Present: Anthropological and Historical Perceptions*, ed. Fiona Bowie et al. (Providence, R.I.: Berg, 1993), 165–86.

25. Sophia Odero and Rose Orondo, interviews by author, March 1988.

26. CMS/UB, Baring-Gould, journal no. 8 of May 1927, acc. 21, 1.

27. Oginga Odinga, *Not Yet Uhuru: The Autobiography of Oginga Odinga* (New York: Hill and Wang, 1967), 4. The item in question was a khaki-colored pullover sweater, with a red-buttoned flap at the back, worn by one of his neighbors in 1918. It had most likely been first issued to someone in the King's African Rifles.

28. The three districts of Nyanza Province were originally named North, Central, and South Kavirondo, and "Kavirondo" was the term used to describe its inhabitants. Observers often distinguished between the "Nilotic Kavirondo" (later known as Luo) and the "Bantu Kavirondo" (later known as Luyia). After 1945 the districts were renamed North, Central, and South Nyanza.

29. See the discussion of these self-conscious pioneers in Margaret Jean Hay, "Hoes and Clothes in a Luo Household: Changing Consumption in a Colonial Economy," in *African Material Culture*, ed. Mary Jo Arnoldi, Christraud Geary, and Kris Hardin (Bloomington: Indiana University Press, 1996), 243–61.

30. This commitment is clear in interviews in KHT with a number of different informants (Samili Olaka, March 11, 1970; Thadayo Obara, October 24, 1969; Joan Arwa, October 10, 1969; and Jeremiah Hokaka, September 12, 1969), but perhaps strongest of all in the testimony of Julius Otieno, April 21, 1970, also in KHT. See also interview with Julius Otieno, March 15, 1969, KHT.

31. In Seme, where I carried out most of my fieldwork, it is rather difficult to sort out the competing pressures of Christianity and the labor market, because many of the early labor migrants tended to be Christian converts as well.

32. See the African testimony in East African Protectorate, *Native Labour Commission, 1912–1913: Evidence and Report* (Nairobi: Government Printer, 1913), especially witnesses 129, 130, 133, 163.

33. At one point, Jeremiah Hokaka drove an automobile home from Nairobi—the first many of his kinsmen had ever seen. See interviews with Omindo Ayieye (December 3, 1969), Jeremiah Hokaka (April 13, 1970), and Johana Ming'ala (October 10, 1969), all in KHT. Note that while many men were forced to leave the reserves for wage labor in the early decades, there was also a good deal of voluntary labor migration among the young, and particularly among those who had studied at mission schools.

34. See Frederick Cooper, *On the African Waterfront: Urban Disorder and the Transformation of Work in Colonial Mombasa* (New Haven, Conn.: Yale University Press, 1987), esp. 28–29, 69–71; Sharon Stichter, *Migrant Labour in Kenya: Capitalism and African Response* (London: Longman, 1982); Gavin Kitching, *Class and Economic Change in Kenya: The Making of an African Petite-Bourgeoisie* (New Haven, Conn.: Yale University Press, 1980), esp. 39–56.

35. Rev. A. E. Pleydell, annual letter dated August 1930, CMS/UB, G3 AL.

36. Odhiambo, "From Warriors to Jonanga," 17. See also his insightful comments on Luo experiences with colonialism more broadly in Cohen and Odhiambo, *Siaya*.

37. Although its greatest impact was among the Gusii, Mumboism began in Central Kavirondo and had numerous "outbreaks" there as well. A number of sepa-

rate, linked occurrences from 1915 through the 1950s haunted British officials, who often responded with force. See PC/NZA 1/1/16, NPAR for 1920–21, 3; PC/NZA 1/1/18, NPAR for 1923, 4–5; PC/NZA 1/1/22, NPAR for 1927, 10; PC/NZA 1/1/25, NPAR for 1930, 16–17; PC/NZA 1/1/28, NPAR for 1933, 9.

38. Wipper, "Gusii Rebels," 185, 193.

39. See PC/NZA 3/26/2, provincial diary for July 1925, where two of the leaders of one such group are ordered to report for roadwork. I have been challenged on my "translation" of the group's name, but the archival materials and Marjorie Perham's book use the English term "fornicators" alone. If dance leaders called themselves "kingi" and "prime minister," using the foreign terms, it is likely they adopted the term "fornicators" as well.

40. Perham, *East African Journey*, 151, photograph facing p. 125.

41. Rev. A. E. Pleydell, annual letter, 1918, CMS/UB, G3 AL 1918. The quotation shows "the young heathen parties" consciously constructing parallels to colonial and Christian institutions.

42. "Native Tribes and Customs: Dancing, Drinking, and Other Excesses," prepared by Mr. Hale, included in PC/NZA 2/1/68.

43. Ibid., 7. In response to related complaints from Luyia elders, the North Kavirondo Local Native Council passed a resolution in 1935 forbidding organized dances except in connection with marriages or funerals. See PC/NZA 1/1/30, NPAR for 1935, 22.

44. PC/NZA 1/1/6, precis of annual report, Nyanza Province, 1910–11.

45. Brett Shadle, " 'Girl Cases': Runaway Wives, Eloped Daughters, and Abducted Women in Gusiiland, Kenya, c. 1900–c. 1965" (Ph.D. diss., Northwestern University, 2000), 203.

46. Quoted from pp. 2–4 of "Odinda's Book of Instructions," included in PC/NZA 1/1/8, annual report for 1913. Considered a progressive leader at that time, Odindo was a British favorite.

47. Wipper, "Gusii Rebels," 186.

48. District commissioner, Central Kavirondo, to Archdeacon W. E. Owen, November 2, 1920, Archdeacon Owen Papers, box 1, MSS 21/1, KNA.

49. PC/NZA 1/1/17, NPAR for 1922, 32.

50. PC/NZA 1/1/20, NPAR for 1925, 8.

51. PC/NZA 1/1/10, NPAR for 1915, 10. In Buganda, Charles Hattersley had noted the appearance of "women suffragettes" as early as 1908: "These insist that if they are not supplied with European clothing, . . . the banana supply for the family will stop; they will no longer cultivate, but will go off and get work as laborers." C. W. Hattersley, *The Baganda at Home: With One Hundred Pictures of Life and Work in Uganda* (London: The Religious Tract Society, 1908), 109.

52. Shadle, "Girl Cases," 201.

53. Nora K. Strange, *Kenya Today* (London: Stanley Paul, 1934), 81, 102.

54. See, for example, NPAR for 1912 (PC/NZA 1/1/7, 26–27), 1916 (PC/NZA 1/1/11, 26), and 1923 (PC/NZA 1/1/18, 33). The Jokoyo (or cultural purists) of Alego also feared that certain people attempted to hide bad diseases, or evidence of witchcraft, under their clothes; see Odhiambo, "From Warriors to Jonanga," 17.

55. See Margaret Jean Hay, "Luo Women and Economic Change," in *Women in Africa: Studies in Social and Economic Change*, ed. Nancy Hafkin and Edna Bay (Stanford, Calif.: Stanford University Press, 1976), 87–109.

56. PC/NZA 1/1/11, NPAR for 1916, 19.
57. Central Kavirondo Annual Report, 1927; see the related discussion in Kitching, *Class and Economic Change*, 159–79. Note the suggestion in the Native Affairs Department's annual report of 1936, p. 184, KNA, that African tailors primarily produced women's clothes (presumably because the men were more likely to buy ready-made).
58. CMS/UB Acc 21, Baring-Gould, journal no. 8 of May 1927.
59. Note the similarity of the clothing prescribed for contemporary members of the Roho or Holy Spirit churches and early Christian clothing in western Kenya. Cynthia Hoehler-Fatton, *Women of Fire and Spirit: History, Faith, and Gender in Roho Religion in Western Kenya* (New York: Oxford University Press, 1996), 88, photographs, 119–26. She explains that "in traditional Luo culture, the color white symbolized purity . . . [and was] associated with spirits," p. 230 n. 25. See also F. B. Welbourn and B. A. Ogot, *A Place to Feel at Home: A Study of Two Independent Churches in Western Kenya* (London: Oxford University Press, 1966).

5 Putting on a *Pano* and Dancing Like Our Grandparents: Nation and Dress in Late Colonial Luanda

Marissa Moorman

> They liked Brazilian music, they danced very well and they liked American cinema.
> I remember that the big stars at the time were Don Ameche and others, obviously
> *cowboy* films. . . . This imaginary of American cinema was reflected in the way
> they behaved, in their suits, in the way they wore their mustaches—in the design
> of their mustaches you would see the presence of the American actor, the white
> actor. And there was certainly the influence of the black actors too, but this was
> mostly reflected in the way they dressed.
>
> —Michel Laban, *Mário Pinto de Andrade, Uma entrevista*[1]

Referring to the 1940s and '50s at the Liga Nacional Africana (National African League) in Luanda, Pinto de Andrade reminisces about his "*mais velhos*"[2] as they performed American-inspired dances and artistic numbers in the halls of an association dedicated to the defense of the rights of Africans. Although the Liga was an elite institution it nonetheless preoccupied itself with the conditions of its downtrodden black brethren just as it sought to reclaim "Africa" from colonial cultural ignominy. Liga members would present a play representing life in the *musseques* (Luanda's urban shantytowns which housed the majority of urban African residents), using local instruments, ways of speaking, and dress as readily as a performance of American-style tap dancing or a Carmen Miranda number.[3] An insistence on this duality of Western and African practices would become the unself-conscious hallmark of this young group. The Liga's position as a loyalist association was the source of intergenerational political conflict as some of this younger generation began to argue for an uncompromising nationalist politics. Like Malcolm X as described in Robin D. G. Kelley's *Race Rebels,* these young men did not associate their dress with political expression. And yet, as Kelley argues, the dance, dress, and culture that Malcolm X later dismissed as the accouterments of a self-hating black man were "not a detour on the road to political consciousness but rather an essential element of his radicalization."[4]

In the Angolan instance, radicalization was bound up with a larger set of cos-

mopolitan cultural practices, of which dress was one. Young Angolans reached beyond the cultural vistas of Angola and the horizons of the Portuguese colonial imaginary to create local fashions and other cultural practices that asserted both their difference and their participation in the "global ecumene."[5] What developed was a cosmopolitan youth culture that recognized itself in the cut of a jacket, the length of a skirt, or the tilt of the hat from elsewhere just as it donned those symbols as intimate expressions of *angolanidade* (Angolan-ness). As the colonial state became more repressive in response to nationalist political activities in Angola, such self-styling grew in its significance, becoming both more widespread (within the capital and throughout the territory) and more meaningful. The possibilities for dress and their consequent meanings varied by gender, and this could not help but have implications for the nation being forged in the seemingly apolitical practices of dress and entertainment.

Cosmopolitanism and the Nation

Mobutu Sese Seko's mandated *authenticité* in independent Zaire is perhaps the most well-known example of the association between dress and politics, dress and nation in Africa. Here the independent state promoted African apparel as a form of roots recovery to advance the nation-building project. African cultural forms were to remedy the European-centered identity that could be discerned in the tendency of at least some urban residents to dress in European styles and to speak French. But as Thomas Turino's recent work demonstrates, borrowed cultural markers and materials can be more than the mere trappings or imitations of another culture. Turino describes this phenomenon as cosmopolitanism and defines as cosmopolitan "objects, ideas, and cultural positions that are widely diffused throughout the world and yet are specific only to certain portions of the populations within given countries. . . . [Cosmopolitanism] has to be realized in specific locations and in the lives of actual people." It is both local and non-local while not necessarily being nationally evident, as it is often tied to specific classes or social groups. Turino argues that nationalism is itself an example of a cosmopolitan doctrine that both arises from cosmopolitan practices and aims to spread them throughout a national territory. What is crucial, Turino claims, is that the forms become internalized by and integral to the people in the group: "*this is part of who they are.*"[6] An African in European clothes is no less authentically African than an African in African clothes. As the quotation that opens this chapter shows, dress can be a way of saying "this is who I am" within parameters that are both local and non-local. In thinking about cosmopolitan cultural practices around music in the Congo, Bob White avers that "unlike 'globalization' or 'modernity,' cosmopolitanism is not something that happens to people, it is something that people do."[7] White underscores Turino's sense that the use of European goods and forms is not imitation or imposition, and he shifts the emphasis from a potentially static rendering of identity to the activity of self-styling. Hence there is room for innovation and creativity, for subversion and play, for combinations that otherwise might be taken as contradictions.

In Angola, particularly in Luanda but in other urban centers as well, dress became one of the ways in which Africans created and expressed their angolanidade—a unique Angolan way of being in the world.[8] Under a colonial regime that defined Angola as part of the Portuguese nation, angolanidade took on nationalist overtones. However, the explicitly nationalist uses of dress that Mobutu's *authenticité* represents, and of music and the discourses around it that Turino's work analyzes, are not the most useful model here. In late colonial Angola, the relationship between music and dress was more tenuous. In order to untangle this relationship we need to distinguish nationalism (and the adjective "nationalist") as a political project relating to territorial sovereignty and state control from nation as a politico-cultural imaginary. Nationalism always requires an articulation of nation but nation does not require the same of nationalism. As Eric Hobsbawm points out, "nations do not make states and nationalisms but the other way round."[9] Yet we should not take this to mean that nation is merely a reflex, or automatic, production of nationalism. In the case of dress in Angola, by taking nation on its own terms we can see the ways in which this cultural practice helped forge the nation and prepare people for the politics of nationalism. Likewise, by attending more closely to cultural practices, we can begin to see how the nation is fragmented[10] along the lines of gender, something that would not be as accessible if we thought only in terms of nationalism, political parties, and the state.

The distinction between nation and nationalism is crucial when thinking about Angola because the high level of political repression after 1959 meant that nationalist politics were largely the provenance of exiles and a small number of clandestine activists. In part composed of a younger generation who parted ways with the reformist politics of the Liga, small underground groups of activists (three to five people) met and engaged in pamphleting and other forms of political provocation aimed at educating their neighbors in the musseques about the necessity of independence. Some of these activists were connected to the Portuguese Communist Party and small local parties that were calling for Angolan independence.[11] In 1959 the colonial government arrested, tried, and jailed some fifty Angolans whom it accused of "activities against the external security of the state"[12] in what is known as the Processo de 50 (Case of 50).[13] Most were civil servants, nurses, workers, and students from the most educated strata of Africans, although many of them lived or spent their free time in the musseques where the majority of Africans resident in Luanda lived. In February 1961 a group of individuals attacked the Luanda prisons (where some of these political prisoners were held), a police barrack, and the radio station.[14] In the same year, this small urban uprising was preceded by a protest turned uprising against the exploitation of cotton production in Kassanje (northeast of Luanda in the Malanje province), and then followed by a revolt in March in the northern Kongo coffee-producing areas. The colonial government was now on the defensive. It responded violently to these uprisings[15] and then cracked down on any sign of political activity, especially in urban areas. Distant as this may seem from questions of sartorial savvy, René Pélissier in discussing this period remarked that "urban Africans tried to pass unnoticed by avoiding in their appearance and attitudes anything (the wearing of clothes too European in style, for example)

which might give rise to the suspicion that they would like to oust the whites."[16] The Portuguese had concluded that those proposing independence and fomenting revolt were, for the most part, well-educated urban dwellers keen on the European fashion that helped them signal their elite status and that differentiated them from the masses. For a moment, following Pélissier, the colonialists understood that European dress did not necessarily mean that the so-called *assimilados* (assimilated) identified with them, unless of course it meant that they had identified too much, had become cheeky and too big for their britches, and deemed themselves capable of self-rule.

After the violent response to the events of 1961 the colonial government made some changes in policy. These changes were implemented as a last-ditch attempt to maintain colonial domination by making life more tolerable for Africans whose living and working conditions might foster revolt. They included the abolition of the *indigenato* system that had divided the African population in two (*assimilados*—assimilated—and *indígenas*—indigenous) and accorded Portuguese citizenship only to the few who managed to achieve the status of assimilado; the implementation of a new rural labor code freeing rural workers from coerced contract labor; the opening of more schools; encouragement of foreign investment, which created more jobs; and the largely overlooked promotion of local culture and recreation (clubs, talent shows, and soccer clubs). The events of 1961 also marked the beginning of the guerrilla struggle as the nationalist movements moved permanently into exile, exchanging their street togs for fatigues. The battle continued on until independence in 1975, and in those years life in the musseques took on a particular cast. While the guerrillas and politicos struggled to assert political sovereignty and control, urban Angolans sang, danced, and dressed their nation in what appeared to the Portuguese as so much bread and circuses. Urban fashions and dress practices, closely tied in with the burgeoning youth scene of music and parties, bespoke a nation whose cultural sovereignty was secured in the swagger of a step, the sweep of a pant leg, or the swell of a fabric wrapped around one's head.

Looking beyond the Metropole: Dress in the 1940s and 1950s

Under the indigenato system, which was in place until September 1961, Africans were divided into two groups: assimilados and indígenas. The former, according to the 1940 and 1950 censuses, accounted for less than 1 percent of the population, giving the lie to Portuguese claims of racial equality and harmony.[17] Theoretically, anyone could become an assimilado and have access to a Portuguese identity card (required to enter the school system or the civil service and exempting one from contract, i.e., forced, labor). But the reality was much different. Decisions about who was an assimilado could be quite random and depended upon the whims of Portuguese shop owners in the musseques and *chefes de posto* (local administrators) outside the city who supported, or did not support, the citizenship applications of Africans in their area. To be categorized as an assimilado one had "to be eighteen years old, demonstrate the ability to read, write and speak Portuguese fluently, earn wages from a trade, eat, dress, and worship as the Portuguese,

maintain a standard of living and customs similar to the European way of life, and have no record with the police."[18] But so arbitrary was the system that people living in the same household could have different statuses.[19] As in many other colonial situations, European dress was one of the markers of civilization. However, as Mário Pinto de Andrade recalled, many male assimilado youth in the 1940s and 1950s looked to Brazil and to American film actors as the benchmark of fashion. If Portuguese clothing was meant to mark one as captured, in a sense, by the colonial system, these young men mocked the Portuguese by setting their sartorial sights beyond the metropole.[20]

Promoting Portuguese dress as a standard of civilization was only part of the colonial policy related to clothing. African dress was denigrated, considered quaint enough for folkloric performances and tourist snapshots but not suitable for urban wear.[21] Albina Assis remembers that

> Those who wore *panos* [pieces of fabric] every day could not enter into buses—it was prohibited. Later, after the fourth of February [1961] . . . is when they created, and you can write this down, the *munhungo*[22] bus that was to serve poor people, low-income people, more or less *pé descalço* [without shoes]—and it was only in these buses that the women in panos were allowed to ride. . . . It was for this reason that a large part of the people took the route of using [European] dresses because, in general, the dress, overall here, even at the level of the city of Luanda, was panos. . . . All of my aunts wore panos, even those who were the wives of Portuguese men—two of them, even today, have never stopped using panos.[23]

As Assis notes, panos were a common form of urban female attire as well as the traditional attire of fishermen from the island of Luanda. Women from the urban elite were referred to as *bessanganas* and their use of panos was quite distinct, involving a series of undergarments, four layers of panos over a long-sleeved blouse, and a smaller pano wrapped around the head.[24] By the early 1970s it was mostly older women who maintained this form of dress. Younger women routinely donned European-style dresses, though often with a pano wrapped around the outside and rolled at the waist, and a headscarf. Writing in the early 1970s on the musseques, Ramiro Ladeiro Monteiro noted that "this piece of clothing defines a woman's social status and its absence, in the midst of certain social strata, is noticed. That is why the washerwoman we see in her boss's house dressed in European style, upon returning to the *musseques*, concerns herself with putting a *pano* around her waist."[25] This was, perhaps, less a question of peer pressure than of dignity and adaptation of practices, as Assis's final remark about her aunts suggests. At the same time it was not uncommon to see younger women in miniskirts, again with scarves on their heads, and panos wrapped around their waists to facilitate carrying babies on their backs.[26] Women's quotidian acts of self-styling gave local forms of dress a new meaning. Young women who used panos with miniskirts or European dress nodded to the bessanganas' style as uniquely Angolan while also adapting it. By neither dismissing it as archaic nor reproducing it layer by layer, these young women demonstrated a new posture of Angolan womanhood that was both local and worldly.

Figure 5.1. The singer Belita Palma dressed as a *bessangana*. No date. Courtesy of ENDIPU (National Company of Disks and Publications).

If young women paraded the fashionable miniskirt, it was still the complex dress of the bessanganas which held sway in the dance called *rebita*. As Jacques dos Santos asserts more generally about Luanda, "fashion and dance always had affinities."[27] Rebita was a dance popular among Luanda's Africans in the 1930s (although it dates as far back as the mid–eighteenth century)—when, dos Santos argues, it was still respectable to be a laborer—and these workers formed rebita groups in the musseques and other neighborhoods.[28] It is nonetheless associated with an older urban elite. Rebita is a dance done in a large circle formed by couples. It includes elements both European (including some instructions called out in French by the emcee)[29] and African (women's dress and particular dance steps like the *umbigada* or stomach thrust). The dress code was rigorous, with men clad in European suits and ties and women dressed à la bessangana.[30] The emcee generally checked to make sure that the dancers were properly attired. Thus, as early as the 1930s, dress

was already used by the elite to distinguish themselves and to express a unique style that showcased African dress as worthy of partnership with European dress. For as much as some social scientists wanted to claim the presence of European dress as a sign of progressive acculturation,[31] rebita bespoke a sensibility much more cosmopolitan than metropolitan. It did not elevate Portuguese culture or dress over African but wedded European cultural practices of salon dancing, dress, and language with African instruments, clothing, and social codes to create a novel local practice.

For those women, like Assis's aunts (one of whom was married to a Portuguese man and lived in the metropole), who maintained the dress of bessanganas outside of the context of rebita, this form of dress was a way of maintaining cultural practices and pride in the face of colonial discrimination. It would be difficult to call this dress nationalist resistance, but it points to the variety of ways in which gendered practices of dress contributed to the construction of a sense of nation. By continuing to dress in panos despite the lack of access to public transport and public buildings that doing so entailed, these women insisted that urban space was African and Angolan. Those women who continued to use panos in conjunction with European dress also saw no contradiction in being both urban and Angolan; this was who they were and it was legible in the way they dressed.

The youth of the 1950s self-consciously used such forms as templates for their political involvement. For the most part, the young men and women who were involved in politico-cultural activities in the late 1950s and early 1960s dressed in European style. As students in the city's schools and holders of identity cards, they had little choice. Young women who attended schools would not have worn panos, not even just as headwraps, except perhaps on the weekend. The musician and historian Carlos Lamartine noted that "as a rule, people had to dress in the Western style—this was even a way of depersonalizing and incorporating the Angolans. This not just from the point of view of clothes but almost everything that people did. When we went to school, upon entering the school we had to present ourselves as European individuals."[32] But as many of this generation noted, their mothers, aunts, or grandmothers still maintained the typical Luandan manner of wearing panos. These young students were, as well, quite conscious of the various kinds of discrimination practiced against Africans under the Portuguese colonial system. Many of their parents were involved in the Liga and they had certainly heard about the evils of contract labor. They heard the Portuguese disparage Kimbundu by calling it the "language of dogs," and their parents' attempts at social advancement within the colonial system led to their own inability to speak the language. These attempts gave them access to formal education, but for this they paid the price of cultural alienation.

They began to question why their education had everything to do with Portugal and nothing to do with Angola. In small politico-cultural groups formed in the musseques, and which sometimes performed at the Liga, they sought to revalorize and rediscover local cultural practices. A burgeoning literary movement, sprouting in part from the Liga and Anangola (Association of Angolan Natives), had already, in its own way, created cosmopolitan practices of writing (essays, poems, and

estórias[33]—short tales based on the Kimbundu traditions of *misoso*) that made local culture and day-to-day experiences available to Angolans and the world in the form universally recognized as "literature." Politico-cultural groups like Bota Fogo, the girls' group Santa Cecília, and the theater group Ngongo recited this poetry and presented the stories and dramatized scenes of daily life in the musseques as theatrical pieces, thereby sowing the seeds of cultural renovation beyond a limited literate and literary public. Many of these young folks were quite politicized in the sense that they were already thinking about and discussing Angolan independence. They saw their cultural work as a way of educating the masses of the musseques by representing back to them the contradictions and tensions of quotidian experiences of colonial oppression. Central to their performances—whether theatrical or musical or literary—was the use of local forms of dress.

These performances did not so much meld styles as present what was denigrated in the Portuguese colonial order as representative of something meaningful and something uniquely "ours." In terms of clothing, this was generally women's dress. But this did not mean that they advocated a return to dressing in panos or did so themselves. Albina Assis put it most succinctly: "we were students and we went and did African dance, dancing like our grandparents or ancestors, exactly in order to show that the dance of Africans—putting on a pano and dancing—did not take away from us our cultural education or the [academic] education that we had . . . and we saw that this caused a shock with the system."[34] The point was not to suggest that panos represented an authentic or real Angola but, instead, to emphasize the duality of being both educated and African without contradiction. This challenged the colonial system with the proposition that one could be Angolan and not Portuguese, even when dressed in European styles. What made the use of local styles of dress cosmopolitan, in this instance, was the contexts in which they were presented—i.e., in theatrical performances, in matinees for children, in poetry recitations and discussions of local literature, and as a self-conscious commentary. Likewise, the ideas with which many of these young folks approached these activities reflected a sensibility that refused the metropole and its decrees, laws, and prohibitions while still embracing other more cosmopolitan practices of literary production, dress, and education.

"He Had a Talent for Dressing!": Dress after 1961

The arrest, detention, trial, and then imprisonment of nationalists beginning in 1959 meant that the Portuguese state's secret police, the PIDE, began to pay closer attention to political activity in the musseques and that the Liga was itself subject to greater censure. The three uprisings in 1961, which received international attention,[35] compounded the political troubles of the Portuguese administration in the colony (actually called an "overseas territory," an extension of the Portuguese nation much as Algeria was in the French imaginary). The PIDE throttled local political activity and the government deployed counterinsurgency troops in tactics that meant that the war had begun in earnest.

If political repression created greater secrecy, self-censorship, and even the

avoidance of political questions, a sort of shrinking away from the political, some of the new colonial policies were used by urban Africans to make culture flourish. The encouragement of foreign investment meant more jobs were available locally, access to credit allowed many urban Africans to build and purchase their own homes, the opening of schools made education more widely available (though still quite limited), and the promotion of local culture meant to distract the Angolan urban masses actually consolidated a sense of angolanidade. It is important to note, however, that the colonial government did not actually spearhead cultural developments; it merely followed African initiative. For example, clubs and bands existed in the early 1960s but the creation of the Angolan Center for Tourism and Information (CITA) by the colonial government in the mid-1960s allowed activities to be coordinated and promoted on a broader scale. This new system had its limitations—CITA also meant oversight and control, and the censorship board tried to see to it that potentially inflammatory lyrics did not make it to the stage. In this context, politics was a dangerous and necessarily secretive business and those who had not been arrested in the sweeps of 1959 and 1961 either left to fight with the guerrillas or engaged in extremely low-level clandestine activities. Even those who merely followed political developments via the MPLA's radio broadcast *Angola combatente* listened alone or with one or two friends, often under beds or in cars parked in empty soccer fields, so terrified were they of being labeled an enemy or a terrorist and jailed.[36]

Entertainment, on the other hand, even though somewhat constrained, was encouraged. Yet the effects of this were not what the colonial government expected. Entertainment, specifically music, brought people together in public, largely all-African spaces (i.e., owned by Africans, located in the musseques, and attended overwhelmingly by Africans). These clubs would have attracted significantly larger numbers of youth than had the politico-cultural groups of the 1950s. Not only had the urban population nearly doubled between 1950 and 1960 and more than doubled between 1960 and 1970,[37] but this new form of entertainment took parties and dancing out of the homes and backyards of neighbors and friends to a larger, more public platform where one could more easily escape the watchful eyes of parents and family. The gatherings had a broader appeal, and this in turn increased the size of the venues. This had different implications for young men and young women, as the clubs were often deemed potentially liberating by young women and potentially dangerous by young women's parents. Clubs like the famous Clube Maxinde were built and rebuilt to be able to hold up to several hundred people, and stationed bouncers at the door to enforce dress codes, collect tickets, and control the entry of a public whose basic social background was the musseque but whose names and faces were not necessarily known.[38] Bota Fogo was much smaller in size, and it was easy to see and meet everyone who was attending an event. The clubs, with their larger size and degree of anonymity, lent a sense of participating in a shared cultural practice without necessarily knowing everyone else who was there.[39]

Of course, the PIDE were not so naive as to leave the clubs and young *farristas* (partiers) to their own devices, but they tended to take a literalist approach to the

music and the scene, worrying about musical lyrics and political conversations. By government order, club statutes prohibited membership by anyone who had been arrested for political activities, though they could still attend events.[40] That young Africans gathered meant that the PIDE knew where to find them, dancing and partying until the wee hours instead of plotting against the government. But this line of thinking missed what was at stake. People were gathering to hear a new form of music that was uniquely Angolan while being in many ways similar to the foreign (European, Brazilian, Cuban, Congolese) music with which most urban Africans were familiar: the songs, like foreign ones, were a few minutes long; they were meant to be danced to; and they were performed by nattily clad band members playing electric guitars. Coming together to hear this music created a sense of being a part of something located both in and far beyond the musseques. The fact that clubs were owned by individual Africans or groups of Africans and that one spent one's hard-earned salary to attend dances and shows by local performers could not but forge a feeling of economic and cultural self-sufficiency.

In the interviews I conducted in late 2001 and early 2002, I was constantly struck by the aura of nostalgia associated with this period. At first I found it deeply troubling that the late colonial period would be remembered in such romantic terms and set up so favorably against the present. But I soon came to realize that what had been lost was this sense of being in control of one's life and being able to take care of oneself, and the association of that feeling with the idea of being Angolan. Consumer practices that involved everything from buying new clothes to paying the entrance fee at a club or buying records of the new style of Angolan music played there generated an experience of personal and community independence that prepared urban Angolans for, or in Kelley's terms radicalized them for, nationalist politics. They had created and secured the nation in the quotidian cultural practices of music, dance, and dress.

More than a few times, reveries about the good old days of music included the comment "and people used to dress well!"[41] A sense of self-respect was one of the marks of a growing dignity in the nation. People took the time and care to dress well and they spent the fruits of their toil on doing so. They were not extravagant and, for the most part, people took care to spend their money intelligently. Hence it was common, among both the working classes and the elites of the musseques, to buy cloth at one of the large retailers in the musseques[42] and then take it to a seamstress or tailor to have clothing made. Musseque dwellers may have been dependent on Portuguese retailers, but when they could they took their business to their neighbors and avoided buying ready-made clothing in the shops of the city center.[43] This was both more economical and a way of recognizing the talents and skills within their own community. In fact, some people much preferred having clothes custom-made to buying premade clothes, no matter what their quality, since they would not be perfectly fitted to their wearer. Chico Coio explains,

[People] dressed well in those days and things were cheap. There was Gajageira, the colonialists were here. . . . in those days, any old person could dress well, the seamstresses made money, but today no, because of the *fardos* [markets of secondhand

imported clothing]. The tailors made money because no one bought already-made pants—I would buy fabric and have them made, they would take my measurements and make me a pair of pants. . . . Shirts were not purchased already made, you would go to a seamstress or tailor, they would take your measurements. . . . everyone had a seamstress, everyone had their tailor and you would go to your tailor and say, "ay-pa [a common exclamation], I am going to a party!" . . . People worked hard and that bit that they earned was enough to pay the rent and feed and sustain the family. . . . It was because of this that people dressed well and then would go to those parties where you would party, dance, and hear the music of your favorite band.[44]

Dressing well was associated with pride in working hard and providing for oneself and one's family and with entertainment. Those young men and a few women (including some musical artists) who made enough money to shop in the stores of the city center could even buy on credit.[45]

The favored style of dress, while considered Western or European, was not necessarily Portuguese. Many people remembered looking through catalogues and magazines at the tailor's shop or at stores and mentioned the influence of magazines and films on local fashion.[46] They mentioned Italian, Brazilian, French, and American styles most frequently. People began to invent their own manner of dress in a way that inserted them in this line-up of styles defined by nation. By the late 1960s, the rock 'n' roll revolution of Britain and the United States had also touched Angola. Local rock bands (which played what was called "yeah-yeah" music) existed, but far more popular were bands that played Angolan *semba* and Congolese and Cuban-style rumba. Semba is an Angolan urban popular form of music that combines both European and African styles; European instruments are played in local styles, songs are dance-length but their lyrics are in Kimbundu, and ballads are set in the quotidian context of the musseque. Local musicians became famous and, as in many places, trendsetters. Musicians paid particular attention to how they dressed. African-style dress was largely reserved for performances for tourists (and, after independence, for shows outside the country which required musicians to represent the nation),[47] while European styles were followed and reinvented locally. The fashions associated with rock 'n' roll in the U.S. and Europe were part of this local scene. The composer Luís Martins, or "Xabanu," linked fashion to music in Angola in a way that once again looked past Portugal:

> our evolution began, practically, when Roberto Carlos expanded in Brazil as a musician. So we then saw the French style, the American and the Brazilian. . . . We didn't pay much attention to the Portuguese style, and especially not since some of the Portuguese would say to us, "look, dressing like that," excuse the expression, "is risqué." Sometimes the whites would call us names or make fun of us. [Imitating what they would say:] "This style of dress is a ridiculous way of dressing." Because they didn't like it. They liked to wear their pants like this, here at the belly button, and we wore them here [points to his hips].[48]

Record album covers and photographs from the period show bell bottoms, ample shirt collars, big sunglasses, wide belts, and big hair.[49] Like Pinto de Andrade's "*mais velhos*" in the '40s, the urban Angolan youth of the late '60s and early '70s

Figure 5.2. The musician Lakes Alberto. No date. Courtesy of ENDIPU (National Company of Disks and Publications).

also took its cue from African-American style, in this case returning "Afros" to Africa.

Male performers often garnered fame for their style of dress. The composer Xabanu was a close friend of the singer Urbano de Castro, who was one of the musicians known for his distinctive style of dress. In describing de Castro's flair Xabanu exclaimed, "He had a talent for dressing!"[50] Urbano de Castro was quite keen on wearing suits and shirts, crafted by his own tailor and adorned with big medallions. He was one of the most popular figures in the musseques.[51] His talent for dressing was matched by his talent for singing the realities of urban African life. According to another musician, Carlos Lamartine, de Castro had a song about

Figure 5.3. The musician Santocas. No date. Courtesy of ENDIPU (National Company of Disks and Publications).

mabela zole, a sturdy fabric the Portuguese marketed particularly to Africans in order "to differentiate them from the European women." Class and race combined to denigrate the material in the minds and imaginaries of those who had more means. Among the elite it was seen as the cloth of the poor and the rural. But de Castro's song lauded the material and, Lamartine notes, "since he praised it in one of his songs, naturally people became more conscious and today they wear it."[52] This fabric, like the practice of wearing panos, was reclaimed and reinterpreted outside the confines of metropolitan designs.

The club scene and the music scene were defined primarily by male prerogative. Historically, bands emerged in the musseques in association with the musical components of *carnaval* groups called *turmas.*[53] Although carnaval groups were composed of both men and women, and indeed women were quite central figures, the turmas were predominantly male. To a certain degree, the emergence of the music

Figure 5.4. The musician Urbano de Castro. From the cover of the CD *Reviver Urbano de Castro* (Produções Teta Lando, Luanda, 1998). Reprinted with the kind permission of Produções Teta Lando.

and club scene in the 1960s and '70s marginalized women as cultural producers, though their presence in the clubs and in musical lyrics attests to their continuing importance. Early bands which were not direct emanations of turmas were formed by groups of young men who knew each other from the neighborhood or school, and playing in a band was often and increasingly associated with winning female attention as the club scene grew. While female vocalists did exist, they were fewer in number and faced the prejudices of a society that associated female performance at clubs with prostitution. Hence, while male performers and male and female audience members donned the latest styles, female performers more commonly performed in panos or conservative female dress and eschewed social involvement in the club scene. By embracing local styles of dress, female performers guarded their reputations and made themselves representatives of the nation that did not trouble

social norms.[54] Male musicians, on the other hand, managed to elevate the status of musicians through the music's tremendous popularity and its association with the nation without having to strike more conservative social postures.[55] Thus the gendered meanings of nation and adornment played out somewhat differently for men and for women at the level of performance in clubs.

Dress in late colonial Luanda was a cosmopolitan practice in which people engaged to say something about who they were both as individuals and as a group. What seemed either innocuous or even a positive sign of acculturation to the colonial administration was actually radicalizing for Africans. The male youth generation of the 1940s to which Pinto de Andrade refers used dress to differentiate themselves from their elders, the colonial rulers, and the majority of the population.[56] Their style of dress was part of a larger set of practices and beliefs oriented by international trends but also oriented to and by their life in Luanda. They learned French, American, and Brazilian style from the films and popular culture of those countries. They dressed and coifed themselves in the image of film heroes both white and African-American in order to more clearly express who they were and how they were Angolan. By the 1950s those youth involved in the politico-cultural groups of the period dramatized the colonial politics of dress and refused the Manichean colonial vision meant to divide assimilados and indígenas. They embraced their education, their European-style dress, and their grandparents' dances and panos in the same gesture.

By the early 1960s politico-cultural groups were banned, European dress was the rule, and a cultural project intended to distract Africans from the war between the nationalist guerrillas and the colonial forces was in full swing. The cultural politics of dress were neither as stark as they had been just a decade earlier nor taken up as explicitly. With an influx of rural and young immigrants the bessanganas were a minority, and young women adapted panos for use with European-style dress that proclaimed an urban Angolan-ness. African dress was sometimes worn by musicians, and more frequently by female than male artists, but generally when they were performing in Portuguese clubs or for foreign dignitaries. However, to view this as "Europeanization" or a success for Portuguese rule would be a mistake. In the clubs and parties of the musseques international styles, particularly those of Brazil, France, and the U.S., were adopted and adapted. They were part and parcel of a musical culture that forged a unique style that was based both in the quotidian realities of the musseques and in the international flows of popular culture (film, music, dance, and dress). This assertion of angolanidade that was at once urban, African, cosmopolitan, and gendered inserted Angola alongside other clearly definable nations as one among equals in cultural terms. Despite the fact that the media was heavily censored and news about the nationalist struggle difficult to come by, these Angolans were engaged in a politics of the quotidian that radicalized them for and allowed them to find a place for themselves in the nationalist politics that were to come. Their self-styling and cultural, and sometimes economic, self-sufficiency gave them a lived experience of independence which made political sovereignty both imaginable and desirable. That this experience was gendered meant

not that the nation was not viable but that it did not mean the same thing for everyone.[57] Nationalist leaders who struggled from exile did not understand the implications of quotidian cultural practices in the musseques and were dismissive of the activities of those who had not left to take up armed struggle (who were in fact the overwhelming majority), while at the same time MPLA leaders, at least, depended on many of the young folks from this milieu, including Urbano de Castro and other musicians, to convince the musseques' population to support their party.[58] What both the MPLA (as well as the FNLA and UNITA)[59] and the earlier colonial government failed to recognize was that cultural practices were not just a distraction for the masses or an alternative organ of communication, but something which reordered and rearranged relations between those participating and the world around them.

Notes

1. Michel Laban, *Mário Pinto de Andrade: Uma entrevista* (Lisbon: Edições João Sá da Costa, 1997), 30–31. Translations from Portuguese are my own.
2. *Mais velhos* means elders, but not in the sense of village elders so much as anyone older than you who therefore deserves your respect. Pinto de Andrade was referring to the young men of his brother's generation, who were about ten years older than he was and whom he looked up to.
3. Laban, *Mário Pinto de Andrade*, 43.
4. Robin D. G. Kelley, *Race Rebels: Culture, Politics, and the Black Working Class* (New York: Free Press, 1996), 163.
5. Ulf Hannerz, "Sophiatown: The View from Afar," in *Readings in African Popular Culture*, ed. Karin Barber (Bloomington: Indiana University Press, 1997), 164. Hannerz sets up an opposition between a view of the world as a global mosaic (with distinct cultures, peoples, and territories: a view characteristic of the nation-state) and the global ecumene (seeing culture as collectively held meanings that are a part of social relationships that don't necessarily fit the boundaries of the nation-state).
6. Thomas Turino, *Nationalists, Cosmopolitans, and Popular Music in Zimbabwe* (Chicago: University of Chicago Press, 2000), 7, 10–11, 9.
7. Bob W. White, "Congolese Rumba and Other Cosmopolitanisms," *Cahiers d'étude africaines*, no. 168 (2002), special issue on world music, 681.
8. The term *angolanidade* emerges from a literary movement that arose in the 1950s and 1960s, primarily in Luanda. It was coined by the literary critic Alfredo Margarido in 1962 to describe what was distinct about this generation of writers and the nascent project they were engaged in. I use it here to mean "the quality of being Angolan" but remain conscious of the context (urban, cosmopolitan) in which the term was originally used. I would not, for example, suggest that the term is apt for describing anyone with Angolan nationality.
9. Eric Hobsbawm, *Nations and Nationalism since 1780: Programme, Myth, Reality* (Cambridge: Cambridge University Press, 1993), 10.
10. I take this idea of fragmentation from Partha Chatterjee's *The Nation and Its*

Fragments: Colonial and Postcolonial Histories (Princeton, N.J.: Princeton University Press, 1993).

11. Among the groups formed between about 1953 and 1960 were the Angolan Communist Party (PCA), the Party of United Struggle for Africans in Angola (PLUA), the Union of Angolan Populations (UPA), which later became the National Front for the Liberation of Angola (FNLA), and the Popular Movement for the Liberation of Angola (MPLA). The official date of the MPLA's founding is 1956 but this has been contested recently by a number of scholars, including Marcelo Bittencourt, *Dos jornais às armas: Trajectórias da contestação angolana* (Lisbon: Vega, 1999); Laban, *Mário Pinto de Andrade;* Carlos Pacheco, *Repensar Angola* (Lisbon: Vega, 2000); and Jean-Michel Tali, *Dissidências e poder de estado: O MPLA perante si próprio (1962–1977),* 2 vols. (Luanda: Editorial Nzila, 2001).

12. "Pronunuciados por actividades contra a segurança do Estado mais trinta e dois indivíduos na Comarca de Luanda," *Jornal ABC: Diário de Luanda,* December 18, 1959.

13. One of the people jailed, Liceu Vieira Dias, was among the group that Mário Pinto de Andrade was referring to in the quotation at the opening of this chapter. He was a public functionary (at the national bank) who was involved in clandestine political activities and had also started the band Ngola Ritmos, which was one of the first bands to self-consciously play popular Angolan tunes on local instruments. They transformed popular songs into a more danceable form, extending lyrics and enhancing the instrumentation so that they became less repetitive.

14. Responsibility for this attack was almost immediately claimed by the MPLA, although recent historical work has debunked this connection and pointed rather to Cônego Manuel das Neves, an Angolan Catholic priest who also served on the legislative council (an advisory council to the governor). See Bittencourt, *Dos jornais às armas,* 131.

15. Napalm bombings in Kassanje, murderous white militias in the musseques, and decapitation in the north were among the tactics used by the colonial government in repressing and redressing these revolts. See Douglas Wheeler and René Pélissier, *Angola* (New York: Praeger, 1971), 173–92.

16. Ibid., 186.

17. Gerald Bender, *Angola under the Portuguese: The Myth and the Reality* (Berkeley: University of California Press, 1978), 151.

18. Ibid., 150. Ironically, as Bender points out, many Portuguese immigrants could not meet these criteria.

19. Alberto Jaime, interview by author, December 4, 2001. (All interviews were conducted in Luanda, Angola.) Jaime told me that while a local military officer who was a friend of his mother's helped him to get an identity card (i.e., qualify as an assimilado), his brothers and sisters, with whom he was living, did not receive them until the changes implemented in late 1961 abolished the indigenato code and generalized Portuguese citizenship.

20. Bob White deftly discusses this phenomenon in relation to the popularity and influence of Afro-Cuban music in the Belgian Congo. See White, "Congolese Rumba and Other Cosmopolitanisms."

21. See, for example, "Folclore para turistas" (Folklore for tourists), *Notícia,* August 27, 1968, 8–11.

22. According to Domingos Coelho, "*o maximbombo do munhungo*" referred to the buses that had been retired from service in the central city to ferry Africans in the musseques. *Munhungo* means "prostitute," "and this was also a way to say that this bus was for the lowest level people, and (black) prostitutes were evidently a good example to portray that sector of the population." E-mail to author, April 6, 2003.

23. Albina Assis, interview by author, January 17, 2002.

24. Ana de Sousa Santos, "Aspectos de alguns costumes da população Luandense," *Boletim do Instituto de Investigação Científica de Angola* 7, no. 2 (1970): 55–71.

25. Ramiro Ladeiro Monteiro, *A família nos musseques de Luanda: Subsídios para o seu estudo* (Luanda: Fundação de Acção Social no Trabalho, 1973), 317.

26. Ibid., 316–18. For a photo see the article "'Tentação do subúrbio," *Semana ilustrada* 85 (February 8, 1969): 8–9.

27. Jacques Arlindo dos Santos, *Abc do Bê O* (Luanda: Chá de Caxinde, 1998), 211.

28. Ibid., 253–55.

29. Dionísio Rocha, interview by author, May 15, 1998.

30. José Redinha, "Angola terra de folclore," *Boletim cultural (repartição estatística, cultura, propaganda e turismo)*, July–September 1967, 57.

31. José da Sousa Bettencourt, "Subsídio para o estudo sociológico da população de Luanda," *Boletim do Instituto de Investigação Científica de Angola* 2, no. 1 (1965): 127; and Monteiro, *A família nos musseques de Luanda*, 363.

32. Carlos Lamartine, interview by author, September 4, 2001.

33. José Luandino Vieira, *Luuanda: Short Stories of Angola*, trans. Tamara Bender (London: Heinemann, 1980).

34. Assis, interview.

35. The February 4 attack on the Luanda prisons was timed to coincide with the presence of the international press in Luanda. The reporters were awaiting the arrival of the luxury liner *Santa Mária*, which had been hijacked by the Portuguese Henrique Galvão and was supposed to dock in Luanda. Galvão was a former government official who joined the Portuguese opposition to the fascist regime of António Salazar. According to John Marcum, Galvão did not support Angolan independence but wanted a different relationship between metropole and colony than that which prevailed under Salazar. The ship never arrived. The March 15 uprising coincided with a U.N. Security Council session on the question of the Portuguese colonies. See John Marcum, *The Angolan Revolution* (Cambridge, Mass.: MIT Press, 1969), vol. 1, 126–27; and Wheeler and Pélissier, *Angola*, 176.

36. Olga Baltazar, November 22, 2001; Luís Martins ("Xabanu"), November 21, 2001; and Abelino "Manuel" Faria, March 19, 2002; interviews by author.

37. Bettencourt, "Subsídio para o estudo sociológico," 95; and Fernando Mourão, "Configurações dos núcleos humanos de Luanda, do século XVI ao século XX," in *Actas do Seminário: Encontro de Povos e Culturas em Angola* (Lisbon: Comissão Nacional para as Comemorações dos Descobrimentos Portugueses, 1997), 206.

38. The clubs were not, however, totally anonymous spaces. Each club had its regulars and bouncers generally knew who had a reputation as a troublemaker or prostitute. Bouncers policed behavior, real and imputed, as much as dress.

39. Benedict Anderson argues that this sort of anonymity is what makes nations "imagined" communities, because we cannot possibly know everyone, yet "in

the minds of each lives the image of their communion." Benedict Anderson, *Imagined Communities* (London: Verso, 1991), 6.

40. Alberto Jaime, interview by author, December 12, 2001.

41. Chico Coio, interview by author, February 15, 2002; Faria, interview.

42. Favorite clothing stores included Dona Amália in Rangel and Gajageira in Marçal. A 1969 article in the popular urban magazine *Notícia* claimed that shopping there was "in style" among Europeans in Luanda. It was the people of the musseques who had given the store its name. "Babel do Trapo," *Notícia,* October 25, 1969, 34–41.

43. It is perhaps no coincidence that in the Angolan writer Luandino Vieira's work *A vida verdadeira de Domingos Xavier* (The true life of Domingos Xavier), the most politicized character we encounter is the tailor, who is involved in the nationalist struggle and is constantly educating his clients and others in the neighborhood about relations of power and exploitation.

44. Coio, interview.

45. Lamartine, interview.

46. Laban, *Mário Pinto de Andrade;* Lamartine, interview; "Xabanu," interview; Matumona Sebastião, interview by author, February 27, 2002.

47. Notable exceptions included Fernando Sofia Rosa, who wore a pano around his waist and went shoeless for his performances, as well as the band Ngola Ritmos, who sometimes wore panos and *missangas* (beads) around their necks in performances.

48. "Xabanu," interview.

49. I listened to, and examined the covers of, hundreds of albums at the music archives of the Rádio Nacional de Angola (the national broadcasting company) and electronically scanned twenty-three album covers from the period.

50. "Xabanu," interview.

51. The musician Teta Lando, who has his own production company and has pioneered in reissuing music from this period which had become unavailable, suggested that Urbano de Castro (along with other popular musicians like David Zé and Artur Nunes) was killed in the repression which followed the attempted coup in May 1977 not so much because he was involved with the coup plotters (though he may have been) but because he was the voice of the people and more well known and loved among musseque residents than the political leaders of newly independent Angola. Alberto Teta Lando, interview by author, May 6, 1998.

52. Lamartine, interview.

53. Jomo Fortunato, "A música tradicional na consolidação do semba," *Jornal de Angola,* February 14, 1999, Vida e Cultura section, 1–2.

54. In *The Nation and Its Fragments* Chatterjee discusses the ways in which the rights and roles of women, or the "woman question," are subordinated to the question of political independence in Indian nationalist ideology. See in particular chapters 6 and 7. See also Nira Yuval-Davis, "Gender and Nation," *Ethnic and Racial Studies* 16, no. 4 (1993): 621–32, on women as symbols of culture in nationalist ideology.

55. Female musicians tangled with the assumption that they were morally besmirched and male musicians with the stereotype of the irresponsible bohemian. And the former proved more entrenched than the latter.

56. Pinto de Andrade mentions that his sister dressed up like Carmen Miranda for

a performance at the Liga, but otherwise he does not mention female dress. For the most part, female urban residents would have dressed in the bessangana style or in European-style dresses, skirts, and blouses. It is difficult to find material (photographic, documentary, or otherwise) that speaks to the question of dress, male or female, in this period.

57. This would also be true along a number of other axes, such as urban/rural, generational, and racial.

58. See Tali, *Dissidências e poder de estado,* vol. 2. Tali does not specifically address the role of musicians but speaks rather of the critical importance of urban youth to the MPLA's success in Luanda.

59. The MPLA (Popular Movement for the Liberation of Angola), FNLA (National Front for the Liberation of Angola), and UNITA (National Union for the Total Independence of Angola) were the three main movements for independence. On the eve of independence they were reconstituted as political parties vying with each other for control of the new nation's helm. The MPLA unilaterally declared independence for Angola on November 11, 1975, just hours after having successfully defended the capital from an attack by FNLA troops in the north and South African troops (supporting UNITA) in the south.

6 "Anti-mini Militants Meet Modern Misses": Urban Style, Gender, and the Politics of "National Culture" in 1960s Dar es Salaam, Tanzania

Andrew M. Ivaska

> Here in town clothes make the man.
>
> —J. A. K. Leslie, *A Survey of Dar es Salaam* (1963)[1]

On Thursday, October 3, 1968, residents of Dar es Salaam awoke to front-page newspaper headlines announcing a bold new declaration by the Youth League of Tanzania's ruling party, TANU. As the *Standard* put it, "TANU Youths Ban 'Minis': Sijaona Announces 'Operation Vijana.'"[2] Announced by the general council of the TANU Youth League (TYL), this act prohibited the use of a range of items—mini-skirts, wigs, skin-lightening creams, tight pants or dresses, and short shorts—as "indecent," "decadent," and antithetical to Tanzania's "national culture." The ban was to take effect on New Year's Day, 1969, and would be enforced by members of the male-dominated TYL. The ambiguity of the "operation's" code-name, *vijana* (which means "youth," but frequently connotes young men), lent it a striking economy. For not only did it name "youth" as both the targets *and* the enforcers of the campaign, but it also hinted at what would be the gendered nature of the ban's enforcement—an all-male affair primarily directed against female "offenders."[3]

Although they were just one set of a raft of resolutions announced at the conclusion of the three-day-long TYL general council meeting, it was these "Cultural Resolutions" that grabbed the intense attention of the press. Nor did this attention prove fleeting, as Operation Vijana dominated public debate during the three months between its announcement and its launch. Even as Dar es Salaam's newspaper editors weighed in on the issue, their offices were flooded with letters and poems from readers articulating a range of positions on the ban. From October 1968 through January 1969, the opinion pages of *Ngurumo*, the *Standard*, *Uhuru*, and the *Nationalist*, the country's four leading dailies, produced a complex, multi-layered debate that was extraordinary in its scope and intensity. Debating Operation Vijana meant debating issues ranging from national culture, authenticity, gen-

der roles, and sex to concepts such as *heshima* (respectability), *uhuni* (indecency, immorality, vagrancy), youth, and the modern. All told, between October 3, 1968, and February 1, 1969, over 150 letters, 16 poems, and 19 editorials—not to mention over 50 news items—concerning Operation Vijana appeared in Tanzania's press.

Engagement with Operation Vijana was not, however, confined to the press. Within four days of the TYL's announcement, Tanzania's Field Force Unit, or riot police, was called to the Kariakoo bus station (one of Dar es Salaam's main transport nodes) to control "gangs of [male] youths" who were "harassing all girls wearing mini-skirts or tight dresses."[4] These young men—some of whom were witnessed boarding buses and pulling "indecently dressed" young women off for beatings—were eventually dispersed with tear gas.[5] Denying that TYL members took part in this violence, which came months before the ban was to take effect, a TYL spokesperson said he was not surprised "if the youth found the deadline too far away for them."[6] As the deadline approached, after weeks that saw several attacks on "indecently dressed" women reported, posters appeared about the capital depicting models of proper and improper dress for women and men. The TYL, which had organized the canvassing, also held a press conference at which top leaders of the league displayed more examples—stylized sketches this time, rather than photos—of "decent" and "indecent" apparel.[7] On New Year's Day, 1969, "Operation Vijana" was launched in Dar, with five hundred male Youth League members selected as the enforcers of the ban. Outfitted with walkie-talkies to communicate with TYL headquarters and thirty centers of operation across the capital, the cadres patrolled streets and offices on the lookout for offenders.[8] By the second week of January the campaign was being heralded as a success by TYL leaders and supporters, but this "success" appears to have been, at best, short-lived. Within the year, "indecent dress" was back on the streets of Dar es Salaam, provoking at least two more campaigns to ban it (in its ever-mutating forms) in the early 1970s.[9]

This essay begins by situating debates over Operation Vijana within a bundle of intersecting historical contexts that I suggest are important to understanding the campaign. Keeping these historical contexts in mind, I then proceed to tell two overlapping stories of Operation Vijana. In the first, I consider the campaign in the context of TANU's project of "national culture" and explore ways in which some fundamental terms of this project—in particular, notions of "the modern"—were contested by Tanzanians opposing Operation Vijana. In the second story, I situate the controversy over the ban at the intersection of anxieties over women's work and mobility in urban space, and the politics of sex in Dar es Salaam. Arguing throughout that "the city"—both as an imagined space and as the site of particular social struggles—was central to Operation Vijana, I chart attempts to fashion viable urban personas and the limits of these attempts. Each of the two "stories," I argue, captures something essential about Operation Vijana. For if the ban was conceived within a framework of national cultural planning, its social life was quite another matter. On the streets and in the press, this campaign quickly became a site for both challenges to "national culture" and the battling out of social conflicts (most prominently around gender) in which far more than national culture was at stake.

Figure 6.1. On the eve of Operation Vijana, TANU Youth League officials display for the press some examples of "indecent" dress. From left to right are Brigadier Rajabu Diwani, Minister L. N. Sijaona (TYL chairman), Joseph Nyerer (TYL secretary-general), and Moses Nyauye (TYL deputy secretary-general). Unidentified photographer, *Standard*, December 30, 1968.

Some Postwar Contexts: Migration, Work, Gender, and "National Culture" in Dar es Salaam

After decades in which migration in colonial Tanganyika had been primarily rural-rural in nature (and linked largely to sisal plantation labor), the early 1950s saw migration to the cities rise steeply, beginning an urban population boom that was to last for decades.[10] Receiving a disproportionate number of these migrants, Dar es Salaam's population nearly quadrupled between 1947 and 1967, but the provision of jobs, housing, and social services lagged far behind this population growth—and, importantly, failed to keep up with a significant expansion in primary schooling—under both colonial and postcolonial rule. Although in the colonial period, and even during the 1950s rural-urban migration boom, most of those moving to town were men, the 1960s saw a sharp rise in the proportion of women among the migrants.[11] This trend not only significantly changed the demographic character of urban areas, it also made possible new kinds and intensities of gender conflict in town.

While the shortage of jobs in Dar es Salaam continued through the 1960s and affected both women and men, life in the capital may have fulfilled women's aims

and expectations in moving to town somewhat better than it did those of men. There is growing historical evidence, both from Tanzania and from research on other African contexts, to suggest that women's motives for, and expectations and experiences of, rural-urban migration differed considerably from those of men. New arrivals in town were overwhelmingly young, regardless of gender, and scholars have long suggested that a primary motivation for migrating was to circumvent the control that elders in rural areas held over marriage options. But if for young migrant men the dream was to quickly earn a cash dowry and return, respected and admired, to the village to marry on their own terms, for many young women "migration [was] seen as an end in itself": an attempt to take more permanent advantage of the opportunities for autonomous accumulation that the city seemed to offer.[12] For Dar es Salaam's newly arrived female migrants, of whom an increasing number were unmarried and had some schooling,[13] there were a range of such opportunities—from "informal" work like street hawking, small trade, beer brewing, and domestic employment;[14] to niches in wage employment—secretarial work, for instance—that had been male preserves in the colonial period;[15] to relationships with men—including sex work, provision of the "comforts of home" to regular clients, non-marital cohabitation, and cultivating multiple lovers who helped pay the rent—that offered young women a greater degree of social and economic autonomy than could be gained through formal marriage and were said by a contemporary observer to have "raised the bargaining position of women in the town."[16] This is not to suggest that most women in Dar es Salaam were well off, or earning a wage, or building futures free from male-dominated social structures. What I do suggest is that, if one compares the aims, expectations, and outcomes of rural-urban migration for men and women, urban life afforded *relative* gains for young women that it did not afford for their male counterparts, whose "frustration" was frequently noted by contemporary observers.[17]

State responses to the challenges posed by Dar es Salaam's rapid population growth were characterized by striking continuities between the 1950s and the early 1970s, as the postcolonial nationalist government took charge. Long wary of the presence of "detribalized" Africans in urban areas, the colonial state had pursued a dual strategy of cultivating a "stable" and "respectable" urban working class, on the one hand, and attempting (without great success) to forcibly "repatriate" the urban jobless to the rural areas, on the other.[18] Dominated by a nationalist elite that shared with colonial officials a vision for developing a modern, orderly capital, the postcolonial state continued efforts to evict "unproductive" "*wahuni*" (hooligans, vagrants, undesirables) from Dar es Salaam. In the course of the 1960s—and particularly after the 1967 Arusha Declaration—these efforts were buttressed by a state ideology valorizing the rural as the appropriate sphere for the performance of Tanzanian citizenship. The articulation of both this rural ideal and the foil of a "decadent" city against which it was conjured were key features of the official project of "national culture" launched by President Nyerere in 1962 and pursued in earnest through the 1960s and 1970s. Combining a mandate to nationalize "tribal tradition" with an increasingly explicit goal of ensuring that the resulting "national culture" would be a "modern" one, the project was also constituted *against* a set of

Figure 6.2. Young "Green Guards" bearing *jembes* (hoes) march in formation at the 1968 National Youth Festival. Unidentified photographer, *Standard,* February 6, 1968.

"decadent" cultural forms that included not only the fashions targeted in Operation Vijana, but also soul music, beauty contests, and racy films and magazines. Mostly unsuccessful in eradicating them, campaigns against such forms were nonetheless crucial for the portrait of the city they painted: a site of spoiled femininity and decadent consumption, the ugly foil against which *ujamaa*'s productive, rural idyll could emerge.[19] ("Ujamaa" literally means "familyhood," but President Nyerere used it to designate his version of "African socialism.")

The historical dynamics sketched out above—booming migration, shifting job opportunities, women coming to the capital and claiming public space in new ways, an energetic state initiative to construct urban ills as cultural ones—all portray a Dar es Salaam that in the late 1960s was in the midst of considerable social change. If this was the context within which Operation Vijana was launched in October 1968, then the heated debate over the campaign showcases the way that fashion encapsulated and became a battleground for the social struggles brewing in the city. The TYL sought to portray the ban as a matter of national culture. But in the debate that gripped the capital, significant challenges to dominant notions of national culture emerged, even as discourse on the operation spilled out beyond TYL's framing of the campaign to engage issues of urban respectability and sexual politics in Dar es Salaam. I now turn to examine this complicated debate, focusing first on the ban's contested framing as a matter of "national culture."

"There Is Nothing Modern about Mini-skirts": Operation Vijana in a National Cultural Frame

From the moment of its official announcement, TYL leaders sought to portray Operation Vijana as a measure "aimed at defending Tanzania's culture."[20] But as debate over the ban heated up in the letters-to-the-editor pages and editorial columns of Dar's press, this portrayal was repeatedly challenged. The *Standard,*

Dar's semi-independent English-language daily with a readership estimated at fifty-one thousand in 1967, received 108 letters concerning Operation Vijana in a mere sixteen days before the editor closed the correspondence—only fourteen of these supported the ban.[21] Much more than was the case in the Kiswahili press, which we will consider below, the debate in the *Standard* did indeed focus to a great degree on national culture. But if the *Standard*'s correspondents largely debated the campaign as the TYL had framed it—as a national cultural matter—their debate featured important challenges to notions of the "modern" and "youth," categories that were central to TANU's project of socialist modernization.

TYL leaders and ban supporters often based their charge that fashions like miniskirts, tight trousers, and wigs were undermining Tanzania's culture on the contention that such items were foreign in origin. Opponents of the ban contested this logic, suggesting that it was futile to attempt to condemn banned fashion as "imitation" of foreign culture, since all mass-produced commodities (including many that were upheld by TANU itself as good and useful) were originally "foreign." As one put it, "Unless they [the TYL] want to see Tanzanians going naked, they should believe me that we have no fashion in Tanzania which is acceptable as originating from this country. . . . Whatever we choose as our national dress, we shall be deceiving ourselves."[22] Several letter-writers took jabs at the types of dress displayed at state spectacles, with some correspondents arguing that some "traditional" costumes featured in the national dancing troupes were just as revealing as miniskirts, and others suggesting that the TANU elite themselves increasingly favored a "foreign"-inspired sartorial style epitomized by what was popularly known as the "Chou-en-Lai" suit.[23] But what drew the most comment on the perceived official hypocrisy was the comparison of Operation Vijana with "Operation Dress-Up," a TANU campaign held earlier in the year to mandate "modern dress" for Tanzania's Maasai.[24] As one letter-writer, R. N. Okonkwu, argued,

> If they want us to preserve our culture why don't we put on "Rubega" and go half naked as our great grandfathers used to do. Because all the clothes we are putting on now is [*sic*] foreign culture. Moreover, if they want to preserve our culture why are they telling the Masai tribesmen to stop going half naked and put on modern dress like trousers?[25]

Juxtapositions of Operation Vijana with Operation Dress-Up are important to consider closely, for they shed light on the criteria by which the state's makers of cultural policy were evaluating dress and the ironic continuities of such criteria with earlier colonial and missionary initiatives in Tanganyika.[26] Official discourse surrounding Operation Dress-Up consistently decried the "unhygienic," "uncivilized," and "outdated" nature of "traditional" Maasai dress and body-care, which it saw as an affront to Tanzania's "modern development." As an editorial in *Nchi Yetu*, a government journal, declared at the height of the campaign, "Walking around half naked and smearing oneself with mud and ghee, carrying a club and a spear are not at all part of the development plan."[27] Indeed, Maasai wearing "traditional" dress and women in miniskirts were often described in strikingly similar terms: "roaming half-naked," the Maasai with their "buttocks showing," the mini-

skirted women with their "thighs exposed."[28] If in one sense, then, as many of Operation Vijana's opponents noted, the two campaigns were strangely paradoxical, they were also both driven by a single aesthetic ideal of "modern decency" that had its roots, in part, in the mission-school culture within which Tanzania's political elite of the 1960s had largely come of age. Conceived in the heady wake of the Arusha Declaration, campaigns such as Operations Dress-Up and Vijana were part of the modernizationist face of the national cultural project, and not of a "back-to-tradition" endeavor. In an editorial in the party press backing Operation Vijana, a political scientist working at the University of Dar es Salaam put it in no uncertain terms: "Tanzania's goal is to create, in the least possible time, a modern African society."[29]

The premium placed on the "modern" was by no means confined to the discourses of Operation Vijana's supporters. Indeed, letters by opponents of the ban were full of references to the desirability of keeping up with the "modern changes" in a world that "as time passes . . . improves and becomes sophisticated."[30] "We are Tanzanians of 1968 and not Tanzanians of 8000 B.C.," declared one Peter Tweedy.[31] Correspondents' satirical challenges to TYL leaders to enforce a "return" to "bark-cloth" if they were really serious about ridding the country of foreign influences depended upon the assumption that no one really wanted to see Tanzanians walking the streets of Dar es Salaam dressed in such clothing, which was widely seen as a remnant of the past at odds with city life in a modern Tanzania.

But if the supreme desirability of "being modern" in 1968 Dar es Salaam was common sense, securely in the realm of the hegemonic, the debate over Operation Vijana reveals just how unstable and contested was the notion of the "modern" itself. In sharp contrast to those condemning miniskirts, tight trousers, cosmetics, and wigs as affronts to "modern decency," many opposing the campaign insisted that such fashions were eminently "modern." J. N. Mbussa, a TYL member disappointed with the ban, commented, "Most slender men prefer slimline trousers to big and loose trousers (bombos) simply because they look smart in them. . . . Girls also prefer mini-skirts to long gowns, just because they look more modern, attractive and beautiful."[32] Isaac T. Ngomuo, a secondary school student, echoed this: "Nowadays almost everybody has developed the attitude of preferring tight-fitting clothes to others because we look smarter in them."[33] While TANU imagined a model citizenry committed to "modern" nation-building along socialist lines, letter-writers opposing Operation Vijana articulated a notion of "being modern" linked, rather differently, to an imagined network of "international fashion" and (differently) "revolutionary" youth styles associated with the happenings of 1968. Ngomuo declared, "The current youth is well aware of the fashion revolution taking place in many countries. . . . What is widely practiced by many other peoples is also good for us."[34] Many letter-writers explicitly extolled the virtues of "keeping up" with the latest styles, with the comings and goings of "this . . . fashion age."[35] "Django," for instance, complained, "Why then has the Youth League suggested its unwanted styles of dress. Usually people prefer the latest models of everything. This is the century for minis, slack trousers, Texas costume, etc. . . . Not many

people will like to put on gowns, wide trousers, etc. in this day. Such fashion has lapsed."[36]

In statements such as these, a vocabulary extolling modern progress became unmoored from its associations with the national, state-centered vision of development through "hard work" laid out in the Arusha Declaration, and instead was attached to international cultures of self-fashioning through body-adornment and consumption that the state was keen to label "decadent." The responses of TYL leaders and Operation Vijana's most ardent supporters to this semantic challenge (a challenge to what was arguably the central category for the legitimacy of the developmentalist state, not to mention TANU's national cultural project) suggest that they took the challenge seriously indeed. Architects and promoters of Operation Vijana were at pains to repeatedly argue that the claims to "being modern" made by those displaying banned fashion were patently false. Andrew Shija, the TYL branch leader at the University of Dar es Salaam, declared that indecent dress was being paraded "under the cover of modernism," a characterization echoed by another supporter, who called the banned fashions remnants of a "false imperialist modernism."[37] But the point was made most forcefully by Okwudiba Nnoli in an editorial in TANU's Nationalist. Titling his piece "There Is Nothing Modern about Mini-skirts," Nnoli wrote, "The problem as far as the controversy is concerned is the nature of a modern society especially as those who wear mini skirts tend to assume that by doing so they are modern."[38] I suggest that modernity here does not describe a particular social formation or condition; rather it is best regarded as an idiom through which Tanzanians were articulating and defending particular kinds of social selves and political claims.

The identities being articulated—and indeed embodied, on the streets of Dar—by opponents of Operation Vijana were all the more disturbing to the state, I argue, because embedded within them was the performance of a young, urban style that suggested relationships between youth and both the city and the state that were at odds with those envisioned by TANU and its Youth League. Mocking TYL leaders as "old gentlemen who pretend to be youths," letter-writers identified themselves with new vocabularies—"teenagers," "real youths," "unaged youth"—thereby reappropriating youth as an oppositional, and not a TYL-vanguardist, category. In contrast to a model citizen-youth embodied by the TYL cadre evacuating the capital for a new calling in healthy rural production, Dar's new "teenagers" claimed a "right" to fashion selves out of the very signs of leisure and display through which official discourse defined the city as a problematic and ideologically suspect space.

This struggle over the ability to define urban space and personas only begins to hint at the centrality of the city to the Operation Vijana episode. As we turn our focus to the patterns of gendered discourse and violence that erupted in the wake of the campaign's announcement, we will see that, in some quarters, struggle over the ban focused less on "national culture" and rather more on questions of gender relations and sex across a charged urban landscape. Like the debate in the Standard, however, discourse in Dar's Kiswahili press—and particularly in the semi-independent daily Ngurumo—illustrates the way in which people targeted by Operation

Vijana's assault upon particular (life)styles exploited openings in official discourse to renegotiate and sustain identities and lives in the city.

"A Wife Resembles Town": Gender and the City in Operation Vijana

Reminiscing in 1984 about Operation Vijana, veteran Tanzanian journalist Hadji Konde recalled that while the ban had generated much debate in the country's letters-to-the-editor pages, *Ngurumo* had published "only three" letters on the campaign.[39] But while he was correct about one thing—that the debate in *Ngurumo* was markedly different from the one hosted by, say, the *Standard*—Konde was forgetting the dozens of letters, poems, editorials, and cartoons engaging the controversy over dress that appeared in *Ngurumo* in the weeks and months following the announcement of Operation Vijana. Few of these interventions—and of those published in the Kiswahili press more generally—featured explicit debate over "national culture" or "foreign" influence. Instead, correspondents used Operation Vijana, and the attendant focus on women's bodies and clothing, as an opportunity to air profound anxieties about women, sex, work, and mobility in Dar es Salaam. While similar anxieties were long-standing, they were taking on new inflections with the changing face of Tanzania's capital in the late 1960s.

The banned fashions—and particularly women's "indecent" dress—were signs that had long stood for the city. But in the late 1960s, with the Arusha Declaration's inscription of town and country life into a narrative of the battle between the virtuous and the fallen, certain new elements of this association emerged. Several supporters of Operation Vijana connected banned fashion to a perceived crisis of rural-urban migration. Mohamed Jeuri, for instance, argued that instead of "coming to the city in search of entertainment," fans of "*nguo za kihuni*" (immoral or indecent clothing) should be "back" in the villages working the land.

> Can a person like that really become a revolutionary? If she is told to return to the *shamba* [farm] to build the Nation, even if only for a day, will she agree? . . . Where will she put those wigs, fingernails and tight dresses? . . .
>
> And not only that . . . if a woman or man wears so-called modern clothing and goes home to the *shamba,* without a doubt s/he will tempt his or her friends and family greatly, make them regard the *shamba* as not a good place for life; and then they in turn will come to the city to look for that very life. Without knowing it they find themselves extremely oppressed by such a little thing: "*Taiti*" [tight clothing]. In this way, women sell their bodies and men find themselves with the job of ambushing people at night . . . so they can get at least one pair of tight trousers to show off to those they left back on the *shamba*.[40]

As the controversy over Operation Vijana raged, the official press began to supplement its coverage with short stories that focused on the seductive dangers of town and highlighted the role of fashion in accomplishing the seduction. One such story, titled "I'll Never Stay in Town Again," told the tale of Kamili, a young country lad plagued with "*tamaa ya kufika Dar*" (the [very visceral] desire to reach Dar es

Salaam). He ends up making the journey to the capital only to be seduced by a fashionably dressed woman who takes all his money. "What a catastrophe!" cries Kamili, as he recites the moral of the story: "I'd better head back up-country, begin farming in an *ujamaa* village, and start being self-reliant!"[41] The ease and economy with which a miniskirted woman could visually conjure up the relationship between a city of decadent, feminized consumption and a countryside of national productivity is made even more clear in a cartoon published in *Ngurumo* in the late 1960s or early 1970s. It portrayed a woman carrying a handbag and wearing a short dress decorated with *jembes* (hoes), smiling and saying, "Jembe! I can wear it, but I won't wield it!"[42]

In addition to being closely associated with the city, banned fashion also conjured up specific urban characters, particularly female ones. Chief among these was the prostitute. *Ngurumo*'s main page-one story describing the first two days of Operation Vijana's official enforcement proclaimed, "Whores and Undesirables Mind Their Manners."[43] One letter-writing supporter of the campaign asserted that the ban had been imposed by TYL "to mark their anger at the prostitution being installed by some young ladies who are also members of UWT" (TANU's women's wing), and that TYL cadres "must be prepared to cut out the minis not only from Kariakoo but even from the hotels where many are harbored." The letter concluded, "We cannot import culture by promoting prostitution."[44] "Barmaids," generally thought to be engaged in sex work, were a common target of dress-code attacks, even before Operation Vijana was announced. In March 1968, for instance, the press reported the "stoning" of a barmaid on her way to work by a "mob [of] youngsters" who were "apparently incensed at the shortness and tight fit of her mini-skirt."[45]

This association of "indecent" fashion with the figure of the prostitute also had a long history in Tanzania. What Operation Vijana reveals, however, are the ways in which this association was being complicated in the context of a late 1960s Dar es Salaam marked by the shifting political economy of gender and work outlined early in this chapter. For in discourse around the ban and the ensuing physical attacks on women in Dar, the miniskirt and taiti also stood for other urban "types" and tropes: the secretary, the schoolgirl, the girlfriend of the "sugar daddy." These were ambiguous figures, which, while often conflated with that of the prostitute, were also subject to struggles to define new and viable—sometimes even respectable—urban identities for women.

If one maps out the numerous reports of physical attacks on, and discursive condemnation of, women accused of wearing banned dress in the months between Operation Vijana's announcement and its official launch, a patterned geography emerges, focused on specific spaces and sites: hotels and bars (as we have already seen), but also buses and bus stations, downtown streets and offices, and the university. In an editorial on the ban, *Ngurumo* asserted that the "problem" of banned dress manifested itself "especially [among] girls who are working in offices, and a few others . . . who are in various income-earning positions."[46] For its part, the University of Dar es Salaam was a major site for confrontation over Operation Vijana, witnessing a clash between a demonstration supporting Operation Vijana

staged by the campus TYL branch and a "counter-protest" of female students defiantly sporting banned clothing in front of their residence hall. The all-male TYL demonstration had targeted the women's dormitory, and alongside banners condemning "indecent" dress in national cultural terms ("Minis for decadent Europe," for example), the marchers held aloft placards apparently threatening specific women: one read, "Two devils in Hall 3, your days are numbered."[47] But in the geography of confrontation over Operation Vijana, bus routes, bus stations, and downtown streets were particularly, and violently, charged. The attack on women and girls alighting from buses at Kariakoo may have been the first and biggest of the collective attacks (the *Standard*'s reporter dubbed it the "Dar riot"), but several similar scenes—of young women being pulled from buses, or chased down a city center street, and stripped by a group of young men and boys—were reported in the press as the debate over the operation raged. Of the stories of physical attacks reported between September and February, nearly every single one featured the urban workers' commute as its setting.

These spaces, sites, and associated "types" all represented female accumulation, mobility, and autonomy, and it was a geography that was the focus of a great deal of anxiety on the part of many of Dar es Salaam's young men. In the midst of the controversy over the campaign, one S. S. Tofiki of Dar published a poem pointing to demographic statistics as cause for his alarm over women's mobility in town. Referring to women who "roam about" instead of "staying inside," he wrote,

> The census came around, and they increased in numbers,
> I started thinking, and crunched the numbers,
> How have you all gone wrong, failing to stay inside?
> What defect do you have, for your husbands to refuse you?[48]

Another letter-writer, "Socialist," explicitly interpreted the attack on women's dress as evidencing anxiety about women's work and autonomous consumption. "Inside the minis and under the wigs," "Socialist" wrote, "are people with education and intelligence, able to hold down good jobs (sometimes in competition with men), with money of their own to spend, and their own ideas of how to spend it."[49]

But particular kinds of clothes were not only the signs of particular women's accumulation and consumption, mobility and autonomy—banned fashion was also regarded as a catalyst for these phenomena, which many young men in Dar saw as socioeconomic "exploitation" of men by women. As one D. Chokunegela complained in a poem published in *Uhuru*,

> You'll see Bibi Siti, with her basket in her hand,
> Her body clothed in a *taiti*, seeking *Uzunguni* [the wealthy, formerly white area of Dar],
> Pulling cash, from John and Damian,
> As for me, I congratulate the Resolution of the Youth.[50]

This accusation, that those who wore miniskirts or taiti were doing so in order to gain access to men and their money, was leveled frequently and angrily by young men in the debate. As one letter-writer put it, "I must condemn the minis from

start to end. Ladies have to be guided as these young girls surely love the minis for gaining market; one dressing thus will win everybody."[51] Echoing this vocabulary, one letter to the *Nationalist* complained, "our young girls become crazy and the happiest when putting on such kind of dress because they are gaining a market."[52]

Anxieties over young women's "gaining market"—an idiom with connotations of capitalist accumulation and illicit gain that were particularly charged in the wake of the Arusha Declaration's declared war on "all types of exploitation"[53]—were particularly professed by, and ascribed to, male TYL members and male university students. (Indeed, these two categories of people appear to have been the ban's staunchest supporters.) One opponent of the ban charged that TYL leaders and their cadres were jealous, for they "are the very ones who desire the *taiti*-wearers, and as soon as they fail to get them, they look for an underhanded way to take out their anger by forbidding them from wearing [these things]."[54] As for the students, we have already seen that the struggle on campus over Operation Vijana featured male students making angry threats against particular women. I suggest that this anger, and the campus politics surrounding Operation Vijana, related directly to what was perceived by male students as intense competition between themselves and wealthier, older men for sexual relationships with female students on campus—competition in which the male students saw themselves as being at a tremendous economic disadvantage compared to these "sugar daddies."[55]

Thus the office worker, the female undergraduate, and the girlfriend of the "sugar daddy," figures conjured up in public discourse by the sign of banned fashion, were all consistently conflated with the figure of the prostitute. All were represented as being in positions particularly ripe with possibilities for gaining access to men and their money through sex. But in the context of changes in demography and work in Dar es Salaam, this conflation was also unstable. Indeed, public discourse around Operation Vijana featured attempts by some women to reclaim figures linked with banned fashion as viable urban identities. Some of these attempts followed a UWT line that sought to celebrate women's entrance into formal wage labor as a sign of Tanzania's modern progress, while condemning practices like the wearing of miniskirts in much the same terms as the TYL: as "indecent" assaults on respectability under the guise of modern fashion.[56] In an installment of one women's advice column called "Bibi Mapinduzi Asema" ["Mrs. Revolution says"] (which was tellingly inaugurated in *Ngurumo* during the Operation Vijana controversy and featured exhortations against banned fashion), Bibi Mapinduzi herself attempted to distinguish the office-working woman from the prostitute. Taking readers on a virtual tour of downtown Dar es Salaam in which she mapped out a geography of women's burgeoning paid work, Bibi Mapinduzi marveled at the "beautiful image of our . . . well-dressed girls emerging from offices with their purses," and continued, "I didn't know that we had this many women working in government and company offices." Writing pointedly that the majority of these women were "very well-dressed and moved respectably," Bibi Mapinduzi also lamented that their reputations were being tarnished by "certain women who were [recently] arrested for roaming the streets, in hotels and in bars for reasons best known to themselves." These latter women, she said, "don't like real work," and

should be forced "to leave town, to stop stealing people's husbands, and to go back to the *shamba* to farm."[57]

If the UWT leadership, and other prominent women in high political office, took a position promoting public roles and work for women while attacking banned dress,[58] some young women (and a few men)[59] sought to reconcile the two. In October 1968, at the height of the debate over Operation Vijana, the vice president of the UWT met with a group of "girls"—non-UWT members—at their Dar es Salaam hostel to discuss their concerns. In the "heated discussion" that ensued, the "girls" not only "said it was unfair that a body of men should sit down and decide what women should wear," but they also explicitly justified the wearing of "shorter dresses." "Modern style dresses were cheap and suited to town living," the young women told their distinguished visitor. According to the *Standard,* "One girl said that as a secretary she had to do a lot of walking about and shorter dresses made this easier. She said that if she wore long national dress she would not be able to push her way on to crowded buses which she had to do every day."[60]

Statements like these illustrate attempts by working women to subtly reclaim banned fashion by reinscribing it as practical, appropriate, and respectable for new patterns of work and movement in new urban spaces. More difficult to perform in a public discourse dominated by deep suspicion of female sexuality were attempts by women to celebrate banned fashion as a site of female pleasure. One woman referred, rather obliquely, to the capability of fashion to heighten "womanish feelings" that Tanzanian women, "like any other women," had.[61] Another quoted a saying she had "once read somewhere" that "'a woman's dress is like a garden-gate, which protects the property without blocking the view,'" even as she framed her enjoyment of banned fashion safely within the bounds of her marriage and her husband's gaze.[62]

Attempts like these to de-link banned fashion from its association with female accumulation through sex faced in Operation Vijana an attempt to reconflate the figure of the prostitute with figures like the secretary, figures that challenged the operation's stigmatization of particular body-markings. For many of Dar's young men failing to gain the access to resources (and women) that fantasies of city life promised, Operation Vijana promised to eliminate what was seen as a central tool of women who placed themselves out of their material reach. For those participating in attacks on women and even in the TYL-led enforcement of the ban, the campaign provided an opportunity to enact sexualized performances of power over those women in the very spaces that were deemed to provide the conditions of possibility for female accumulation, mobility, and occasional autonomy. In this way, the young male rage generated around what was ostensibly a national cultural issue was intimately related to intersecting anxieties about women in urban space and the politics of sex in a post–Arusha Declaration Dar es Salaam.

Operation Vijana was launched as one of the first of what would be several national cultural campaigns targeting urban "popular" cultures in Tanzania in the late 1960s and early 1970s. And yet, in the way it was seized upon, enforced, and debated by residents of Dar es Salaam, two things happened. First, some fundamental assumptions and vocabularies upon and through which "national culture"

Figure 6.3. Cartoon portraying a woman being scolded by an older man, against the backdrop of the city, on the eve of Operation Vijana. The original caption read, "Asha, what kind of Shameful dress are you wearing? I swear you'll regret it when that day [Operation Vijana's launch] comes!!" "Aaaa . . . step aside old man. Don't bring me any trouble, four eyes." Artist unknown, *Nchi Yetu*, November 1968.

was constituted became contested, albeit within limits that demonstrate just how hegemonic were certain hierarchies of value. If the supreme value ascribed to "being modern" was one such hegemonic notion, rooted firmly in the realm of the commonsensical, its conceptual content was far from stable; and the "modern" of the state that underwrote TANU's nation-building projects was challenged by another "modern," one defined through cosmopolitan associations quite different from TANU's own invocations of socialist internationalism. Secondly, Operation Vijana tapped into anxieties among many of Dar's (often jobless) male youth about new patterns of women's work, sexuality, and mobility in urban space. Such anxieties not only coincided with, and reinforced, the uneasy position of the city—depicted as a disturbing site of decadent consumption and femininity—within a state ideology that valorized the rural as the site of austere hard work; they also fueled the enforcement of the ban, with all its attendant rage and violence against Dar's "new women."

Operation Vijana—and, I suggest, other national cultural banning campaigns that, like it, targeted urban areas—cannot be understood simply in a national cultural frame, without considering various "struggles for the city"[63] that were fundamental to the directions these campaigns took. Conversely, Operation Vijana and, quite possibly, other similar campaigns were appropriated as important sites upon which such urban social struggles—in our case, around gender and generation—could be fought out. As visual signs, fashions like the miniskirt in late sixties Tanzania were extraordinary indices of social conflict, registering debates over national culture and "modern development," the construction and crises of new femininities and masculinities, generational conflicts over resources, and contests over public space in a postcolonial capital. Moreover, what makes fashion such a powerful lens through which to view these struggles is that it highlights intersections between them, making it impossible to regard them as unconnected, discrete dynamics.

Notes

This essay is an abridged and slightly revised version of my article of the same title published in *Gender and History* 14, no. 3 (2002). The title is taken from an article in the *Standard*, October 17, 1968. Funding for the research project on which it is based was provided by the International Dissertation Field Research Program of the Social Science Research Council (with funds from the Andrew W. Mellon Foundation) and a U.S. Department of Education Fulbright-Hays Doctoral Dissertation Research Abroad Fellowship. The project has benefited immensely from discussions with Frederick Cooper, Nancy Rose Hunt, David William Cohen, Kelly Askew, Delphine Mauger, Jim Brennan, Andrew Burton, Leander Schneider, and Ned Bertz. I gratefully acknowledge the further insight and encouragement of Jean Allman, Carole Turbin, Shani D'Cruze, and an anonymous *Gender and History* reader. All shortcomings remain the author's alone.

1. J. A. K. Leslie, *A Survey of Dar es Salaam* (London: Oxford University Press, 1963), 110.

2. *Standard,* October 3, 1968.

3. *Uhuru,* October 3, 1968; *Ngurumo,* October 3, 1968; *Standard,* October 3, 1968; *Nationalist,* October 3, 1968. All translations from Kiswahili are the author's own.

4. *Standard,* October 8, 1968.

5. *Standard,* October 8 and 24, 1968; *Ngurumo,* October 9, 1968; *Uhuru,* October 9, 1968.

6. *Standard,* October 9, 1968.

7. *Standard,* December 29 and 30, 1968; *Nationalist,* December 30, 1968. "Decent" dress included modest collared shirts and slightly baggy trousers, "maxi" dresses, socialist-style suits inspired by Mao, Chou-en-Lai, and Kaunda, and dress common in coastal Dar, such as the Islamic-inspired *kanzu* and *bui-bui,* and the *khanga.* "Indecent" dress included, for men, tight "drain-pipe" trousers and cowboy-inspired outfits ("Texas costume"), and for women, tight "slim-line" dresses and, most notoriously, the miniskirt.

8. *Standard,* January 2, 1969; *Nationalist,* January 2, 1969.

9. *Standard,* January 5, 8, and 10, 1969; *Nationalist,* January 3, 1969; *Nchi Yetu,* April 1981. Campaigns against "indecent" dress were also launched in the late 1960s and early 1970s in Zanzibar. For an analysis of the Zanzibari campaigns, see Thomas Burgess, "Cinema, Bell Bottoms, and Miniskirts: Struggles over Youth and Citizenship in Revolutionary Zanzibar," *International Journal of African Historical Studies* 35, nos. 2–3 (2002): 287–313.

10. Because of space constraints, I can only briefly sketch out these historical contexts here. For a more comprehensive treatment of them, see my longer version of this article in *Gender and History* 14, no. 3 (2002): 584–607.

11. R. H. Sabot, *Economic Development and Urban Migration: Tanzania, 1900–1971* (Oxford: Clarendon, 1979), 43–50, 71, 142, 90.

12. Kenneth Little, *African Women in Town: An Aspect of Africa's Social Revolution* (London: Cambridge University Press, 1973), 28. See also J. A. K. Leslie, *A Survey of Dar es Salaam* (London: Oxford University Press, 1963); Susan Geiger, *TANU Women: Gender and Culture in the Making of Tanganyikan Nationalism, 1955–1965* (Portsmouth, N.H.: Heinemann, 1997), 37–38; Emmanuel Akyeampong, "'*Wo pe tam won pe ba*' ('You like cloth but you don't want children'): Urbanization, Individualism, and Gender Relations in Colonial Ghana, c. 1900–39," in *Africa's Urban Past,* ed. David M. Anderson and Richard Rathbone (Oxford: James Currey, 2000), 222–34; Christine Obbo, *African Women: Their Struggle for Economic Independence* (London: Zed, 1980).

13. Sabot, *Economic Development,* 94–95.

14. Geiger, *TANU Women,* 31–38.

15. P. S. Maro and W. I. F. Mlay, "People, Population Distribution, and Employment," *Tanzania Notes and Records* 83 (1976): 1–20; see also Josef Gugler, "The Second Sex in Town," *Canadian Journal of African Studies* 6, no. 2 (1972): 289–302; and Audrey Wipper, "African Women, Fashion, and Scapegoating," *Canadian Journal of African Studies* 6, no. 2 (1972): 329–49.

16. Leslie, *Survey of Dar es Salaam,* 14; also see Luise White, *The Comforts of Home: Prostitution in Colonial Nairobi* (Chicago: University of Chicago Press, 1990),

for an insightful perspective on the diversity of sexual relationships in an East African colonial city.

17. Leslie, *Survey of Dar es Salaam*, 4.

18. Andrew Burton, "The 'Haven of Peace' Purged: Tackling the Undesirable and Unproductive Poor in Dar es Salaam, c. 1954–85," in *The Emperor's New Clothes? Change and Continuity in East Africa, 1950–2000*, ed. Andrew Burton and Michael Jennings (James Currey, forthcoming); James R. Brennan, "Nation, Race, and Urbanization in Dar es Salaam, Tanzania, 1916–1976" (Ph.D. diss., Northwestern University, 2002); John Campbell, "The State, Urban Development, and Housing," in *Capitalism, Socialism, and the Development Crisis in Tanzania*, ed. Norman O'Neill and Kemal Mustafa (Aldershot: Avebury, 1990), 152–76.

19. For a compelling analysis of a political discourse around consumption in postcolonial Dar es Salaam, see James R. Brennan, " 'Sucking with Straws': Exploitation and Urban Citizenship in Tanzanian Nationalist Thought and Rhetoric," in Burton and Jennings, *Emperor's New Clothes*. For an insightful account of Tanzanian cultural policy through an ethnography of musical performance, see Kelly Askew, *Performing the Nation: Swahili Music and Cultural Politics in Tanzania* (Chicago: University of Chicago Press, 2002).

20. "TANU Youths Ban 'Minis,' " *Standard*, October 3, 1968.

21. *Standard*, October 25, 1968. For circulation figures, see John C. Condon, "Nation Building and Image Building in the Tanzanian Press," *Journal of Modern African Studies* 5 (1967): 335–54.

22. Peter Tweedy, letter to *Standard*, October 17, 1968.

23. See letters by Ukaka Mpwenku (October 14), Zainabu (October 14), Augustine Moshi (October 16), "Regular Reader" (October 22), J. N. Lohay (October 23), "Revolutionary Youth" (October 23), John C. R. Mpate (October 24), M. Sheya (October 10), and R. N. Okonkwu (October 14), all in *Standard*, 1968.

24. For an insightful analysis of Operation Dress-Up see Leander Schneider, "Developmentalism and Its Failings: Why Rural Development Went Wrong in 1960s and 1970s Tanzania" (Ph.D. diss., Columbia University, 2003).

25. R. N. Okonkwu, letter to *Standard*, October 14, 1968.

26. For colonial and missionary efforts to enforce dress codes elsewhere in East Africa, see Atieno Odhiambo, "From Warriors to *Jonanga*: The Struggle over Nakedness by the Luo of Kenya," in *Sokomoko: Popular Culture in East Africa*, ed. Werner Graebner (Amsterdam: Rodopi, 1992), 11–25.

27. "Maendeleo ya Wamasai," *Nchi Yetu*, March 1968.

28. *Nationalist*, February 9, 10, 12, 14, and 19, 1968; Kilua J., letter to *Nationalist*, October 25, 1968; letters by Karim Hirji (October 8), Chake Mussa (October 23), "Supporter" (October 25), all in *Standard*, 1968.

29. Okwudiba Nnoli, "There Is Nothing Modern about Mini-skirts," *Nationalist*, October 21, 1968.

30. "Sadru," letter to *Standard*, October 25, 1968.

31. Peter Tweedy, letter to *Standard*, October 17, 1968.

32. *Standard*, October 10, 1968.

33. Isaac T. Ngomuo, letter to *Standard*, October 16, 1968.

34. Ibid.

35. M. S. Sulemanjee, letter to *Standard*, October 12, 1968. See also the letters by Abu Abdallah (October 4), M. W. Kibani (October 9), M. Sheya (October 10),

Ernestos S. Lyimo (October 11), Pakilo P. Patitu (October 11), "Django" (October 11), R. M. Okonkwu (October 14), Ngomuo (October 16), "Concerned" (October 17), Sr. Mberwa Sleepwell (October 22), Y. Makwillo (October 23), "Unconcerned" (October 24), all in *Standard*, 1968.

36. "Django," letter to *Standard*, October 11, 1968.
37. Andrew Shija, quoted in *Standard*, October 17, 1968.
38. Nnoli, "Nothing Modern."
39. Hadji Konde, *Freedom of the Press in Tanzania* (Arusha: East Africa Publications, 1984), 208.
40. Mohamedi Jeuri, letter to *Uhuru*, October 22, 1968.
41. Thomas Changa, "Sikai Tena Mjini," *Nchi Yetu*, February 1969.
42. Cartoon reprinted in G. Kamenju and F. Topan, *Mashairi ya Azimio la Arusha* (Dar es Salaam: Longman Tanzania, 1971), 48, artist unknown.
43. *Ngurumo*, January 2, 1969.
44. "Supporter," letter to *Standard*, October 25, 1968.
45. *Standard*, March 18, 1968.
46. *Ngurumo*, October 14, 1968.
47. "Anti-mini Militants Meet Modern Misses," *Standard*, October 17, 1968.
48. S. S. Tofiki, "Kina Mama Nambieni," *Ngurumo*, November 1, 1968.
49. "Socialist," letter to *Standard*, October 23, 1968.
50. D. Chokunegela, "Nami Natoa Pongezi," *Uhuru*, October 17, 1968.
51. "Supporter," letter to *Standard*, October 25, 1968.
52. Kilua J., letter to *Nationalist*, October 25, 1968.
53. TANU Publicity Section, *Arusha Declaration* (1967), 2. A 1970 cartoon, subtitled "I Don't Want the Mini's Exploitation Anymore," condemned miniskirts in these very terms; *Nchi Yetu*, February 1970.
54. De Leone, letter to *Ngurumo*, October 24, 1968.
55. For a fictionalized portrayal of campus sexual politics, see Austin Bukenya, *The People's Bachelor* (Dar es Salaam: East African Publishing House, 1972).
56. For UWT statements on the issue of "indecent dress," see *Nationalist*, October 14 and 15, 1968; *Uhuru*, October 14, 15, and 21, 1968.
57. "Bibi Mapinduzi Asema: Mabibi Viwandani," *Ngurumo*, December 14, 1968.
58. See, for instance, Lucy Lameck's letter "Minis Lower the Dignity of Women," *Nationalist*, October 29, 1968, a particularly virulent attack on "derogatory" dress.
59. See, for instance, the letter by T. K. Malendeja in *Standard*, October 24, 1968.
60. "Mini Ban 'Surprise' to U.W.T.," *Standard*, October 14, 1968.
61. "Freedom Lover (Miss)," letter to *Standard*, October 18, 1968.
62. "Mrs. Freedom Lover," letter to *Standard*, October 23, 1968.
63. I borrow this phrase from Frederick Cooper, "Urban Space, Industrial Time, and Wage Labor in Africa," in *Struggle for the City: Migrant Labor, Capital, and the State in Urban Africa*, ed. Frederick Cooper (Beverly Hills, Calif.: Sage, 1983), 7–50.

Part Three: *Disciplined Dress:*
Gendered Authority
and National Politics

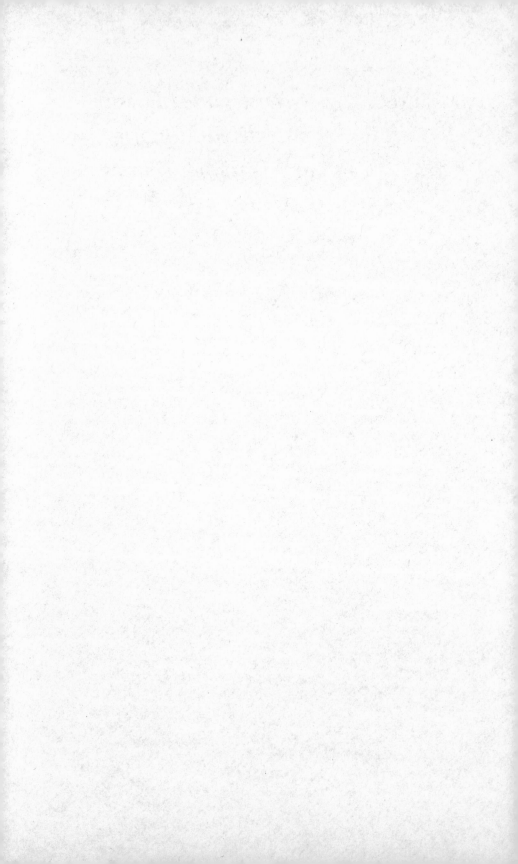

7 From Khaki to *Agbada:* Dress and Political Transition in Nigeria

Elisha P. Renne

A political observer said that if an army sergeant grabs the key to Aso Rock to-morrow, and his wife rises to launch "a program to keep the gutters clean," these same set of people would storm the place in their flowing, richly embroidered *agbadas* and *Babarigas* [*sic*] to clap and cheer her up.[1]

The shift from military to civilian rule in Nigeria is often portrayed in the press in terms of a change in dress—from military uniform, sometimes simply referred to as "khaki," to civilian dress, often referred to as *agbada* (robe). Indeed, the phrase "khaki to agbada" refers specifically to this political transition, and was frequently used to describe the shift in 1999 from military to civilian rule in Nigeria (fig. 7.1). While the Yoruba term *agbada* refers to the large gowns made of locally hand-woven cloth worn by traditional chiefs in southwestern Nigeria, the term *khaki* derives from British colonial experience in India, the first place where a brownish uniform material called *khaki*, meaning "dusty" in Urdu, was used.[2] The historical association of khaki uniforms with colonial and later Nigerian military rule suggests that the transition to civilian dress not only represents a different form of political organization but is also related to historical events associated with colonialism, military rule, and national independence, as well as precolonial forms of political rule. This essay examines the use of military uniforms and civilian dress, particularly embroidered robes—known as agbada in Yoruba and as *babban riga* in Hausa—as expressions both of a particular form of political order—military rule, traditional rule, democratic rule—and of social distinctions—between royalty and commoners, military and civilians, an educated elite and non-literates. These orders and distinctions, however, are not unambiguously admired, as the epigraph above suggests. Thus the army sergeant, dressed in khaki, may be indiscriminately applauded by wealthy traditional rulers and members of the political elite, dressed in "their flowing, richly embroidered *agbadas* and *Babarigas*,"[3] whose wealth may come from questionable sources. Nonetheless, the political transitions from military to civilian regimes represented by "khaki to agbada" are associated with the optimism surrounding Nigerian independence from British colonial rule.

Figure 7.1. Detail of an almanac published in Nigeria in 1999, depicting the death of Sani Abacha, the transition to democratic rule instituted by Abdulsalam Abubakar, and the newly elected president, Olusegun Obasanjo. Purchased in Ibadan, July 1999; photo by Elisha P. Renne.

In this essay, I will focus on shifts in civilian and military leadership and on the changing fashions in political dress, specifically examining the type of robes known as babban riga in Northern Nigeria (rather than their stylistic counterpart, the agbada, worn in southwestern Nigeria) and Nigerian army and civil service uniforms. An analysis of the complexity of these political representations through dress and their shifting fashions in time[4] provides an understanding of the very material ways that political authority and hierarchy are constituted and sustained and that skeptical opposition is expressed.

Robes of Rule in Precolonial Nigeria

During the nineteenth century, missionaries, traders, and explorers noted the distinctive dress worn by the ruling elite (fig. 7.2) in many parts of Nigeria. It is described in accounts by missionaries such as Samuel Ajayi Crowther and J. C. Taylor and explorers such as Heinrich Barth, Hugh Clapperton, MacGregor Laird and R. A. K. Oldfield, Richard Lander and John Lander, Gustav Nachtigal, and Paul Staudinger.[5] For example, William Allen and T. R. H. Thompson noted,

> The Attah [of Eggarah (Igala)] was arrayed in an ample tobe, fantastically brocaded with gold, beneath which was another of red velvet; and judging from his size, many others of various hues might have been his under-garments. The trowsers were loose, and of the favourite color, scarlet. His feet were inserted in a pair of enormous red

Figure 7.2. "The Court of the King of Iddah," depicting the *attah* and his supporters wearing robes and being shaded by an umbrella. From a painting by William Allen in William Allen and T. R. H. Thompson, *A Narrative of the Expedition Sent by Her Majesty's Government to the Niger River in 1841* (1848; reprint, New York: Johnson Reprint, 1967), vol. 1, facing page 293.

leather boots, to which a number of bells were fastened. . . . The principal courtiers were seated close round the throne. . . . They were, for the most part, neatly dressed in white tobes and small caps, though some had them blue or checked, with a sort of embroidery round the opening for the neck.[6]

Similarly, Laird and Oldfield reported that the king of Fundah was "splendidly dressed in silk and velvet robes, and appeared to be a man of immense size."[7] According to Barth, the *serki-n-turáwa* (or "consul of the Arabs") of Katsina was

showily and picturesquely dressed—in a green and white striped tobe, wide trowsers of speckled pattern and color, like the plumage of the Guinea-fowl, with an embroidery of green silk in front of the legs. Over this, he wore a gaudy red bernús, while round his red cap a red and white turban was wound crosswise in a very neat and careful manner.[8]

In these and in other examples, political leaders wore expensive cloth, often made from or embroidered with silk, some of which was imported and some of which was locally produced.[9] While silk velvets would have been imported, some luxury cloth, such as the green and white striped robe and "Guinea-fowl" trousers, would probably have been of Nupe or Hausa manufacture.[10]

Not only were expensive, elaborately embroidered robes made with costly materials used by the political elite to distinguish themselves in precolonial Nigeria,

but these robes were also used to reward individuals for specific deeds and to so-lidify patron-client ties through gifts of quantities of robes to political followers.[11] For example, in the Kano Chronicles, *Sarkin* Mohamma Nazaki of Kano is said to have distributed a thousand gowns to workers who extended the Kano City walls during the seventeenth century.[12] Last cites examples of robes received by and given as gifts to the emir of Zaria and the sultan of Sokoto in the nineteenth century.[13] Bishop Crowther and J. C. Taylor also noted the political importance of robe-giving associated with Muslim holidays, describing the distribution made by one wealthy Nupe man:

> July 24—[1858] The Laya feast, which lasted three days, ended to day. . . . Constant beating of drums, and display of fine cloths prevailed at this time. Tshuwa Kuta, the chief ferry-master, who had a large share of cowries at his disposal, was the most con-spicuous. His wives were dressed in the best country manufactured cloths, and such showy Manchester goods as they could purchase. Robes, which had been collected against this time, were distributed among his under officers as presents, and large sums of cowries were squandered among the drummers and dancers. Thus, he made his name to be spoken of far and wide, as one of the most wealthy and liberal persons in the Nupe country.[14]

In the 1970s, Heathcote observed that in Hausa land, "emirs make regular presen-tations of new gowns to their officials and other people connected with the palace."[15]

Another aspect of these robe distributions was the fact that the value of the robes varied, depending not only on the materials and density of the woven cloth used but also on "the method and quality of the tailoring, the presence of lining, the materials used in the lining and its quality, the materials used in the embroi-dery, and the density and detail of the embroidery."[16] Thus not only was politi-cal allegiance reinforced through robe-giving; the political ranking of individuals could also be represented. The sorts of discriminating choices made in past robe distributions are probably similar to those made by one district head in Zaria City during Eid-el-Fitr in 1991:

E: How many robes were distributed?

T: Ah, let me see, it was about fourteen. But in different categories.

E: What were the categories?

T: Ah, in the first place, there are important or more dignified people who are given the most expensive robes. Say like the *aska biyu*[17] . . .

E: So how many of the aska biyu did you distribute?

T: One.

E: Who did that aska biyu go to?

T: . . . A friend to the district head in Zaria City. . . . All right, then *aska tara* or, in other words, *'yar Dikwa*. I think the sewing of this type of robe origi-nated from Dikwa in Bornu State. That is why it is called 'yar Dikwa. This is my view anyway, but from the name.

E: So how many of these aska tara were distributed?

T: Three.

E: And to which people were these?

T: One of the robes went to his father-in-law, and then two—one was given to one of his village heads, a village head under him, and then one was given to a friend.

E: These are *dinkin hannu* [hand-embroidered]?

T: Yes!

E: These are very costly.

T: Yes! Very costly.

E: There remain ten.

T: OK, there remain ten, *ko*? The rest are just *dinkin keke* [machine-embroidered] and they are two, three categories. One category was given to his subjects, his servants, some of his servants.[18]

The importance of robes for maintaining a political hierarchy—with the sarkin or emir as the head and the political offices of ranked district heads, titled chiefs, horsemen, guards, and other members of the emir's court all visually distinguished— is captured in a description by Captain J. D. Falconer, an officer in the British colonial forces who toured in Northern Nigeria in 1910:

> the *sariki,* resplendent in his green silk cloak, followed by four horse-boys in short kilted rigas and equipped with red blankets, neatly rolled and slung over the left shoulder. Then came the courtiers, in cloaks and gowns of many colours, attended by their favourite slaves on foot, while sometimes in front and sometimes behind rode the court jester or crier, dressed in a tight-fitting suit of red, shouting the praises of his lord and master and of his honored guest until the trees re-echoed with his voice. It was a scene of barbaric splendor, a page from a mediaeval romance, and behind came the incongruous khaki-clad Briton, with his twentieth-century equipment carried by porters for whom it was difficult to find a setting in either the old or new regime.[19]

In casting the sarkin of Ari and his court in terms of "mediaeval romance," he contrasted this "barbaric splendor" with "the incongruous khaki-clad Briton" who was, according to him, neither "the old or new regime" (i.e., neither traditional nor modern). Falconer was also making reference to the annexation of the Northern Province by British forces in 1903. The subsequent imposition of colonial rule included an expanded colonial military presence, with its own hierarchical organization based on racial and social distinctions, reflected in distinctive uniform styles. While indirect rule, the form of political organization used by the British, meant that the use of robes (babban riga or agbada) by traditional rulers was maintained, the power of these rulers was superceded by that of British colonial officials dressed in khaki military or civil service uniforms. This period could be characterized, then, as "from agbada to khaki."

British Introductions: Khaki Uniforms during the Colonial Period

During the nineteenth century, small local military units, such as the Royal Niger Company Constabulary, along with British and West Indian troops, were organized by the British in several parts of West Africa to protect their expanding

interests both in acquiring control over resources and in countering other European powers. These small, locally manned militias wore uniforms. For example, the Lagos Constabulary, organized by Sir John Glover, the lieutenant governor of Lagos in 1862, wore a Zouave jacket over a shirt and trousers (or shorts), and a red fez with a blue silk tassel. The term "Zouave" refers to Berber men from Zouaoua, recruited by the French during their occupation of Algiers in 1830, who wore uniforms which included a sleeveless waistcoat and turban. The Zouave uniform, worn by certain British colonial troops (but not British soldiers themselves), was adopted "after the British experience fighting alongside Zouaves in the Crimea[n War]."[20] These smaller militia were amalgamated under the West African Frontier Force (WAFF) in 1897,[21] which, after 1914, included the Nigeria Regiment, and a similar uniform was devised for them.[22] An illustration of a company sergeant major of the Nigeria Regiment depicts a soldier who is wearing khaki shorts and shirt, khaki-colored puttees without shoes, a red cummerbund and fez, and the Zouave jacket.[23] This short jacket, as well as the fez, distinguished African recruits from British military personnel.

The full dress and working uniforms of the West African Frontier Force regiments changed in various ways during the course of the colonial period.[24] By 1933, for example, soldiers in the Nigeria Regiment wore puttees but not shoes. Wearing shoes or boots was a point of pride for Nigerians,[25] so that not being issued footwear would have been viewed as a humiliating omission. The lack of footwear was explained differently by the British, as is evidenced in the comments of Governor Stanhope Freeman in 1862: "Wearing no shoes, they [Hausa men] do not get footsore on long marches," and in those of one British war historian, discussing the King's African Rifles (East Africa):

> Africans did not take kindly to boots, as it was natural for them to walk bare-footed and boots seemed to them like artificial horses' hoofs, and quite [an] unnecessary infliction.[26]

It was not until 1937 that sandals were included as part of the working uniforms of Nigerian recruits (fig. 7.3).[27] During World War II and thereafter, they were issued boots as part of their standard equipment,[28] as one [British] writer wryly described:

> The last war [WWII] brought boots to torture the unfortunate feet of the soldiers. Years of walking barefoot had given them feet of generous proportions, and when the Ordnance Corps arrived in West Africa with all the normal sizes of boots used in the United Kingdom, it was only to find these were as useless as a "bag of hammers."[29]

However, long shorts continued to be worn by Nigerian soldiers until after independence.

While the use of long shorts, the Zouave jacket, and the fez were justified for reasons both functional (shorts were cooler) and cultural (the Zouave jacket and fez were believed to have originated in [North] Africa), these uniforms also "exoticized" and distanced their wearers from British officials and soldiers.[30] Bernard Cohn, writing about the use of uniforms in other British colonies, noted that

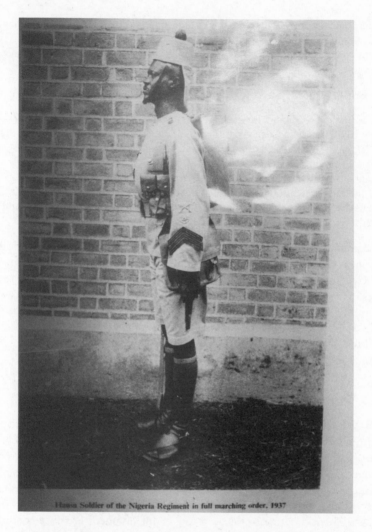

Hausa Soldier of the Nigeria Regiment in full marching order, 1937

Figure 7.3. Nigerian Regiment soldier wearing sandals, 1937. Courtesy of the Nigerian Army Museum, Zaria.

In India, the military "orientalized" to overawe the Indian Princes and the heathen masses; at home, the ruling classes archaized their ceremonial dress to overawe the new middle classes and the potentially dangerous lower orders of society. From the middle of the nineteenth century, the British at home increasingly invented or reinvented civic rituals at all levels of the polity. These rituals called for the creation of costumes, regalia, and accoutrements to mark them as special and hallowed by the past.[31]

That these military uniforms and displays did have an effect on ordinary Nigerians and on at least some traditional rulers is evident from memoirs and novels:

Young boys like myself, all of them with gun and uniform. It is that uniform that I like very much. When I see how they are all marching, priding and singing, I am very happy. But when I see all their uniform shining and very very nice to see, I cannot tell you how I am feeling. Immediately, I know that this soza is wonderful thing.[32]

Some British colonial officers were aware of this effect and sought to capitalize on it:

Under present conditions, however, an Administrative Officer under twelve years' service attends important Council meetings in whatever attire he considers suitable. The Chiefs on the other hand are encouraged and expected to wear the full regalia of their office. In circumstances such as these the Governor's representative should surely maintain dignity, and at the same time efface his individuality, by appearing in a suitable uniform which at once marks him out as the representative of Government. It seems that the psychological aspect which constitutes a potent factor on these and similar occasions is frequently overlooked in this country.[33]

The presence of Hausa men from the Gold Coast Constabulary, dressed in full uniform, at Queen Victoria's Diamond Jubilee in 1897[34] provided evidence of Britain's "civilizing" accomplishments, further justifying colonial policies and expenditures to the British middle classes. Exoticizing African soldiers reinforced a sense of a unified British national identity based on cultural superiority. At the same time, a distinctive social hierarchy within Britain was strengthened through a system of restrictions on the use of visually ranked colonial military and civil service uniforms.

Uniforms for British Officers and Civil Servants

While the uniforms of British officers in the Nigerian Regiment were distinct from those worn by Nigerian personnel, they also identified individual British officers by rank. Various parts of these uniforms, such as the type and placement of badges and whether collars had gorget patches or not,[35] conveyed these ranks to knowing observers. Discussion of the wearing of uniforms is also documented in correspondence among colonial officials. In 1929, for example, the secretary of the Northern Province wrote to the secretary of the Southern Province concerning "the subject of uniforms for administrative officers who are not entitled to wear civil uniforms." In another letter, the wearing of civil service uniforms by administrative officers who had not yet completed twelve years of service was considered.[36]

As these documents suggest, political authority and government were sustained among British and Nigerian personnel alike by a hierarchy of uniform styles. Like the babban riga that ranked members of the political elite and their subordinates in precolonial Northern Nigeria and which continued to be used under indirect rule during the colonial period, the details of British uniforms were closely observed. At the *durbar* (reception) held in Kaduna for Queen Elizabeth in 1956, for example, Sir Rex Niven, president of the Northern House of Assembly, assessed his peers:

This was a full uniform affair, but I did not feel that my velvet was justified (it should not be sat on too long) and so I (as President) wore the dark green barathea with the new hat of the same, which attracted most favorable attention. The Chief Justice and the Judges flatly refused to wear their scarlet—turning up in lounge suits, they looked pretty dim. The Ministers were gay in their best *rigas* and the Sardauna on the royal stand was even more brilliantly dressed.[37]

The velvet that Niven refers to is a robe commissioned by him for use by the president and speaker of the newly formed House of Assembly of the Northern Provinces:

I . . . went to Ede and Ravenscroft, the well-known robe-makers in Chancery Lane, London and put the question to them. We went through their astonishing collection of robes of all kinds and colors then in use for ceremonial. Finally we came to a compromise based on the type of cloak used for the royal orders of chivalry, but joined at the front and not open as they are. We put a great fullness into the shirt, and the directors of the firm gazed with awe at a velvet-embroidered cloak sent for guidance by the Sardauna. To make the robe even more impressive, there were to be gold trimmings and big white satin shoulder knots. The color was emerald green and the material a fine velvet specially made in Germany, with an uncrushable pile, so important in that climate [see fig. 7.4]. . . . For the Clerks at the Table we designed black robes in corded silk for full-dress and stuff for ordinary. On the back and shoulders was the badge of the Assembly, the gold loops of the Northern Knot. They wore gold turbans for special occasions and black skullcaps for ordinary business. It all looked impressive and distinguished.[38]

While ceremonial robes were not given out by the colonial government in the large numbers associated with precolonial robe distributions, robes *were* given for Northern House of Assembly officials' use and as gifts for special occasions, as when traditional Northern chiefs were turbaned:

When a person has been selected for an important Native Authority appointment or traditional title he may be given a present of gowns or cloaks with the traditional "*kayan sarauta*" [literally, "load of the chief"] but this is to be paid for from the Native Authority Funds. Similarly a present to mark specially good service can be given to a Native Authority employee from Native Authority funds.[39]

By insisting that the "present of gowns or cloaks" be paid for by Native Authority funds, British government officials were attempting to limit the extent of these transactions, which they saw as ostentatious and as a form of bribery. It is also possible that, by limiting the distribution of robes and associating the few that were given with state funding, colonial officials sought to circumscribe the political power of high-ranking chiefs that derived from such forms of patronage. They were unsuccessful in this effort. Paradoxically, through the introduction of other avenues for robe distribution, such as the Northern House of Assembly and the more general distribution of uniforms for civil servants and the military, they actually contributed to an expanded continuation of this practice after independence.

Figure 7.4. Sketch for a robe made by Ede & Ravenscroft Ltd., Robe Makers & Tailors, London, for the president and speaker of the House of Assembly, Northern Provinces, in 1956. Courtesy of the National Archives of Nigeria, Kaduna. Ceremonial robes, PRE 1/1 (fourth collection), file no. 335/s.1, Nigerian National Archives, Kaduna.

Khaki Uniforms after Independence

With Nigerian independence on October 1, 1960, a number of changes occurred in the military. In 1960, the name of the Royal Nigeria Military Forces (which had been adopted in 1959) was changed to the Royal Nigerian Army, and again in 1963 to the Nigerian Army. Also in 1963 the former RWAFF dress uniforms were replaced with khaki uniforms, consisting of long-sleeved shirts, trousers, boots, a peaked cap, and a new emblem.[40]

The Nigerian Army presently has five sets of uniforms, which are used for different occasions and are distinguished according to rank. Included in these five sets are ceremonial dress, the mess kit (or dinner dress), service dress, working out dress, and combat dress. Distinctions by rank are represented by differently colored sashes, epaulets, cordings, and gorgets. There have been some slight changes in uniforms since independence—e.g., the color was changed from khaki brown to green, the collar shape changed, and metal epaulets were replaced with cloth ones. More importantly, the khaki used in uniforms is now obtained from manufacturers in Lagos and Kano, rather than overseas.[41] Otherwise, uniforms for Nigerian army officers and soldiers are essentially the same as those used following independence. Yet while they are not the uniforms worn by "the colonial army of occupation," as the nationalist leader and governor-general Dr. Azikiwe described the Zouave-style colonial uniforms in 1961,[42] they have come to be associated by some Nigerians with political license and lawlessness. For example, the hero of the novel *The Sympathetic Undertaker* remarks, "And then in the papers you read about those politicians in military uniform going to Milan to have a toothache examined,"[43] referring to military officers' extravagant use of state funds for trivial, personal purposes. The khaki uniforms worn by officers have come to represent the military regimes which replaced the civilian governments of the First and Second Republics.

Similarly, particular types of civilian dress were associated with the different civilian regimes. For example, the president of the First Republic, Sir Abubakar Tafawa Balewa, who served from 1960 until 1966 when he was shot in a military coup attempt,[44] generally wore voluminous white babban riga. Thirteen years later, when Shehu Shagari began his tenure as president of the Second Republic, his dress reflected a changing sense of Nigerian nationalism. It consisted of a shirt, machine-embroidered in green, worn with a white robe and a tall embroidered cap that came to be known as "Shagari-style" dress. This change from the military rule of General Obasanjo in 1975 to civilian rule under Shagari in 1979 was the first post-independence shift in political power to be described as from "khaki to agbada." However, this shift was reversed after Shagari was overthrown by a coup led by Generals Muhamadu Buhari and Tunde Idiagbon on December 31, 1983, after which political leaders, once again, dressed in khaki military uniforms. Military rule continued after General Babangida took power in 1985 and continued until he was forced to resign after the annulment of the June 12, 1993, presidential election of Moshood Abiola. An interim national government, ostensibly a "civilian" regime led by Ernest Shonekan, was established on August 26, 1993.

As in previous civilian regimes, a particular type of dress or cloth came to be associated with the political leadership and was, in fact, called Shonekan. In this case, it was an inexpensive type of cotton damask used in making babban riga and kaftans. It was introduced during his regime,[45] and its low price allowed many who had not been able to afford to buy cotton damask in the past to purchase it. Even though Shonekan's stay in power was short, this cloth continues to bear his name.

Within a few months, on November 17, 1993, Shonekan was ousted in a bloodless coup by General Sani Abacha, who ruled Nigeria until his death on June 8, 1998. The brutality and corruption associated with Abacha's rule led to domestic unrest in both Southern and Northern Nigeria as well as to various forms of international sanctions during the late 1990s. As a way of regaining international approbation, in December 1995 Abacha announced approval of several committees formed to facilitate the political transition from military to civilian rule.[46] Abacha then announced, in February 1997, that he would be running for the office of president, perhaps following the example of President Jerry Rawling of Ghana. Abacha's forbidding appearance in a khaki green uniform, wearing dark sunglasses, was replaced by photographs of him dressed in a tailored kaftan made of guinea brocade, with modest machine-embroidery around a round neck, with long sleeves and a hemline that extended to the ground. Followers of Abacha began to wear this style of kaftan, which was named *tazarce*, literally "continue" or "carry on," referring to the demands of Abacha's followers that he continue in power as a civilian president.[47]

Khaki to Agbada

After Abacha died, General Abdulsalam Abubakar was named as an interim military ruler. Some were skeptical of his promise to hand over power to a civilian president after elections, which were scheduled to be held in February 1999. However, he kept his promise and another phase of "khaki to agbada" began with the installation of Olusegun Obasanjo as president of the Third Republic in May 1999 (see fig. 7.1). During his first year in office, highly placed political leaders were photographed wearing a range of showy agbada and babban riga at official functions while lower ranked civil servants wore more sparsely embroidered 'yar Dikwa kaftans (as described by the district head quoted earlier). At the same time, khaki was retired to the barracks. President Obasanjo, both at home and overseas, regularly wears agbada-style robes made from a range of materials, including a type of embroidered lace popular in southwestern Nigeria. One particular pattern of this lace, manufactured in Korea, has been named Obasanjo and was selling for N2,800 (around US$30) for six yards in Sabon Gari Market, Zaria, in March 2001.[48]

While many were initially optimistic that the advent of democracy would improve the standard of living in Nigeria, Obasanjo faced many problems, including a large foreign debt and a decimated infrastructure, as well as ethnic tensions over land and access to government funds. Many people became frustrated with the slow pace of change. Further, his dismissal of ninety-three military officers in June 1999,[49] a number of whom were Northerners, while it contributed to increasing

approval in the southwest, undermined support for Obasanjo in the North. This discontent has been expressed in several ways, including in the implementation of Sharia law in many Northern states. However, people are also expressing their dissatisfaction with President Obasanjo's programs through references to dress, specifically the kaftan style known as tazarce, as one Zaria City robe manufacturer explained:

The most popular dress is the one called tazarce. And this type, it fits the situation of the times. For example, the people like us who are forty-five and below, we wear this type of dress. Because babban riga will disturb us [with its floppy sleeves and bulkiness].[50] And this *riga tazarce*, it got its name from a military leader, the former President Abacha, because he's the one who wore this type of dress.[51]

By wearing this style of kaftan, Northern men indirectly criticize Obasanjo by wearing clothing that refers back to Abacha's bid for the presidency. In Northern towns such as Zaria, Kaduna, and Kano, this criticism is also expressed by many microbus drivers who have decorated their buses' rear windows with photographs of Abacha (fig. 7.5) wearing the kaftan known as tazarce with the letters T-A-Z-A-R-C-E placed beside it.[52] While the appearance of these pictures suggests support for the late General Abacha, it is not clear whether the drivers would actually want him to return to power, since his ostensible supporters are safe in the knowledge that he cannot. What these displays do suggest is that many Northerners would like a return to national political rule by a Northern president. It is worthwhile noting that the photographs displayed depict an Abacha dressed in civilian dress, suggesting public support for a return to Northern political leadership rather than a return to military rule.

Dress and Artifice

Dress associated with particular local and national forms of government in Nigeria, specifically khaki uniforms and agbada or riga, has been used to communicate a range of polyvalent political messages. In precolonial Northern Nigeria, political leaders wore large, costly embroidered robes to communicate the quality of *girma*, bigness or grandeur, to their followers, whose loyalty and standing were enhanced through gifts of robes of varying degrees of quality and size. During the colonial period, such displays of bigness by traditional rulers were encouraged, under certain conditions, in ceremonials associated with indirect rule. Furthermore, opportunities for diverse display expanded with the introduction of the West African Frontier Forces, whose Nigerian recruits wore Zouave-style military uniforms, and with the presence of British military personnel and civil servants, both British and Nigerian, who wore a range of distinctly designed service dress. Thus while new forms of dress were introduced to help establish a new form of political organization, namely the colonial state, other forms of dress associated with precolonial rule co-existed with and, indeed, were used by the British in reinforcing their political authority in colonial Nigeria.

Furthermore, by giving uniforms to Nigerian recruits and civil servants,[53] Brit-

Figure 7.5. Bus in Zaria City decorated with photograph of the late General Sani Abacha wearing a kaftan in the style known as *tazarce*, "carry on." Zaria City, March 2001. Photo by Elisha P. Renne.

ish colonial officials also carried on the earlier practice of robe distribution, which established and maintained patron-client ties through the use of dress. The ties they sought to strengthen, however, were between citizens and the state rather than between specific political rulers and their subjects. Ironically, their reliance on indirect rule led them to support both forms of patronage as the state bestowed uniforms and robes on Nigerian political leaders and traditional rulers, while the latter continued to bestow robes on their followers, over British objection to this practice.

After independence, many national civilian political leaders adopted the use of robes for official dress, maintaining the type of "uniform" worn by high-ranking traditional and Native Authority chiefs during the precolonial and colonial periods. In contrast, military leaders quickly abandoned the Zouave military uniforms for a Western-style khaki uniform earlier worn by British officers and soldiers. The use of locally made political dress, agbada or babban riga, based on precolonial precedent, symbolically represented national liberation from the British. However, the form of government—the nation-state—and statewide distributions of uniforms, both civilian and military, were innovations introduced by the British. Thus these paired symbols of Nigerian national independence—khaki and agbada—have come to represent not only a shift from military to civilian rule, but also the ambiguous complexities of politics in contemporary Nigeria. Like its dual legal system that observes both statute and traditional law, political authority in Nigeria has oscillated between civilian and military rule at the national level and between traditional rule and state government at the local level.

Considering Nigeria's political antecedents and the complexities of its political organization, it should not be surprising that regimes characterized by "khaki" and by "agbada" might be viewed with some skepticism. As the preceding sections have attempted to show, while there are distinct differences between military and civilian political rule in twentieth-century Nigeria, there has been considerable overlap of interests and personnel. For example, the present Nigerian head of state, President Obasanjo, was also the military head of state as General Obasanjo from 1976 to 1978. The image of Obasanjo (see fig. 7.1) both refers to his two different identities and celebrates his discarding of khaki in favor of an agbada. Yet the fact that the same man could wear both khaki and agbada suggests that these political distinctions are not altogether clear-cut. The political duplicity that dress facilitates was expressed in one political cartoon that depicted the late General Abacha, hardly an advocate of democratic rule, as a man who "pulls off his uniform and puts on agbada," civilian dress, in his bid for presidency in the upcoming national election. The idea that dress may fraudulently disguise, as well as express, political positions was also succinctly stated in an interview at the time:

"But if General Abacha pulls off his uniform and puts on *agbada,* then he will be contesting as a civilian, how would you feel about it?"
"Oh, this is a familiar fraud, everyone knows it."[54]

The importance of political dress, such as the agbada or babban riga worn by politicians and traditional rulers and the khaki uniforms worn by military officers, in constituting and maintaining particular political regimes should not be under-

estimated. Yet dress also serves as a symbol of public skepticism of the claims of national political leaders. The phrase "khaki to agbada," by representing the shift from military to civilian rule, implicitly refers to independence from both colonial and postcolonial military rule. It also presents a commentary on the complex composition of political authority of the Nigerian state.

Notes

I would like to thank Captain A. A. Akerele, Curator, Nigerian Army Museum, Zaria, for permission to work with the Museum collection, Warrant Officer P. I. Iyonkyo for his helpful assistance, and the staff of the Nigerian National Archives, Kaduna. I am also grateful to Alhaji (Dr.) Shehu Idris CFR, Emir of Zazzau, for permission to conduct research in Zaria City. Additional thanks go to Hassana Tanimu for research assistance and to Alhaji Dogara, Alhaji A. Tijani, Commandant M. Said, Colonel H. M. Lai, Alhaji Muhammadu Munir Ja'afaru *Mni*, Yariman Zazzau, Mallam Aminu Inuwa, and Mallam Y. Tanimu, all of Zaria, for their helpful interviews.

1. Omololu Kassim, "It's My Turn," *Tell*, no. 47 (November 21, 1994): 25.

2. Thomas Abler, *Hinterland Warriors and Military Dress: European Empires and Exotic Uniforms* (Oxford: Berg, 1999), 114; A. C. Whitehorne, "Khaki and Service Dress," *Journal of the Society for Army Historical Research* 15 (1936): 180–83.

3. See Misty Bastian, "Female *Alhajis* and Entrepreneurial Fashions," in *Clothing and Difference: Embodied Identities in Colonial and Post-colonial Africa,* ed. Hildi Hendrickson (Durham, N.C.: Duke University Press, 1996), 105, for another example of the expressive use of these garments.

4. Bernard Cohn, "Cloth, Clothes, and Colonialism: India in the Nineteenth Century," in *Cloth and Human Experience,* ed. Annette B. Weiner and Jane Schneider (Washington, D.C.: Smithsonian Institution Press, 1989), 303–53; Christraud Geary, "Political Dress: German-Style Military Attire and Colonial Politics in Bamun," in *African Crossroads: Intersections between History and Anthropology in Cameroon,* ed. Ian Fowler and David Zeitlyn (Providence, R.I.: Berghahn, 1996), 165–92.

5. Samuel A. Crowther and J. C. Taylor, *The Gospel on the Banks of the Niger: Journals and Notices of the Native Missionaries Accompanying the Niger Expedition of 1857–1859* (1859; reprint, London: Dawsons of Pall Mall, 1968), 90; Heinrich Barth, *Travels and Discoveries in North and Central Africa* (New York: Harper and Brothers, 1857–59), vol. 1, 446; Hugh Clapperton, *Journal of the Second Expedition into the Interior of Africa* (1826; reprint, London: Cass, 1966), 47; Richard Lander and John Lander, *Journal of an Expedition to Explore the Course and Termination of the Niger; With a Narrative of a Voyage down That River to Its Termination,* 2 vols. (New York: Harper and Brothers, 1854), vol. 2, 216–18; Gustav Nachtigal, *Sahara and Sudan* (1881; reprint, London: C. Hurst, 1980), vol. 2, 60.

6. William Allen and T. R. H. Thompson, *A Narrative of the Expedition Sent by Her Majesty's Government to the Niger River in 1841* (1848; reprint, New York: Johnson Reprint, 1967), 293–94.

7. MacGregor Laird and R. A. K. Oldfield, *Narrative of an Expedition into the Interior of Africa by the River Niger in the Steam-Vessels Quorra and Alburkuh in 1832, 1833, and 1834* (1837; reprint, London: F. Cass, 1971), 199. Laird adds, "On inquiry of the owner of my hut, he informed me, and I afterwards found it to be the case, that on all great occasions it is customary for the king and his attendants to puff themselves out to a ridiculous size with cotton wadding" (202).

8. Barth, *Travels,* vol. 1, 446.

9. Venice Lamb and Judith Holmes, *Nigerian Weaving* (Roxford: H. A. and V. M. Lamb, 1980), 40; J. Chunwike Ene, "Indigenous Silk-Weaving in Nigeria," *Nigeria Magazine,* no. 81 (1964): 127; Philip Shea, "Kano and the Silk Trade," *Kano Studies,* n.s. 2, no. 1 (1980): 96–112.

10. Judith Perani and Norma Wolff, *Cloth, Dress, and Art Patronage in Africa* (Oxford: Berg, 1999), 143; John Picton and John Mack, *African Textiles* (London: British Museum, 1979), 113 n. 11.

11. Along with prestige, the political power associated with robe-wearing is suggested by the fact that the Hausa word for robe, *riga,* may be used metonymically to stand for the power of the emir. See David Heathcote, "The Embroidery of Hausa Dress" (Ph.D. diss., Ahmadu Bello University, Zaria, Nigeria, 1979), 239. Heathcote also notes that the phrase *rigar sarki,* literally "robe of the king," is used to refer to the riders who accompany an emir, while the term *tu'be,* literally "taking-off of a garment," also refers to deposing an emir.

12. H. R. Palmer, "The Kano Chronicle," *Journal of the Royal Anthropological Institute of Great Britain and Ireland* 38 (1908): 83.

13. Murray Last, *The Sokoto Caliphate* (New York: Humanities, 1967), 105 n. 59, 196–97.

14. Crowther and Taylor, *Gospel,* 191.

15. David Heathcote, "Hausa Embroidered Dress," *African Arts* 5, no. 2 (1972): 14.

16. Colleen Kriger, "Robes of the Sokoto Caliphate," *African Arts* 21, no. 3 (1988): 56.

17. Ibid., 54, 57.

18. Mallam Aminu Inuwa, Majidadin Danburan, interview by author, Zaria, Nigeria, May 14, 1995. This man is a close confidant of the district head and also holds the title of *maji dadi.* Men holding this title are responsible for commissioning and distributing robes, as Maji Dadi Zazzau is for the emir of Zaria (cf. Kriger, "Robes," 55).

19. John D. Falconer, *On Horseback through Nigeria* (London: T. Fisher Unwin, 1911), 241.

20. Abler, *Hinterland Warriors,* 108.

21. S. C. Ukpabi, "The Origins of the West African Frontier Force," *Journal of the Historical Society of Nigeria* 3, no. 3 (1966): 486.

22. Anthony Kirk-Greene, "A Preliminary Note on New Sources for Nigerian Military History," *Journal of the Historical Society of Nigeria* 3, no. 1 (1964): 129.

23. Robert M. Barnes, *A History of the Regiments and Uniforms of the British Army* (London: Seeley Service, 1960), 276.

24. Michael Brady, "The Changing Uniforms of RWAFF," *West African Review,* March 1954, 216–17.

25. Ken Saro-Wiwa, *Sozaboy* (Port Harcourt, Nigeria: Saros, 1985), 163; see also Geary, "Political Dress," 184.

26. Barnes, *Regiments and Uniforms*, 266.
27. Nigerian Army Museum, *The History of the Nigerian Army in Pictures* (Abuja: Office of the Chief of Army Staff, 1987), 28.
28. Barnes, *Regiments and Uniforms*, 288.
29. Brady, "Changing Uniforms," 217.
30. In an example from colonial Cameroon, Geary documents the unease of German officials with Bamum production of German-style military uniforms for King Njoya's guards and their subsequent abolishment. The governor later noted with satisfaction that "Yoya [King Njoya] who has exchanged his tasteless European fantasy uniform for Fullah dress and disbanded his troops who had worn European-style uniforms, was accompanied by one hundred mounted men and perhaps a thousand foot soldiers, all in Hausa gowns and armed with spears." Geary, "Political Dress," 188.
31. Cohn, "Cloth, Clothes, and Colonialism," 330.
32. Saro-Wiwa, *Sozaboy*, 53.
33. A. E. F. Murray, memorandum, December 27, 1929, pp. 8–9, in "Civil Service Uniforms," file no. 519, 1929–1936, Kadmin. Agric. Papers, Nigerian National Archives, Kaduna.
34. Abler, *Hinterland Warriors*, 108.
35. War Office, Great Britain, *Dress Regulations for the Officers of the Army (Including the Militia)* (1900; reprint, London: Arms and Armour Press, 1969), 1, 75.
36. A. D. Hamlyn, letter, March 29, 1930, p. 1; and D. J. Jardine, letter, November 19, 1923, pp. 4–5; both in "Civil Service Uniforms," file no. 519, 1929–1936, Kadmin. Agric. Papers, Nigerian National Archives, Kaduna.
37. Rex Niven, *Nigerian Kaleidoscope: Memoirs of a Colonial Servant* (London: C. Hurst, 1982), 263–64.
38. Ibid., 252.
39. Northern Region of Nigeria, *Report on the Exchange of Customary Presents* (Nigeria: Government Printer, 1954), 13.
40. Norman J. Miners, *The Nigerian Army, 1956–1966* (London: Methuen, 1971), 103.
41. Commandant Mohammed Said, interview by author, Zaria, Nigeria, February 21, 2001.
42. Miners, *Nigerian Army*, 103.
43. Biyi Bandele-Thomas, *The Sympathetic Undertaker and Other Dreams* (Portsmouth, N.H.: Heinemann, 1991), 26.
44. Trevor Clark, *A Right Honourable Gentleman: Abubakar from the Black Rock* (London: Edward Arnold, 1991), 802.
45. I do not have information about the origins of this cloth or whether its introduction at this time was intentional or fortuitous. It may be a type of Chinese cotton brocade that is presently available in Nigerian markets.
46. Richard Synge, "Recent History," in *Africa South of the Sahara 2001*, 30th ed. (London: Europa, 2001), 871.
47. Mallam Yau Tanimu, interview by author, Zaria, Nigeria, March 1, 2001.
48. Alhaji Aminu Tijani, interview by author, Zaria, Nigeria, March 7, 2001. There is a similarly patterned machine-embroidered lace called Capitalist. I was also told of a type of cloth that has been named Atiku for the vice president, although I was unable to see it.
49. Ima Niboro, "Obasanjo's Operation Sweep," *Tell*, no. 26 (June 28, 1999): 21.

50. See R. J. Pokrant, "The Tailors of Kano City," in *From Craft to Industry: The Ethnography of Proto-industrial Cloth Production,* ed. Esther Goody (Cambridge: Cambridge University Press, 1982), 93. Pokrant noted this preference for lighter and less bulky robes in Kano.

51. Alhaji Dogara, interview by author, Zaria, Nigeria, February 26, 2001.

52. I was told that some Southerners in Kaduna decorated the back windows of their buses with pictures of Obasanjo, with the word "Baba" pasted beside him, although I did not see any during my brief visit there in March 2001.

53. See Federation of Nigeria, "Royal Nigerian Military Forces Ordinance, No. 26 of 1960," *The Nigerian Official Gazette* [Supplement] 47, no. 61 (September 29, 1960): A198. Unlike distributed robes, uniforms did not automatically become the property of military officers.

54. Usman Bugaje, "Interview with Usman Bugaje," interview by Danlami Nmodu, *Tell,* no. 44 (November 3, 1997): 32–33.

8 "Let Your Fashion Be in Line with Our Ghanaian Costume": Nation, Gender, and the Politics of Cloth-ing in Nkrumah's Ghana

Jean Allman

"We all voted to gain Independence for Ghana and to become one people," Hannah Kudjoe told audiences throughout northern Ghana in 1964.

> The barrier which the Imperialists created to divide the then Gold Coast in order to have the access of cheating us has now been broken and burnt into ashes by our illustrious Leader Osagyefo Dr. Kwame Nkrumah, Founder of the Nation. As we are now one, our fashion, culture and the way of life must also be identical. It [is] not good for some of us to prefer going out naked for some reasons. If it [is] due to custom, we should realise that such a custom is out-moded; and if it [is] due to poverty, we should all try to work hard to earn our living. . . . one expose[d] oneself to all sorts of dangers if one went about naked. The practice is also not in conformity with Ghanaian culture. . . . There [are] some people who [are] not actually nudes. They at least put on something, but they [are] too shabby. . . . [You must let your] fashion be in line with our Ghanaian costume.[1]

Kudjoe, a Convention People's Party (CPP) activist, founding member of the All-African Women's League and secretary and organizer of the Afro-American Ghanaian Women's Friendship League, launched a non-governmental campaign a year after Ghana's independence to address the problem of "nudity," particularly female nudity, in northern sections of the new nation.[2] The problem was considered an urgent one, and it attracted the attention of a wide range of individuals, some Ghanaian, some European (primarily missionaries), and some from the broader African Diaspora. In 1958, the eminent Pan-Africanist sociologist St. Clair Drake led, at the government's request, a large-scale research project on the "customs and attitudes relating to the wearing of clothing and ornaments in selected areas of northern Ghana."[3] By 1964, after non-governmental efforts had made little headway against the "problem," Nkrumah placed Kudjoe in charge of an intensive government campaign, under the aegis of the Ministry of Social Welfare, to combat what was considered an entrenched "social evil."

In her important 1996 publication, *Clothing and Difference*, Hildi Hendrickson

Figure 8.1. Prime Minister Kwame Nkrumah and his cabinet, 1954. Courtesy of Ghana Information Services.

writes of the body surface as a "principal site of social and political action." She proposes that "clothing and other treatments of the body surface are primary symbols in the performances through which modernity—and therefore history—have been conceived, constructed and challenged in Africa."[4] To date, however, only a few historians have explored the quite intimate connections between dress and national and Pan-African identities in post–World War II Africa and the Diaspora. Based on government documentation, newspaper coverage, and preliminary interviews with those involved in Ghana's "anti-nudity campaigns," as well as with those who were the intended recipients of Kudjoe's message, this essay explores the connections between dress, gender, nation, and power in Nkrumah's Ghana from 1957 to 1966. Its primary concern is with the public and nationalist discourse surrounding dress and "Ghanaian-ness" during the early and often heady years of African liberation. This discourse was certainly nationalist, Pan-Africanist, and, at moments, womanist or feminist in its vision. Yet it also embraced, in very specific ways, a colonial or missionary grammar of the "primitive," the "tribe," and the "down-trodden" as it articulated powerful hegemonic pulses from the southern Akan areas of the nation aimed at transforming so-called "Northerners" into proper "Ghanaians" through dress.

Clothing and Nudity: The "Civilized" and the "Savage" in Colonial Ghana

Nudity as a "national" problem may date to Ghana's independence, but the historical binary of "the naked and the clothed," as Esther and Jack Goody have demonstrated, is one that reaches far back into antiquity.[5] While this is not the place to review that story, a few general historical points should be made to provide

some context for understanding the campaigns led by Hannah Kudjoe and her comrades. First, we should be reminded that "nakedness" and "nudity" are socially and historically constructed. None of the groups targeted by Kudjoe in the 1950s—Talensi, Builsa, Nankanni, Dagara, and several others—considered themselves to be "undressed" or "nude."[6] Items of dress, which included skins, waist beads, and leaves, covered the genital areas of adult men and women and served to mark gender, status, and age. These societies did not, however, produce or weave cloth.[7] In that very specific sense, then, their members were "un-cloth-ed." Equally important, these were societies which were "stateless" and had been resistant to the spread of Islam. Historically, they constituted a belt of so-called "acephalous" societies, which ran west to east, bisecting the complex of Mossi-Dagomba kingdoms to the north and to the south. Inhabitants of those savanna kingdoms, some of which date back to the fifteenth century, were undoubtedly among the first to view the Talensi, Dagara, and others as "unclothed" or nude.[8] For them, not wearing cloth was a sign "at once of the pagan ('those who do not pray to God'), and of the savage (the wild, the 'men of the bush'), of those who live without the law of God or of man."[9]

Such perceptions notwithstanding, the Dagara, Talensi, and others were not isolated from exchange networks and were not without access to cloth. With their communities straddling north-south trade routes, they certainly could obtain cloth from Mossi traders well before the advent of colonial rule. Yet cloth was a foreign luxury item, and its use remained limited. Indeed, one reason for their rejection of cloth, the Goodys have argued, "was an opposition to those states with whom it was associated as well as to their traders, who were seen as legitimate prey by the acephalous peoples."[10]

External perceptions of these "unclothed" communities as "naked" and "primitive" thus have a long and complicated precolonial history—one that is imbricated in meta-narratives of long-distance trade, slavery, state formation, and the spread of Islam. It was a history, moreover, that did not end with the advent of colonial rule. The first British officials in the area derived their initial perceptions of the "uncloth-ed" peoples of the "Ashanti hinterland," as R. S. Rattray would later term it, from the "clothed"—from the inhabitants of those centralized savanna states which were earlier and more easily brought within the British Protectorate of the Northern Territories. Those perceptions both shaped and coalesced with extant racist and imperialist imaginings of the protectorate's "wild" northern frontier. The very first Annual Report on the Northern Territories, for the year 1898–99, for example, described the frontier as being "composed of men whose naked savagedom was a by-word of contempt among the more civilised inhabitants of the Mamprussi towns."[11]

Indeed, throughout the colonial period the binary of the "naked" and the "clothed" invigorated colonial discourse, while clothing, in its most literal sense as the donning of woven cloth, served as a barometer of the success, or failure, of the British "civilizing mission." Official diaries are replete with references to the presence or absence of cloth (local and imported) in the market and people's willingness to

purchase it.[12] That cloth was powerfully and symbolically implicated in the so-called civilizing mission on the northern frontier is perhaps nowhere better evident than in the colonial state's 1915 attack on the Talensi in the Tong Hills.[13] One of the very last areas to be brought within the colonial system, the Tong Hills had been "pacified" by British forces in 1911. However, by 1915 it was clear that the Talensis were still visiting "their great fetish place in the hills" and had not been effectively brought into the protectorate. The state decided to act, but this time cloth was more central to the attack than were guns. Having learned that a *tendaana* or earth priest wore only skins, the chief commissioner ordered that one of the main tendaanas for the Bona'ab shrine "divest himself of his skins and put on a native smock." The priest was paraded through the area, where his "arrival . . . robed in a cloth created an immense sensation."[14] In some ways cloth had accomplished what guns had not: the ritual disarming (for the moment, anyway) of the Talensis and their incorporation into the colonial state. Indeed, for many of the "stateless" on the protectorate's frontier, colonization came through cloth and clothing. The chiefs appointed by the British to rule over them were immediately distinguished by their flowing robes and the red fez atop their heads.

In the early years of colonial rule, cloth thus served initially as a means for comparing levels of civilization among the colonized, and then as a colonial index by which to measure the march toward civilization of the "wild" and "naked tribes" of the northern frontier. As that frontier was increasingly incorporated into the emerging colonial economy of the south, largely as a reservoir of cheap male migrant labor after 1910, cloth became a ready index of the extent of capitalist penetration. Again, diaries are replete with references to the growing number of young men from the far north "proceeding to Coomassie to work without money or clothes and returning with money or money saved in the form of trade goods."[15]

This was a process, colonial officials early realized, that was gendered in very explicit ways. As the 1910 Annual Report on the Northern Territories recorded, "cloth . . . is not yet in demand for their women and if peace and the beginning of civilization has created more demand for cloth for the men it is not noticeable among the women."[16] In the decade following the First World War, the colonial image dominating much official discourse on northern men was that of the increasingly clothed (read: increasingly civilized and subject to the cash economy) migrant worker. And what of his female counterpart? In a turn that is not all that surprising, she was, quite literally, left in the dust of civilization's march—untouched and untouchable by cloth, cash, or capitalism. If, according to colonial discourse, the northern frontier had been inhabited by "wild men" and "brutal savages" at the opening of the twentieth century, four decades later the "wild men" had been clothed and the "wild women" had been pushed, in their "simplicity," outside the march of history. In a twist that is perhaps best described as the feminization of the "noble savage," British colonial discourse of the late 1930s and '40s began to extol the "morals of the women whose only clothing is a bunch of leaves," arguing that they "are on a considerably higher plane than those who wear Manchester cotton goods."[17] This was the image that came to dominate colonial dis-

Figure 8.2. "Na Naam Bion, Chief of Tongo, wearing his red fez (mun) the chief emblem of his office, and clad in his finest ceremonial robes." From Meyer Fortes, *The Dynamics of Clanship among the Tallensi* (London: Oxford University Press for the International African Institute, 1945). Reprinted with the kind permission of the International African Institute.

course in the final years of colonial rule. As one officer wrote, "their women are naked; but it occurs to the writer that their women wear with their nakedness a dignity and purity in very favourable contrast to the bedizened license of the young ladies of more highly developed communities."[18] By the end of the colonial era, the binary of the "naked" and the "clothed" had thus shifted, however subtly, once again—this time into an explicitly gendered discourse of feminine savage nobility vs. masculine migrant work in the colonial cash economy.

"Nudity" as a Southern/National/Pan-African Problem?

It was as a perceived manifestation of female subordination and of northern regional backwardness that the problem of the "unclothed" entered into public debate in the wake of Ghana's independence in 1957 and the country's assumption of a prominent, vocal role in the Pan-African struggle for liberation. For the most part, this was a new, national discussion carried out in the southern regions of the nation—in the halls of parliament and in the pages of daily newspapers in Accra and Cape Coast. Yet in many ways, as we have seen, it was a discussion with very old roots—roots which reached back to early-twentieth-century colonial binaries of civilized and uncivilized, as well as to precolonial divisions within the north

between "state" and "state-less," Muslim and "pagan." As importantly, it was a national discussion which resonated with precolonial southern, primarily Akan, indigenous discourses regarding the naked, the wretched, and the unfree of the northern frontier.[19] This is not the place to grapple with the complexities of that particular history, but it is important to be cognizant of its existence. In 1935, for example, the chief of Osina complained to the *omanhene* of Akyem-Abuakwa about some "fetish practices" which had been imported from the north and established in his town. Not only were the southern adherents "bared nudely," but "during the course of the dance they will be employed as *kayakaya* [carriers] in different directions, some carrying water at the request of applicants for monetary reward and some too serving as menials after the fashion of the Northerners."[20] Here the Osina chief's remarks echoed both contemporary colonial discourses of the civilized and older Akan imaginings of the north and of northerners.

When the problem of the "unclothed" of the far north entered national public debate, therefore, it came not as a simple problem of fashion, Hannah Kudjoe's remarks notwithstanding. It was historically loaded—culturally, economically, and politically. It came in a tangle of indigenous, colonial, and postcolonial discourses, knotted around questions of power that were gendered, regional, and national. And it entered national public debate precisely at the moment that Ghana sought a leading role on the international stage, as the Black Star of Africa. From newspaper columns to the meetings of various women's organizations to the halls of parliament, the problem of the "unclothed" acquired a great degree of urgency. In large part, that urgency was about constructing Ghana's national image for a global audience—an effort to which many, from northern and southern parliamentarians to journalists to women's leaders, hoped to contribute. Yet for women activists, the problem of the "unclothed" was also very much a women's problem. As Mrs. E. Amarteifio, secretary general of the Federation of Ghana Women, told an audience in Tamale late in 1958, "nudity in the farther north was not only an eye-sore to the country but also did not reflect favourably on the high respect and reputation this country had achieved among the world." She continued, "Now that this country is free, we women must help to uphold her dignity. I therefore appeal to you women particularly in Tamale to visit your homes in the farther north and advise naked women to put on clothes."[21]

The national government's first concerted effort to grapple with the "problem of nudity" came in 1958, when the Department of Social Welfare and Community Development approached the Department of Sociology at the University College of Ghana with a request to conduct a careful study "which might provide a basis for understanding the reasons why some people in Northern Ghana do not wear clothing and what their attitudes are toward efforts to change their customs."[22] Research teams, organized by St. Clair Drake and made up of second-year students in sociology and social administration, were sent to three areas of the Northern Region to undertake a pilot survey over the Christmas vacation of 1958. Interestingly, Drake did not begin the project from the premise that nudity was inherently problematic; he saw it very much as a discursive problem in the sense that it was a

"social condition which a considerable number of ordinary people or some influ-
ential leaders consider undesirable and in need of change. In this sense, 'nudity' is
rapidly being defined as a social problem in Ghana." He continued,

> Patriotic people from all sections of the country who feel that the presence of un-
> clothed people elicits ridicule and scorn from foreigners; Northern Members of Parlia-
> ment who feel that "nudity" stigmatises their area as backward; members of the
> Northern Regional Assembly's women's leaders who feel that it is a symbol of the sub-
> ordination of women; and some Christians and Muslims who consider lack of cloth-
> ing a sign of paganism and immorality—all have, in recent months, begun to organise
> public support for a campaign to eradicate nudity from Northern Ghana.[23]

From the beginning, Drake insisted that the survey would not try to answer the
question of whether or not people should change their customs with regard to
clothing and, in the end, it did not. Indeed, rather than echoing broader public
concern about "backwardness" or "national reputation," Drake's final report sought,
in extremely critical ways, to unpack the problem. What struck him most from the
evidence gathered by the student researchers was the gendered nature of the prob-
lem in the 1950s: the fact that most northern men had access to clothing and many
women did not, but expressed an interest in clothing themselves. "Since there is a
feeling among many of the women," he argued,

> that a society in which men wear clothes but they do not is one where nudity becomes
> the symbol of their inferior status, this suggests that the whole problem of nudity
> might be linked with that of improving the status of the women generally. This, inci-
> dentally, raises the whole problem out of the realm of extending Puritan morality or
> defending the national reputation, into one of general humanitarian interest and in
> line with United Nations commitments to try to give equality of treatment irrespec-
> tive of sex. It has the additional merit of basing a campaign upon wishes and desire of
> the people affected rather than solely upon the wishes and desires of people from the
> outside whether they be Southerners or Northern groups which wear clothing. . . . As
> one reads the student reports, one is continually made aware of the fact that dignity
> and warmth, intelligence and character, exist among the unclothed as well as among
> the clothed. And that there is certainly a desire on the part of a significant proportion
> of the women to adjust their clothing habits to the new and sometimes bewildering
> values of those who think nudity is unbecoming. It is upon these qualities latent in
> the people that a programme should be built, if a decision is made that nudity must be
> eradicated.[24]

In many ways Drake's report was quite remarkable, given the time and the con-
text in which it was written. Being "unclothed" for Drake was not, in and of itself,
a social problem. If, however, it expressed or embodied gender inequalities in given
societies, then it was a problem, though a very different one from the problem
identified by many of the nationalists who were engaging in public debates over
nudity. Drake's report encouraged policy-makers to look inward and to be less con-
cerned with the country's international image and more concerned with the dy-
namics of power within Ghana. Any campaign against nudity should not be driven
by southern desires or hegemonic impulses, nor by concerns for Puritan morality

or national image. Indeed, Drake even left open the possibility that "nudity," in this context, need not be eradicated at all. His final report instead highlighted the complexity of the so-called problem, often by letting those whom the students had interviewed speak for themselves. As one farmer explained to student researcher K. S. Arhin,

> My friend, go to the yard. There you will see my six wives. They all wear leaves. They have pieces of cloth for market days but not for others. It is because we cannot sell all our millet in order to get clothes; we would die of starvation. To us life is more important than clothes. You people in the South are blessed. You have work to do. Here are boys who have just finished school and we know nobody in the South who can find them jobs. They come back to the farm to work clothed in rags. Tell the white man who sent you here to bring us jobs and we shall wear clothes.[25]

Although Drake's report did not dwell on the long historical trajectory of the "problem of nudity," it was an insightful, critical report that went a long way toward disentangling the issues and foregrounding both gender inequalities and uneven development between the regions. In short, it provided just the kind of information and insight that was capable of shifting the terms of the national debate and refocusing public concern.

But, unfortunately, Drake's report suffered a fate shared by many scholarly exercises which don't fit neatly into extant paradigms or which challenge the assumptions upon which popular opinion is based. It was swallowed up and eventually lost in the bureaucratic belly of the new state. It did not set the public or national agenda. The questions it raised were not, by and large, the questions that would guide policy-makers in the coming years. Rather, the "problem of nudity" would remain a tangled discursive problem subject to the changing personalities and shifting political exigencies of the day. In that sense, it was true to its long and troubled past.

The National Campaigns against Nudity

The campaigns that were ultimately launched to combat nudity and other "undesirable social practices" within Ghana from 1959 until Nkrumah's overthrow in 1966 did not, for the most part, build on the insight and promise of Drake's report by transcending modernizing (colonial) discourses regarding civilization or by challenging southern indigenous imaginings of a "primitive" north. The visions fueling the campaigns consistently slipped and slid between regional uplift, national unity, and Pan-African civilization. But they also incorporated—first to a great extent, and then to a much diminished degree—concern for gender equality, albeit a concern hitched to southern perceptions of a backward north inherently more hostile to women's concerns. Where British colonial officers saw "purity," "simplicity," and "noble savagery" in the unclothed women of the northern frontier in the 1930s, many women's leaders and CPP activists of the 1960s saw subordination and exploitation, and therefore sought to foreground the struggle for gender equality in their work. Indeed, how the anti-nudity campaigns (as they were

termed) of 1958–66 pulled from and utilized these overlapping and competing discourses over the first years of independence, I would argue, tells us much about dynamics of power within Ghana's national project and the fate of the women's question in that project.

Central both to the national project and to debates on the position of women was Hannah Kudjoe, a CPP activist and women's leader whose career, in many ways, maps the trajectory of the campaigns in the early national period. The first concerted national campaign to end nudity originated as a non-governmental initiative with Kudjoe and the All-African Women's League, which she chaired. From 1958 to 1960, the AAWL, with the assistance of its associated organization, the Afro-American Ghanaian Women's Friendship League (for which Kudjoe also served as secretary and organizer), brought in gift parcels of old clothing from abroad and distributed them to people in the north.[26] This early non-governmental campaign was clearly grounded in and energized by the interactions between Ghanaian and diasporic women.[27] While it was concerned with Ghana's national image, the status of women and women's role in the construction of that national image remained of paramount concern.

Government officials had mixed reactions to Kudjoe and the AAWL's early work. On one hand, many expressed profound gratitude for the work being done. As Salifu Yakubu (CPP representative for Savelugu) stated in parliament in July 1960, "It is inspiring to look at the fine work done to eradicate nudity in the North by that woman philantropist [sic] by name Mrs. Hanna Cudjoe. She has traveled all over the North . . . to teach the people in that region to clothe themselves, and even she has been to the region of the former Leader of the Opposition in the House to educate the womenfolk there to cloth themselves."[28] On the other hand, government officials who were primarily concerned with national image feared that any publicity regarding the campaign would reflect poorly on the nation as a whole. For example, L. R. Abavana, the northern regional commissioner, worried that Kudjoe's collection of second-hand clothing abroad "drew attention to the problem overseas."[29] In a concerned letter to Nkrumah, he wrote,

> My Secretary has been officially informed that you have indicated uneasiness over the implications of the campaign being carried on in this Region by Mrs. Hannah Cudjoe's organisation, the main aim of which is to eradicate nudity which is practised in certain areas. . . . I understand that you feel that arrangements for dealing with the problem of nudity should be under my supervision and that there should be a suitable programme and procedure. . . . I feel that the press publicity on this subject may tend to suggest that the degree of nudity in this Region is greater than it is in fact; and I therefore intend to arrange that more publicity is given to such activities as health projects, nutrition work, and infant welfare and less to anti-nudity "campaign."[30]

As Abavana's letter indicates, CPP leaders, Nkrumah included, were extremely concerned about bad press and national reputation. Nkrumah wrote to Krobo Edusei on October 5, 1959, stating that he was aware of Kudjoe's campaign, but also of similar work by religious bodies and other organizations. He concluded that unless "something was done at the official level to co-ordinate all these efforts very

little lasting results would be achieved."[31] While lasting results were certainly desirable, keeping the campaign low-profile and bringing non-governmental women's organizations like the AAWL under government purview were clearly of paramount importance.[32] As the northern regional commissioner's secretary explained to the principal community development officer,

> the Prime Minister sometime ago indicated uneasiness about the publicity being given to the anti-nudity campaign which has been carried on by Mrs. Hannah Cudjoe in a largely independent role. He expressed the view that arrangements should be under the supervision of the Regional Commissioner and that if Mrs. Hannah Cudjoe should continue to work in this Region she would work within a suitable programme run by the Regional Office and your Department.[33]

By the close of 1960, therefore, what had been a non-governmental movement spearheaded by women's leaders in Ghana who drew from and sought to inspire a broader Pan-African women's agenda was being brought within the purview of the state. There, CPP leaders hoped, it could be more closely monitored and more intimately tied to the national project.

Yet, largely because of the efforts of southern women activists speaking from within and outside state and party offices, this was easier said than done. The gendered dimensions and implications of the campaigns were consistently reinserted into the national project. Perhaps it is not so surprising, therefore, that the regional commissioner for the north described "this question of nudity in the Northern and Upper Regions . . . as a complete headache to the Osagyefo [Nkrumah] and the Convention People's Party Government."[34] From 1960 to 1963, the government, through the Department of Social Welfare and Community Development, tried to coordinate the efforts of governmental and non-governmental organizations, while lowering the profile of the "nudity problem." In very concrete ways, that meant contending with the overlapping but often competing interests of southern, largely Akan, women activists and of male government officials, like the regional commissioner, who originally hailed from the north. Up to 1964, the government was not particularly successful. Anti-nudity campaigns were launched and relaunched in the first three years of the decade, but invariably with Kudjoe—a formidable leader—at the helm. Although the campaigns, administered through the Department of Social Welfare, fell increasingly within the purview of the state, tension continued between those, like Kudjoe, who saw the problem of nudity as one of poverty and women's subordination, and those who were concerned primarily with the national project—with Ghana's national image and reputation and the north's contribution to that image. For example, while Kudjoe continued to travel through the north, distributing clothes and lecturing women on various forms of self-help, the regional commissioner fretted over national reputation and refused to accept any excuses from his countrymen for the "outmoded practice." He told listeners throughout the north in public rallies,

> The government is anxious that I should report to them in two months' time that the practice has stopped in this area and I want you all to co-operate so that even early

next month I should be able to tell them that Nudity does not exist anymore in this area. . . . I am particularly anxious that all women clothe themselves immediately. . . .

It is not a question of lack of money which prevents you from buying clothes for your wives to put on, because we all know that [you] are hardworking farmers who grow a lot of the crops in this area and sell, apart from owning large herds of cattle. The question of poverty is therefore ruled out. We have also ruled out the question of the practice being a custom handed down to you by your ancestors because it is a bad custom so there is no reason why the practice should continue.

Many visitors come to this country and some of them take photographs of the nude women which they take away to their countries to show people to the discredit of Ghana.

The Ghana Government is determined to root out this practice. If you do not heed the appeal and stop voluntarily, then they will be forced to take necessary action to stop it.[35]

The analysis of the problem set out by the commissioner in his regional tour certainly differed markedly from that set out by Drake in his 1959 report. A discursive problem, reflecting specific social conditions and national concerns at the dawn of independence, had become very much a political problem, even a political football. And the tension between nation and gender, between Regional Commissioner Abavana's mission to quickly clothe the north for the sake of the nation and Kudjoe's mission to uplift, mobilize, and politicize northern women, became increasingly problematic for the CPP.[36]

Early in 1964 Nkrumah moved to address this tension once and for all. Earlier, Kudjoe had been brought into the Ministry of Labour and Social Welfare as the national organizer and secretary of the Ghana Day Nurseries. In January, her position was extended to include directing "anti-nudity operations" in what were now the Northern and Upper Regions of the country under the auspices of the ministry. Initially, her operations were placed under the auspices of a National Committee for Anti-Nudity.[37] A few months later, undoubtedly because of concern about publicity and national image, that original committee was disbanded and the operations were placed under a newly constituted National Committee for Social Advancement. As Kudjoe explained in an early memo, "the functions and duties of this National Committee for Social Advancement . . . were not very clear and definite enough as it appears the National Committee is concerned with many social aspects of Ghanaian life, of which the campaign against nudity and other undesirable social practices forms just one aspect of it."[38] Thus it was that Kudjoe's anti-nudity campaigns were again relaunched, in June 1964, as one of a number of state-controlled and state-coordinated efforts carried out under the national rubric of social advancement. All operations, moreover, were placed under a "policy of 'no-publicity.'"[39]

What did the operations entail? Fortunately, because Kudjoe's efforts were now fully within the purview of the state, we have ample documentary evidence about the campaigns. Centers for the campaign were set up in Bolgatanga, Bawku, Navrongo, Sandema, Wa, and Lawra, and field assistants were hired to carry out work which was intended to focus, initially, on "house to house visits" aimed at "educat-

Figure 8.3. Hannah Kudjoe with northern elders and chiefs. No date. Courtesy of her nephew, Peter Dadson.

ing people on the need for clothing and personal hygiene."[40] Kudjoe instructed each assistant to

> study carefully the psychology (and history) of the people among whom she is working and apply this approach to win their confidence. . . . Never allow people . . . to go about naked. It is indecent. Urge and encourage mothers to clothe themselves. Defy beliefs in relation to nudity. Instruct and give simple needlework lessons to the public. Teach and educate the public about clothing. Young people imitate or copy adults. Set a good example to them.[41]

Meanwhile, Kudjoe herself took an extremely active role in the campaigns, undertaking frequent tours throughout the region, holding public rallies at open markets, providing demonstrations, and distributing free articles of clothing. (Her own account of a public rally opened this chapter.) But Kudjoe's efforts did not entail just motivational speaking and the distribution of free clothing. She worked very closely with so-called traditional rulers and had an especially close relationship with *Sandemanaaba*, whose own daughter, Margaret Azantilow, would become an enthusiastic participant in Kudjoe's campaigns. Azantilow's recent reminiscences suggest that the transformative potential of Kudjoe's efforts was far greater than her rhetoric about fashion and about clothing the nation might suggest. In areas where women did not traditionally farm, Kudjoe worked with them to set up cooperative farms in order for women to provide their own food, as well as income for clothing and other personal needs:

> So when she started we would meet in groups and we worked to convince the women that it was high time that they stopped using the leaves [as dress]. And when Miss

Hannah Kudjoe came she brought some old clothes and every two weeks we would meet and she would contribute something. And during the hunger time, there is no food at all and Miss Hannah Kudjoe would appeal to various organizations to donate food for the people here in the north. Rice, millet, corn. And then, from there, she said we should make farms, that women should make farms. So then every Saturday we would gather together at a place and all of the women would do the farming. We would show them how to do it. And she, herself, would come here at least every three months. She would go and make her rounds and come back. And then later, we did needlework with the women.[42]

Unlike many of her contemporaries in government, Kudjoe increasingly understood that the "problem of nudity" struck at the very core of domestic economies in the areas in which she worked: the sexual division of labor, marriage negotiations, and the rights and responsibilities of spouses and of parents. As she explained in one memo, women often complained that their husbands did not buy them clothes. Men, in turn, argued that they had given cows to these women's parents when they were betrothed and therefore the women should insist that their parents sell the cows to purchase clothing for their daughters. By including in her campaign economic self-help, education, work with local authorities, and institution-building among local women, Kudjoe tried to get inside those local domestic economies. Through such multifaceted efforts, she believed, the problem of nudity would be solved: "if the operation . . . continued this time, without break, nudity and other undesirable social practices in the country [would] be eradicated once and for all."[43]

The National Project, the Women's Question, and Anti-nudity Operations in Retrospect

How does a historian, looking back on these 1964 campaigns with nearly forty years of hindsight, begin to make sense of them? Certainly, Kudjoe and those who worked closely with her throughout the Nkrumah period did an extraordinary job of asserting the centrality of women's issues to the new national project. Despite continual state efforts to reel Kudjoe in, her agenda remained stubbornly consistent and public. Was it a feminist agenda? A womanist agenda? I am not convinced that those are the most interesting questions to ask, at this stage. Indeed, what is so fascinating about the anti-nudity campaigns and the discourse surrounding them is that they do not fit nicely into neat and tidy categories. Clearly Hannah Kudjoe had a vision of the nation—no less than Nkrumah, Abavana, or any other activist or CPP official during this period. But for her, the national project needed to grapple, directly and publicly, with the women's question, with the position of women in Ghana and their role in the construction of a Ghanaian nation. If that meant exposing gendered cracks and crevices in the national façade, so be it. And in that particular and very important sense, Kudjoe's work was very much in the spirit of St. Clair Drake's 1959 report.

Yet there was much in Kudjoe's rhetoric which was neither transcendent nor liberatory. Rather, it (re)inscribed southern or Akan hegemony over the very con-

struction of "nation," as it painted northern "backwardness" onto the national palette with indelible ink. The "Ghanaian costume" in which Kudjoe sought to dress the north was very much based on southern Ghanaian notions of what it meant to be "clothed" (though the actual clothes distributed were seldom "in line" with "Ghanaian fashion" and were made up primarily of second-hand European and North American items brought in by various non-governmental organizations). Her vocabulary of uplift, moreover, often echoed earlier colonial and missionary discourses of modernization. For example, the free distribution of clothing, she explained in 1965, "is only meant . . . to serve as inducement and encouragement to the nudes. As industrialisation and development spread over the Region, it is our hope that the nudes, after acquiring the habit of clothing themselves, will in due course, be able to acquire their own articles of clothing."[44] This kind of modernizing discourse permeates the records of the anti-nudity operations from 1964 to 1966. A field assistant was described as having "demonstrated to them the proper way to bathe oneself. . . . [she] gave the needy nudes some clothings and urged them to follow up what she had taught them."[45] Twenty years before, in the heart of Ghana's Akan south—Kumasi—a British missionary, Kathleen White, had written home, "I used this initial visit to talk to the women on cleanliness in their homes and in most of the villages I bathed babies and washed sores."[46] In many ways, it is difficult to differentiate between what has been described as the "missionary feminism" of the 1930s and '40s and what we perhaps might call the "nationalist" or "postcolonial feminism" of the immediate post-independence years. Those women in the south, like Hannah Kudjoe, who had been on the receiving end of such discourse in the colonial period made it their own in the nearly national period, as they turned to uplift those whom they saw as their more unfortunate sisters in the north.

Regretfully, we cannot assess the long-term impact of Kudjoe's efforts—of a struggle that had begun as a non-governmental initiative by Ghanaian and African American women activists and had wound up as an "Operation" under the aegis of a National Committee for Social Advancement, overseen by the Ministry of Labour and Social Welfare through its Department of Social Welfare and Community Development. Less than two years after "sustained" operations were launched, Nkrumah's government was overthrown in a military coup and the National Committee for Social Advancement went the way of most of the CPP's public campaigns. Hannah Kudjoe, however, did not simply fade into the sunset. One of her assistants recently recalled that she continued to do philanthropic work on her own, much as she had done when she began her work on the eve of independence. Indeed, up until a few months before her death on March 9, 1986, Kudjoe continued to make journeys to the Upper and Northern Regions.[47] But without organizational or state support, her work was seriously curtailed.

Meanwhile, subsequent Ghanaian governments—military and civilian alike—have taken up in their turn the "problem" of nudity in the northern regions, but in comparatively superficial ways. The national project—so boldly and confidently begun by Nkrumah and the CPP—was a very different project for the soldiers of 1966 and for the civilians of 1972, as nationalist dreams gave way to neocolonial night-

Figure 8.4. Hannah Kudjoe tending a child's wound. No date. Courtesy of her nephew, Peter Dadson.

mares. Efforts to combat nudity were sporadic and fragmentary, at best. They were also completely bereft of any gender analysis or gendered social policy. The national project had indeed changed, and one measure of that change was the almost complete exclusion of women and the women's question from that project. In important ways, the construction of Ghana as "nation" prior to 1966 included a place to debate gender, however couched that debate might have been in discourses of modernization and however hard women like Hannah Kudjoe had to struggle to keep that space open. The national project after 1966 left little room. Several times in 1968 and 1969, A. I. K. Quainoo, the chief community development officer in the Northern Region, blamed the ongoing problem of nudity on what was happening on the other side of the national border in Côte d'Ivoire, where nudity had been outlawed. He argued that the real problem was that people were running away to the Ghanaian side of the border, "where they were not troubled."[48] If we think of the changing public debates about nudity and clothing as a window through which to view the construction of a Ghanaian nation, then post-1966 debates suggest that the national project now had far more to do with recognizing and upholding national borders and far less to do with debating women and gender.

So, through all of this, were people from Ghana's far northern regions eventually molded into "proper Ghanaians" through dress? Those who handed out second-hand European and American clothes year after year, Kudjoe included, always believed the distributions were a temporary measure and that eventually people of the north would "catch on" and buy clothes of their own accord, thus marking their maturation into fully fashioned national citizens. Yet in many areas, despite

Figure 8.5. Hannah Kudjoe with a great-niece. No date. Courtesy of her nephew, Peter Dadson.

sustained efforts, that simply did not happen. Many on the receiving end of these operations assumed that if the government wanted them to wear clothes, it should provide them and keep providing them.[49] As one Navrongo chief's wife told Drake's research assistant in 1958, "Go and tell the Government to bring us clothes if the Government wants us to wear clothes."[50]

Still, if you travel through the Tong Hills or Builsa land today, the "problem" of the "uncloth-ed" seems largely to have vanished, but it is hard to attribute that change to the success of a national project aimed at making a nation by clothing it. Few elderly women in the north would offer such an explanation. Today, when you ask them when they began putting on dresses, many recall doing so only recently, connecting wearing clothes to their increased participation in farming activities over the past two or three decades. As the economy declined, beginning in the 1970s, and more and more of their children headed south in search of work, women began to assist their husbands with farming and thereby began to claim some of what was produced for themselves. Out of that configuration of changes, they argue, women began to acquire dresses.[51] Such tales of dress and (second-hand) clothing, of gender and farming, ground social change in the daily lives of ordinary folks, in domestic economies, in the uneven development of Ghana, and in the economic marginalization of the north. But the anti-nudity campaigns of the 1960s, as they sought to forge a nation between north and south, did not in-

Figure 8.6. Talensi women sifting millet in Tenzug, 2001. Photograph by Jean Allman.

corporate a close questioning of those powerful realities, much less of the diverse range of local patriarchies, north and south, that continued to circumscribe women's autonomy. In the end, and despite the concerted and well-meaning efforts of Hannah Kudjoe, the fashioning of a Ghanaian nation only reinscribed old (colonial and precolonial) stories in new national ways.

Notes

This chapter has grown out of a much larger project on Talensi and Ghanaian history, *Tong: Of Ritual, Resistance, and Transmigration in West Africa,* which I am working on in collaboration with John Parker, School of Oriental and African Studies, University of London. The sections dealing with clothing and civilization in the early colonial period draw from our collective efforts. My research on that larger project has been generously supported by the National Endowment for the Humanities and the Department of Education's Fulbright-Hays Program, as well as by the University of Minnesota and the Institute of African Studies,

University of Ghana. See Allman and Parker, "Tonna'ab and Nana Tongo in the Religious Landscape of Twentieth-Century Ghana," in *Religious Modernities in West Africa: New Moralities in Colonial and Post-colonial Societies,* ed. John Hanson and Rijk van Dijk (Bloomington: Indiana University Press, forthcoming).

1. Regional Archives of Ghana, Tamale [hereafter RAGT], NRG 9/2/6: Hannah Kudjoe, "Report of My Recent Tour of the Northern and Upper Regions on Anti-Nudity Operations from 16–27 June 1964." Note that Kudjoe's name is sometimes rendered "Cudjoe" in the archival record. In her own correspondence, she uses a "K."

2. Despite Kudjoe's central role in women's struggles and in the nationalist movement, she has not received the attention she warrants from scholars of Ghana's recent past. An important exception is Takyiwaa Manuh's "Women and Their Organizations during the Convention People's Party Period," in Kwame Arhin, ed., *The Life and Work of Kwame Nkrumah* (Trenton, N.J.: African World Press, 1993), 101–28.

3. RAGT, NRG 8/2/152: St. Clair Drake, "Nudity as a Social Problem in Ghana," Department of Sociology, University College of Ghana, 1959.

4. Hildi Hendrickson, *Clothing and Difference: Embodied Identities in Colonial and Post-colonial Africa* (Durham, N.C.: Duke University Press, 1996), 3, 13.

5. Here I am borrowing directly from Esther Goody and Jack Goody's important article "The Naked and the Clothed," in *The Cloth of Many Colored Silks: Papers on History and Society, Ghanaian and Islamic, in Honor of Ivor Wilks,* ed. John Hunwick and Nancy Lawler (Evanston, Ill.: Northwestern University Press, 1996), 67–90.

6. Ibid., 70.

7. Here I am following the lead of scholars of clothing and apparel in differentiating between "dress" and "clothing." Eicher and Sumberg define dress as "an assemblage of modifications of the body and/or supplements to the body [which] includes obvious items placed on the body (the supplements) such as garments, jewelry, and accessories, and also changes in color, texture, smell and shape made to the body directly." When I use the term "clothing" I am referring specifically to the use of cloth to cover parts of the body. See Joanne B. Eicher and Barbara Sumberg, "World Fashion, Ethnic, and National Dress," in *Dress and Ethnicity,* ed. Joanne B. Eicher (Oxford: Berg, 1995), 298. Among the Talensi, key items of dress include *gbung* (skin), *kpalang* (loincloth) for men, and *vok* (loincloth) for women. Gorogonaba Yikpendaan Wabazaa (aged about eighty-nine) and his junior brother, Chuhiya Doukoobik, interview by Jean Allman and John Parker, in Gorogo, August 21, 1999.

8. Allman and Parker, "Tonna'ab."

9. Goody and Goody, "Naked and the Clothed," 69.

10. Ibid., 73.

11. Public Record Office [hereafter PRO], Colonial Office [hereafter CO] 879/58: Correspondence Relating to the Northern Territories 1899, no. 96, Northcott to CO, July 9, 1899, 180. See also Allman and Parker, "Tonna'ab."

12. See, for example, National Archives of Ghana [hereafter NAG], ADM 56/1/126: acting commissioner, North-Eastern Province, to chief commissioner, Northern Territories, August 22, 1911, which includes an excerpt from Capt. D. Nash's report dated August 7, 1911: "Another fact that tends to enhance the price of in-

digenous products here is the presence of a large crowd of middle men, chiefly Dagombas, Hausas and Moshis. They will go round to the various native compounds and buy food supplies in exchange for cloth, etc. and then retail the food in the market at an enhanced price." See also NAG, ADM 63/5/2, district record book, Navrongo, 1909–1918. "There is a small caravan route passing through the town from Moshi. The traders from the latter town bring down cloth and exchange it for sheep which they take down country with them." February 25, 1906.

13. The Tong Hills are located approximately eight miles southeast of Bolgatanga, the regional capital of today's Upper East Region. See Allman and Parker, "Tonna'ab."

14. NAG, ADM 56/1/207: "Notes of Evidence Taken . . . in Connection with the Renewal of the Fetish in the Tong Hills," Zourangu, February 2, 1915. See also PRO, CO 96/557: governor to Harcourt, April 22, 1915, and Allman and Parker, "Tonna'ab."

15. RAGT, NRG 14/6/7: "Notes of a Meeting of the Sub-Committee on Migratory Labour held in the Commissioner of Labour's Office on 7 Oct. 1952," citing a 1912 report. In the many life stories from the area, this is a common narrative— walking to the south unclothed and returning with clothes.

16. NAG, ADM 56/1/448: Annual Report, Northern Territories, 1910.

17. RAGT, NRG 6/3/1: Annual Report, Navrongo Area, 1934–35.

18. RAGT, NRG 8/3/160: Annual Report, Mamprusi District, 1948–49.

19. For a much fuller discussion of Akan views of the northern frontier, see Allman and Parker, "Tonna'ab."

20. Akyem-Abuakwa State Archives 3/282: *ohene* of Osina, Barima Otu DArko II, to *omanhene* of Akyem-Abuakwa, Osino, August 13, 1935. See also, in the same file, Isaac Newman Boadu and others to omanhene, Akyem-Abuakwa, Abomosu, August 15, 1935, in which Boadu complains of the "Gare Cult" [Tigare]:

1. That the so-called Moshi area has diabolically enchanted fifty two Christians in town whose names are herein attached.

2. That they intentionally parade in streets with beating of drums, singing, yelling and firing of arms, during service hours on sabbath days.

3. That one of service hymns which runs in Twi as "Yere beyi Abwuade Aye" has been recomposed by one Kwasi Atobra to "yere Beyi Gare Aye" to promote riot.

4. That education has been eschewed by pupils of Gare worshipping families.

5. That open-air-services are looked upon as a mere gathering of drunkards.

6. That drinking has been their daily diet as the wives or Gare priestesses have not time to approach the kitchen for cooking or attending farms. A stranger from Accra strangely asked as he dropped from a lorry "What is the great funeral in this town?" The answer to the gentleman was, "We are worhipping Onyame Gare."

7. That stagnant waters has been kept in their shrine which in their ignorance don't consider that mosquitoe is another devil in disguise.

8. That sanitary condition is neglected. . . .

9. That the said witchcraft dance has created hateful competition between Christians and Gare worshippers . . .

10. That farming has been eschewed and drinking, fighting and unnecessary gossipping have substituted.

11. That women walk nakedly, behave disgracefully, eat in streets, eating a snake, cobra.

We are sorry that true sons and daughters of Akim Abuakwa have entirely changed their custom, living and manner and language into Moshi.

21. RAGT, NRG 10/15/02: "Nudity in Northern Region is Eye-Sore," *Ghanaian Times*, November 26, 1958.
22. Drake, "Nudity as a Social Problem."
23. Ibid.
24. Ibid.
25. Ibid. This particular interview was conducted by K. S. Arhin (also known as Arhin Brempong), who would go on to be a leading scholar of Ghanaian and Asante history.
26. RAGT, NRG 10/15/2: J. E. K. Mould, permanent secretary, Ministry of Finance, to director, Department of Social Welfare and Community Development, "Exemption from Customs Duty: Afro-American Ghanaian Women's Friendship League," Accra, March 11, 1959.
27. These culminated in the large Conference for Women of African and African Descent which was held in Accra July 15–25, 1960. The evidence I have come across indicates that George Padmore played an instrumental role in organizing the conference before his death. See NAG, ADM 13/1/20: cabinet minutes, June 17 and 24, 1960.
28. NAG, ADM 14.2.109: *Parliamentary Debates*, vol. 20, July 29, 1960, col. 376.
29. RAGT, NRG 8/2/152: "Meeting of the Ministry of Health and Social Welfare with the Director of Social Welfare and Representatives of the Ministry on Nudity in the North held at the Regional Commissioner's Office," Tamale, January 18, 1960.
30. RAGT, NRG 9/2/6: L. R. Abavana to Kwame Nkrumah, August 19, 1959.
31. RAGT, NRG 9/2/6: Kwame Nkrumah to Krobo Edusei, Accra, October 5, 1959.
32. RAGT, NRG 9/2/6: principal secretary, Ministry of Social Welfare, "Memorandum on Nudity in the Northern and Upper Regions," Accra, September 3, 1960.
33. RAGT, NRG 9/2/6: E. S. Packham, secretary to the regional commissioner, to principal community development officer, Department of Social Welfare and Community Development, Tamale, October 3, 1959.
34. RAGT, NRG 8/6/28: regional commissioner to national organizer, Ghana Women's League Accra, Tamale, January 18, 1961.
35. RAGT, NRG 8/2/152: "Speech by the Regional Commissioner Northern Region at Rallies at Sawla and Tuna against Nudity and Other Undesirable Practices, on 1 February 1961." The commissioner was not simply blowing hot air. One of the first responses by the CPP government to the "problem of nudity" came in the course of a cabinet meeting in August 1960 when members ultimately decided that "steps should be taken to abolish nudity . . . in Ghana by law." The decision was postponed for the time being, but was used as a threat by government officials throughout the period. See NAG, ADM 13/1/20: cabinet minutes, August 2, 1960.
36. Note, for example, complaints by women activists in the north that they were being marginalized by men activists and government officials. See RAGT, NRG

8/6/48: "Minutes of Proceedings of Meeting held at Women's Section of CPP Tamale at the Chairlady's Residence," Tamale, July 2, 1962.

37. The Northern Region was divided into a Northern Region and an Upper Region in 1960. RAGT, NRG 9/2/6: principal secretary, Ministry of Labour and Social Welfare, to secretary to the regional commissioner, Upper Region, Accra, January 27, 1964. The committee was composed of A. Asumda, regional commissioner of the Upper Region, as chairman; Mr. Chirnayira, the regional secretary of the CPP in the Upper Region, as vice chairman; and the following representatives: a member of the Ministry of Labour and Social Welfare; Bolga Naa; Chanipio; Sandemanaba; Asana Wara; the CPP Woman Chairman, Navrongo; the CPP Woman Chairman, Bongo; the CPP Woman Chairman, Lawra; Nandom Naa; and Mrs. Agnes Tahiru, the secretary of the National Council of Ghanaian Women. Its ex-officio members were all the members of parliament and district commissioners in the Upper and Northern Region; the regional information officer; the regional education officer, the regional nutrition officer, the CPP regional organizer, and the CPP regional secretary.

38. See RAGT, NRG 9/2/6: director, "Anti Nudity Operations," "Progress Report, Campaign against Nudity and Other Undesirable Social Practices in the North of Ghana, July–September 1964." The new committee comprised the minister of labor and social welfare (chair) and Hannah Kudjoe, S. O. Obuobi, A. C. Salami, S. C. Jiagge, Cecilia Bukari-Yakubu (M.P.), M. N. Honsby-Odoi, E. E. A. Brew, Magnus George, Lily Appiah, A. J. Hughes, and J. K. Yorke. The committee's funding for 1963–64 was 5,000 Ghana Pounds, although it was actually allotted only 3,340. For the draft constitution of the committee, see RAGT, NRG 9/4/8: "Draft Constitution for the National Committee for Social Advancement." Its aims and objects are described there as being

a. To Organise Campaigns against nudity and undesirable social practices among certain people of the community throughout Ghana.
b. To discourage and ultimately abolish tribal marks on the face and body.
c. To abolish female circumcision.
d. To instill in the minds of the people the need for proper care and training of children.

Membership: Membership of the Committee shall be open to men and women who have the interest of the people in Ghana at heart and preferably are resident in Accra. The number shall however not exceed 20.

See RAGT, NRG 7/11/11 for correspondence relating to the difficulties of getting committee work operationalized.

39. See, for example, RAGT, NRG 8/3/260: "Monthly Progress Report on Nudity, 1964–73."

40. RAGT, NRG 6/2/6: secretary to the regional commissioner to district commissioners, regional office, Bolga, June 22, 1964.

41. RAGT, NRG 10/15/1: Hannah Kudjoe, "Report of My Recent Tour to the Northern and Upper Regions on Anti-Nudity Operations from 16th–27th June, 1964."

42. Margaret Azantilow, interview by author, in Sandema, June 13, 2001.

43. RAGT, NRG 10/15/1, Hannah Kudjoe, "Report of My Recent Tour to the Northern and Upper Regions on Anti-nudity Operations from 16th–27th June, 1964."

44. RAGT, NRG 7/11/11: Social Advancement Unit of the Ministry of Social Welfare, "Progress Report for the Period October, 1964 to March, 1965."
45. RAGT, NRG 8/2/216, "Kate" (for director) to regional commissioners, Northern and Upper Regions, Accra, March 27, 1965.
46. Wesleyan Methodist Mission Society, Women's Work Section: K. White to Miss Walton, Kumasi, June 17, 1941.
47. Peter Dadson, interview by author, in Accra, July 27, 2002.
48. RAGT, NRG 8/2/216: Mr. Quainoo, chief community development officer, "Nudity in the North: Report of a Visit to the Northern and Upper Regions, 2–4 December 1968."
49. RAGT, NRG 8/2/216: district administrative officer, Damongo, to regional administrative officer, Tamale, Damongo, October 19, 1972.
50. Drake, "Nudity as a Social Problem."
51. See, for example, Punaar and Maryama, in Kpatar, Tenzuk, June 8, 2001; Dema'ame, in Gundaat, Tenzuk, June 8, 2001; Gorogonaba Yikpendaan Wabazaa, in Gorogo, June 9, 2001; Goring, in Sheaga-Tindongo, June 12, 2001; interviews by author.

9 Dressing Dangerously: Miniskirts, Gender Relations, and Sexuality in Zambia

Karen Tranberg Hansen

Of all objects of everyday life in Zambia, a former British colony in south-central Africa, clothes are among the strongest bearers of cultural meaning both for the people who wear them and for those who perceive their dressed bodies. Widespread cultural sensibilities about gender, sexuality, age, and status converge on the dressed body, weighing on women's bodies much more heavily than on men's. Local reactions to the miniskirt go to the heart of normative cultural assumptions that are deeply embedded in the hierarchical nature of gender relations in most of Zambia's ethnic groups and across that country's class spectrum.

Public debates about African women's dress are not confined to Zambia, nor do they involve only the length of their skirts. Controversy has arisen over African women's use of cosmetics, their hairstyles, and their wearing of swimsuits in beauty contests.[1] Yet outcries over a variety of African women's dress practices come together, I suggest, in controversies about the length of their skirts.

Miniskirts were banned in several African countries of the region in the late 1960s and early 1970s, including Tanzania, Kenya, Malawi, and Uganda.[2] The miniskirt debates from this period have much to say about the cultural politics of their time, yet they shy away from the salient question: What is it about miniskirts that continues to provoke public ire about questions concerning culture, gender, and sexuality? The matter of skirt length becomes contentious in different contexts and for different groups. When miniskirts first became fashionable in Zambia in the late 1960s and early 1970s, they fueled discussion about women's proper place in the new nation; "foreign" influences were blamed for independent women's lack of morality. The debate that arose when the miniskirt returned in the 1990s had a sharper and violent edge, mobilizing ideas that associated sexuality with women's dress practice.

Drawing on a range of reactions to women wearing miniskirts in Zambia, this chapter examines some of the entangled issues of gender relations, sexuality, and power that the dressed body both conceals and reveals. The discussion draws on research I conducted during the 1990s into the international commercial trade in secondhand clothing and the consumption practices this trade gave rise to in Zam-

bia.[3] Grappling with how to cast light on Zambian understandings and usages of dress, I explored how meanings became attached to clothing in a variety of contexts. The chapter also uses a range of sources from the early 1970s on, including newsprint media.[4]

I begin with a brief discussion of the special significance of the dressed body and particular cultural notions about gendered bodies and clothing conventions in Zambia. Then follow several distinct parts, introduced by brief remarks about the economic, political, and cultural transformations in Zambian society that serve as a backdrop for shifts in the experiences that entangle the construction of women's bodies. The differences and similarities in reactions to miniskirts that cut across this range of sources ultimately move, I suggest, in a single direction, sharpening the debate to turn the wearing of miniskirts in public into an increasingly dangerous dress practice.

Bodies and Dress: Clothing Traditions and Encounters

What accounts for the power of the miniskirt to push such sensitive buttons as culture, gender relations, and sexuality in Zambia? The explanation has in part to do with the special way in which the dressed body mediates between self and society. Erasmus of Rotterdam recognized this when, anticipating the coming of the modern individual, he likened dress to "the body of the body," in this way capturing how bodies are worn through the attributes of the person. That is, people both create and are created by the clothes they wear and the bodies with which they are worn. Terence Turner's designation of the body surface as a "social skin" invites us to explore the individual and social identities that the dressed body creates. Extending Turner's insights to analysis of dress practices in Africa, Hildi Hendrickson has explained their value: "Being personal, [the body surface] is susceptible to individual manipulation. Being public, it has social import."[5]

Clothing foregrounds the body by revealing or concealing it. Because of the "frisson" their interaction engenders, it is difficult to separate a discussion of clothing from the body.[6] In addition to the general significance of clothing in mediating notions of self and society, the special power of the miniskirt to provoke debates over culture, gender, and sexuality has to do with the closeness of this particular garment to the body, and with that body itself and its cultural construction. This material specificity of dress practice has been slighted in recent scholarship on representation and cultural diversity. Such concerns too easily divert attention away from the institutional contexts that help to structure inequality, and therefore, as Susan Bordo has pointed out, they prevent us from criticizing the hierarchical power relations that sustain them. Bordo admits that it might be unfashionable to talk about "the grip of culture on the body," yet this is precisely what I invite us to do in this case.[7]

To explain Zambian reactions to miniskirts, we must reckon both with inscription of cultural constructions on bodies and with those bodies themselves. Above all, we must reckon with what Foucault did not, namely the differential regulation of the gendered body. A woman's body partially clothed in a miniskirt in Zambia

today receives far more critical attention than her great-grandmother's near-naked body would have provoked during the opening decades of the twentieth century. Culturally and historically shifting shame frontiers have helped redefine the naked body, attaching sexual charge to different body parts and prompting the development of notions of what is acceptable and proper dress and of how and when clothes should be worn.[8] These notions weigh down on women's and men's dress practices on different terms, which are sustained by the unequal power relations through which masculinity and femininity are constructed in society at large. The dress conventions they help to produce constitute a bodily praxis which, as Henrietta Moore has observed, "is not simply about learning cultural rules by rote, it is about coming to an understanding of social distinctions through your body . . . and recognizing that your orientation in the world . . . will always be based on that incorporated knowledge."[9]

People in what today is Zambia have been "clothing-conscious" for a long time, as have people elsewhere in the region. The anthropologists who worked here during the colonial period were struck by the active interest local people took in clothing. European traders, missionaries, and settlers were important actors in introducing both cloth and clothing and, along with them, new notions of morality and dress conventions. While long-held notions of status and rank informed the ways garments and apparel were put to use, the dress practices that evolved also helped change these notions.[10]

By the 1950s, Western-styled clothing had become part and parcel of African dress repertoires in Northern Rhodesia. Then, as now, clothing was important in marital and sexual relationships, status competitions, and economic exchange. The clothing consumption practices that emerged in this process were thoroughly gendered. Men on labor migration took to Western-styled clothing much earlier than women, whom colonial authorities attempted to keep in the rural areas. Cultural norms held that husbands, fathers, or guardians should provide women and children with clothing at regular intervals. When women came to the towns in larger numbers during the post–World War II period, they went for the new fashions with abandon.[11] Touching the core of widespread Zambian sensibilities, the engagement with clothing goes to the heart of women's and men's different experiences of socioeconomic change.

Zambia: Dressing the New Nation

When the miniskirt swept onto the scene in the late 1960s and early 1970s, Zambia was a newly independent country; it had obtained freedom in 1964. By African standards, the economy was booming. World market prices for its main source of revenue, copper, were favorable. The government and the ruling party of the First Republic (1964–72) expanded the educational system, established import substitution industries, and built infrastructure. The first cohort of well-educated women found salaried work in the government's many new departments, and more women were seen in previously male-dominated jobs.[12]

The new nation made little effort to define its independence in terms of dress.

"Because we did not have a national dress as such in Zambia," noted Vernon Mwaanga, a long-time politician, recalling his appointment as deputy high commissioner in the United Kingdom just prior to independence in 1964, "the High Commissioner's wife improvised togas of African print. . . . It turned out to be a very ordinary piece of red and white stripe[d] cloth material . . . available from the shops [in London]."[13] Although Kenneth Kaunda, Zambia's first president, and some of his colleagues wore a similar wrap at Zambia's independence celebration, this dress practice never took hold. In fact, in the neighboring countries, "Kaunda" has become a term for the bush suit of colonial vintage that he popularized as the "safari suit" in Zambia. Vice president Simon Kapwepwe was the only politician in the First Republic to advocate cultural nationalism with reference to dress. Often wearing a *chitenge* shirt rather than a safari suit, he railed against miniskirts.[14] Regardless of his arguments, people in Zambia have made Western-styled clothing their own. The chief exception is women's chitenge suits, a postcolonial invention of tradition that has developed with increasing complexity since independence.

When miniskirts first appeared in the late 1960s and early 1970s, young urban women eagerly wore them. Young women's love of miniskirts provoked at least two reactions from within the established polity of the new nation. One was expressed by the House of Chiefs, supposedly the guardians of tradition and authority, whose role was to advise parliament; the other came from the Women's Brigade, an auxiliary body of the ruling United National Independence Party (UNIP) and ostensibly the advocate for women's affairs as wives and mothers. Although the details of the two debates differ, they each encompassed a spirited defense of an imaginary, partial history of tradition that projected backward and forward a remodeled version of women's dress that fitted awkwardly with the world of its wearers.

The House of Chiefs in 1971 passed a motion stating that "Women's dress above the knee should be condemned." Introducing the motion, Chief Shibwalya-Kapila from Northern Province argued that the House, as the forum for traditional rulers, had the responsibility of stamping out miniskirts. He called on the government, parents, and teachers to take action. "This kind of dressing," he explained, "is certainly against the tradition. . . . mini dress above the knee exposes the private parts of a woman's body and thus it tempts or attracts man's natural inclination for curiosity and sexual pleasure. So no serious parent would ever like to see his or her child work or sit in her presence in such a costume."[15]

All the other chiefs supported the motion. Chief Mpamba from Eastern Province argued, "When we men see a woman or a girl walking half naked, we are naturally attracted. . . . it is disgraceful to parents to see the private parts of their daughters." Chief Mwansakombe from Luapula Province added, "We are losing our national culture, [yet] some people say we are building national culture, [still] I do not see whether we are building national culture." And Chief Ingwe from North-Western Province invited the government "to ban the factories which are tailoring such clothes . . . then we shall go back to our customary way of dressing."[16]

The miniskirt was not banned. Nor was it exactly clear what the chiefs had in mind when calling for a return to "our customary way of dressing." Throughout most of the nineteenth century, dress in this part of Africa had exposed the body;

Figure 9.1. National dress? Mrs. Betty Kaunda wearing *chitenge* dress and President Kaunda wearing a *safari* suit in front of State House, Lusaka, mid-1980s. Courtesy of Zambia Information Services.

Figure 9.2. Miniskirts from the early 1970s. Graduates at Evelyn Hone College, Lusaka. Courtesy of Zambia Information Services.

it consisted of bark cloth and animal hides. In some local groups, women's dress included tattoos and cicatrices; beads around the waist signaled adult female status. Although clothing "tradition" had an uncertain foundation, there were other groups within the body politic who, like the House of Chiefs, substituted themselves for parents and guardians in arguments for restoring "customary dress." A vocal voice was that of Chibesa Kankasa, the chairperson of the Women's Brigade in the early 1970s, who added fuel to the debate by conflating dress practice with women's "proper roles" as wives and mothers.

The Women's Brigade (renamed the Women's League in 1975) largely attracted urban women who had reached adulthood during the late colonial period. It was concerned primarily with moral and ethical issues.[17] The league was hostile to the independent, educated women, blaming them for the moral decay and loss of cultural values in the new nation. Ilsa Schuster's study of Lusaka's young single professional women, who were beginning to fill important positions in the early 1970s, captures Zambian society's ambivalent attitude toward their new emancipation. In the mind of the Women's League, dress functioned as a proxy for women's role in society. These single professional women purchased their own clothing and did not select "proper" dress styles. Advising women to wear more respectable attire than miniskirts, Mrs. Kankasa played a prominent role in the invention of the "tradi-

tional" chitenge suit: a skirt or wrap with a top. Her hallmark was a headscarf elaborately folded in the West African manner.[18]

Both strands of the early miniskirt debates shared notions of tradition that made young women's bodies an index of the nation and of their place within it. In advocating "traditional dress," the House of Chiefs and the Women's League depicted wearers of miniskirts as women who had been warped by non-traditional influences. Such dress practice unsettled authority relations, challenging long-held norms and patterns of behavior. In many societies in this region, the father-daughter relationship was characterized by avoidance. Women's dress was construed as "respectable" when it did not reveal "private parts," which, as the House of Chiefs debate reveals, includes thighs. Taking for granted that men's sexual desire was aroused by the display of women's "private parts" in miniskirts, this early debate expressed a cultural nationalism with a marked male and generational bias. It viewed independent women in miniskirts as warped by "foreign" influences that threatened cultural notions of authority. It considered such women promiscuous, and miniskirts became, as they remain today, a ready shorthand for prostitutes.

Interlude

Zambia's Second Republic (1972–91) was a one-party state with a socialist-inspired command economy. A steady economic decline quashed most expectations of leading better lives. While the miniskirt went out of fashion, women's dress continued to provoke occasional commentary. Concerns were raised about "see-throughs" that belittled Zambian culture. Women's wearing of trousers also came in for criticism. The president's wife, Mrs. Betty Kaunda, who often wore chitenge suits, urged women to "guard their independence for the benefit of [the] future," adding, "we should not copy everything that comes from foreign countries, but only good and decent attire."[19]

As the Zambian economy continued to decline during the 1980s, it became difficult to find "good attire." The two state-owned textile mills exported most of the country's cotton cloth and yarn, while import restrictions limited the availability of dress fabric and ready-made garments. It was dress in general rather than women's clothes in particular that drew most attention. How could police work effectively while wearing *pata pata* (plastic sandals), students respect poorly dressed teachers, and newspaper vendors expect to sell the dailies when wearing rags? So scarce was good clothing during the 1980s that army wives on the Copperbelt wore military attire.[20]

The Second Republic turned the promise of gender equality into an illusion in many fields. Women's presence in formal jobs declined. Instead, they turned to informal work, providing the margin that ensured survival in the face of men's shrinking wages. But as household heads, Zambian men have conventionally held claims on their wives' incomes, time, and sexual attention. By the end of the 1980s, the disjuncture between those claims and actual economic strategies made the hierarchical nature of gender relations problematic on the home front and in society at large.

Figure 9.3. *Chitenge* dress, early 1980s. Mrs. Betty Kaunda (center) in Maputo Airport, Mozambique, with female entourage and Mrs. Chisano (right), wife of the minister of foreign affairs in Mozambique. Courtesy of Zambia Information Services.

Street Vendors, Dancing Queens, and Rape

When the miniskirt reappeared in the early 1990s, the Zambian scene had changed in many respects. Multiparty elections in 1991 ushered in the Third Republic and a policy of rapid liberalization. The poor economic performance of the two previous decades had turned Zambia, in United Nations categories, into one of the world's least developed countries. In education, health, longevity, child mortality and nutrition, formal employment, and wages, among other indices, Zambians were worse off than they had been in the mid-1970s. What is more, poverty had grown because of HIV/AIDS.

Because of its singular significance in mediating notions of both self and society, clothing consumption offers rich insights into how individuals deal with their place in society. My exploration of why the miniskirt was construed as inappropriate was inspired by young women's reactions. Essays on clothing consumption written in 1995 by women and men aged between seventeen and twenty, in their final year of two urban and two rural secondary schools in Zambia, offer telling insights into the desires and anxieties of young people at the brink of adulthood in a hierarchically structured and male-dominated society.[21]

The students who wrote essays for me liked "to move with fashion." Unlike their

peers a decade earlier, who shopped at state-owned stores with limited choices, this cohort pursued almost unbounded clothing desires. They could shop at "Sally's Boutique," a common name for the shops selling commercially imported second-hand clothing from the West that have proliferated with the opening up of the economy. Young people from better-off households also bought new clothes in regular stores, boutiques, and outdoor markets, mostly imported from South Africa and Southeast Asia. But regardless of background, they all frequented Sally's, where they found not only better value for their money but also a diversity of style that allowed them to pursue individuality and uniqueness while looking for "the latest."

Zambian youth do not put together their clothing universe at random, but in ways that implicate cultural presuppositions about gender and authority. These cultural ideals are a product of socialization and everyday social interaction. Through their early socialization, young girls acquire clothing competence. This competence hinges on what they describe as "private parts," which include thighs, and "body structures," which refers to weight and height; it also has to do with comportment and presentation. Young girls are taught to wrap a chitenge around their waist when working around the home, and to wear loose and non-revealing dresses and skirts below the knee when in public. They should not wear short skirts when sweeping, for example, because bending over and displaying the thighs is considered indecent. In short, young women constrain their bodily praxis through the culturally specific ways in which they dress, carry, move, and position their bodies in space.

Young women redefine these ideals within specific contexts. When away from the controlling sphere of the home, where they are supposed to wear chitenge wraps, and outside the regulatory space of the school, where they wear uniforms, young women are cautious in their pursuit of "the latest." Some young urban women who want to "move with fashion" dress in miniskirts when their parents are out, while others dare to wear miniskirts in public. But many are apprehensive about exposing the body. While this concern arises from the need to show respect to elders, it also pertains to the issue of decency and the miniskirt's implication of loose morals. When characterizing clothes, young women drew connections between sexuality and the social construction of femininity and masculinity in society at large. As Abigal, a grade twelve student in Lusaka, explained, "the clothes I like least are short [mini] and tight clothes; and I like them least because here in Zambia when you dress in such kinds of clothes people may start having ideas about you, because some people think that if you dress in miniskirts or dresses, you are a prostitute because they think prostitutes dress like that. . . . I can give you one example," she went on: "Here in Zambia, if you put on a mini and tight clothes, men can easily rip your clothes and you might be raped at the same time."

Abigal's remarks touch on a highly charged issue that preoccupied at least the one-third of the young women in her class of forty-nine who drew connections between miniskirts and rape. The specific backdrop was the stripping of a woman wearing a miniskirt by street vendors at Kulima Tower, a major bus stop, on March 18, 1994. The incident was widely discussed in the press and prompted demonstrations by women's groups, addressing two specific issues. One was the growing in-

cidence of sexual violence against women, and the other was women's right to dress the way they want.[22] This particular stripping incident was not the only event of its kind. According to Jessie, "Here in Zambia when you go to town the street vendors tear your dress . . . because it is very short. And they call you all kinds of names, for instance *hule* (prostitute) and they can rape you." Cleopatra was more explicit: "In Zambia there is no freedom of dressing. If you wore miniskirts, bicycle shorts or leggings and decided to go shopping in town, you would be stripped naked . . . ; this kind of dressing arouses men's emotions."

The direct association between miniskirts and rape was informed by several events. Some of them have taken place in connection with music performances, in particular the dance routines of the scantily dressed "dancing queens" who accompany popular Zairean rhumba stars, among them Tshala Muana, Koffi Olomide, and Madilu Systeme Bialu. At one outdoor performance by Olomide in December 1993, five women were raped in the melee that broke out when the delayed concert was called off at sunset. While drunkenness and crowding contribute to the violence that often accompanies such performances (which sometimes escalates to include police fire and tear gas, as at a Tshala Muana event in Lusaka in 1996), it is Zairean music and dancing queens that have become associated with sexual violence.[23]

Above all, instances of public stripping have dramatized the association between women's dressed bodies and sexual violence. The 1994 Kulima Tower incident involved a close encounter with rape when young male street vendors stripped naked a woman on account of what they claimed to be her indecent dress. The woman, described as "middle-age," wore "a skin-tight skirt just above her knees," according to eyewitnesses. A reporter matter-of-factly described the event: "A large crowd of onlookers besieged the scene as the vendors pinned the helpless woman to the ground while others held her legs apart. . . . The youths after satisfying their curiosity grabbed a Chitenge from an old woman, wrapped their victim in it and bundled her into a taxi."[24]

With so much public attention focused on the dressed body, it is not surprising that the young women who wrote essays for me were preoccupied with managing their bodies through dress. Their social and sexual identity is very much lodged in the way in which the body is worn through clothes.[25] Compared to many of their age-mates, these young women were relatively privileged because they had made it to the final grade of secondary school. Close to half of Zambia's school-age girls do not attend school. Approximately equal numbers of girls and boys enroll in grade one, but the attrition rate of girls is higher than that of boys at all succeeding levels.[26] These gender disparities reflect societal norms, discriminatory school allocation ratios, and the fact that many girls drop out of school because of pregnancy. Young women's prospects are further handicapped. Rates of HIV infection among women between fifteen and nineteen are reported to be seven times higher than for men of the same age.[27] Added to that are marked increases in the incidence of child sexual abuse, incest, domestic violence, and rape.[28]

Against this backdrop, the likelihood of violent sex and premarital pregnancy is great. We can almost hear the young women's pained voices when they describe the

Figure 9.4. The Tshala Muana skirt. Singer Tshala Muana in concert at Woodlands Stadium, Lusaka. The high slit gave rise to that year's fashion: a pencil tight skirt with a very high slit. Courtesy of the *Post*, October 10, 1992.

Figure 9.5. Decent dress. Women wearing (front row from left to right) a *chitenge* wrapper and two-piece "office wear," popular in the first half of the 1990s. Courtesy of Zambia Information Services.

discomfort they experience as objects of the male gaze and targets of violent male desires. The dress practices they describe in their essays draw on their understanding of their own gender as very much constructed through sexuality and on their knowledge that their place in society is shaped by that construction.

The National Bedroom

The social and political landscape in which the events I described above took place is changing in complicated ways.[29] In spite of Zambia's economic decline, women's lives have not simply changed for the worse. Although poverty is growing, the opportunity structure is shifting, and, for instance, there are more women in politics than ever before.[30] Women's lobby groups and advocacy organizations are taking issue with inequality on many fronts, including sexual violence in homes and on streets. Women's dress and miniskirts in particular continue to preoccupy many women who like to dress in style, and women's dress continues to agitate their critics.[31] But whereas in the late 1960s and early 1970s debates over women's dress were largely orchestrated from within the established body politic, the 1990s discussions took place throughout society.

Unlike the young women students whose preoccupations with miniskirts expressed their anxieties about growing up in a male-dominated society, some adult women in positions of relative power and prestige have dared to wear miniskirts in public. Their dress choice provoked reactions that demonstrate the significance of this particular garment in the problematic mediation of individual desires and group norms in Zambia. The seven-day suspension of the popular television personality Dora Siliya by the Zambia National Broadcasting Corporation for "insubordination arising from her wearing miniskirts" in 1997 had extensive news coverage.[32] So did the hounding out of the parliament chamber of the health minister, Professor Nkandu Luo, for wearing a short skirt in 1998. Discussions following this and a similar incident involving the ejection from parliament of Finance Minister Edith Nawakwi turned women's dressed bodies into a battlefront for struggles over their place in contemporary Zambia.

Let me retrace one of these events. Entering the National Assembly on April 3, 1998, MP Nkandu Luo, in her forties, a professor of microbiology and pathology, wore a skirt some two inches above her knees with a back slit, a loose shirt in a colorful floral print, and high-heeled shoes. She was seated in the front row with her knees and legs exposed, and her troubles began when a male MP raised a point of order, suggesting that Ms. Luo's dress provoked male MPs. She instantly became the object of sneers and jeers from male parliamentarians who shouted, "It is too much." Ms. Luo left the chambers before the deputy speaker described the MPs' comments as "enough testimony for female MPs to dress properly." When another woman MP raised a point of order about male parliamentarians harassing their female colleagues, the deputy speaker asked whether she was "trying to change this chamber into a bedroom? It is a well-known fact," he went on, "that all men should wear trousers, shirt, tie and jacket and female members should dress in conformity

with the dignity of the House. Any normally dressed [female] member should be in an attire inches below the knee." When MP Edith Nawakwi wore a miniskirt to a session of parliament later the same year, she was also pressured to leave.[33]

Why do miniskirts continue to provoke public reactions that invade women's bodies both literally and figuratively in Zambia? One issue has to do with dress codes in institutional settings which strong-willed women challenge by insisting on their freedom to dress as they please. Another is the impression a woman's body dressed in a miniskirt provokes in the viewer. This impression is context-dependent and shaped by the age, gender, and class difference of the parties involved. Above all, it is informed by what people construe as decent dress, which in Zambia is over-whelmingly determined by men.

Divergent reactions, some supportive, others critical, entangled the issues. The reactions did not follow clear gender lines. What was wrong with Ms. Luo's wearing a miniskirt in parliament, according to some men, was its arousal of male sexual desires. Albert Ndhlovu from Lusaka thought that it was "unacceptable for ladies in leadership to dress as if they are going to disco session or indeed . . . copying of what their own children are doing in the name of fashion." In his view, leaders were "duty bound to obey conventional etiquette." But some women considered that dress codes in institutions should be abolished. Esther Mabeya from Lusaka re-called that "our mothers—some of them nurses and air hostesses used to wear [miniskirts]. Why should they be an issue today?" Still other women considered miniskirts indecent. One mother from Lusaka who said that she had scolded her seventeen-year-old daughter "for her skimpy clothes, accusing her of peddling her body" described Ms. Luo as a poor role model. She argued, "Ladies whether we like it or not men are attracted to naked thighs and there is only one thing that comes in their mind—bedroom."[34]

Supporters, both female and male, of women MPs' freedom to dress as they liked viewed the treatment of Ms. Luo and Ms. Nawakwi as sexual discrimina-tion.[35] Some men saw the event as evidence of sexism rather than an enforcement of dress code. Urging female MPs to work together to change the "archaic code of dress," Charity Kangwa from Lusaka captured a widely shared impression: "I see no difference between the *mishanga* street boys, who are in the habit of harassing women in the streets for their dress codes and parliamentarians. . . . the Deputy Speaker, whose role is to ensure that the house maintains its dignity and respect, has defeated this purpose by disrespecting the female members of parliament by his unfortunate 'bedroom' remarks."[36]

Across these disparate reactions, it is the particular garment, the miniskirt, which is at issue. It exposes the thighs, that culturally constructed part of women's bodies which in Zambia is highly charged with sexual significations. Age and rank inter-sect with gender in these events, construing the National Assembly as a stage on which mature women "ought" to dress in a dignified manner. Wearing a miniskirt discredits the integrity of their high office because of its association in the minds of many, both women and men, with sex. When they wear miniskirts, women members of parliament, intentionally or not, unsettle male control of dress, thus

challenging men's hold on the nature and reins of power. In effect, rather than representing cultural backlash, the recurring controversies over miniskirts in Zambia are direct engagements with the changing social world of their wearers.

Moving with the Times

Whether they love or hate them, people in Zambia have dealt with miniskirts, and variously so, since the late 1960s and early 1970s. Their debates about miniskirts have diverged in tenor because the socioeconomic and political circumstances against which they have played out are different. The sharper edge of the 1990s miniskirt controversy has to do both with the dangers of sexual invasion of young women's bodies and with the accentuated sexualization of adult women's bodies. In many sectors of Zambian society, men continue to objectify women, seeing them as targets for lust and domination. This is why the young women who wrote essays for me were actively concerned with managing their sexed bodies through dress, in this way seeking to control the construction of their bodies. This is also why some highly profiled women who work in the public view and dress in miniskirts are fighting an uphill battle, challenging men's objectification of them.

To be sure, women's dressed bodies receive considerable critical scrutiny in Zambia, as they do in many other countries. But controversies over miniskirts in the West, Africa, and elsewhere cannot be explained away as being "all the same." The circumstances that give rise to them, the contexts in which they develop, and the weight of their anti-feminism most likely differ, as do the cultural politics of their specific generation, time, and place. When the miniskirt first burst onto the Zambian fashion scene, it provoked a debate that centered on women's proper place in the new nation and blamed "foreign" influences, among them miniskirt fashions, for independent women's lack of morality. The debate that arose in the wake of the miniskirt's return in the 1990s had a much sharper and more violent edge. The "foreign" origin of the miniskirt was no longer an issue; what was at stake now was the item of clothing itself and the local interpretations it engendered. Today's clothing discourse increasingly associates sexuality with women's dress practice. The accentuated tenor of the debate is underpinned by sexually repressive handling of young women on the one hand and sexually degrading treatment of adult women in public life on the other. Indeed, miniskirt incidents such as those I have described here from the 1990s are among the most dramatic invasions of women's freedom as private individuals and public citizens.

In contrast to the situation in the early 1970s, a variety of women's support groups and organizations have been active since the 1990s, lobbying for change in the many ways in which Zambian society subordinates women to men. Transformations in gender relations of power require resources of a magnitude that are difficult to imagine in one of the world's least developed countries. But lessening the attribution of danger to young women's dressed bodies also depends on altering the organization of everyday life. Such alteration hinges on institutional practices and the importance that changes in schooling, in the world of work, and within private households may have in reshaping the opportunities for young

Figure 9.6. Freedom to dress? Health minister Professor Nkando Luo at the official opening of a pedestrian walkover bridge in Lusaka. Courtesy of the *Post*, January 25, 1999.

people, providing them with ways and means to fashion a differently gendered landscape from the one in which they are growing up.

The debate that arose over the length of women's skirts in the 1990s has slowly begun to shift. All hell broke loose when dozens of women in "slut wear" were stripped in Lusaka in January 2002 by youths allegedly acting on behalf of newly elected president Levy Mwanawasa's "smart casual dress" directive. The State House promptly denied this directive, twenty-five youths were arrested, and the president condemned the stripping as a disgrace that denied women their freedom to dress as they liked. Women's groups and human rights organizations protested, while "women and girls from all walks of life . . . in outfits ranging from miniskirts to hipsters and skin-tight jeans" demonstrated. Although some men disapproved of the stripping, they also considered "ample female human flesh exposed in the wrong place in the wrong way" an assault on their sensibilities.[37] There is little doubt that some segments of Zambian society will continue to attribute highly charged sexual meanings to women's dressed bodies. Indeed, it will take more than public declarations to challenge long-held norms of everyday male/female interaction. But perhaps these norms may, in their breach, become subject to reinterpretation as women in Zambia try to free their dressed bodies from the control of the male gaze.

Notes

My research for this essay was supported by grants from the Social Science Research Council, the Wenner Gren Foundation for Anthropological Research, and the University Research Grant Committee of Northwestern University. I thank Owen Sichone for inspiring me with an unpublished essay, "In the National Interest: Women, Mini Skirts, and Party Ideology in Zambia" (Department of Social Anthropology, Witwatersrand University, 1994).

1. Amy Stambach, "Curl up and Dye: Civil Society and the Fashion-Minded Citizen," in *Civil Society and the Political Imagination in Africa,* ed. John L. Comaroff and Jean Comaroff (Chicago: University of Chicago Press, 1999), 251–66; "Beauties Reject Swim Suits," *Post,* July 18, 1997, 20; "Tanzania Bans Beauty Contests," *New African,* September 1997, 2.

2. Ali A. Mazrui, "Miniskirts and Political Puritanism," *Africa Report,* October 9–12, 1968, 11, and "On Revolution and Nakedness," in *Violence and Thought: Essays on Social Tensions in Africa* (London: Longmans, 1969), 289; Audrey Wipper, "African Women, Fashion, and Scapegoating," *Canadian Journal of African Studies* 6, no. 2 (1972): 329–49.

3. Karen Tranberg Hansen, *Salaula: The World of Secondhand Clothing and Zambia* (Chicago: University of Chicago Press, 2000).

4. My principal sources are the two government-controlled dailies, the *Times of Zambia* and the *Zambia Daily Mail,* and the privately owned *Post,* which was launched as an opposition paper during the early 1990s, when freedom of ex-

pression was newly allowed in print prior to multiparty elections at the end of 1991. All three are published in Lusaka.

5. See Norbert Elias, *The Civilizing Process: The History of Manners* (New York: Urisen, 1978), 78; Terence S. Turner, "The Social Skin," in *Reading the Social Body*, ed. Catherine B. Burroughs and Jeffrey David Ehrenreich (1979; reprint, Iowa City: University of Iowa Press, 1993), 15–39; and Hildi Hendrickson, introduction to *Clothing and Difference: Embodied Identities in Colonial and Postcolonial Africa*, ed. Hildi Hendrickson (Durham, N.C.: Duke University Press, 1996), 2.

6. Jennifer Craik, *The Face of Fashion: Cultural Studies in Fashion* (London: Routledge, 1994), 116.

7. Susan Bordo, *Unbearable Weight: Feminism, Western Culture, and the Body* (Berkeley: University of California Press, 1993), 218 and 260.

8. See Elizabeth Grosz, *Volatile Bodies: Toward a Corporeal Feminism* (Bloomington: Indiana University Press, 1994), and Elias, *Civilizing Process*, 164–66.

9. Henrietta L. Moore, *A Passion for Difference: Essays in Anthropology and Gender* (Bloomington: Indiana University Press, 1994), 78.

10. Phyllis Martin, "Contesting Clothes in Colonial Brazzaville," *Journal of African History* 35, no. 3 (1994): 401–26; Audrey Richards, *Land, Labour, and Diet in Northern Rhodesia* (1939; reprint, Oxford: Oxford University Press, 1969); Godfrey Wilson, *An Essay on the Economics of Detribalization in Northern Rhodesia*, vol. 2, Rhodes-Livingstone Papers 6 (Livingstone, Northern Rhodesia: Rhodes-Livingstone Institute, 1942); J. Clyde Mitchell, *The Kalela Dance: Aspects of Social Relationships among Africans in Northern Rhodesia*, Rhodes-Livingstone Papers 27 (Manchester: Published on behalf of the Rhodes-Livingstone Institute by Manchester University Press, 1956); J. Clyde Mitchell and A. L. Epstein, "Occupational Prestige and Social Class among Urban Africans in Northern Rhodesia," *Africa* 29, no. 1 (1959): 22–39. Owen Sichone reminded me (personal communication, 1997) that the clothing that attracted Bemba migrants to town was viewed as wealth rather than simply dress fashion. While I welcome this important clarification, I also suggest that by the 1950s ongoing socioeconomic transformation might have unsettled earlier distinctions between clothing as wealth and clothing as a commodity.

11. Jane L. Parpart, "'Where Is Your Mother?' Gender, Urban Marriage, and Colonial Discourse on the Zambian Copperbelt, 1924–1945," *International Journal of African Historical Studies* 27, no. 2 (1994): 250–54.

12. Ilsa G. Schuster, *New Women of Lusaka* (Palo Alto, Calif.: Mayfield, 1979).

13. Vernon J. Mwaanga, *An Extraordinary Life* (Lusaka: Multimedia Publications, 1982), 95.

14. Unlike the bush suit of colonial vintage, which almost invariably included shorts, the safari suit features long trousers. *Chitenge* is a Nyanja word for brightly printed cloth.

15. Republic of Zambia, *House of Chiefs Debates*, Tuesday, September 28–Wednesday, September 29, 1971 (Lusaka: The Government Printer, 1971), cols. 73–74.

16. Ibid., cols. 74–77.

17. Gisela Geisler, "'Sisters under the Skin': Women and the Women's League in Zambia," *Journal of Modern African Studies* 1, no. 25 (1987): 48.

18. Schuster, *New Women*, 167 and 163.

19. "Modern Dresses are Tempting," *Times of Zambia*, letter to the editor between June and September 1981; "See-Throughs Belittle Our Own Culture," *Times of Zambia*, letter to the editor, August 23, 1985; "Woman in Pants," *Times of Zambia*, letter to the editor, July 18, 1985; "Nab Women in Men's Wear," *Times of Zambia*, letter to the editor, September 25, 1985; "Dress Decently," *Times of Zambia*, letter to the editor, February 4, 1985.

20. "How Can Police in Pata-Pata Nab Thieves?" *Times of Zambia*, letter to the editor, October 26, 1986; "Poorly Dressed Teachers," *Times of Zambia*, letter to the editor, April 28, 1987; "Dress Up Newspaper Sellers," *Times of Zambia*, letter to the editor, June 6, 1987.

21. A total of 173 students wrote essays: 49 at Kabulonga Girls Secondary School and 57 at Kabulonga Boys Secondary School, both in Lusaka, and 38 at St. Mary's Secondary School for Girls in Kawambwa and 29 at St. Clement's Secondary School for Boys in Mansa, both in Luapula Province. The excerpts I include from the essays are direct quotations. Aside from adding occasional parenthetical explanations and clarifying spellings, I have not edited the students' narratives.

22. "Vendors Blasted for Undressing Woman," *Zambia Daily Mail*, March 23, 1994; "Lusaka Ruffians Taking Law into Own Hands," *Zambia Daily Mail*, March 24, 1994.

23. "Five Raped after Koffi Rhumba Show," *Times of Zambia*, December 6, 1993; "Arrests in Connection with a Rampage at Independence Stadium," *Times of Zambia*, December 7, 1993; "Show Fracas Could Have Been Avoided," *Times of Zambia*, December 10, 1993; "Is Stage Porno to Blame for Rape?" *Sunday Times of Zambia*, December 12, 1993; "Hell Descends on Tshala Show," *Zambia Daily Mail*, November 8, 1996.

24. "Fashion Conscious Ladies in Mini-skirts Nightmare at Kulima Tower," *Weekly Standard* (Lusaka), March 21–27, 1994; Mukamba Phiri, "The Stripping of Women in Short Skirts Is 'Violation of Human Rights,'" *Weekly Post* (Lusaka), March 25, 1994, 4; "Lusaka Ruffians Taking Law into Own Hands."

25. Craik, *Face of Fashion*, 56.

26. Tyrell Duncan, *Prospects for Sustainable Human Development in Zambia* (Lusaka: Government of the Republic of Zambia and the United Nations System in Zambia, 1996), 47.

27. Two-thirds of Zambian women either have had children or are pregnant by the age of nineteen, usually by much older men. With HIV/AIDS adult prevalence rates estimated at between 22 and 25 percent in urban areas (and between 10 and 13 percent in rural areas), urban adolescent women are particularly vulnerable. Ibid., 58–59; see also Douglas Webb, "The Socio-Economic Impact of HIV/AIDS in Zambia," *SafAIDS News* 4, no. 4 (1996): 2.

28. Darlene Rude, "Reasonable Men and Provocative Women: An Analysis of Gendered Domestic Homicide in Zambia," *Journal of Southern African Studies* 25, no. 1 (1999): 7–28; Monica G. Shinkanga, *Child Sexual Abuse in Zambia* (Lusaka: YWCA HIV/AIDS Prevention Project for Out-of-School Youth, 1996); Young Women's Christian Association, *Violence against Women: Zambian Perspectives—An Evaluation Report of the Initiatives of the YWCA of Zambia* (Lusaka: YWCA, 1994); Young Women's Christian Association, *Incest: Confronting the Hidden Crime in Zambia* (Lusaka: YWCA, 1997).

29. Owen Sichone and Bornwell Chikulu, eds., *Democracy in Zambia: Challenges for the Third Republic* (Harare: Sapes, 1996).

30. A. J. Sampa, "Unequal Access to Power: Policy Making and the Advancement of Women in Zambian Development," in Sichone and Bornwell, *Democracy in Zambia,* 214.

31. "Woman Divorced for Donning Mini-skirts," *Chronicle* (Lusaka), July 5–11, 1996, 5; "Is Wearing Minis a Sin?" *Zambia Daily Mail,* feature article, August 21, 1997, 4; Wam Kwaleyela, "Mini-skirts Is Food for Your Eyes," *Zambia Daily Mail,* April 11, 1998.

32. "The Mini-skirt Debate . . . And What about Decent Executive Trousers?" *Times of Zambia,* feature article, April 13, 1998.

33. See "Dora Siliya's Minis Annoy ZNBC Bosses," *Post,* May 22, 1997, 1 and 5; "Dora Siliya's Miniskirts Defended," *Post,* letter to the editor, May 26, 1997; "Dora Siliya Defended" and "Siliya's Suspension Hailed," *Post,* letters to the editor, May 28, 1997; "Professor Luo Hounded Out of Parliament," *Times of Zambia,* April 4, 1998; "Luo's Minis," *Post,* editorial comment, April 6, 1998; "Speaker Shouldn't Have Sent Nawakwi Home," letter to the editor, and "Gender Focus: Is Parliament Dress Code Exclusively for Female MPs?" *Zambia Daily Mail,* September 24, 1998.

34. "Luo's Choice of Dress" and "Dignified Dress," *Post,* letters to the editor, April 14, 1998; "The Mini-skirt Debate"; "Set Good Examples for Girl Child," *Post,* letter to the editor, April 8, 1998.

35. "Speaker Shouldn't Have Sent Nawakwi Home" and "Gender Focus."

36. *Mishanga* is the Nyanja word for stick. It was used in the early 1980s to refer to vendors who sold single cigarettes and has since come to refer to street vendors in general. See "Luo's Choice of Dress" and "Dignified Dress."

37. "Mobs Strip Zambian Women Naked over Miniskirts," Reuters, January 15, 2002; "Lusaka Women Protest against Harassment," *Times of Zambia,* January 19, 2002; "Women Stripping: Who Is to Blame?" *Zambia Daily Mail,* January 24, 2002, 6; "Was the Stripping of Women in Lusaka Justified?" *Times of Zambia,* letter to the editor, January 24, 2002.

Part Four: *African "Traditions"*
 and Global Markets:
 The Political Economy
 of Fashion and Identity

10 Fashionable Traditions: The Globalization of an African Textile

Victoria L. Rovine

[Africa] is children singing and the crazy rhythm of funerals, the tempo of rites of passage, the cry of wild animals and the gaze of women whose silhouettes, painted by their boubous and kangas, stand out gracefully on the line of the horizon.

—Stéphane Guibourgé, *African Style*[1]

As the Costume Institute show illustrates, men from the Dinka tribe of Sudan restrict their apparel to corsets elaborately beaded to convey status, affiliation, wealth and, if photographs are any guide, their considerable beauty. Similarly, women of the Parisian haute couture tribe wear beaded corsets from the ateliers of John Galliano or Mr. Gaultier to convey status, affiliation and all the rest.

—description of *Extreme Beauty: The Body Transformed,* an exhibition at the Metropolitan Museum of Art's Costume Institute, 2001[2]

Last season I produced a collection called "Tribal Traditionalism." . . . For the first time in my life, I felt ready to express my cultural and ancestral spirituality in a collection. I allowed the spirit and colours of Africa to flow through everything that I created. At long last I felt the confidence to do this without feeling stereotyped.

—Ozwald Boateng, Ghanaian designer, 2002[3]

Garments, unlike other commodities, are very literally embodied; when they travel, they serve as shorthand referents to the people and cultures with whom they originated. They offer a medium by which to declare local identities and a means of "trying on" new identities. Africa is a powerful force in contemporary fashion markets, providing a source of both identity and inspiration for fashion designers around the world. In New York City, Paris, and other centers of Western fashion, designers have long been inspired by, borrowed from, and appropriated African forms. African garments may evoke a romanticized vision of an eternal, picturesque Africa (*boubou*- and *kanga*-clad[4] women silhouetted on the horizon) or, alternatively, they may lend the Western consumer a tinge of Africa's exoticism (the shared tribal quality of the Dinka men and the Parisian fashion devotees). Simultaneously, African designers are striving to find a place in the global fashion marketplace alongside their Western counterparts. Several have gained interna-

tional renown, despite the economic and infrastructural challenges many African designers face. Ironically, those who do gain international exposure often find themselves stereotyped, expected to create recognizably African designs. Those who do use African materials and styles must confront the connotations those forms have acquired outside Africa. The garments that have emerged out of Africa's engagement with fashion are extraordinarily varied, reflecting the many Africas that exist both in reality and in the imaginations of designers.

My exploration of Africa's role in international clothing design and marketing centers on two key concepts whose close ties are infrequently acknowledged: fashion and tradition. A single African textile, closely associated with traditional cultures in its place of origin, serves as a guide through the diverse markets and styles in which tradition and fashion intermingle. The travels of this textile, variously called *bogolan*, *bogolanfini*, or mudcloth, offer an opportunity to explore the implications of adaptations, revivals, and transformations of a distinctively African form via fashion. Here, my focus is on the role of African designers and African markets in this textile's transformations. I will describe how the careers and the work of two designers, Chris Seydou and Alou Traoré, draw together bogolan's associations with longstanding traditions and its potential use in innovative fashion design. I will close with a brief discussion of the changing meanings of the cloth as it has been adapted to contemporary markets in the United States. I begin with an exploration of the often strained relationship between fashion and tradition.

The Focus on the Traditional

As I will describe, forms associated with traditional[5] cultures are a key aspect of African designers' practice, either as markers of personal identity or as symbols of the past against which to measure their innovations. Many Western designers also make use of traditional African styles, often emphasizing the appeal of these forms' distance from the familiar. Two quotations from popular sources, separated by seventy years, indicate the longevity of this Western focus on traditional African attire. Both authors use garments as part of their evocation of Africa as picturesque and distant, drawing attention to those garments' "exoticism" by citing unfamiliar names:

> Two hundred natives from the farthest provinces give the whole of the Section [the French West Africa section at the 1931 Colonial Exposition in Paris] a touch of simple exoticism that draws . . . the crowd. The white boubous of the Senegalese, the blue coats of the Moors, and the black robes of the Peulhs, next to the raphia skirts of the natives of the Ivory Coast.[6]

> Native notions such as single-shoulder togas, asymmetrical hemlines, tunics, and draped, fluid clothing are common denominators on the modern fashion landscape. Collections in New York and Europe are laced with Masai beadwork, spice drenched sarongs, flowing caftans, and vibrant kente cloth from Ghana.[7]

While boubous, robes, raphia skirts, beadwork, and caftans fascinate Western observers, and may provide inspiration for Western fashion, in popular parlance

they are not fashion in their own right.[8] Instead, they are described by terms such as "costume," "dress," and "garb," words often modified by the overarching adjectives "traditional," "native," "indigenous," and "authentic." None of these terms carry implications of change over time, for traditional practices are generally conceived of as *being* changed rather than *creating* change. They are associated with local cultures rather than international markets, with the past rather than the future. Craik summarizes this distancing of fashion from non-Western cultures: "Symptomatically, the term fashion is rarely used in reference to non-western cultures. The two are defined in opposition to each other: western dress is fashion because it changes regularly, is superficial and mundane, and projects individual identity; non-western dress is costume because it is unchanging, encodes deep meanings, and projects group identity and membership."[9]

I use the term "traditional" in my discussion of bogolan's role in contemporary fashion despite its connotations of timelessness and communal identity, for the concept is crucial to the cloth's success in both local and global contexts. Traditions—the practices, objects, and beliefs that are marked off as particularly central to a culture's essence—are generally treated as self-evident and unchanging. Yet the designation of particular aspects of culture as traditional may be strategic; traditions may be employed to reinforce local identities during a time of change, or they may be used by cultural insiders to market their products to outsiders. Hobsbawm and Ranger's seminal edited volume, *The Invention of Tradition*, addressed the production of traditions in European, Asian, and African contexts. In his introduction, Hobsbawm distinguishes between "custom" and "tradition," a distinction that informs my own use of the latter term. Traditions, he notes, are characterized by an imagined invariance: "The past, real or invented, to which they refer imposes fixed (normally formalized) practices." Custom, which may be still more deeply rooted in history, is more explicitly changeable: "It does not preclude innovation and change up to a point. . . . What it does is to give any desired change (or resistance to innovation) the sanction of precedent."[10] Bogolan exists in both realms, simultaneously tradition and custom, although my research has focused on the impact of the cloth's designation as traditional.

Like all cultural practices, the use of bogolan emerges out of a specific history of development and change; it is far from timeless and static. Even in apparently conservative contexts, such as the production of bogolan tunics as ritual protection for hunters (described below), artists are innovative and styles change.[11] My discussion of bogolan centers on the ways in which this textile's designation as traditional has propelled it into new forms and new markets. My focus is on the artists, merchants, and consumers who are drawn to bogolan's special status as traditional, rather than on the primarily rural villagers for whom the cloth embodies custom—part of the changing life of the community. In none of its incarnations is bogolan unchanging; rural and urban artists have both innovated to suit changing markets. In the pages that follow, I will discuss the diverse incarnations of bogolan clothing, describing its continuing life as rural custom, as well as its urban, international adaptations, which are predicated on bogolan's status as an emblem of indigenous, "traditional" Malian culture. Bogolan's story demonstrates that tradition is far

from static and eternal; it emerges out of specific contexts and, as in the case of bogolan, may serve as an engine for change.

Despite the complex interplay of history, politics, economics, and expectation that informs the designation of some practices as traditional, in common parlance tradition is extracted from these contexts and treated as a marker of a pure, unchanging past. Clothing, a highly visible marker of cultural identity, provides one illustration of this conception of tradition. Numerous discussions of African attire have lamented the loss of that continent's traditional, authentic forms, treating change as a symptom of loss rather than of creative adaptation. Angela Fisher's commentary in her popular book *Africa Adorned* typifies this stance: "During seven years of traveling in Africa to research this book, I was constantly aware that many traditions—including some outstanding styles of jewelry and dress—were rapidly becoming rarer or had already disappeared. . . . That this should be so is tragic but understandable." In contrast, Fisher admires the few peoples whose "cultural and moral framework is still strong, who guard their traditional beliefs."[12] The implication of such declarations, common in rhetoric surrounding non-Western cultures, is that the adaptation of Western-style garb constitutes a loss, a breach in the vigilance of "traditional" peoples. Tomlinson described the expectation that African and other non-Western ("Third World") cultures should remain untouched by global influences: "It is as though the Third World is attributed with a special need and even a special *responsibility* to resist the enticements of an ersatz commodified culture."[13] While the impact of global commodity culture might be characterized as positive or negative, depending upon the specific circumstances and on one's perspective, the notion that "traditional" cultures should remain outside the reach of global currents denies their awareness of and involvement in contemporary international culture. As my discussion of bogolan's adaptations to fashion demonstrates, tradition's orientation toward the past does not preclude its active engagement with global influences in the present.

While tradition is characterized as static, fashion is defined by energetic change: "Fashion comes from Paris, and one of its greatest characteristics is that it changes. No sooner is something 'in fashion' than it is 'out of fashion' again."[14] The shifts in hemlines or color combinations that mark fashion's changing seasons epitomize rejection of the past in an unending search for the new, most vividly illustrated by haute couture design, whose practitioners endeavor twice yearly to set new trends.[15] Styles change dramatically, in some instances marked by each season's "ethnic" influence, or influences, of choice. In one of many French publications aimed at defining trends for the fashion industry, 1989–90 is heralded as a year of many influences: "a year of all styles, all blends, all combinations. From the East to the West, from the Arctic to the Antarctic, from exoticism to folklore, from the past reassembled into the 1980s."[16] Similarly, in 2002 *Style.com*, a website sponsored by *Vogue* and *W* magazines, identified global influence as a prominent element of the season's trends: "Like a faint whiff of patchouli, the hippie spirit lingered over Fall's collections, as designers made boho-inspired stops in Africa, Scandinavia, South America and the Tyrol."[17] Such global sampling epitomizes the fashion industry's reputation as a constantly shifting and apparently random medley of styles.

Little wonder, then, that the themes of this essay—"fashion" and "tradition"—seldom share the same discursive space. The conceptual distance between the two concepts has led, in some cases, to assertions that societies characterized as traditional did not know fashion until they encountered Western practices.[18] In fact, forms identified with (African) tradition and those associated with (Western) fashion may interact, blend, and elucidate each other as part of the negotiations by which contemporary identities are declared. Just as Western designers have long drawn inspiration from African forms, so too have African designers been influenced by Western styles, techniques, and materials. While Western forms may be borrowed or copied, more frequently they are transformed, shaped to suit the needs and desires of new markets. Lamine Kouyaté, a Malian-born designer whose brand Xuly-Bët has gained international renown, vividly described the creative adaptation of Western garments—both garments themselves and their depictions—to African markets: "At home, all the products come from foreign places. They're imported from everywhere, made for a different world with another culture in mind. A sweater arrives in one of the hottest moments of the year. So you cut the sleeves off to make it cooler. Or a woman will get a magazine with a photo of a Chanel suit, and she'll ask a tailor to make it out of African fabric. It completely redirects the look."[19] Garments and styles are thus translated and transformed as they move between continents, shaped by the needs and desires of consumers.

The interplay between indigenous and global influences in the realm of fashion is further complicated by the multidirectional movement of designers and their work in international markets. Kouyaté, whose brand is based in Paris, incorporated the sweaters he observed in his youth into his haute couture fashion designs—his cut and stitched jeans, sweaters, and shirts were acclaimed in Paris and New York. This work, aimed at European markets, emerged out of Kouyaté's experiences of distinctly local African attire, but it is surely not "traditional," nor is it "Western." This instance dramatically demonstrates the mobility of forms, ideas, and people which makes simple definitions of identity impossible. Even the "African fabric" of Kouyaté's Malian youth, which he saw local tailors transform into Chanel-style suits, was likely based on European precedents (the factory cloth produced in England or Holland for the African trade) or, equally likely, was actually imported from Europe or Asia. The "globalization" of this essay's title thus refers to several phenomena: the movement of African designers into global markets, the impact of Western designers on African markets, and the movement of garments, images, and ideas between cultures and markets. Using a single African textile, closely associated with tradition both in its place of origin and abroad, I will explore the diverse outcomes of interactions between fashion and tradition.

Fashioning Meanings through Bogolan

Bogolan is in fact a mosaic of fantasy and reality. Bogolan is a technique that our ancestors have left us.

—Kandiora Coulibaly, Malian artist and designer[20]

I am a contemporary designer who knows what I can do technically and how to do it. Bogolan can simply be a cultural base for my work.

—Chris Seydou, Malian designer[21]

When Mary McFadden knocks off mudcloth—as she did last spring—you can assume it's purely because she likes the way it looks.

—Patricia McLaughlin, "Style with Substance"[22]

The Malian textile variously called bogolan, bogolanfini, and mudcloth vividly illustrates the intersecting worlds of tradition and fashion. Its connotations are, as the above quotations demonstrate, as varied as its names. The realms of fashion and tradition interact through bogolan; overlapping, intersecting, and drawing on each other, each realm finds in the other a source of both inspiration and validation. This textile is closely associated with indigenous Malian attire, and with ritual practices among members of the Bamana ethnic group.[23] Its association with tradition has propelled bogolan onto international fashion markets and motivated its transformation into distinctly contemporary forms. Bogolan's position at the confluence of fashion and tradition demonstrates the malleability and the modernity of textiles and garments associated with indigenous cultures. Contemporary bogolan has been adapted to diverse contexts, traversing conceptual categories and cultural divides. What follows is a brief description of the cloth's contemporary manifestations, all of which co-exist and cross-pollinate.

In rural contexts, bogolan tunics are worn by hunters to provide protection from the dangerous spirit forces of the wilderness. Young girls in villages and small towns also wear bogolan, which they wrap around their waists as spiritual protection during the liminal periods following their initiations into womanhood, marriage, and childbirth. In these contexts, bogolan is closely associated with Bamana culture and history. These wraps and tunics are made of cotton that is woven in strips and stitched together to create larger cloths. The cloth is decorated by women, who use local materials and a labor-intensive technique to apply bogolan's distinctive geometric patterns.[24] These patterns carry specific symbolic meanings, closely tied to Bamana mythology and history. Bogolan's functions and its forms have been passed down over the course of generations as part of local custom. As noted above, bogolan's patterns and styles have changed over the course of its history. In but one instance of such change, one rural bogolan artist described some of the patterns she uses as "Bamana" and others as "Mali"; the former patterns are associated with pre-independence (1960) styles and the latter patterns were developed after 1960.[25]

Since at least the 1980s, bogolan has thrived in several other markets, most prominently in urban settings, where it has undergone dramatic changes in style and function. Tourists at hotels, restaurants, and bustling shops in Mali's capital, Bamako, encounter the same cloth, sold in wrapper-sized pieces or cut and sewn into a variety of products, including pillows, vests, hats, and bags. This version of bogolan is also handmade; like the rural cloth it is made of strip-woven fabric and

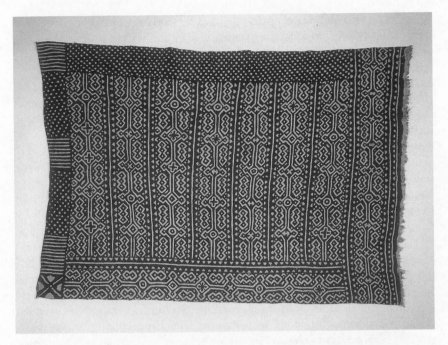

Figure 10.1. Woman's wrapper (*bogolan*). Artist unknown, Mali, mid-twentieth century. *Bogolan* pigments on cotton strip cloth. Courtesy of University of Iowa Museum of Art. Purchased with funds from Robert F. and Delores DeWilde Bina. Photograph by Steve Tatum.

each cloth is individually painted. However, the abstract designs are applied to the cloth using time-saving techniques, such as stenciling, and the much-simplified patterns do not have symbolic meanings. The bogolan found in these contexts was made for sale to tourists rather than for ritual use.

Bogolan also appears in museums and art galleries in Bamako, where visitors may find paintings made by local artists who learned bogolan techniques at the country's only art school.[26] Artists use techniques of their own invention, such as collage and splattering of pigments, to depict figures, landscapes, and abstractions. They use either industrially produced canvas or strip-woven cloth as their support. Most of these artists are men, marking a dramatic shift in gender from the exclusively female production of bogolan in its rural contexts. They adapt the cloth to their work because it is a part of their heritage, and because they recognize that some collectors will be drawn to the cloth's associations with traditional practices.

Finally, in the streets of African, European, and North American cities and towns, bogolan is worn in the form of garments in a wide range of styles. In the United States, bogolan's patterns are reproduced on t-shirts, skirts, jogging suits, and countless other garments. These versions of bogolan, which are more accurately called "bogolan-style" rather than "bogolan," are as likely to be mass-produced in facto-

ries as made by hand. Bogolan clothing may be worn as a signal of national or ethnic identity, an expression of a generalized identification with African heritage, or an evocation of the "exotic." ·

I have discussed elsewhere bogolan's adaptations to tourist markets and to studio art.[27] Here, my focus is on the cloth's sartorial adaptations, in which bogolan attains its greatest stylistic variety and its highest visibility. In a Bamako market in 1994, for example, I encountered a hunter clad in a protective bogolan tunic standing beside a French resident of the city wearing a bogolan robe stenciled with dancing figures and patterns borrowed from factory-printed cloth.[28] The hunter's garment was made according to generations of Bamana practice; the expatriate's was of a type invented only three years earlier.[29] The former was deeply rooted in Bamana custom; the latter was aimed at a contemporary, international market for changing fashions. Bogolan garments in varied styles also appear in fashion shows, tourist markets, nightclubs, and museum displays, as well as in small towns and villages. From the women's wraps and hunters' tunics of bogolan's rural incarnations to boubous and baseball caps, the creators of bogolan and bogolan-style garments traverse, meld, or disregard the divide between tradition and fashion.

Despite the immense variety of bogolan's contemporary forms, a shared characteristic links all of its incarnations: from hunters' tunics to miniskirts, bogolan carries associations with traditional cultures and practices. In his discussion of Native American basketry, Cohodas measures his subjects' associations with "authentic tradition" by assessing "the degree to which Native American objects and practices could operate as metonyms for the pre-modern, constructing a purified, ostensibly precontact past."[30] The bogolan worn by a Bamana hunter exemplifies the cloth's associations with traditional Malian culture, for it serves as a metonym for many aspects of Mali's precolonial and pre-Muslim past. Bogolan hunters' tunics, as well as the bogolan wrappers worn by girls following initiation, make reference to religious, historical, technological, and aesthetic aspects of indigenous Malian culture.

Bogolan serves ritual functions that are deeply rooted in Bamana religious beliefs, protecting its wearers against the malevolent forces that may be directed against them through sorcery. That bogolan is associated with the mythic heroism of hunters and the strictly gendered initiation process also makes it an effective symbol of indigenous culture. The symbolic nature of the cloth's motifs further enhances bogolan's efficacy as a symbol of Malian—specifically Bamana—history and mythology. The precise meanings of the motifs are, in this instance, relatively unimportant, for they serve as generalized references to indigenous knowledge and practices.

Bogolan is also distinctly local—the cloth is uniquely Malian, the only one of Mali's many indigenous textiles that is made nowhere else. The Bamana ethnic group is the one most closely associated with bogolan.[31] Significantly, bogolan production is historically rooted in the Beledougou, a region north of Bamako that is associated with adherence to Bamana customs, including religious practices that predate Islam (often characterized as "animist") and with long resistance to the French colonial forces in the late nineteenth century.[32] Bogolan's strong connections to a particular place (Mali) and population (the Bamana ethnic group) place

it within a specific narrative that may enhance the cloth's associations with traditional cultures as it travels into new markets.

Other aspects of bogolan's rural manifestations augment its capacity to serve as a symbol of tradition. Key among the cloth's attributes are the labor-intensive technique by which it is made and the division of labor according to gender and age in its production. In his discussion of the Western fascination with Asian carpets, Spooner described how information about "traditional" production practices is central to the marketing of the carpets: "the fact of their being hand-made became a significant characteristic and . . . the survival of traditional relations of production became an additional factor [in their success on the international art market]."[33] That bogolan is made in accordance with past practices, the skills required to create the cloth handed down over the course of generations from elderly women to girls and young women, similarly enhances its identity as a traditional art form. In these numerous attributes—production, iconography, ritual functions, geographic specificity—bogolan garments made for use by hunters and young women epitomize those aspects of Malian culture that are associated with tradition.

Bogolan jackets, vests, miniskirts, baseball caps, and robes emerge out of the codification of tradition, a codification that is self-conscious, contemporary in its conception, tied to specific elements of the cloth's appearance, and international in its orientation. As bogolan is adapted to contemporary international markets, its handmade quality and information about its production and its ritual functions remain, to varied degrees, attached to the cloth. As I will describe, its connections to tradition are preserved, though they may become increasingly tenuous as bogolan clothing travels far from its origins.

In Mali today, bogolan clothing is worn by increasing numbers of young people, particularly in the country's cosmopolitan capital. Some of the artists and designers who have created new forms of bogolan clothing seek to re-create or update Malian traditions, deliberately basing their work on clothing and textile styles associated with indigenous Malian culture. Other creators of bogolan clothing view their work as a project of modernization, adapting bogolan's patterns and dyeing techniques to garments aimed at a contemporary international market.

Alou Traoré and Chris Seydou: Bogolan's New Clothes

Two creators of bogolan clothing, one based in Bamako's local markets and the other in international haute couture design, exemplify the diverse sartorial manifestations of this Malian textile. While the two men differ in their motivations for making use of bogolan, their methods of working with the cloth, and the styles of the garments they create, Chris Seydou and Alou Traoré share an interest in the cloth's identity as a traditional art form. As men participating in an art customarily practiced by women, they illustrate the dramatic shift in the gender profile of bogolan producers in recent years.[34] The two are among many Malians who have turned to bogolan in the past two decades in an effort to create clothing that is at once contemporary and distinctly Malian. The following descriptions of their careers and their work illustrate the many factors, both local and international, that

have shaped their contributions to Malian and international fashion design as well as their dedication to bogolan as a symbol of both tradition and contemporaneity.

Alou Traoré's work exemplifies the use of bogolan to create clothing that emerges out of past practices, updating indigenous forms to create new styles. His contribution to contemporary Malian fashion lies in a combination of technical precision and an ability to recognize the modernity of garments with deep local roots. His innovations are subtle, for his goal was to reshape rather than to revolutionize preexisting clothing. From 1991 until 2000, when he took a full-time teaching job, Traoré made bogolan boubous and wrapper-sized cloths adorned with elaborate stenciled patterns. In addition to occasional commissions from Malian and expatriate clients, Traoré's robes and wrappers were sold at a stall in one of Bamako's large markets. He designed his stencils, which were cut from cardboard or sheets of plastic, so that they could be used in a wide range of combinations to create richly layered patterns, distinctly different from both the locally produced bogolan and the factory-printed cloth that was sold alongside his creations.

Traoré's stenciled patterns include a wide range of abstract forms, none of which are based on the designs that appear on cloth used for ritual purposes. He also incorporates figurative motifs. His abstract designs are inspired by the vibrant factory-printed textiles that abound in Bamako's streets and markets, by flowers and leaves, and by the geometric styles of the bogolan cloths he encountered. The figurative stencils depict popular motifs from tourist art and fine art markets, including *ci wara* figures,[35] cowrie shells, and masked dancers. These are images that serve as emblems of indigenous Malian culture in the tourist art trade and in official contexts, such as on the sides of public buildings and in official logos.[36]

Along with his innovative designs, Traoré also set his work apart from both precedents and his contemporaries through his use of his garments' surfaces. Boubous are customarily adorned with embroidered patterns that are focused around the garment's yoke. Since the advent of widely available industrial textiles in the late nineteenth century, boubous have been made of printed textiles, often with machine-stitched embroidery patterns. Traoré was not the first artist to bring bogolan to the creation of boubous, but his work is distinctly innovative, for it breaks free of long-standing precedent.[37] Traoré reconceptualized the garment, covering the entire surface with intricate patterns and occasional figurative elements constructed out of layered, interlocking stencils.

In an effort to streamline his work, Traoré offered potential clients a model book, containing more than twenty photographs illustrating combinations of stenciled motifs, from which to commission boubous and cloths. Traoré's wife and other family members then duplicated the pieces in the photographs, making changes or adding newly designed motifs under Traoré's direction. This method broadly resembles the apprenticeship structure used in rural contexts, but its intention was to speed production rather than to train future generations.

Like many producers of bogolan in Bamako, Traoré took up bogolan production as an adult, though he had some experience with the technique as a child. Traoré is from San, a city north of Bamako renowned as a source of inexpensive, quickly produced bogolan aimed primarily at the tourist art market in Bamako.[38] Traoré

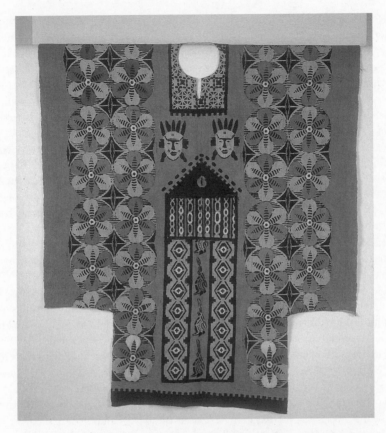

Figure 10.2. Stenciled *bogolan* robe (*boubou*). Alou Traoré, 2000. *Bogolan* pigments on cotton strip cloth. From the collection of William F. Blaire. Photograph by Steve Tatum.

trained as a primary school teacher, and he taught briefly in Bamako. He lost his job in 1991 during the cuts in governmental employment following the popular overthrow of President Moussa Traoré in March of that year.[39] Traoré learned basic bogolan-making skills as a child in San, where many of his friends and acquaintances made bogolan to be sold in Bamako's tourist art markets: "I am not an artist by training but since I was born in a city where people make bogolan, when I found myself unemployed I began to make bogolan."[40] Bogolan's popularity in the tourist art trade and its growing visibility in international markets (a topic addressed below) increased its appeal as a means of earning at least a partial living.

Traoré's identity (as a man making bogolan), artistic practice (using stencils instead of applying bogolan pigments by hand), motivation (to earn money in urban markets), and work style (creating his own abstract and figurative motifs) all clearly separate his work from bogolan made according to past practices. Yet the core identity of the garments he produces is distinctly local and indigenous: he makes primarily boubous, wrapper-sized cloths, and drawstring pants, all clothing typical

of Malian, and West African, style. By combining two forms associated with traditional attire, one a garment and the other a textile-dyeing technique, Traoré creates garments that defy neat categorization—his work is an updating of tradition that grows out of his contemporary, urban milieu.

Although Traoré and other artists who have used bogolan to create distinctly Malian garments have found a very limited market for their work outside Mali, the ornately adorned garments have wide visibility abroad. Bogolan clothing is popular among musicians and other entertainers, worn on stage and in music videos or pictured on compact disc covers. Contemporary musicians who have worn bogolan clothing on stage or in videos include Djeneba Seck, Habib Koita, and Toumani Diabaté, all of whom are major stars in Mali and increasingly visible in Europe, the U.S., and elsewhere. Mali's most prominent film directors also make use of this style of bogolan attire in costume and set designs.[41] Thus garments that are based on forms associated with tradition have gained visibility through contemporary, global media. Bogolan-dyed boubous by Traoré and other artists, whether sold in Bamako's markets or worn on stage in New York, defy divisions between local and global, tradition and modernity.

Though he worked in a completely different style, Chris Seydou also used bogolan to create distinctly contemporary fashion. Seydou (1949–94) was Mali's most famous fashion designer; he was, in fact, among a select group of African designers to gain an international reputation. He worked both inside and outside of Africa, and his designs reflect his efforts to draw together forms associated with both local tradition and international haute couture. I will dwell at some length on Seydou's work and his career because of his seminal role in contemporary African fashion design and because his work draws on both the tension and the energy produced by the intersection of forms characterized as traditional and those associated with Western fashion. His career also illustrates the impact of the contemporary globalization of both fashion and fashion designers.

Chris Seydou worked and showed his designs with internationally renowned designers, most notably Paco Rabanne and Yves Saint-Laurent. He made a place for himself in the competitive Parisian fashion industry, and was among the first to promote African fashion designers on the international market. Along with Alphadi and Kofi Ansah he founded the Fédération Africaine de Prêt à Porter (African federation of ready-to-wear designers).[42] After Seydou's death in 1994, obituaries appeared in French as well as Malian and Ivorian newspapers and magazines. The designer's importance as an ambassador of Malian culture was celebrated, as was his crucial role in bogolan's revival: "Through his creations, Mali became better known throughout the world for its cultural treasures, all the way to America where black Americans today make bogolan into a source of cultural identity."[43]

Unlike Traoré and other artists whose innovations are focused on skillfully combining bogolan techniques with local garments, Seydou's work approaches bogolan from the perspective of international fashion, seeking to adapt the cloth to garments popular in global markets. Seydou's skills lay in the design of tailored garments rather than in the use of bogolan pigments. In fact, Seydou himself never

Figure 10.3. Model wearing ensemble by Chris Seydou, Dakar, 1992. Photograph by
Victoria L. Rovine.

made bogolan; instead, he purchased it in markets or commissioned it from art-
ists.[44] Far from producing garments associated with indigenous culture, such as
boubous, Seydou was best known for his use of bogolan to create distinctively
Western-style garments. He tailored the cloth into tight-fitting miniskirts, motor-
cycle jackets, and bustiers, using shapes and techniques that emerged out of his
haute couture training. In a description of the "Chris Seydou phenomenon," one
journalist noted several of his distinctive garments: "very sophisticated little cami-
sole blouses which are very low-cut, shoulder-straps, strapless bras; sewn ensem-
bles cut at the waist, very tight, with pompoms everywhere; short dresses."[45] All of
these garments are clearly more closely associated with international fashion than
with Malian, or African, precedents.

Seydou's professional identity, indeed his very name, emerged out of a deep
engagement with international fashion. Chris Seydou was born Seydou Nourou
Doumbia in Kati, a small town centered on a military base forty kilometers north
of Bamako. Because Seydou's mother worked as an embroiderer, he was from an
early age familiar with the tools of the clothing trade. At fifteen, he left school to
pursue his interest in fashion, beginning as an apprentice to a local tailor. In 1969
he relocated to Ouagadougou and the following year he moved to Abidjan. Begin-
ning in 1972, Seydou spent seven years in Paris, where he studied European cou-
ture.[46] When he embarked on a career in fashion, he changed his name to Chris
Seydou in homage to Christian Dior, whose work he admired and studied. Seydou's

designs were worn by celebrities and luminaries including Bianca Jagger,[47] Princess Beatrice of the Netherlands, and Madame Mobutu, wife of the infamous president of Zaire.[48]

In 1990, much to the surprise of many Malians, Seydou returned to his home country. He opened a boutique and workshop in Bamako's chic Quartier du Fleuve district in order to work with "the authors, the origins" of "the real African traditions."[49] Tradition was an attribute of such value for Seydou that it drew him back to Mali from the fashion centers of Abidjan and Paris, cities with large markets and cutting-edge fashion. Only in Mali did he have access to the weavers and dyers who were the sources of his raw materials.[50] Much of his attention was focused on bogolan, which he had used for years and which he felt was at risk of deteriorating. In order to preserve this symbol of Mali's traditional cultures, Seydou strove to make bogolan relevant to contemporary, international clothing styles.

Seydou cited a single event as the catalyst for his appreciation of bogolan as a traditional art form and his recognition of the cloth's potential relevance to his fashion design. On returning to Paris after a visit home in 1973 or 1974, he found in his suitcase several pieces of bogolan he had received as gifts. Though he was familiar with bogolan from his childhood in Kati, he associated it with hunters, dances, and ritual rather than with his own interest in fashion. But when he encountered bogolan in Paris, the familiar cloth was transformed into a memento: a reminder of the place and the people of home.[51] Like the foreigners who purchase bogolan in the tourist art market, at a hotel or restaurant souvenir stand, Seydou used bogolan to embody his memories of Mali once out of the country. He began showing his bogolan designs in 1975–76, while still living in Paris.

During his years abroad Seydou found himself classified as an *African* designer rather than simply a designer. He was determined to place himself within the same international arena as other designers he worked with in Paris. Simultaneously, he asserted his Malian identity through his choice of fabrics, creating a bricolage intended to please a wide variety of clients, African and European. Seydou spoke of struggling to negotiate the dueling expectations he faced, with African clients seeking him out to lend them "Western style" and Western clients drawn to his "African sensibility."[52] While many other artists and designers have focused their attention on preserving bogolan's "traditional" techniques and styles, Seydou's work seems to remove any doubt of bogolan's relevance to contemporary pursuits. His bogolan clothing was one line of designs among many, and was not singled out to be marketed as the revival of a traditional textile. Editing, modifying, or discarding the techniques and the material that characterize bogolan are central to his design practice.

One of Seydou's modifications of the cloth addressed the density of its designs, which he altered to suit his use of bogolan as a medium for tailored garments. The number and variety of distinct motifs on a single piece of cloth makes cutting and assembling a garment extremely difficult, for no two portions of the cloth are identical. According to Seydou, this cloth is "too full": "there are ten designs in the same piece—one can make ten maquettes from a single one [a single cloth]."[53] Seydou responded to his difficulties in utilizing the cloth available to him by creating his

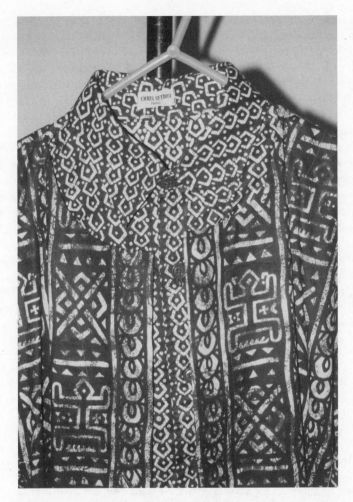

Figure 10.4. Industrially produced cotton cloth, 1991–92.
Chris Seydou, Mali. Photograph by Victoria L. Rovine.

own versions of bogolan, isolating a single pattern in a process he referred to as "decoding" the cloth. The resultant cloths are easier to cut and assemble as his designs require. Because he did not himself make bogolan, Seydou commissioned artists to produce the cloth according to his designs.

Seydou's reluctance to utilize the cloth in its original form, with its symbolic motifs, was also a reflection of his respect for the cloth's significance in rural contexts, where it is imbued with great protective power. While he himself did not profess the same beliefs, or comprehend the specific meanings of the symbols, he respected bogolan's symbolic and ritual functions. This respect made him hesitant to cut the cloth when he first started using it: "For me it was symbolic. For me,

I didn't want to cut bogolan early on—it was difficult to put my scissors to it."[54] The same associations with indigenous Malian culture that drew Seydou to bogolan also shaped his method of working with the cloth.

In all of its forms, Seydou preserved bogolan's Malian identity. His efforts extended into the realm of industrially produced cloth, with his 1990 designs for the Industrie Textile du Mali (ITEMA), a Malian textile producer. He designed a cloth based on bogolan's patterns, which ITEMA printed in both brown and blue. Though the creation of industrially produced bogolan may initially appear to contradict Seydou's efforts to support bogolan producers and enhance bogolan's success in world markets, in fact his intention was to secure the patterns for a Malian textile company so that at least the cloth would bear a "Made in Mali" label. Other textile companies were already making bogolan-style cloth, and the patterns were being copied, transferred, and recycled in every conceivable form, from bedsheets to dinnerware. Seydou spoke of his consternation at viewing bogolan-patterned industrial cloth in the window of the Parisian furniture and housewares store Roche-Bobois (part of a large chain). The fabric was labeled "tissu Mexico" or "Mexico fabric."[55] The diffusion of bogolan, which continues today, was a matter of concern for Seydou and occupies the attention of other Malians seeking to support the production of bogolan as a source of income and recognition for their compatriots. Ironically, the same associations with traditional Malian culture that have made bogolan the object of Malian designers' attention have also lent the cloth its "exotic" appeal abroad, where it has become a part of the long history of Western fashion designers' adaptation of non-Western forms.

African Forms and Western Designers

There is a wide barrier between the primitive savage of the Belgian Congo and the modern, well-dressed woman of Fifth Avenue. There is a tinge of the paradoxical in the statement that the latter would find in the former an inspiration for her dress. . . . But facts are often more interesting, and sometimes stranger than fiction. And it is a fact that the modern woman of America has found in the Congo savage a source of inspiration for her dress. Those of an incredulous mind had only to view the beautiful display of women's apparel in the Fifth Avenue windows of Bonwit, Teller & Co., New York, to be convinced.

—1923 description of women's sportswear in fabrics inspired by Kuba raphia cloth[56]

Above all, at a time when Western fashion seems to have reached an impasse on its stony road to the future, traditional African clothing seems to have a point and a purpose, expressing symbolically the culture and the ideals of a society and passing them on to the next generation.

—Suzy Menkes, New York fashion journalist, 1997[57]

Whether grudgingly acknowledged or sincerely admired, African forms have long had an impact on Western fashion design. Fashion offers a vivid illustration

of the multidirectional nature of globalization, with influences moving back and forth between cultures. In his discussion of early European fashion, Braudel cites a sixteenth-century observer's description of the international sources of a British dandy's attire: "His Codpeece is in Denmarke, the collar, his Duble and the belly in France, the wing and narrow sleeve in Italy."[58] Arbiters of Western fashion today have looked much further afield for inspiration, including into the non-Western world.

The appearance of bogolan clothing in U.S. markets illustrates the potency of the cloth's associative powers. Even as the technique by which it is made, the products into which it is fashioned, and the contexts in which it appears bear no resemblance to its rural, Malian contexts, bogolan clothing outside Mali continues to carry associations with "tradition." My discussion of bogolan fashion in the United States focuses on the maintenance of this association with tradition, which is most vividly manifested in the information that accompanies bogolan shirts, dresses, jackets, bags, and other items. Clothing catalogues, in which descriptions of garments supplement the information provided by photographs, provide a wealth of insight into the role of tradition in the marketing of bogolan clothing in the United States.

My focus here is not on the occasional use of bogolan by non-Malian haute couture designers, for the cloth appears less frequently in these markets and therefore does not provide as rich an illustration of bogolan's connotations in Western markets. I will, however, briefly mention two of these adaptations, to demonstrate bogolan's malleability in the hands of international designers. In 1990, renowned Japanese designer Issey Miyake created draped garments made of textiles whose bold black and white patterns strongly resemble the style of bogolan associated with San, Alou Traoré's childhood home. The designs were likely influenced by Miyake's visit to Mali in the late 1980s to learn more about the country's textiles.[59] More recently, American designer Daryl K. created women's pants made of strip-woven bogolan turned inside out.[60] The designers have not publicly discussed their motivations for using bogolan, and the clothing is not accompanied by information about the cloth that inspired it.

Bogolan and bogolan-style clothing aimed at broader markets in the U.S., often marketed with references to its African origins, offer fascinating comparisons with Malian use of bogolan clothing. A fundamental distinction separates the appearance of bogolan clothing in the United States from its recent Malian adaptations: rather than constructing the local, bogolan in the U.S. is associated with distant, exotic cultures. A great deal of the bogolan clothing sold in American shops, catalogues, and other outlets caters to Western expectations and preconceptions concerning Africa in which the continent's cultures are conceived of as "traditional," "authentic," "primitive," and "exotic." Advertisements for bogolan clothing extol the cloth's handmade production, focusing on the singularity of each item, on the labor-intensive production process, on the exotic locales from which they originate. So important is bogolan's low-tech production that consumers seeking to purchase bogolan pants and shirts from one catalogue are reassured by the fact that not even the clothing sizes of bogolan garments are uniform (a notion that would likely

cause consumers chagrin if applied to most other articles of clothing): "All items are handmade and no two are exactly alike. Slight variations in color, design, and size from the items pictured in this catalogue are guaranteed and should be considered a part of the unique crafts of Africa."[61]

This emphasis on singularity is epitomized by one catalogue company's assertion that the cloth's production is limited not only to Mali but to a single village. Bogolan's hand-made production is also emphasized:

> The Malian edge of the Sahara. This village is its own planet with its own art and its own quiet. . . . They cut up empty flour sacks and paint them with a mixture of mud and tree sap, painting and washing and painting again. The mud in Mali has its own chestnut pigment; the sap fixes the color to the cloth. No other village has their technique.[62]

Even a company assembling bogolan garments in the U.S. affiliates itself with tradition by providing (erroneous) information on the cloth's production and by assuring consumers that even garments assembled domestically are pieced by "native" workers: "Authentic mud cloth vests. Very special natural hand-dyed cloth from Mali, Africa. The color that is painted onto the cloth comes from ground rock in the local area. Sewn in the U.S. by a native African women [sic], each is unique."[63]

Other outlets for the sale of bogolan emphasize African cultural identity, making the wearing of the cloth a personal statement rather than a means of experiencing an aspect of "exotic" cultures. *Ebony,* in cooperation with the clothing company Spiegel, encouraged African-American readers to "Show your pride in this patchwork cardigan made of authentic African mud cloth, Kente cloth and printed silk." [64] McCall's, a major producer of clothing patterns, used bogolan as a sample fabric for its 1995 "Afrocentric Extras" line of hats, shawls, belts, and head-ties. Clothing companies might declare their African-centered identities by offering bogolan fashions in catalogues whose names imply their identification with Africa as a source of cultural identity, such as "Homeland Authentics" and "NU NUBIAN." Here, bogolan vests, hats, ties, jogging suits, children's clothing, and myriad other garments are offered to Americans seeking to give their wardrobes a sense of traditional African identity. Whatever its connotations, from exotica to authentic African identity, bogolan's adaptations to contemporary American fashion rely heavily upon the cloth's associations with traditional cultures and traditional technologies.

Bogolan clothing's varied forms in Mali and in the United States point to its versatility and its visual potency, for the cloth retains its distinctive appearance even when stretched into diverse styles and media. Bogolan's many sartorial manifestations also illustrate the fertile ground that lies at the intersection of fashion and tradition, for in all of its myriad contemporary forms—from Alou Traoré's stenciled boubous to bogolan-patterned polyester jogging suits featured in an American clothing catalogue—the cloth's affiliations with "traditional" cultures are never severed. Bogolan is just one of the many African textiles whose adaptation to contemporary global fashion demonstrates the vitality of African clothing and textiles.

Indeed, contemporary fashion may enhance the relevance of indigenous African forms, extending their symbolic and formal power into entirely new contexts.

Notes

My research for this chapter was made possible by support from a variety of sources. Most recently, a Getty Foundation Curatorial Research Grant enabled me to conduct research on fashion history in Paris and New York City. My initial research in Mali (1992–93) was funded by a Fulbright-IIE Pre-dissertation Fellowship. At the University of Iowa, an International Programs Travel Grant and an Arts and Humanities Initiative Grant funded my work in Mali in 1997, and grants from the Rockefeller Foundation and the National Endowment for the Arts provided support for my exhibition on contemporary bogolan. I thank Dr. William Blair, who supported my travel to Mali in 2000 in preparation for that exhibition. My thanks also to many friends and colleagues in Mali, too numerous to name, but especially to the Sissoko family of Medina-Coura, Mr. Oumar Konipo, and Mme. Lalla Tangara Touré. Many thanks also to Jean Allman, for conceiving of and organizing this volume.

1. Stéphane Guibourgé, *African Style* (Paris: Flammerion, 2000), 7.
2. Guy Trebay, "Tortured Bodies: Vanity through the Ages," *New York Times*, November 13, 2001, A14.
3. Ozwald Boateng, "Ozwald Boateng: Exclusive Interview," interview by Nana-banyin Dadson, *Agoo* 1, no. 2 (April–June 2002): 32.
4. A boubou is a large, minimally tailored robe worn by men and women in many parts of West Africa. Similar garments, assigned different names, are worn in other parts of Africa. Kangas, associated with the Swahili Coast of East Africa, are rectangular cloths worn in pairs by women. Kangas are typically decorated with bold patterns and often with a printed proverb.
5. The terms "tradition" and "traditional" will be used here to refer to practices and objects that look primarily to the past for inspiration.
6. "Deux cents indigènes venus de plus lointaines provinces donnent á l'ensemble de la Section une note d'exoticisme de bon aloi qui attire . . . la foule. Les boubous blancs des Sénégalais, les manteaux bleus des Maures et les robes noires des Peulhs, voisinent avec les jupes en raphia des indigènes de la Côte d'Ivoire." Louis Valent, "L'AOF à Vincennes," *Le livre d'or de l'Exposition Coloniale Internationale de Paris* (Paris: Librairie Ancienne Honoré Champion, 1931), 85.
7. Francine Parnes, "Out of Africa, onto the Runways: Symbolism of Native Costumes Is Part of Universal Appeal," *South Coast Today*, June 9, 1997, n.p. *Kente*, strip-woven cloth adorned with elaborate, brightly colored patterns, has long been familiar to students of African textiles. Unlike bogolan, which in its rural, "traditional" forms is associated with initiatory contexts and ritual protection, kente is associated with royalty and social status in the kingdoms of the Akan (most notably the Ashanti) in Ghana and Côte d'Ivoire. For a detailed analysis of kente's production and its uses as a symbol of identity both in Ghana and in the United States, see A. Boatema Boateng, chapter 11 in this volume, and

Doran H. Ross, *Wrapped in Pride: Ghanaian Kente and African American Identity* (Los Angeles: UCLA Fowler Museum of Cultural History, 1998).

8. This acceptance of African clothing's influence without admitting it into the rarified realm of "fashion" has a direct parallel in the treatment of African sculpture in the early twentieth century. African sculpture, too, was a source of inspiration for Western artists long before it was admitted into the canon of world art.

9. Jennifer Craik, *The Face of Fashion: Cultural Studies in Fashion* (New York: Routledge, 1994), 18.

10. Eric Hobsbawm, "Introduction: Inventing Traditions," in *The Invention of Tradition*, ed. Eric Hobsbawm and Terence Ranger (New York: Cambridge University Press, 1983), 2.

11. Nakunte Diarra, a well-known bogolan artist, offers but one example of such innovation. A hunter's tunic in the collection of the University of Iowa Museum of Art incorporates a combination of patterns created by Diarra specifically for the commissioner of the tunic, an American resident of her town. Michael Annus, personal communication, 1995.

12. Angela Fisher, *Africa Adorned* (New York: Harry N. Abrams, 1984), 9–10.

13. John Tomlinson, *Cultural Imperialism* (Baltimore: Johns Hopkins University Press, 1991), 120.

14. Charlotte Seeling, introduction to *Fashion: The Century of the Designer (1900–1999)*, ed. Charlotte Seeling (Cologne: Könemann, 1999), 9.

15. I refer here to the regular spring and fall fashion shows at which designers introduce new work.

16. "L'anneé de toutes les modes, de tous les mélanges, de toutes les mixités. De l'Orient à l'Occident, de l'Arctique à l'Antarctique, de l'exoticisme au folklore, des passés recomposés aux années quatre-vingt." Dominique Brabec and Martine Silber, *La mode 89/90* (Paris: La Manufacture, 1989), 11.

17. "Globetrotting," *Style.com,* 2002, http://www.style.com/trends/trend_report/072902/index.html, accessed September 16, 2003.

18. This view is powerfully stated in the influential work of sociologist Georg Simmel, who in 1973 wrote that non-Western peoples fear novelty and change, so that "primitive conditions of life favor a correspondingly infrequent change of fashions." Quoted in Craik, *Face of Fashion*, 3. Historian Gilles Lipovetsky notes that fashion is "a way out of the world of tradition . . . the negation of the age-old power of the traditional past." Gilles Lipovetsky, *The Empire of Fashion: Dressing Modern Democracy,* trans. Catherine Porter (Princeton, N.J.: Princeton University Press, 1994), 4, quoted in Leslie W. Rabine, *The Global Circulation of African Fashion* (New York: Berg, 2002), 92–93.

19. Amy M. Spindler, "Prince of Pieces," *The New York Times,* May 2, 1993, section 9, 1, 13.

20. Clément Tapsoba, "Les signes du bogolan comme base de créativité," *Écrans d'Afrique* 24, no. 2 (1998): 99.

21. "Moi je suis un créateur contemporain qui connais techniquement ce que je peux faire et comment je peux le faire. Le bogolan peut être simplement une base culturelle." Chris Seydou, interview by author, Bamako, March 6, 1993.

22. Patricia McLaughlin, "Style with Substance: Black Style Is a Fashion Statement and a Political Statement," *Philadelphia Inquirer Magazine,* March 8, 1998, 18.

23. The Bamana or Bambara are the largest of Mali's many ethnic groups.

24. Specific information on the complex technique by which bogolan is produced

may be found in several sources, including Tavy Aherne, *Nakunte Diarra: A Bógólanfini Artist of the Beledougou* (Bloomington: Indiana University Art Museum, 1992); John B. Donne, "Bogolanfini: A Mud-Painted Cloth from Mali," *Man* 8, no. 1 (1973): 104–107; Victoria L. Rovine, "Bogolanfini in Bamako: The Biography of a Malian Textile," *African Arts* 30, no. 1 (1997), 40–51, 94–96, and *Bogolan: Shaping Culture through Cloth in Contemporary Mali* (Washington, D.C.: Smithsonian Institution Press, 2001); Sarah Brett-Smith, "On the Origin of a New *Tapis* Mud-Cloth Design," *African Arts* 27, no. 4 (1994), 16–17, 90, and "Symbolic Blood: Cloths for Excised Women," *RES* 3 (1982): 15–31; and Claire Polakoff, *Into Indigo: African Textiles and Dyeing Techniques* (Garden City, N.Y.: Anchor, 1980).

25. Aherne, *Nakunte Diarra*, 15.

26. The Institut National des Arts has, since the late 1980s, offered courses in bogolan techniques and symbolism.

27. My book *Bogolan* discusses many of the artists and merchants who have taken part in the tourist art and studio art markets for bogolan.

28. I later learned that the bogolan robe (or boubou) was made by Alou Traoré, an artist whose work is discussed below. The two stood in front of a market stall that sold both local medicinal products (animal parts and herbs used in indigenous healing practices) and bogolan bedspreads, robes, and shirts by Traoré.

29. Alou Traoré began making stenciled bogolan boubous in 1991. Interview by author, Bamako, Mali, March 3, 1993.

30. Marvin Cohodas, "Elizabeth Hickox and Laruk Basketry: A Case Study in Debates on Innovation and Paradigms of Authenticity," in *Unpacking Culture: Art and Commodity in Colonial and Postcolonial Worlds,* ed. Ruth B. Phillips and Christopher B. Steiner (Berkeley: University of California Press, 1999), 146.

31. The Bamana are not the only ethnic group associated with bogolan production, but they have been most closely linked to the cloth both in Mali and in non-Malian publications. In Mali today, members of nearly every ethnic group make bogolan, largely due to the cloth's marketability.

32. See, for instance, B. Marie Perinbam, *Family Identity and the State in the Bamako Kafu, c. 1800–1900* (Boulder, Colo.: Westview, 1997), 89, 232; and Pascal James Imperato and Marli Shamir, "Bokolanfini: Mud Cloth of the Bamana of Mali," *African Arts* 3, no. 4 (1970): 31, 34.

33. Brian Spooner, "The Authenticity of an Oriental Carpet," in *The Social Life of Things: Commodities in Social Perspective,* ed. Arjun Appadurai (New York: Cambridge University Press, 1986), 222.

34. I discuss this gender shift in *Bogolan.* My research on the subject indicates that the large increase in the number of men engaged in bogolan production since the late 1980s reflects the growth of markets for the cloth (largely in the tourist trade) and the reduction of the government bureaucracy that had provided employment for many educated young men.

35. Ci wara figures, carved wooden representations of antelope, are worn on the heads of male dancers at agricultural festivities in some Bamana regions. The sculptures have become prominent in tourist markets in Mali and neighboring countries.

36. For example, the ci wara appears on the façade of the national art school, on one of the stamps used to sign official documents, and formerly on the tail fin of the national airline's planes. In his use of such identifiably Malian motifs,

Traoré reflects the broad Malian celebration of local cultures evident in fine art as well as in the fashion markets. I discuss in *Bogolan* the contemporary use of the ci wara and other motifs as symbols of Malian culture.

37. The Groupe Bogolan Kasobane, a group of five artists who work collaboratively, have been using bogolan to adorn boubous and other garments since the mid-1970s. They created matching bogolan ensembles for members of social groups, to be worn at festivities. The other major creators of bogolan boubous are the members of another cooperative group, the Atelier Jamana.

38. Two researchers from the Musée National du Mali wrote a report on bogolan in 1985 in which they noted San's reputation for bogolan production. They described how residents of all ages and both genders took part in bogolan production, which, they feared, "runs the risk of becoming completely commercial." Youssouf Kalilou Berthe and Abdoulaye Konaté, *Un mode de teinture: "Le bogolan"* (Bamako: Musée National du Mali, 1985), 10.

39. Traoré is an extremely common surname in Mali. Moussa Traoré, who took power in a military coup in 1968, led a repressive single-party regime. The 1991 uprising, led by students and women whose children had been tortured by government agents, spurred an expansion of public discourse—newspapers and political parties exploded in number. The new government, however, faced severe financial challenges.

40. Traoré, interview.

41. Members of the Groupe Bogolan Kasobane have designed costumes for Djibril Kouyaté and Cheik Oumar Sissoko, including Kouyaté's *Tièfing* and Sissoko's *Guimba: Un tyran, une époque* and *Genèse*.

42. Kofi Ansah described how the group of three designers determined to inaugurate their new organization with a fashion show, held in Abidjan in the mid-1980s. Interview by author, Accra, Ghana, June 28, 2002.

43. "Chris Seydou," *L'essor*, no. 12673 (March 8, 1994): 4. The use of bogolan as a symbol of African American cultural identity is discussed below.

44. On his return to Mali, Seydou hired a graduate of the Institut National des Arts who had studied bogolan techniques with three members of the Groupe Bogolan Kasobane.

45. Macy Domingo, "Ciseaux d'Ivoire/Ivory Scissors," *Revue Noire* 2 (1991): 6.

46. Seydou, interview, March 6, 1993.

47. Pauline Awa Bary and Jean Loup Pivin, "Quelques dates d'une vie de Chris Seydou," *Revue Noire* 13 (1994), 56.

48. "Chris Seydou: Le roman d'une vie," *Africa International*, July–August 1994, 34.

49. Seydou, interview, March 6, 1993.

50. Maïmouna Traoré, "Chris Seydou: La mort d'une étoile," *Nyeleni* 5 (1994): 26.

51. Seydou, interview, March 6, 1993.

52. Ibid.

53. Chris Seydou, interview by author, Bamako, Mali, January 21, 1993.

54. Seydou, interview, March 6, 1993.

55. Seydou, interview, January 21, 1993.

56. "Textile Designs from Primitive Sources," *Lace and Embroidery Review/Dress Essentials*, May 1923, n.p.

57. Suzy Menkes, "The Real Thing: Celebrating Africa's Design Heritage," *International Herald Tribune*, October 28, 1997, n.p.

58. "Thomas Dekker (1572–1632)," in Fernand Braudel, *Capitalism and Material*

Life, 1400–1800, trans. Miriam Kochan (New York: Harper and Row, 1973), 234. The same cultural exchange via fashion is also evident within Africa: "The clothing traditions of the various ethnic groups and cultures are now shifting and interacting to create a new African aesthetic which includes an universal element. The people of coastal and central Africa now wear boubous and bogo-lan, while kente and raffia are now found in the countries of the Sahel." Aminata Dramane Traoré, "African Fashion: A Message," in *The Art of African Fashion,* ed. Els van der Plas and Marlous Willemsen (The Hague: Prince Claus Fund; Trenton, N.J.: Africa World Press, 1998), 8–9.

59. Personal communication, Violet Diallo, January 1993.
60. The pants are pictured in a fashion spread on Daryl K. in the *New York Times Magazine,* September 22, 2002, 81.
61. African Connexion catalogue, 1995, Gaddie McBride, Rentia Hobbs, and Elizabeth Klopper, Ferndale, Calif.
62. The J. Peterman Company, "Owner's Manual No. 36b," catalogue, summer 1995, 100.
63. Trade Routes: Alternative Market catalogue, winter 1995, 29.
64. Spiegel in association with *Ebony,* "E-Style," catalogue, summer 1994, 24.

11 African Textiles and the Politics of Diasporic Identity-Making

Boatema Boateng

Africans in the Diaspora have sought—in symbolic and material ways—to maintain their ties to their continent of origin ever since their forcible transportation to the Americas. Thus Diasporic Africans in different parts of the New World have sought to preserve their religions, languages, and clothing. More direct physical links have included various back-to-Africa migration movements since the United States' declaration of independence from Britain in the late eighteenth century, as well as political and economic collaboration between Africans and African Americans in the African nationalist struggles of the first half of the twentieth century, Black nationalist struggles in the United States in the 1960s, the anti-apartheid struggle in South Africa in the 1980s and 1990s, and the economic summits instituted in the 1990s.

This chapter examines the symbolic links established through the use of textiles by Diasporic Africans to create an African identity. Those links are not only part of the historical context outlined above, but are also mediated and affected by globalization in its current form of accelerated capitalist expansion. Against this background, this chapter examines the relationship between African Americans and Ghanaians in the production and use of cloth as part of a process that began with the African Diaspora and also as one instance of the cultural flows that are bound up with globalization.

This subject is one facet of an extremely large and complex issue—the issue of the appropriation and economic exploitation of the cultural production of indigenous peoples and of communities located mostly in the global South. African textiles represent one form of such cultural production that is increasingly being exploited in this way. This trend was a key factor in Ghana's inclusion of folklore in the country's revised copyright laws of 1985 and 2000. As defined by these laws, folklore is not limited to oral narratives and music but extends to items of material culture, including textiles. Indeed, the revision to the law has been partly attributed to the fact that imitations of local handmade *adinkra* and *kente* textiles were being mass-produced by East Asian textile factories without the payment of royalties to Ghana for the use of cloth designs that the country considered to be part of its culture (*Public Agenda*, 1996).[1]

Despite the existence of these laws and a growing movement calling for the in-

ternational protection of indigenous knowledge, the mass production of textiles imitating those from different parts of the African continent has continued. While acknowledging the fact that these textiles are appropriated and exploited in both the Ghanaian and United States markets, this chapter focuses on the United States market because of its importance as an incentive for the imitation of these textiles, and because of the issues it raises about relationships between Africans in different parts of the Diaspora.

In light of the historical links between continental and Diasporic Africans outlined above, it would be inaccurate to characterize African American use of pirated African textiles as the exploitation of a subordinate group by a dominant one. Instead, this chapter takes the stance elaborated by scholars like Lisa Lowe and David Lloyd,[2] who seek to refine the traditional Marxist analysis of global power in terms of center and periphery, arguing that the margins of global capital are not limited to specific geographic locations, such as Africa and Asia. Those margins are also found in the supposed centers of power. Thus much of the history of African Americans has been a history of oppositional struggle within the United States, from margins defined by a combination of race, class, and gender inequality. African Americans are therefore considered, in this essay, to occupy positions in the global economy that are analogous to those occupied by Africans. While there are clear exceptions in both groups, this is the situation of the majority. From such a perspective, Diasporic and continental Africans occupy similar locations in the global economy and their historical relationship with each other, as well as their production and consumption of culture, is mediated by that economy.

The chapter argues, therefore, for a resumption of political and economic collaboration between continental and Diasporic Africans around the production and use of culture—a collaboration that leads, in the case under discussion here, to consumer consciousness and activism within the African American market for African textiles. Currently, that consciousness is limited to a relatively small group of African Americans. For the most part, the African American community patronizes imitations of African cloth and other artifacts, often without realizing that they are imitations or that their purchase undermines the work of the African artisans who produce the originals. This practice is at variance with the concern that creates the demand for such African products in the first place, namely African Americans' concern to demonstrate pride in their African heritage and to draw attention to the richness of that heritage.

This call for consumer consciousness on the part of African Americans in their use of African products is not a new one. Indeed, as will be shown below, similar concerns have been expressed by some African Americans. Further, the latter's use of African textiles to create an African identity has been discussed by other scholars. Doran Ross, for example, has produced what might be called the bible of such identity creation with regard to kente in his project *Wrapped in Pride: Ghanaian Kente and African American Identity* (1998).[3] That project culminated in a museum exhibit and book in which the origins, production, and use of kente by both Ghanaians and African Americans are exhaustively documented. The goal of this chapter is to extend the discussion in light of Ghana's attempts to use copyright law to

stem the exploitation of adinkra and kente textiles, and to examine more closely the possibilities for achieving the kind of consumer activism that occurs around the cultural production of other communities at the margins of the global economy.

The chapter first examines the use of African textiles by African Americans in constructing an African identity for themselves. It considers the ways in which African identities have been presented in two African American magazines, *Ebony* and *Essence,* over the last decade. It then discusses Ghana's copyright protection of adinkra and kente textiles, drawing upon interviews with Ghanaian policy-makers and textile producers. Finally, it considers ways in which a new Pan-Africanism might include political action by African Americans and Ghanaians around cultural products.

Creating an Afrocentric Identity

Since their arrival in North America in the early seventeenth century, African Americans have drawn upon the aesthetics of their original homelands in defining a unique identity for themselves. As noted by White and White,[4] there was very little scope in the race and class arrangements that existed in North America from the early 1600s to the mid-twentieth century for transplanted Africans and their descendants to assert an overtly African identity. Thus upon their arrival in America, slaves' African clothing was almost immediately replaced by Western. However, African Americans put their own imprint on Western clothing in a variety of ways, wearing it in unique color combinations or defiantly wearing clothes of a higher quality than those prescribed for people of their class. White and White refer, for example, to the "African textile traditions, handed down and adapted by African-American women, that helped to shape the appearance of the antebellum slave community."[5] Those traditions were evident in the use of color in the cloth that these women wove and in the patterns of the quilts that they pieced.

The open expression of an explicitly African identity through the use of clothing is part of a much more recent political moment—that of civil rights, particularly the more militant forms that not only challenged the injustice of racism but went further to challenge the Eurocentrism of mainstream American society. The Black nationalist movement of the late 1960s and early 1970s saw African Americans defying this Eurocentrism in their clothing and hairstyles. During this period Maulana Karenga founded a Black nationalist organization, Us, whose members wore African clothing. Us reflected Karenga's principle of *Kawaida,* which "stressed that black liberation could not be achieved unless black people rejected the cultural values of the dominant society."[6]

That concern to assert a distinct African or Afrocentric identity continues today. The festival of Kwanzaa, founded by Karenga in 1966 and also based upon the principle of Kawaida, has become an important focal point for the expression of Afrocentric cultural identity and an integral part of mainstream African American society. According to Yousef and Spencer, Kwanzaa, which is celebrated annually from December 26 to January 1, was originally based upon East African harvest festivals.

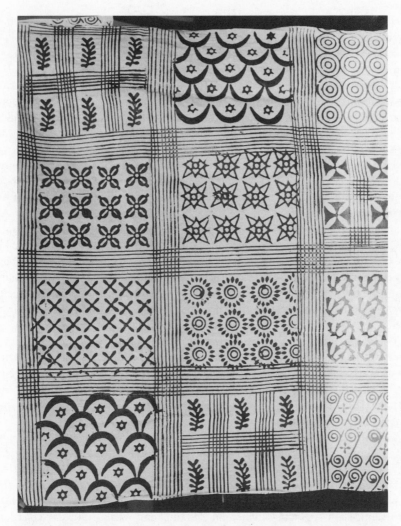

Figure 11.1. Section of hand-stenciled *adinkra* cloth from a specially commissioned piece showing several symbols. Normally only one or two symbols are used. Photograph by Boatema Boateng.

Each day of the week is devoted in turn to one of seven principles expressed in Swahili as follows: *umoja* (unity), *kuchagulia* (self-determination), *ujima* (collective work and responsibility), *ujamaa* (cooperative economics), *nia* (purpose), *kuumba* (creativity), and *imani* (faith). The celebration of the festival also involves the use of seven symbols: *mazao* (crops) that stand for the harvest, *mkeka* (the mat) for the foundation of tradition and history, *kinara* (the candleholder) for the African people, *muhindi* (ears of corn) for children, *mishumaa saba* (the seven candles) for each of the seven principles, *kikombe cha umoja* (the cup of unity), and *zawadi* (the gifts) for parenthood.[7]

The other national focal point for the expression of Afrocentric identity in the United States is Black History Month in February. During the celebration of both Kwanzaa and Black History Month, African Americans wear different kinds of African clothing, or simply accent Western clothing with accessories made from African fabrics and jewelry that use motifs and materials originating from or associated with Africa. The use of kente in such celebrations is exhaustively discussed in Ross's *Wrapped in Pride*. The Afrocentric rather than African nature of this identity creation is part of the reason for the limited knowledge that leads to the indiscriminate use of imitation kente and other African textiles. Intellectual and sartorial Afrocentrism are similar in that they draw upon all of Africa rather than from specific groups or traditions. Intellectually, this is a deliberate position that is stated by one of the primary theorists of Afrocentrism, Molefi Kete Asante, as follows: "by African I mean clearly a 'composite African' not a specific discrete African orientation which would rather mean ethnic identification i.e., Yoruba, Zulu, Nuba etc." Further, for Asante, the historical starting point of Afrocentric scholars or "Africalogists" is that of "the classical African civilizations, namely Kemet (Egypt), Nubia, Axum, and Meroe."[8]

The intellectual idea of a composite African finds concrete expression in popular notions of "the Motherland" and images of that Motherland in African American culture. While some African Americans opt for a "specific discrete African orientation"—by becoming Yoruba priestesses, for example—the general tendency is toward a composite. Thus the Motherland is simultaneously Ancient Egypt and the nineteenth-century Asante kingdom; it is Swahili and Yoruba; it tends to be traditional rather than contemporary, and it is often regarded as pure, heroic, or noble. For example, in a January 2000 *Essence* article entitled "The Roots of Wellness," African American Patricia Smith documents her trip to Ghana to try and "regain peace of soul and body by embracing the plain practices of the ancestors, still in place thousands of miles away." Smith rejects the Ghanaian capital as being too similar to the United States and finds "the plain practices of the ancestors" in the less urbanized north.

The preference for a composite, traditional, and pure Africa not only is justifiable in terms of the intellectual need to take Africa as a whole, but also makes practical sense for the descendants of enslaved Africans whose specific cultural origins were systematically devalued and erased as they were forced to abandon all their ways of remembering their identity through names, clothing, and religious practices. Further, for some Pan-Africanists the continent of Africa exists prior to

its national and ethnic groupings, and they maintain that the focus should be on the whole of Africa rather than on individual cultures within it.

Despite its merits, the focus on a composite Africa can sacrifice depth for breadth and can also homogenize Africa. Commenting on the use of kente, Nii O. Quarcoopome notes, "When coupled with buzz words like *rich, cultural, heritage, roots,* and *pride,* kente becomes a potent expression of Afrocentrism. Such a presentation does little to demonstrate the diversity in ethnic groups, colors, languages, and cultures that exist on the continent today."[9] An Afrocentric view can also freeze Africa in a golden past that bears little resemblance to the realities of contemporary Africa. Commenting on Kwanzaa in a December 1997 *Essence* interview, bell hooks makes a number of critiques including the following: "the other difficulty I have with Kwanzaa is the very fact that it doesn't exist in Africa. It's a fantasy Africa, but I'm much more interested in the real Africa." Despite such criticism, however, Afrocentrism remains an active philosophy, whether it is overtly articulated as a theoretical position or less consciously informs everyday cultural practice.

American popular magazines provide several examples of Afrocentric cultural practice. They showcase African or "African-inspired" fashions and accessories and may occasionally include a feature article highlighting some aspect of African life—usually in a way that presents it as the source of simpler or more wholesome practices that African Americans should draw upon. When I surveyed the December 1999 to December 2000 issues of *Essence,* I found a range of these. In the December 1999 issue, a feature on the family begins with an article on African rituals of community written by a Burkina Faso–born couple, Sobonfu and Malidoma Somé, in which they focus on African values of community that strengthen the institution of the family. Later in the feature the Rawlings family, Ghana's first family at the time, is presented as an example of a contemporary African family. The February 2000 issue offers a guide to different African masks and their meanings, while the April 2000 issue includes a feature on "fashions and elaborate designs from Africa." In the July 2000 issue African American interior designer Courtney Sloane presents a number of alternative decors and offers the following commentary on the African-inspired option: "Afrocentric interiors depend on natural textures, earth prints and patterns found in the Motherland. This wall is swathed in African mud cloth and hung with mirrors in bamboo frames." An August 2000 article on hair by Pamela Johnson makes reference to the symbolic use of hairstyles in Africa before slavery and in the present. In the lifestyle section of the December 2000 issue, there is a section on "sites celebrating African and African-American culture with books, movies, art, crafts, fashion and food." The "contemporary expressions of African culture" on offer include Ndebele design candles, mud-cloth wine bags, and a dinnerware and mug collection from the Ivory Coast called the Mombasa Collection. In these examples from *Essence,* kente and adinkra sometimes make an appearance. For example, in the December 1999 feature on the family, the sections on Africa are illustrated with photographs of a Ghanaian queen mother and Ghana's first couple—all wearing kente. In the September 2000 issue, an article on schools in Milwaukee includes a photograph of children and their teacher clothed in kente vests.

My examination of the December issues of *Ebony* and *Essence* magazines from 1990 to 2001 confirmed these trends in the use of kente and adinkra. I chose December because it has a relatively high level of Afrocentric cultural content, since Kwanzaa is celebrated during that month. Each magazine was examined for images of, and references to, kente and adinkra in articles and advertisements. These images and references supported the trends noted above about the ways in which the two textiles are used.

Adinkra barely made an appearance in the magazines studied. The two exceptions were in the December 2001 issue of *Essence* and the December 1993 issue of *Ebony*. In the former, an article on a series of travel films, including one on Ghana, made reference to adinkra stenciling at the town of Ntonso and was illustrated with a photograph of an adinkra maker at work. The article seemed to assume that its readers were familiar with adinkra, and did not explain the cloth or the symbolic images used in its production. In *Ebony*, an article entitled "Dreaming of a Black Christmas" was illustrated with a photograph of a family celebrating Kwanzaa. The mother was shown wearing a jacket made out of printed fabric incorporating the popular adinkra symbol "Gye Nyame" in its design, while her son wore a cap trimmed with kente. There was no mention of either of the two textiles in the text of the article.

Hand-woven kente appeared in *Ebony* most often in the form of stoles worn by men—including two ministers pictured wearing such stoles over their clerical robes, one in a December 2001 feature on mega-churches, and the other in a December 1995 article entitled "How to Put the Family Back into Christmas." An advertisement for Canadian Mist whisky in the December 1993 issue of the same magazine featured a male model wearing a hand-woven kente stole as part of formal evening attire. The December 1993 issue of *Essence* included an advertisement for the *Essence* catalog featuring a male model wearing a kente stole. An interview with Maulana Karenga in *Essence* in 1992 showed the Kwanzaa founder also wearing a hand-woven kente stole. In addition to stoles, hand-woven kente appeared twice in *Ebony* in the form of men's ties. In the December 2001 issue of the same magazine, actress Etta Moten Barnett was pictured wearing a hand-woven kente shawl during a visit to Ghana. Standing next to her was Ghana's former prime minister, Kwame Nkrumah, also clothed in hand-woven kente.

There was only one instance of hand-woven kente being used for an entire outfit, and that was in the December 1993 issue of *Essence,* where an advertisement for Ashanti perfume featured a female model wearing a dress made out of hand-woven kente. This indirect link between kente and the Ashanti—or Asante—people was the only reference in all the magazines I examined to the ethnic origin of kente cloth. In the few other cases where the origins of the cloth were mentioned, the reference was to Ghana or to Africa generally, even though the kente that appeared in most cases—with or without comment—was distinctly Asante in its motifs and color palette. Apart from clothing, hand-woven kente was used in the background of advertisements for Chevrolet and Kodak. The former appeared in the December 1995 and 1996 issues of *Ebony* and showed the seven symbols of Kwanzaa arranged on hand-woven kente cloth. The Kodak advertisement appeared in the December

1992 issues of both *Ebony* and *Essence* and featured a photograph of a child with a doll standing next to a Christmas tree with kente drapes in the background.

Most imitation kente was machine-printed; however, in a few cases the imitations were the machine-woven version commonly referred to in Ghana as "Spintex kente," after the factory that first produced it. Two examples of the use of Spintex kente as stoles for clerical robes appeared in the December 1994 issue of *Ebony* in a feature titled "Putting the Spirit Back into Christmas." In the same month, a picture of Ossie Davis in *Essence* showed him wearing a Spintex kente vest.

Printed imitations of kente also appeared in advertisements, both as a backdrop and as clothing for Afrocentric dolls. Such kente was used as the background of an advertisement for Blockbuster gift certificates that appeared in both *Ebony* and *Essence* in December 2001, and for Coca-Cola in *Essence* in December 1994. Printed kente also appeared in advertisements for "the world's most exotic dolls" from the Georgetown collection, in *Ebony* in December 1998; "Kids of Color" dolls from Playskool, in both magazines in 1993; "Hollywood Hounds" from Cultural Toys, in *Essence* in 1993; the "Imani African Princess" line of dolls from OLMEC in *Ebony* in 1992; and Margo Lynn dolls in *Essence*, also in 1992. In a departure from its use for backgrounds and doll clothing, printed kente appeared in the December 1998 issue of *Ebony* in a GTE advertisement highlighting the company's commitment to diversity. That diversity was portrayed in the form of a piece of patchwork incorporating sixteen squares of textiles representing different parts of the world. Apart from advertising, printed kente occasionally appeared as clothing. For example, an advertisement for an *Ebony* feature on actor Taurean Blacque in December 1990 showed him dressed in a red tracksuit with printed kente trim.

In almost all the examples above, kente was used without comment, appearing as a silent and immediately recognizable marker of Afrocentric identity, needing no explanation. This lack of comment was evident in articles referring to adinkra, such as the *Essence* travel article described earlier. In the one case where kente was mentioned, the reference was somewhat contradictory and did little to inform readers about the fabric. A December 1991 *Ebony* feature entitled "A Celebration of Black Identity Toys" included a photograph of dolls from OLMEC's Imani line with a caption that said of one, "she can be dressed in traditional African kente cloth, Caribbean style wide skirt or a contemporary mini." Despite this description and its suggestion that kente was only used in one of the three outfits, all three incorporated printed kente. Thus there was little besides skirt style and length to support the distinctions made between African, Caribbean, and contemporary clothing. Here, as in other cases, there was no reference to the source or meaning of kente, and no distinction between Asante and Ewe kente.

Of all the images and articles reviewed, only one made any reference to African cloth producers and the difference between their textiles and printed imitations. This was a 1997 feature on designer Ahneva Hilton in *Essence*. The article stated,

Unlike some designers of cultural clothing who rely solely on cotton African prints, Hilton employs authentic African weaves for her Ahneva Ahneva line—*rabbel* from Senegal, kente from Ghana, mud cloth and *korhogo* (her signature fabric) from Mali—

and marries them with organza, wool, silk and linen. Says the Chicago native, who sells from her gallery boutique in Los Angeles, "They're the richest fabrics for what I create." They have also been the catalyst for what she calls her personal sankofa: her sojourns to the Motherland to learn the art of cloth-making from master weavers. "It helped me develop an appreciation for cloth outside of fashion," she says.

In addition to its distinction between print and "authentic" African cloth, this passage is interesting for the way it mentions kente and mud cloth. Unlike the words *rabbel* and *korhogo*, the names of these fabrics are not italicized, suggesting that they are part of the English language. While this may be literally true and therefore unremarkable in the case of "mud cloth," the English translation of *bogolanfini*, it is striking in the case of kente and a further example of the way in which knowledge of kente seems to be generally assumed.

An article that made no reference to kente or adinkra but is important for its reference to West African artisans appeared in the December 2000 issue of *Ebony*. The article, entitled "Kwanzaa Becomes $700 Million Business," refers to the "wave of discomfort [that] washes over some people when they discover that many of the carved Kwanzaa items that they buy are not produced by Blacks." The article includes the following explanation of this fact:

> "When we started our company, I said I would only distribute pieces that were by artists who were of the culture," said Richard Todd, owner of Designs for Better Giving, one of the nation's leading distributors of Afrocentric greeting cards, artwork and Kwanzaa merchandise. "But when we checked into having our kinaras and unity cups produced on the West Coast of Africa, the price was just too exorbitant."

This comment raises the important issue of cost, which is a factor in the popularity of imitations of kente both in the United States and in Ghana. While the stoles and other accessories that use hand-woven kente require less fabric than the full ensembles that a Ghanaian would wear, they are still quite costly—especially after one takes vendors' overhead costs into account. The important point must therefore be made that imitations bring kente within the reach of the average person. That fact, however, does not undermine the right of producers of the original textiles to profit from their popularity and to keep their craft alive in the face of encroachment from cheap imitations. Ghanaian consumers resolve this tension somewhat by ranking these textiles in a hierarchy where the imitations have their uses, and the hand-woven originals have theirs. In the African American market, however, there is little such ranking and the two appear to be perceived as interchangeable.

Despite the offhand references to kente in *Essence* and *Ebony*, African Americans, for the most part, do not appear to have much knowledge of the African elements that they draw upon in creating an Afrocentric identity. A vendor of Afrocentric goods in Champaign, Illinois, whom I spoke with in October 2001, confirmed the generally low levels of knowledge of Africa among African Americans and added that some of her clients refuse hand-woven kente, protesting that it is not the real thing. She said, "I have two kinds of clients. The first kind want one good piece to add to their wardrobe; the latter just want something African to wear once during Black History month." She added that the second kind are the majority and have

very little knowledge of the African items that they buy. This vendor uses the term "cultural community" to describe African Americans like herself, who are knowledgeable about African culture, as distinguished from those like her second group of customers, who are not.

This lack of knowledge can partly be attributed to the composite Africa that makes up the Motherland in Afrocentrism and in the popular African American imagination. There are few sources of popular education about Africa and its history—even from an Afrocentric perspective. As Quarcoopome puts it, "knowledge about Africa has always been privileged, even among African-Americans."[10] The privileged few appear to be Afrocentric and Africanist intellectuals and members of the African American "cultural community." The limited knowledge on the part of the general African American populace has two main consequences. First, it leads them to buy mass-produced imitations of kente, adinkra, bogolanfini (or Malian "mud-cloth"), and other African textiles, thereby maintaining a business that results in little or no profit for the makers of the handmade originals in African communities. Second, they often use these textiles in ways that Africans and some African Americans consider demeaning. For example Betsy Quick, writing in *Wrapped in Pride* about the use of kente cloth for everyday objects, states, "there was in effect a line drawn in the sand; either kente was viewed as sacred, as special or it was viewed as anything you want it to be. Often Ghanaians took the former stance; African Americans, the latter."[11] The use of kente for items like umbrellas, beach balls, and furnishings is considered to degrade a cloth that is normally reserved for ceremonial use.

It is at this point, where for African Americans kente is "anything you want it to be," that the issue of globalization becomes most pertinent, for the kente in question is usually not the hand-woven product that is only obtainable from Ghanaian craftsmen, but imitations thereof. Within the global economy, sophisticated communications and reproduction technology give an advantage to producers who have the resources to quickly access market information and turn it to their advantage. Thus East Asian and other producers (some within Africa) undercut indigenous producers of kente, adinkra, and other handmade textiles. Their ability to profit from this is partly due to consumers' acceptance of their imitations. The relationships between African Americans and Ghanaians around cloth are thus mediated by these third parties, to the disadvantage of the original producers. Here are some of the comments of those original producers—Asante kente and adinkra makers—on the imitations of their cloth from interviews I conducted in 1999 and 2000 (I have given them pseudonyms):

Akosua (weaver): Ours [hand-woven cloth] is ours, there's a difference, and ours is better than theirs [machine-printed imitations], so when I see theirs I don't like it, and I don't have any of that type.
Kwame (adinkra maker): White people also make some and bring it, you see? But it is not up to the standard of ours . . . after all the white people have tried for a long time but they can't do it. . . . ours, the cultural one, is more beautiful than what they might import.

Kwabena (weaver): It is cheating; they are cheating our industry. . . . I remember once, Mandela, they say he went to America and he wore kente, he wore some kente jumper and wore it there. So when he got there the Americans were so happy and wanted some. A certain Ghanaian came and placed an order in Ghana. He waited for a large quantity to be made. This work too cannot be rushed. By the time he returned [to America] some country had taken a picture and sent it and the Abidjan people had made about three containers full and sent it there. His enterprise failed.

Kofi (weaver and adinkra maker): It is ugly! . . . if they use the machine, they must use their own work because they must not be allowed to come and take our designs.

Kwaku: They are spoiling our trade.

Yaw (adinkra maker): Since they did that [introduced the machine-made cloth] it has reduced [the demand and market for] ours.

Mensah (adinkra maker): Dumas [wax prints] and the Abidjan type, that is what has spoiled ours. When they come, they say "as for this, when you wash it, it doesn't fade." You see? So that's what they like. And that is what has made our work collapse.

Kojo (adinkra maker): Everyone wants money. You can't [issue a] decree preventing people asking them why have you made some [by machine] to sell. You see? There is no law against it.

For some of these kente weavers and adinkra makers, factory-produced imitations have had a direct impact upon their livelihood, while others are secure enough to dismiss the imitations as inferior and therefore not in direct competition with what they produce. Some members of this second group nonetheless see themselves being cut off from a wider international market by factory-produced imitations. Kwabena's anecdote about the Ghanaian entrepreneur who placed a large order for hand-woven kente being undercut by another person who simply ordered machine-made reproductions from Côte d'Ivoire expresses this concern and also echoes the Ghanaian government's motivation in protecting these textiles under copyright law. Kwabena also refers to the ignorance of American consumers as a factor in the second entrepreneur's ability to undercut the first, because, to the undiscriminating consumer, there is no difference between hand-woven and printed kente: "as for a white person when he's seen that it is the same, for him it is cloth, then he buys it." While Kwabena refers to Caucasian Americans, it is clear from the observations of Quarcoopome and others that his comment is applicable to many African Americans.

These craftsmen and -women (Akosua is one of the few women in a predominantly male trade) operate in the historical centers of adinkra and kente production in the Ashanti region of Ghana, in varying relationships to the international market. Producers like Kwabena and Kojo are individually more secure than other producers, because they have access to local tourist markets and are therefore able to sustain their livelihood despite the demand for imitations. However, their relationships to the outside market are quite different. Kojo has had several people

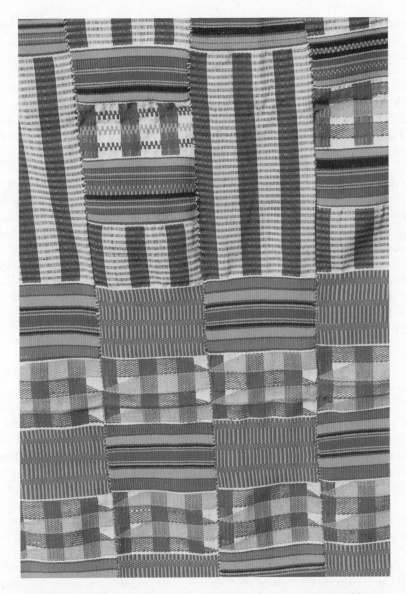

Figure 11.2. Detail of hand-woven *kente* cloth showing how strips woven in alternating plain-weave and double-weave blocks form a secondary "checkerboard" design when stitched together to form the final cloth. Photograph by Boatema Boateng.

come from Europe and North America to learn the craft of adinkra from him and he feels that the imitations are inevitable in an open market. Kwabena, however, strongly disapproves of the imitations even though his town sees a steady flow of tourists who help to sustain the industry. He contrasts the poor physical infrastructure of the town with the reputation that it has in Ghana and abroad as the center of kente production and considers that any income from the American demand for kente should come to the town rather than to outside entrepreneurs. It should also translate into improvements in the town, in its schools and other social amenities, and not just flow to individual producers.

The situation of these artisans puts the issue of the use of imitations of their work into a new light. Ultimately the choice between imitation and hand-produced African textiles translates into a choice between supporting or undermining the producers of those textiles. As the case of adinkra shows, the problem of imitations and their consequences for Ghanaian artisans is clearly both national and international. The international aspect of the problem is particularly important because of the magnitude of the potential hard currency revenues that the Ghanaian government and people lose when imitations of Ghanaian cloth are sold in the U.S. market without any of the earnings returning to Ghana. Also, cultural sovereignty is infringed when cloth designs that Ghanaians regard as part of their cultural heritage are appropriated and exploited without any respect for Ghana's prior claim as the country of origin of these designs.

The Copyright Protection of African Cultural Production

A glance at the "ethnic" or African prints section of a U.S. textile store or the selection of African textiles available through vendors in the African American "cultural community" makes it clear that East Asian, "Abidjan," and other kinds of imitation kente continue to proliferate, and equally that Ghana's copyright protection of its folklore is largely ineffective. The vendor in Champaign, for example, expressed surprise when I told her about the law, stating that when she enquired into the copyright implications of using an adinkra symbol as her business logo in the early 1990s she was told by U.S. officials that it was a folkloric item that had passed into the public domain—this after the Ghanaian law had been in existence for about five or six years.

Ghana's inability to gain international recognition and enforcement of its copyright law is due partly to the perception of folklore as belonging in the public domain, and also to the country's position in the international regulatory arena for intellectual property. An examination of the international intellectual property regulatory climate over the past twenty years demonstrates quite clearly that economic power translates into the power to change the meanings of intellectual property and to determine what can and cannot be protected as intellectual property. In a process that began in the 1980s with lobbying from knowledge-dependent U.S. corporations, intellectual property protection has shifted into the arena of international trade regulation. As a result of this process, new areas such as computer software and integrated circuits have come to be included in international copy-

right regulations. Indigenous knowledge and folklore, however, have yet to be included among the new forms of intellectual property, despite the fact that intellectual property laws such as patent laws are used by Western corporations in the appropriation of that knowledge. While it is debatable whether the international regulatory framework and, indeed, intellectual property as it is generally conceptualized are suitable for protecting such knowledge, they provide a short-term option. This appears to be the view of the Ghanaian government in using copyright law to protect traditional knowledge that does not always fit neatly within the category of copyright.

With the marketplace and market power having become key determinants of intellectual property protection, the African American market for African textiles could press for the protection of African cultural production such that producers benefit from—or are at least compensated for—its appropriation and mass exploitation. This is something that must be done in concert with African producers and consumers, for the Ghanaian state and other African governments with similar provisions need to be held accountable to their people in this. Under Ghanaian law the intellectual property rights to folklore are held by the state rather than by local producers. In the view of some of the kente and adinkra producers quoted above, however, the state is not trustworthy as the holder of these rights and as the custodian of their interests.

Ghanaian folklore producers are currently not sufficiently organized to hold the state accountable. For the most part they point with a certain resignation to the fact that they operate individually rather than collectively and therefore cannot easily form a lobby to protect their interests. Such lobbies could be created among both producers and consumers of Ghanaian folklore. African American consumers, in particular, can play a vital role here. That role requires a level of engagement that goes beyond economic interest to political commitment. A return to the Diasporic and continental solidarity that characterized the mid-twentieth century Pan-Africanist movement would be one way of achieving such engagement.

Pan-Africanism

Despite the difficulties it has encountered since its beginnings in the eighteenth century, the Pan-Africanist movement had one important feature that is worth aspiring to, and that is the way that Africans from around the Diaspora engaged with each other on concrete issues of African and Black nationalism. That commitment needs to be revived and to inform and deepen the political dimension of the broader intellectual, cultural, and economic forms of contemporary Pan-Africanism. Informed and activist African American consumer organizations acting in concert with African textile producers could join indigenous peoples in lobbying for broader definitions of intellectual property that include indigenous knowledge and folklore. A Pan-Africanist consumer lobby could also hold individual African nations accountable to the artisans who make the products that constitute their national heritage. The basis for such activism already exists in the concern on the part of members of the African cultural community to ensure that the

African products that they procure and sell are made by African artisans who bene-
fit from their sale. Such a lobby could play a crucial role in moving Africa beyond
its current status as a market and source of cheap labor in the global economy. In
so doing, it could also transform the myth of a glorious and strong Motherland
into reality.

Notes

1. *Public Agenda* (Accra), November 4–6, 1996.
2. Lisa Lowe and David Lloyd, introduction to *The Politics of Culture in the
 Shadow of Capital,* ed. Lisa Lowe and David Lloyd (Durham, N.C.: Duke Uni-
 versity Press, 1997), 2–3.
3. Doran H. Ross, *Wrapped in Pride: Ghanaian Kente and African American Iden-
 tity* (Los Angeles: UCLA Fowler Museum of Cultural History, 1998).
4. Shane White and Graham White, *Stylin': African American Expressive Culture
 from Its Beginnings to the Zoot Suit* (Ithaca, N.Y.: Cornell University Press, 1998).
5. Ibid., 23.
6. Waldo E. Martin, "Karenga, Maulana (Everett, Ronald McKinley)," in *Encyclope-
 dia of African-American Culture and History,* ed. Jack Salzman, David L. Smith,
 and Cornel West (New York: Macmillan Reference, 1996), 1526.
7. Nancy Yousef and Robyn Spencer, "Kwanza," in Salzman, Smith, and West, *En-
 cyclopedia of African-American Culture and History.*
8. Molefi Kete Asante, "The Principal Issues in Afrocentric Identity," in *African In-
 tellectual Heritage: A Book of Sources,* ed. M. K. Asante and Abu S. Abarry (Phila-
 delphia: Temple University Press, 1996), 256, 259.
9. Nii O. Quarcoopome, "Pride and Avarice: Kente and Advertising," in Ross,
 Wrapped in Pride, 194, emphasis in original.
10. Quarcoopome, "Pride and Avarice," 194.
11. Betsy D. Quick, "Pride and Dignity," in Ross, *Wrapped in Pride,* 252.

Afterword

Phyllis M. Martin

Clothing matters and dress is political. These are the grand themes that run through this collection of essays. Contributions on diverse societies with highly distinctive dress traditions affirm that everyday garments and high fashion, casual clothes and uniforms, voluminous robes and miniskirts, and a host of other styles may be terrains of power. If dress is a matter of individual choice, it can also mark larger group identity; if threatening, it can also express conformity; if worn by elites to assert rank, it may be a "weapon of the weak." It can help shape national identity or aid gendered empowerment. The case studies are distinctive in their time and place, in their protagonists, and in their local circumstances. They deal with societies experiencing substantial change in colonial, postcolonial, national, cosmopolitan, and diasporic situations. Yet, although these essays and photographs reveal dazzlingly divergent tastes and traditions, some common themes seem worth reiterating.

First, Africans have permeated dress with meaning for centuries. Colonial employees who spent their wages on clothing and children who went to school to acquire a shirt might have been attracted by opportunity and novelty, but they were grafting new garments onto older traditions of bodily adornment. Throughout the continent, social and cultural identities of ethnicity, gender, generation, rank, and status were conveyed in a range of personal ornamentation: garments made from raphia, cotton, bark, or leather materials; body paint, tattooing, and elaborate hairstyles; and accessories such as head coverings, footwear, fur, and jewelry. Nor were items of clothing necessarily of local provenance, for in many areas regional and international markets were long developed. Textiles crossed the Sahara to Sahelian populations.[1] West, Central, and East Africans embraced cloth from the East Indies and Europe as a marker of status. As raphia cloth had before, trade cloth became a means of exchange and a resource in social transactions, such as dressing the bodies of the powerful for sumptuous burials or giving bridewealth to the family of a prospective spouse.[2] Debates might shift over time but the language of dress in modern Africa resonates with cultural practices of the past.

Second, dress is a readily accessible statement about identity, a practical and immediate means of expression within the grasp of many. Colonial occupation in western Kenya triggered changes in Luo self-perception that were played out initially in dress. In substantial and telling ways individuals could make a statement about their social niche in periods of transition and transformation, or their aspirations to another position. Putting on a new garment is usually easier than learn-

ing a language. In Zanzibar, women implemented dress in new initiation rituals that incorporated different clothing styles derived from the mainland and from the Omani ruling class. Dress was critical in establishing common aspirations of membership in an emerging cosmopolitan society. Here, the poor who could not afford the fancy accouterments and tailoring of the Omani styles found patrons to help them out.

The sheer versatility of dress and the multifarious purposes to which it may be put are striking. For Abeokuta women who came together in the Women's Union it was a means of integration. They had a common interest in opposing colonial policies on a range of social and economic issues but they came from social milieus that made communication and cooperation difficult: Christian, Muslim, educated, non-literate, and market women. How might these differences, initially sites of tension, be overcome? Yoruba dress was traditionally an indication of an individual's socioeconomic status, and elite women wore better quality cloth than less wealthy members of society. During the colonial period, some might wear European dress in public. But developing a uniform dress code among the association's members was one way in which women blurred divisions and helped to empower themselves collectively. Likewise, in the American Midwest, Somali women have in their diasporic ethnic community chosen dress as an aid to integration, publicly recalling and imagining their disintegrated nation and signaling its continuing significance to each other and to the populations among which they live. If men in the homeland seem largely responsible for the break-up of the nation-state, women in the diaspora are engaged in mothering a common national identity through dress styles that express their cultural and religious values.

The versatility of dress is also demonstrated as it becomes increasingly commodified in the international market. African models, styles, and designs are employed and displayed by Western couturiers and glossy magazines. Shows in African cities such as Kinshasa incorporate colors and trends from Paris collections and influence the orders placed by elite women with their seamstresses. Through textiles and designs such as Malian *bogolan* or Ghanaian *kente* and *adinkra,* African and Western notions of fashion and identity interact and draw on each other for sources of inspiration, although at times with conflicted and compromised outcomes.

The visible and public face of dress makes it significant in the asserting of state power, yet uniforms, "asking to be taken seriously"[3] and projecting authority, can become subversive on the wrong bodies. In Tanganyika, colonial administrators who paraded in shows of uniformed force were alarmed by uniforms worn by the opposition nationalist party. Fearing the popularity of the organization so publicly displayed, the administration issued a "Political Uniforms Prohibition" that made it a violation for any person to wear "a uniform or distinctive dress which signifies association with any political organization or the promotion of any political objective in a public place or public meetings." Penalty for violation of the ruling included six months' imprisonment or a fine or both.[4] In Nigeria, too, where robe-giving by the politically powerful had long been a means of marking and maintaining hierarchy, the British introduced their style of military uniforms, which continued to

be worn by high-ranking officers as they moved into civilian political life in the postcolonial period. Yet uniforms could send the wrong message and become a liability as the political process turned to democratization, leading highly placed party dignitaries to dispense with their military garb and return to embroidered robes as markers of power. Not that a skeptical public, well versed in the politics of dress, were necessarily convinced that a change of clothes meant a change in priorities and policy, a situation that lent itself well to political cartooning.

The association of dress with both the physical body and the body politic is a potent combination. Being "taken seriously" may be as much an issue in the selection of everyday dress as it is in the wearing of uniforms. This seems to have been one aspect of the campaign by southerners to reform northern dress in postcolonial Ghana, where the nation-conscious elite tried to project their image of a "modern" state in debates about "appropriate" clothing. In so doing, they attempted to convert northerners, who wore few garments but marked status, gender, and age with skins, beads, and leaves, to their dress styles. A discourse on "nudity" and its national implications appeared in parliamentary proceedings, official reports, and the southern press. At the same time, elite southern women saw dress as a medium through which to lead northern women to a different understanding of social improvement.

Thus dress in its public and visible form may be threatening to observers and even dangerous for wearers. As sensibilities about gender, sexuality, age, and status converge, the dressed (or undressed) body may be a site of contestation. Opinions on dress may differ widely between wearers and observers and incite all kinds of emotions as values, morality, and religious belief permeate perceptions of what is appropriate, especially in times of social transformations. In Congo-Brazzaville, dress has in recent decades become an arena of struggle and a means of resistance for unemployed young men who, building on preexisting clothing traditions, create new and fanciful styles that contest their marginalization. Under the Marxist regime of the 1970s and 1980s, their fashion-consciousness became the basis for a counter-culture. It was and is a "cult of elegance" that has spread through immigrant groups to Paris and been taken up in other parts of West and Central Africa as an alternative culture with its own rules and expectations.[5] Yet it is women who primarily carry the burden of cultural sensibilities when issues of power, control, and sexuality converge on their dressed bodies. In Zambia, Tanzania, and elsewhere in the context of rapid urbanization, debates on the place of women in the workforce, and gendered issues of freedom and control, a miniskirt can attract opprobrium and even violent retribution on its wearer.

Finally, the exploration of dress as political culture challenges us to think through some of the issues in the literature, interdisciplinary, comparative, and theoretical. The relevance of the topic to the fashioning of power has been suggested in the introduction and vividly demonstrated in the essays. They have a great deal to tell us about the limits of hegemony; about the working out of tensions within and between societies on local, national, and international levels; about the importance of middle grounds; about the overlap of terrains and the fluidity of categories. The essays also alert us that in our predilection for negotiation as an analytical tool, we

may diminish lived experience that involves stands taken and shame and violence suffered. If these essays speak of the limits of hegemony, some also show the limits of negotiation. Nor should we forget informants who speak seriously and proudly of their dress but who also convey the pleasurable, funny, and "feel-good" aspects of creating and wearing clothes. Dress is symbolically powerful, made all the more so by its monetary, emotive, moral, and aesthetic implications. Power resides in unexpected domains.

Notes

1. Paul E. Lovejoy, *Transformations in Slavery: A History of Slavery in Africa* (Cambridge: Cambridge University Press, 1983), 103–107.
2. Phyllis M. Martin, "Power, Cloth, and Currency on the Loango Coast," *African Economic History* 15 (1987): 1–12.
3. Paul Fussell, *Uniforms: Why We Are What We Wear* (New York: Houghton Mifflin, 2003), 3.
4. Susan Geiger, *TANU Women: Gender and Culture in the Making of Tanganyikan Nationalism, 1955–1965* (Portsmouth, N.H.: Heinemann, 1997), 159–60.
5. Justin-Daniel Gandoulou, *Dandies à Bacongo: Le culte de l'élégance dans la société congolaise contemporaine* (Paris: L'Harmattan, 1989); C. Didier Gondola, "Dream and Drama: The Search for Elegance among Congolese Youth," *African Studies Review* 42, no. 1 (1999): 23–48.

Contributors

Heather Marie Akou is a Ph.D. student in Design, Housing, and Apparel at the University of Minnesota. Her essay was drawn from her M.A. thesis, "Rethinking Fashion: The Case of Somali Women's Dress in Minneapolis–St. Paul as an Evaluation of Herbert Blumer's Theory on Fashion."

Jean Allman teaches African history at the University of Illinois. She is author of *The Quills of the Porcupine: Asante Nationalism in an Emergent Ghana* (1993) and, with Victoria Tashjian, *"I Will Not Eat Stone": A Women's History of Colonial Asante* (2000). She recently edited and introduced *Women in African Colonial Histories* (2002) with Susan Geiger and Nakanyike Musisi. Her research on gender, colonialism, and social change has appeared in the *Journal of African History; Africa; Gender and History;* and *History Workshop Journal.*

Boatema Boateng is Assistant Professor of Communications at the University of California, San Diego. Her research interests include global cultural flows and their regulation.

Judith Byfield teaches African history at Dartmouth College. She was guest editor of a special issue of *African Studies Review,* "Rethinking the African Diaspora," and is author of *The Bluest Hands: A Social and Economic History of Women Dyers in Abeokuta (Nigeria), 1890–1940* (2002). Her research primarily focuses on women's social and economic history and nationalism in colonial Nigeria.

Laura Fair is Associate Professor of History at the University of Oregon. Her first book, *Pastimes and Politics: Culture, Community, and Identity in Post-abolition Urban Zanzibar, 1890–1945* (2001), explores the social history of various forms of urban culture, including dress. She is currently working on a history of commercial cinema in colonial East Africa.

Karen Tranberg Hansen teaches anthropology at Northwestern University. She recently completed research into the international trade in, and consumption of, secondhand clothing in Zambia, with specific focus on exploring the nature of local clothing "theories." Her most recent book from this research is *Salaula: The World of Secondhand Clothing and Zambia* (2000). Her *Keeping House in Lusaka* (1997) is based on longitudinal research in a low-income area on household dynamics, gender, and work. She is continuing her research in Lusaka with a focus on youth as part of a collaborative project with colleagues from the University

of Copenhagen entitled *Youth and the City: Resources, Skills, and Social Reproduction.*

Margaret Jean Hay teaches African history at Boston University and is editor of the *International Journal of African Historical Studies.* She has edited and introduced two collections on African women (*African Women South of the Sahara* [1984, 2nd ed. 1995] with Sharon Stichter, and *African Women and the Law: Historical Perspectives* [1982] with Marcia Wright), and recently edited and introduced *African Novels in the Classroom* (2000).

Andrew M. Ivaska is Assistant Professor of History at Concordia University in Montreal. He recently completed a doctoral dissertation at the University of Michigan entitled "Negotiating 'Culture' in a Cosmopolitan Capital: Urban Style and the State in Colonial and Postcolonial Dar es Salaam." With research interests in the cultural politics of African cities, he has written on cinema, modernity, and youth in twentieth-century Tanzania.

Phyllis M. Martin teaches African history at Indiana University. Issues of cloth, dress, and fashion have been important aspects of her publications, including *The External Trade of the Loango Coast, 1576–1870: The Effects of Changing Commercial Relations on the Vili Kingdom of Loango* (1972); *Leisure and Society in Colonial Brazzaville* (1995); articles in the *Journal of African History, African Economic History,* and *Muntu;* and a chapter in *Macht der Identität–Identität der Macht: Politische Prozesse und kultureller Wandel in Afrika,* edited by Heidi Willer, Till Förster, and Claudia Ortner-Buchberger (1995). She has edited with Patrick O'Meara *Africa* (1977, 2nd ed. 1986, 3rd ed. 1995), and with David Birmingham *History of Central Africa* (three volumes, 1982–98), and is a former editor of the *Journal of African History.*

Marissa Moorman is a Ph.D. candidate in African History at the University of Minnesota. She is presently writing her dissertation, entitled "'Feel Angolan with This Music': A Social History of Music and the Nation, Luanda, Angola, 1945–75."

Elisha P. Renne is Assistant Professor in the Department of Anthropology and the Center for Afroamerican and African Studies, University of Michigan. She is author of *Cloth That Does Not Die: The Meaning of Cloth in Bunu Social Life* (1995) and co-edited *Regulating Menstruation: Beliefs, Practices, Interpretations* (2001) with Etienne van de Walle, and *Population and Development Issues: Ideas and Debates* (2000) with J. A. Ebigbola. Her research on the anthropology of cloth, gender, religion, and social change has appeared in the journals *Africa Today; African Arts; Economic Development and Cultural Change; Ethnology; Journal of the Royal Anthropological Institute;* and *RES.*

Victoria L. Rovine is Curator of the Arts of Africa, Oceania, and the Americas at the University of Iowa Museum of Art. She has conducted research on urban art

markets in Mali, focusing on the intersections between fine art, tourist art, and fashion. Her book *Bogolan: Shaping Culture through Cloth in Contemporary Mali* (2001) examines the current revival of a distinctively Malian textile associated with the country's traditional cultures.

Index

Diasporic Africans, textiles creating an African identity in, 1, 212–214, *215*, 216–222, *223*, 224–226
Dinka peoples, 189
Dior, Christian, 201
Dirac, 54, *57*, 58
Disease, Western clothing covering signs of, 77
Diwani, Rajabu, *106*
"Django" letter, 110
Djibouti, Somali refugees in, 56
Domestic violence, incidence in Zambia of, 175
dos Santos, Jacques, 89
Doumbia, Seydou Nourou, 201
Drake, St. Clair, 144, 149–150, 154, 156, 159
"Dreaming of a Black Christmas," 218
Dress and fashion: anthropological/ethnographic approach to, 2; as an archive, 4–5; cultural/historic approach to, 2; defined, 146, 161n7; dress, defined, 32, 45n3; ethnicity and role of, 13, 227; Eurocentric vision of, 2–3; fashion as energetic change, 192; as indication of status, 13, 227; as between individual self and public, 5, 230; interaction between "fashion" and "tradition" in, 193; as a local and vernacular language, 6, 227; as marker of class, 13, 227; non-Western dress as costume in, 191; pleasurable aspects of, 230; as political praxis, 6; as unity and/or difference, 7, 227; "vernacular modernities" of, 3; western dress as fashion in, 191. *See also* African garments and *specific countries*

Earth priests, 147, *148*
East Africa: Somali refugee camps in, 50; *unyago* initiation ceremonies practiced in, 21–22
Ebony, 206, 214, 218, 219, 220
Ede & Ravenscroft Ltd., 133, *134*
Edun, Adegboyega, 35
Edusei, Krobo, 152
Egba Council, 40, 43
Egbas, 34, 35, 38, 47n26
Egypt, Islamic pilgrims from, 53
Eicher, Joanne, 2, 32, 33, 51
Eid-el-Fitr, 128–129
Elizabeth, 132
Elliot Commission, 36
"Embodied identities," 3, 4
Embroidery: *babban riga* embroidered robes in Nigeria, 125–126; in Yoruba clothing, 33–34
Entwistle, Joanne, 1–2, 9n6
Essence, 214, 216, 217, 218, 219, 220
Ethiopia: colonization of Somalia by, 53; Ogaden region of, 55; regime of Haile Selassie of, 55; Somali refugees in, 56

"Eurocentrism in the Study of Ethnic Dress" (Baizerman, Eicher, and Cerny), 51
Ewe kente, 219

Fabrics/textiles: barkcloth in, 110; calico cloth in, 34, 80n23; consumer lobby for integrity of, 225–226; copyright protection of African prints in, 212, 214, 224–225; in cotton damask used in Nigeria, 136; creating an African identity with, 212–214, *215*, 216–222, *223*, 224–226; early Somali trade for, 52–53; European cloth as Yoruba *olaju*, 34; factory-produced imitations of, 221–222, 224; *garbasaar* in, 54; globalization of African textiles in, 189–207; indigo dyers in Abeokuta, Western Nigeria, 39, 40; kente cloth in, 51, 190, 207–208n7; khaki associated with government changes in Nigeria, 125–140; *mabela zole* from Portugal, 96; Manchester prints in, 34; for marinda pants, 26; *merikani* cloth in, 14–15, *15*; Obasanjo lace in, 136; of Somali material, 57; velvet used in Nigerian ceremonial robes, 126–127, *134*; Yoruba clothing and aesthetics of, 33–35. *See also Bogolan*
Fadipe, N. A., 35
Falconer, J. D., 129
Fédération Africaine de Prêt à Porter, 200
Feminism, efforts of Hannah Kudjoe in, 157
Fez: distinguishing Africans from British military personnel, 130; of *tendaanas* in Ghana, 147, *148*; worn by Kenyan leaders, 69, *76*
Fisher, Angela, 192
"Folk dress," 3
Foot/feet: bare feet during *kunguiya* dance, 26; barefoot slaves in Zanzibar, 15
"The Fornicators," 74
Foucault, Michel, 167
Fourah Bay College, 36
France: colonization of Somalia by, 53; national dress of, 51; occupation of Algiers by, 130
Freeman, Stanhope, 130
Fry, Mary, 51
Fundah, king of, 127
Fur, body ornamentation with, 227

Gambia, foodstuffs from, 39
Garbasaar, 50, 54, *57*, 58, 59
Gays, Mohamedan costumes worn by, 33
Gbadebo, 43
Gele, 32, 41
Gender: in adornment of men and women in Angola, 98–99; differential regulation of gendered bodies in, 167–168; dress and relations in Zambia, 166–169, *169*, 170, *170*, 172–173,

Ilorin Province, Nigeria, 39
Imani, 216
"Imani African Princess" dolls, 219
Incest, incidence in Zambia of, 175
India: British colonial uniforms in, 131; *sari* wear in, 54
Industrie Textile du Mali (ITEMA), 204
Ingwe, Chief, 169
The Invention of Tradition (Hobsbawm and Ranger), 191
Iran: *chador* garments of, 60; government based on Islamic law in, 59; Muslim dress in, 59; *rupush-rusari* form of dress in, 55
Iranian Revolution, 55
Iraq: Islamic pilgrims from, 53; Muslim dress in, 59
Irobinrin, 32, 41
Islam: conversion of Somalis to, 52; as form of resistance against colonial rule, 54; Mecca as center for resistance to colonialism, 53; transformation of rituals in Zanzibar, 16, 20, 24
Italy: colonization of Somalia by, 53; Somali refugees in, 50, 56
Ivory, trade for, 52
Ivory Coast, 217
Iya egbes, 38–39, 48n43
Iyalode, 40

Jagger, Bianca, 200
Jeuri, Mohamed, 112
Jewelry: early Somali trade for, 52–53; materials used, 52–53; in the *ndege* dance, 26; as personal ornamentation, 227; as portable wealth of Somali women, 52–53; role in dress, 32
Jilbaab (jelaabib), 50, 55, *57,* 58–60
Jina, on *kangas,* 24
Johnson, G. W., 35
Johnson, Oshokale Tumade, 35
Johnson, Pamela, 217
Johnson, Samuel, 32, 34
Johnson-Odim, Cheryl, 39
Jojolola, Madam, 40
Jordan, *jilbab* garments in, 55
Joseph, Japuonj, 72
Juma, Bakia binti, 22

Kaduna, Nigeria, 137
Kaffiyeh, 61
Kaftans: in postcolonial Nigeria, 136; tazarce style in Zaria City of, 137, *138;* in Western wear, 190
Kanga za mera, 18–19, *19,* 20
Kangas: as fashionable traditions, 189, 207n4;

limited editions of, 19; worn by Zanzibari women, 19, 23–24, *24,* 28
Kangwa, Charity, 179
Kankasa, Chibesa, 171–172
Kano, Nigeria, 137
Kano Chronicles, 128
Kanzu, 16, *16,* 18, *19,* 68, 69
Kapwepwe, Simon, 169
Karenga, Maulana, 214, 218
Kaunda, Betty, 169, *170, 173*
Kaunda, Kenneth, 169, *170*
"Kavirondo," 73
Kawaida, 214
Kelley, Robin D., 84, 93
Kemet, 216
Kente cloth: "Abidjan" imitation of, 224; ethnic symbolism of, 51; hand-woven example of, *223;* Western fascination with, 5, 8, 190, 206, 207–208n7, 212, 214, 217, 228
Kenya: ban of miniskirts in, 166; Somali refugees in, 50, 56. *See also* Western Kenya
Khaki: in British uniforms during colonial rule of Nigeria, 7, 129–131, *131,* 132, 228–229; in clothing of Western Kenya, 68, 69, 72–73, *76;* historical association of, 125; Nigerian local sources of, 135
Khimar, 55, *57,* 58
"Kids of Color" dolls, 219
Kikombe cha umoja, 216
Kilemba, 15–16, *16,* 25, *25,* 26
Kimbundu, tradition and language of, 90, 91, 94
Kinara, 216
King's African Rifles, 130
Kiswahili, 27, 111, 112
Kodak, kente cloth used in ad of, 218–219
Kofia, 16, 18, *19*
K'Ogwaw, Opiyo, 73
Koita, Habib, 200
Konde, Hadji, 112
Korhogo, 219, 220
Kouyaté, Lamine, 193
Kuchagulia, 216
Kudjoe, Hannah, *155, 158, 159;* anti-nudity campaigns in Ghana by, 144, 145, 146, 149, 152, 155, *155;* promoting economic self-help of women by, 155–156, 160; view of nudity as economic problem in Ghana by, 153–155, *155*
Kufi, 61
Kunguiya: dance movements of, 27, 30n36; *kangas* worn by Zanzibari women in dance of, 23–24, *24;* in public initiation dances in Zanzibar, 23–24, *24,* 25, *25,* 26–28
Kungwi, 21

Said, Seyyid, 14, 17, 20–21
Saint-Laurent, Yves, 200
Salaula: The World of Secondhand Clothing and Zambia (Hansen), 3
Salme, Seyyida, *17, 18*
Salum, Nunu binti, 26
Samuel, J. H., 34–35
Sandals: of fashion/status conscious in Zanzibar, 16; with uniforms of Nigerian recruits, 130, *131*
Santocas, *96*
Sari, 54
Sarongs, 190
Saros communities in Nigeria, 33, 35
Saudi Arabia: Somali refugees in, 50, 56; use of *niqab* in, 59
Schuster, Ilsa, 171
Scotland, national dress of, 51
Seck, Djeneba, 200
Secondhand clothing, international trade of, 155, 156, 157, 158–159, 166–167
Selassie, Haile, 55
Senegal, 219
September 11, 2001, events of, 59
Sexual violence, incidence of, 174–175
Sexuality: associated with women wearing mini-skirts, 166; expression in *mkinda* of, 23
Seydou, Chris: as an African designer, 190, 202; death of, 200; fashion studies in Paris of, 201–202; modifications in making *bogolan* patterns by, 202–203, *203*; preserving *bogolan* techniques by, 202; view of *bogolan* as international fashion by, 197, 200–201, *201*, 202–203, *203*, 204
Shadle, Brett, 75, 77
Shagari, Shehu, 135
Shash, 59
Shibwalya-Kapila, Chief, 169
Shija, Andrew, 111
Shoes/boots: of chiefs in Western Kenya, *76*; effects on Yoruba clothing attire, 34, 46n18; the *pé descalço* in colonial Angola, 88; as personal ornamentation, 227; puttees worn by soldiers in the Nigeria Regiment, 130; as source of pride for Nigerians, 130
Shonekan, Ernest, 135–136
Shuka, 55, *57*, 58
Sierra Leone: Creole dress reform movement in, 34; foodstuffs from, 39; Saros settlement in, 33
Sijaona, M. L., 104, *106*
Siliya, Dora, 178
Silver, 52

Skins/animal skins: as dress in northern societies of Ghana, 146, 161n7; worn by Kenyan men and leaders, 68, 69, 70, 75, *76*, 77
Slaves/slavery: African dress and fashion during, 5; African textile traditions in, 214; clothing of slaves in Zanzibar, 14–15; female puberty *mkinda* after abolition of, 21–24, *24*, 25, *25*, 26–28, 29n22; North Atlantic trade of, 3; shaved heads of both genders in, 15, *15*; transformation of Islamic rituals by, 16, 52; Zanzibar abolition of, 13, 16, 17, 19–20
Sloane, Courtney, 217
Smith, Patricia, 216
"Socialist," letter, 114
Sodeinde, Bisi, 37
Sokoto province, Nigeria, 39, 128
Solanke, Ladipo, 36
Sole Native Authority, 32, 43–44
Somali national dress: adoption of Middle Eastern *shuka* and *khimar* in, 55, *57*, 58; "Arabization" of, 59; "cultural" dress styles of, 57, *57*; *dirac* in, 54, *57*, 58; *garbasaar* in, *57*, 58, 59; *gorgoro* in, *57*; *hijab* in, *57*; history of, 52–56; *jilbaab* (*jelaabib*) in, *57*, 58–60; leather garments in, 52; *masar* or scarf of, 56–57, *57*; as nationalism without a nation, 52, 228; *niqab* in, *57*, 59; "religious" style of, *57*, 58–59; *saalwar qamis* of, 54; *shash* in, 59; for wedding celebrations, 57, 58, *58*; wrapper sets in, 54
Somalia: Arab influences on, 52–54; arrival of Western styles of wear in, 54–56; *buona costuma* police division in, 54–55; collapse of national government in, 50–51, 55–56; colonization of, 53; "dervishes" in, 53; dress styles and growth of Islam in, 55–56; early trade for cloth/clothing and jewelry, 52–53; history of Somali dress in, 52–56; independence of, 54; military coup of government in, 55–56; Mogadishu as capital of, 54; national clothing as resistance to colonial rule, 50; refugees from, 50–51; rule by Barre of, 55; style of dress for men in, 55
Somé, Malidoma, 217
Somé, Sobonfu, 217
Sorunke, E. B., 43
Soviet Union, Somali Cold War involvement with, 55
Sowunmi, Mrs. O., 37
Soyinka, Wole, 37, 39, 43
Spencer, Robyn, 214
Spiegel, 206
"Spintex kente," 219
Spooner, Brian, 197

1455

desires and women's dressed bodies in, 178–180; response to appearance of miniskirts in, 168–169, 171, *171*, 172, 173–175, *176, 177*, 178; "Sally's Boutique" in, 174; sexual violence in, 174–175, *176*; "smart casual dress" directive in, 182; stripping incidents in, 174–175, 175, 182; United National Independence Party (UNIP) in, 169; Women's Brigade of, 169, 170, 171; Women's League of, 171

Zambia National Broadcasting Corporation, 178

Zanzibar: abolition of slavery in, 16, 17, 19–20; adoption of *mtindo wa kiparisi* ("fancy dress") in, 25, 26, 28; African photographers in, 70; Arab aristocracy in, 13, 21; cosmopolitanism of women in, 13–14; dress as transformation of identity in, 13–15, *15*, 16, *16, 17*, 18, *18*, 19, *19*, 20–24, *24*, 25, *25*, 26–28; female puberty ritual of *mkinda* in, 21–24, *24*, 25, *25*, 26–28, 29n22; freeborn Swahili in, 16, *16*; as historic city of trade, 14; Islamic law and East African customs in, 20; "mixed children" in, 20; *mstaarabu* as cultured or civilized in, 27; *nguo za kiarabu* costumes of, 25, *25*; Omani ruling class in, 15–16, *16*, 228; as the "Paris of East Africa," 19; ritual and public performance of elite women in, 21–24, *24*, 25, *25*, 26–28; "Swahili" dress of, 18–19, *19*, 20; women's puberty initiation ceremonies in, 13, 228

Zaria City, Nigeria, 128, 137, *138*

Zawadi, 216

Zouaoua, 130

Zouave uniform, 130, 135, 139